W9-BBM-793

BARNETT NEWMAN

Paintings · Sculptures · Works on Paper

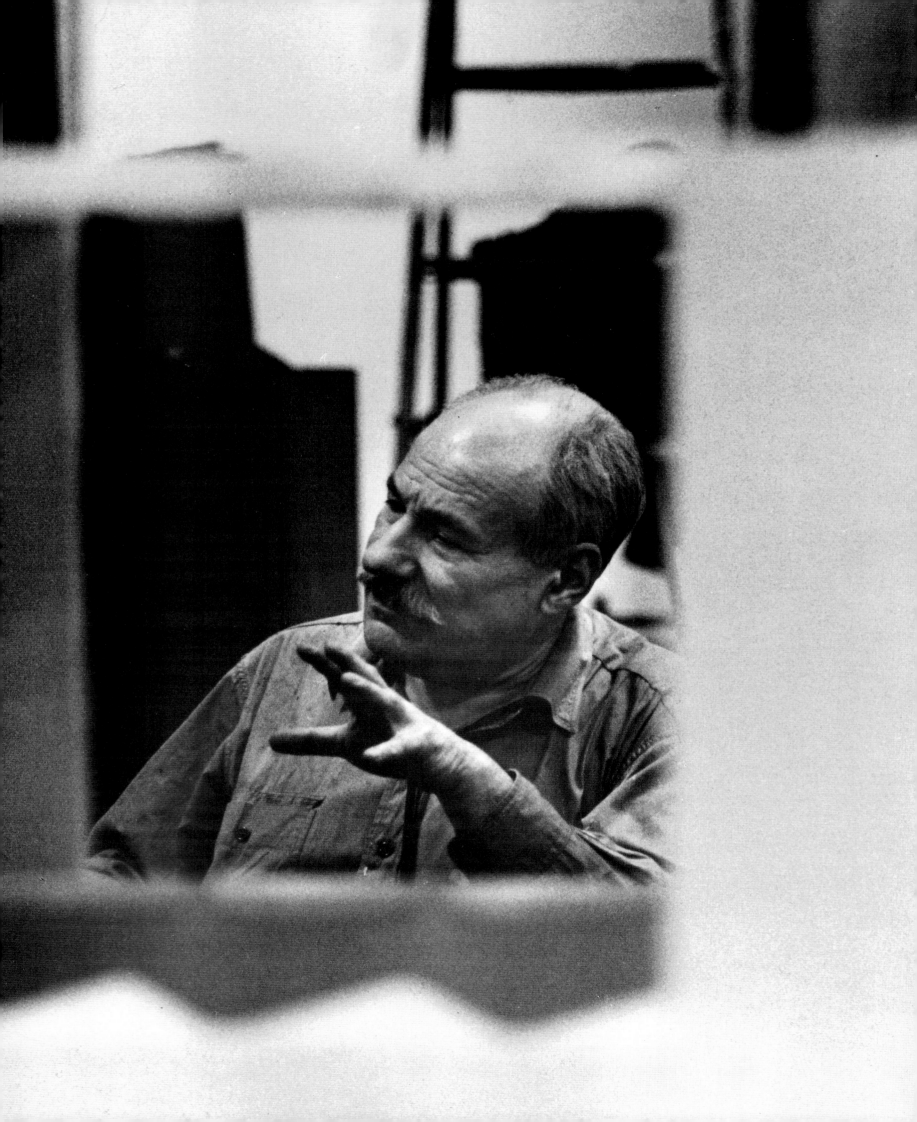

BARNETT NEWMAN

Paintings · Sculptures · Works on Paper

Armin Zweite

HATJE CANTZ PUBLISHERS

Author:
Armin Zweite

Graphic design:
Konnertz Buchgestaltung, Cologne

Jacket design:
Saskia H. Rothfischer

Printed by:
Dr. Cantz'sche Druckerei, Ostfildern-Ruit

Revised edition of the original German-language publication
Barnett Newman · Bilder · Skulpturen · Graphik, 1997

The English-language edition of this volume was translated from the German by John Brogden
with a grant from The Barnett Newman Foundation, New York. The English version was edited by
Jane Bobko of The Barnett Newman Foundation

Jacket illustration:
Barnett Newman, "Untitled (Number 2)", 1950 (Cat. No. 7), The Menil Collection, Houston
Frontispiece:
Barnett Newman, photographed through one side of his Model for a Synagogue, 1963

Published by:
Hatje Cantz Publishers
Senefelderstraße 12
D-73760 Ostfildern-Ruit
Tel. 0049/711/4405-0
Fax 0049/711/4405-220
Internet: www.hatjecantz.de

Distributed in the US by:
D.A.P., Distributed Art Publishers, Inc.
155 Avenue of the Americas, Second Floor
New York, N.Y. 10013-1507
Tel. 001/212/6271999
Fax 001/212/6279484

ISBN 3-7757-0795-6 (English edition)
ISBN 3-7757-0680-1 (German edition)

Printed in Germany

CONTENTS

6

Barnett Newman, one of the most significant and influential painters of the second half of the twentieth century, did not develop his unmistakable style until 1948 when, on his forty-third birthday, he painted "Onement I". From then on, Newman's paintings were dominated by homogeneous fields of color and vertical stripes. Often narrow and featuring sharp or jagged edges, these vertical stripes seemed to function either as lines which tore the picture plane apart or as seams joining two fields of color together. Ambiguous in their effect, these vertical elements—which Newman called "zips"—became the leitmotif of his oeuvre and performed a variety of functions in his works. They dispelled spatial illusion, destroyed atmospheric effect, and evoked feelings of wholeness, simultaneity, and fulfillment—in other words: Newman's "zips" were meant to convey an experience of totality.

Newman's artistic ethos, his formal reductionism, and his absolute purism irritated rather than impressed the New York art world. From the outset, it was impossible to overlook the differences between Newman and other protagonists of the New York School of the fifties, such as Jackson Pollock, Mark Rothko, Clyfford Still, and Adolph Gottlieb, among others. Despite their differences, they were all concerned—as they themselves said—with visualizing absolute feelings. Their paintings were meant to embody the tragedy of existence and the terror of the unknowable. Transcendence of immediacy was their declared aim. Rothko, for example, saw painting as a "revelation, an unexpected and unprecedented resolution of an eternally familiar need."[1] For him art was an "anecdote of the spirit, and the only means of making concrete the purpose of its rapid quickness and stillness."[2] All the Abstract Expressionists strove to enact an "idea-complex" which, said Newman, "makes contact with mystery—of life, of men, of nature, of the hard, black chaos that is death, or the grayer, softer chaos that is tragedy. For it is only the pure idea that has meaning. Everything else has everything else."[3]

In our sophisticated modern times, with buzz words like "anything goes", "getting nowhere fast", and "electronic superhighway", the pathos of such statements may seem strange. Indeed, when we think of the constant deluge of digitally manipulated images, the blurring of generic demarkations, the widespread addiction to simulation, and the persistent invasion of our lives by virtual reality, Newman's oeuvre seems to be the exact opposite of what attracts and appeals today. The powerful suggestiveness of his works seems to act from afar, to be removed from reality. Newman's insistence on the absolute autonomy of art and his endeavors to substantiate the claim without historical reference, and with an argument that proceeds from ethical principles, are precisely what makes us question the relevance of his approach and the significance of his work in the future's past. Nonetheless, Newman's oeuvre has, like hardly any other, proved resistant to every misguided attempt at monopolization. It has never been given a place in the Cultural Hall of Fame. Its effect seems never

to have worn off, and its inherent truth seems never to have wavered. An extraordinarily sensuous esthetic presence is one aspect of Newman's oeuvre, the other is the claim to exclusivity which is closely bound up with this presence. Today, when the simultaneity of the dissimultaneous rules, when all criteria and boundaries have become totally blurred, it is important that Barnett Newman's position be clearly defined.

Permit me to make another observation in this connection. In 1970, shortly before his death, Barnett Newman made the following statement in an interview: "I think, in a sense, my painting removes the observer. At the same time I'm not too happy about those writers who always talk about some of my large paintings as environmental, in which the observer becomes part of the painting. I like to think of the person becoming part of the painting in terms of its meaning, because in the end I feel that most of my paintings are hostile to the existing environment."[4] This polarity, the observer's becoming part of the painting and the painting's hostility to the environment—in other words, the polarity of spiritual participation and physical refusal—seems to be central to understanding Newman's oeuvre, and certainly to Newman's own understanding of it during the last years of his life. The question whether the observer in fact responds to Newman's works in this way may be left open for the time being.

Today, our approach to the problem of reading meaning in abstract art has changed in many respects, and this approach is sometimes more negative than positive. Ever since Kandinsky, Malevich, and Mondrian, associating meaning with an individual canon of forms and colors without any representational elements has seemed a shaky, not to say questionable, concept. The doubts, however, arise less because of any particular artist than because of the general premisses of abstraction. It is under such premisses that we must come to terms with a radical kind of art which, in vindicating its claim to autonomy, allows no references to the real physical world. When the exponent of Appropriation Art Philip Taaffe takes up a painting like Newman's "Who's Afraid of Red, Yellow and Blue II", transforms the "zips" into plaited ribbons, and then gives the finished work the title "We Are Not Afraid", the result is a cheap ornamentation which is not just ironic but also an incredible assertion that the lofty intentions of classic modernism as a whole—and Barnett Newman may indeed count among its rightful heirs—have now become obsolete. These anemic surrogates cannot of course claim to be on a par with the impressive originals, but such pretenses of refutation through paraphrase and appropriation seem to be symptomatic of a time which, as its emancipatory horizons broaden, seems no longer to appreciate the value of an art whose utopian aim is, partially, to accord the viewer an unusually high degree of autonomy whilst overwhelming him emotionally, and to overwhelm him emotionally whilst affording him the possibility of emancipating and, by the same token, fortifying himself.

8

This double autonomy—of the work and of the viewer—was Newman's constant preoccupation. Let us therefore go back to the question of the reception of Newman's art, the question as to whether Newman's works did in fact fulfill their promise. The question can be answered not theoretically but rather—and here we must agree with the painter—through direct confrontation with the work itself. Hitherto we have had little or no such opportunity here in Germany. An exhibition of Newman's works would have been an adequate means of getting to the bottom of the problem, but such a project is an extremely complicated one. The fragility of the works and the amount of irreparable damage hitherto sustained by some of them make it virtually impossible to gather together a large quantity of paintings, sculptures, and drawings. Added to this is the problem posed by the limited size of Barnett Newman's oeuvre. Indeed, with just over a hundred paintings, approximately eighty drawings, two series of prints, a few single prints, and a handful of sculptures, Barnett Newman's oeuvre is, in terms of quantity, extremely modest. Nevertheless, the risk has been taken—at a most unsuitable time, as it turns out, and in a place which, architecturally, does not readily lend itself to such a project. Our exhibition of Newman's works was prompted by, among other things, the museum's acquisition of Newman's posthumously fabricated sculpture "Zim Zum II". This work, which in my eyes is Newman's sculptural legacy, arrived at the Kunstsammlung Nordrhein-Westfalen three years ago. Our initial preparations for the exhibition were guided by the realization that it would be more advantageous to concentrate on an easily surveyable selection of works, especially since the spectrum of possible experiences conveyed by Newman's works is not particularly broad or diversified, and, moreover, the painter himself made a point of using a limited formal vocabulary.

The obvious idea of exhibiting all seven of Newman's sculptures together with his Synagogue Model was subsequently expanded to include a limited number of paintings, drawings, and prints. It was our intention not to mount a retrospective of Newman's works but, rather, to design an exhibition which, whilst still having a definite focal point, would be better able to accommodate the architectural shortcomings of the museum. The scope of the project was limited in two respects. All the sculptures, especially the twenty-six-foot-high "Broken Obelisk" and the voluminous, approximately twenty-foot-long "Zim Zum II", had to be shown indoors. Considering the risk of damage—our city center is a veritable playground for spray-can vandals—it would have been irresponsible to show these monumental sculptures outdoors. The second problem was posed by the limited transport facilities inside the museum. Such large-format paintings as "Cathedra", "Anna's Light", and "Who's Afraid of Red, Yellow and Blue IV" could not be installed on the second floor where the lighting is much better. Thus it was necessary to show three of the sculptures, the Synagogue Model, and four large paintings together in one room. Particularly problematical were the enormous differences in

scale, and the different modes of perception which paintings and sculptures demand. Yet the extraordinary height and length of the exhibition hall afforded us a unique opportunity of presenting the paintings and sculptures such that the room itself could decisively influence the way they were perceived. Newman's works appear here in a new constellation of surprising contrasts, and in diffused-lighting conditions which seem to emphasize the graphic, planar qualities of the sculptures, thus counteracting the otherwise more dominant three-dimensional effect. Above all, however, this arrangement shows how important Newman's sculptures are within the context of his oeuvre as a whole. The uniqueness and boldness of "Broken Obelisk" have probably never been more overwhelmingly expressed than in the brightly and evenly lit exhibition hall of our museum. Moreover, the conjunction of "Broken Obelisk" and "Zim Zum II" reveals only too clearly the Janus-faced aspect of Newman's sculptural oeuvre. On one hand, Newman evidently worked according to traditional concepts; on the other, his two plinthless, walk-through sculptures "Zim Zum I" and "Zim Zum II" are decidedly future-oriented.

At his second exhibition at the Betty Parsons Gallery in the spring of 1951, Newman tacked to the wall of the gallery a brief statement instructing the visitor to view his large-format paintings at close quarters. Such viewing conditions are no longer possible. Indeed, every lender of Newman's paintings insists—and rightly so—that a relatively large distance be maintained between the work and the viewer. It turns out, however, that Newman's paintings permit an astonishing diversity of experiences when viewed at different distances, close range being just one of many. Even the atmospheric change from the first-floor exhibition hall to the second-floor gallery favorably influences our perception of the works. Newman's four other sculptures and his smaller paintings, drawings, and prints not only benefit from the lower ceilings and smaller rooms but also engage in a kind of dialog.

Although this Düsseldorf exhibition was not intended as a retrospective, it does differ fundamentally from all previous showings of Newman's works, with the exception, perhaps, of the large posthumous retrospective exhibition which opened at the Museum of Modern Art, New York, on October 21, 1971[5], was then shown at the Stedelijk Museum, Amsterdam, and the Tate Gallery, London, and ended at the Grand Palais, Paris, on December 11, 1972. This was the only comprehensive showing of Newman's works. It was a unique event, and one which could never be repeated, for it also showed that the audience for Barnett Newman was still limited. This circumstance was borne out by subsequent attempts at coming to terms with his work, which all concentrated on individual paintings or relatively small groups of works. Thus all other previous exhibitions were devoted to individual media, such as drawings[6] or prints[7], or were confined to an easily surveyable number of exhibits[8], or were focused on a certain period.[9]

Much of Newman's hermetic oeuvre defies explanation, and this catalog does not pretend to answer all the questions it raises. Indeed, Newman himself had become aware, certainly from 1948 onwards, of the difficulty of describing and analyzing what one saw. The visual image could not be readily translated into language. Without language, however, the visual image was incommensurable. Newman once touched upon this problem in an interview: "And the reason I am willing to speak here is that I know that it is impossible to talk about my work. And since it's impossible for me or anybody else to talk about my work, I feel I might as well talk about it."[10] Newman's statements about his work are frequently very enlightening and should, whenever the opportunity presents itself, be given serious consideration. Of course, we must always query the intentions behind them, for whatever opinions Newman expressed in his statements, interviews, essays, and polemical writings, they were always bound up with his own specific objectives, or they at least sought to favor his own specific idea of himself, his public image, as it were. Newman's writings, of which I have availed myself considerably in the following chapters, undoubtedly provide us with the prerequisites for a better understanding of many of the phenomena of his oeuvre, many of his reactions to his contemporaries, and many of his strong opinions. The ideal approach—though impossible within the limited scope of this catalog—would be to contextualize Newman's entire oeuvre, including everything he said and wrote. Newman repeatedly claimed that, as a painter, he had to start from scratch after the Second World War, without precedents, as it were. His published writings, however, reveal exactly the opposite, and an analysis of his work might show how Newman's art refers again and again to the art of others. The four versions of "Who's Afraid of Red, Yellow and Blue", for example, awaken associations not only with Mondrian and, because of its title, the filmed version of Edward Albee's play starring Elizabeth Taylor and Richard Burton (the title of a 1993/94 work by Dan Flavin for the Baltimore Museum of Art testifies to this association: "Untitled—to Barnett Newman for 'Who's Afraid of Virginia Woolf'") but also with Ellsworth Kelly in general and with Jasper Johns's "Field Painting" of 1963/64 in particular, and all the more so because Johns was later to incorporate Newman's motifs in his own paintings. What is most important, however, is how Newman himself related to his contemporaries, and in this regard we may look forward with anticipation to the results of Gabriel Ramin Schor's research on the relationship between Newman and Pollock.

Today, we can no longer react to Newman's art as the painter Günter Fruhtrunk did in 1981. Independently of Newman, Fruhtrunk sought to achieve a similar objective in his own particular way. Like many other artists, Fruhtrunk donated one of his works in aid of the Berlin Nationalgalerie's drive to purchase "Who's Afraid of Red, Yellow and Blue IV", paying homage to Barnett Newman with the following words: "Color, intoxicated with freedom, its

doubts, its negative vibrations, anything between a mere worrying throb and a revolt against the taming of mankind. Not a tasteful, symbolic life-saver; not a leitmotif, not luxury bound by painterly constraint. Not a law, but sheer color, motivation."[11] Fruhtrunk grasps and names the essence: the high motivation which manifests itself in color but does not obey any rigid rules. "Not a law, but sheer color, motivation." That was how a painter was still able to see things twenty-odd years ago, but how should we, today, approach Newman's epochal oeuvre, an oeuvre that has defied definition like hardly any other of this century; an oeuvre that has no patina; an oeuvre that has lost nothing of its impressive radiance; an oeuvre that has directly influenced two decades of the century which is now drawing to a close.

1 Cf. Mark Rothko, *The Romantics Were Prompted*; in: *Possibilities 1*, Winter 1947/48, p. 84. Here quoted from Dore Ashton, *About Rothko*. New York, 1983, p. 115.

2 Cf. Mark Rothko, *Personal Statement*; in: *A Painting Prophecy—1950*. Washington, D.C.: David Porter Gallery, 1945. Here quoted from: *Mark Rothko 1903–1970*. The Tate Gallery, London, June 17– September 1, 1987, p. 82.

3 Barnett Newman, *Selected Writings and Interviews*, ed. by John P. O'Neill; text notes and commentary by Mollie McNickle; introduction by Richard Shiff. New York, 1990, p. 108.

4 Newman, *Writings*, pp. 306–307.

5 *Barnett Newman*, The Museum of Modern Art, New York, October 21, 1971–January 10, 1972. The text of the New York exhibition catalog was written by Thomas B. Hess and must be considered as one of the seminal works on Bar-
nett Newman, though Hess's interpretations of some of Newman's works place exaggerated emphasis on kabbalistic influences. The many quotations from Newman's then-unpublished writings, the information furnished by Hess from his own interviews with Newman, and the abundance of illustrations make this catalog indispensable reading for anyone interested in the life and work of Barnett Newman. The catalogs accompanying the European showings of the exhibition were far less well gotten up and designed, a circumstance which was undoubtedly indicative of the reception of Newman's work on this side of the Atlantic at that time.

6 *Barnett Newman, The Complete Drawings, 1944–1969*, ed. by Brenda Richardson, The Baltimore Museum of Art, April 29–June 17, 1979. The exhibition had several additional venues in the United States and Europe: The Detroit Institute of

12 Arts, August 7–September 30, 1979;
Museum of Contemporary Art, Chicago,
November 2, 1979–January 6, 1980; The
Metropolitan Museum of Art, New York,
February 12–April 9, 1980; Stedelijk
Museum, Amsterdam, September 8–
October 19, 1980; Centre Georges
Pompidou, Paris, November 12, 1980–
January 4, 1981; Museum Ludwig, Cologne,
February 9–April 5, 1981; and Kunstmu-
seum Basel, May 11–July 5, 1981.

7 *The Prints of Barnett Newman*, by Hugh
M. Davies and Riva Castleman, Amherst,
University of Massachusetts, November 5–
December 18, 1983. The exhibition had a
total of ten venues in the United States,
followed by a European tour: *Barnett New-
man. Die Druckgraphik 1961–1969*, Staats-
galerie Stuttgart, June 29–September 8,
1996; Camden Arts Centre, London, Sep-
tember 20–November 10, 1996; Kunstmu-
seum Bern, December 3, 1996–January 26,
1997; Graphische Sammlung Albertina,
Vienna, February 13–April 20, 1997. The
well-researched catalog text by Gabriele
Schor not only contains comprehensive
information on Newman's preferred tech-
niques but also deals with correlations
which extend far beyond the scope of the
exhibition.

8 *Barnett Newman, Paintings*, Pace
Gallery, New York, April 8–May 7, 1988.
The exhibition showed twelve paintings
from the period 1946–1970; the accom-
panying catalog contains a seminal essay by
Yve-Alain Bois entitled *Perceiving Newman*,
p. 1 ff. *Barnett Newman, Zim Zum II*,
Gagosian Gallery, New York, January 29–
March 14, 1992. The catalog assembled by
Robert Pincus-Witten and Ealan Wingate
contains material relating to the Syna-
gogue Model and the sculptures.

9 *The Sublime is Now: The Early Work of
Barnett Newman. Paintings and Drawings
1944–1949*. Organized by the Pace
Gallery, New York, this exhibition was
shown first at the Walker Art Center,
Minneapolis, March 20–May 29, 1994, then
at the Saint Louis Art Museum, July 1–
August 28, 1994, and finally at the Pace
Gallery, New York, October 21–
November 26, 1994. The exhibition was
accompanied by a catalog with an excel-
lent essay by Jeremy Strick, *Enacting
Origins*, p. 7 ff.

10 Newman, *Writings*, p. 281.

11 *Hommage à Barnett Newman*, Natio-
nalgalerie Berlin, Staatliche Museen –
Preußischer Kulturbesitz, Berlin,
1982, n.p.

ACKNOWLEDGEMENTS

This exhibition at the Kunstsammlung Nordrhein-Westfalen could not have been mounted 13
without the help and support of a great many private individuals and public institutions. Above
all, I should like to thank the lenders to the exhibition, who have made the exhibition possible
in the first place. I am indebted both to the directors and curators of museums and public
institutions and to the private collectors who, understanding my needs, have been prepared
to part with their "Barnett Newmans" for several months. The museums and institutions
which have each placed several works at our disposal should be singled out. These are: Kunst-
museum Basel; Staatliche Museen – Preußischer Kulturbesitz Berlin, Nationalgalerie and
Kupferstichkabinett; The Art Institute of Chicago; The Menil Collection, Houston; Louisiana
Museum of Modern Art, Humlebaek; the Tate Gallery, London; The Metropolitan Museum
of Art and the Museum of Modern Art, both in New York; Musée national d'art moderne,
Centre Georges Pompidou, Paris; and the Daros Collection, Switzerland. I wish to thank all
the lenders, both those mentioned by name in this catalog and those who have wished to
remain anonymous, for their generosity and for the trust they have placed in us.

In view of our museum's somewhat strained financial situation at the present time, I
should like to say a special word of thanks to the Stiftung Kunst und Kultur des Landes
Nordrhein-Westfalen (North Rhine-Westphalian Arts Foundation) whose involvement
has enabled us to realize this project in the desired form. Our thanks go in particular to
Reinhard Linsel, the Secretary of the Foundation, and to his deputy, Fritz Theo Menniken.
Both of them recognized immediately the special significance of this project.

I am also very much indebted to Annalee Newman, the artist's widow. In all our many
discussions leading up to the exhibition—these began as long ago as 1992—Annalee New-
man offered abundant helpful information on specific works and shed light on many works'
historical background. The same goes for The Barnett Newman Foundation. During my
research for the exhibition and the catalog, Jane Bobko and, in particular, Heidemarie
Colsman-Freyberger furnished me with valuable information which I could not possibly have
obtained elsewhere. John P. O'Neill, in his capacity at the Foundation, has kindly granted
us the right to reproduce Barnett Newman's works, and to quote from his writings, in this
publication. I am also grateful for the information provided by the sculptor Robert Murray,
who not only assisted in the making of Newman's Model for a Synagogue but also witnessed
at close quarters the production of several of Newman's sculptures.

As the Kunstsammlung Nordrhein-Westfalen was fortunate in acquiring Newman's "Zim
Zum II" in 1994, it seemed appropriate that this exhibition should focus on Newman's sculp-
tures, which meant that all seven works, and also the Synagogue Model, should be shown in
Düsseldorf. This seemed an impossible goal at first, and it was not until the Museum of Mod-
ern Art agreed to lend us "Broken Obelisk" that we began to pursue it with any vigor. Once

14 all the technical and logistical problems had been sorted out, we realized that we had laid the foundation on which the rest of the exhibition could now be built. Thus it is to Kirk Varnedoe, Chief Curator, Painting and Sculpture Department, at the Museum of Modern Art, that I owe particular thanks, for I was well aware that without "Broken Obelisk" our project would not have come to fruition. After all, this sculpture is not only one of Newman's chief works but also one of the most significant sculptures of the second half of the twentieth century. And so I am indebted to all who helped to make this first step towards the success of this project possible: my colleagues at the Museum of Modern Art and at the Kunstsammlung Nordrhein-Westfalen, and also the transport companies responsible for the shipment of "Broken Obelisk" from New York to Düsseldorf and back. A further prerequisite for the success of the project was the cooperation of other collections able to place Newman sculptures at our disposal. That some of these collections even canceled other obligations for the sake of the Düsseldorf exhibition has been noted with much gratitude and, naturally, satisfaction. Newman's sculptures are large, heavy, and unwieldy, and thus I wish to make special mention of Ernst Fuchs and his team who assumed the responsibility of installing the sculptures—no easy task in view of the difficult access afforded by our museum. Careful examinations of the works upon their arrival were conducted by Ursula Tenner with characteristic thoroughness.

Exhibitions are always the result of purposeful and dedicated cooperation, and I am greatly indebted to all who have helped to realize this ambitious project. I should particularly like to mention those of my colleagues at the Kunstsammlung Nordrhein-Westfalen who had a considerable role in the project. They are: Gudrun Harms, Dorothee Jansen, Doris Krystof, Birgid Pudney-Schmidt, Renata Sharp, Otmar Böhmer, Manfred Huisgen, and Henri Vauth. The museum's staff as a whole also deserves much appreciation, especially as the installation of the exhibits was difficult and time-consuming.

In assembling the catalog I have been able to rely on the editorial skills of Dorothee Jansen, Doris Krystof, and Maria Müller, while Winfried Konnertz was responsible for its layout and design. I thank them for their circumspection, patience, corrections, and suggestions for improvement.

My special thanks, too, go to John Brogden for his translation of the catalog text into English and to Jane Bobko of The Barnett Newman Foundation for having edited this translation most critically and carefully. She has checked countless details and offered numerous suggestions for improvement. Her painstaking attention to detail has been of inestimable value for the English version of this catalog.

Many people have helped to realize this first large exhibition of Barnett Newman's work in Germany. The exhibition would not have been possible without their untiring dedication,

useful suggestions, valuable information, and enthusiastic help and encouragement. My special

15

thanks go to Heinz Althöfer, Doris Ammann, Richard Armstrong, Michael Auping, Stephanie Barron, Douglas Baxter, Graham W. J. Beal, Yve-Alain Bois, John Brogden, James Cuno, James T. Demetrion, Magdalena Dabrowski, Susan Davidson, Alexander Dückers, Wolf-Dieter Dube, Richard L. Feigen, Peter Fischer, Barbara Flynn, Suzanne Folds McCullagh, Rudi Fuchs, Larry Gagosian, Madeleine Grynsztejn, Olle Granath, José Guirao, Sumi Hayashi, Noboyuki Hiromoto, Christian von Holst, Dieter Honisch, Walter Hopps, Otto Hubacek, Jay Krueger, Katsumi Kawamura, Kurt H. Kiefer, Walter Klein, Georg W. Költzsch, Dieter Koepplin, Phyllis Lambert, Donald B. Lippincott, Mario-Andreas von Lüttichau, Carol Mancusi-Ungaro, James Mayor, Cammie McAtee, Thomas M. Messer, Philippe de Montebello, Lars Nittve, Nina Öhman, Anthony d'Offay, Nicholas Olsberg, Mark Pascale, Robert Pincus-Witten, Earl A. Powell III, Marla Prather, David Platzker, Peter Raue, Joan Rosenbaum, Phyllis Rosenzweig, Cora Rosevear, David Ross, Margit Rowell, Marc Scheps, Katharina Schmidt, Angela Schneider, Lucas Schoormans, Peter-Klaus Schuster, Daniel Schulman, Richard Serra, Sir Nicholas Serota, Lowery S. Sims, Werner Spies, Jeremy Strick, Margret Stuffmann, Germain Viatte, Robin Vousden, Evelyn Weiss, Clara Weyergraf-Serra, Paul Winkler, Wolfgang Wittrock, James N. Wood, and Heidi Zuckerman.

Newman's aim was always to create a sense of place, to enable the beholder to realize where he or she actually was, and in what situation. This exhibition seeks therefore not only to inform visitors about Barnett Newman but also to enable them to experience what was so important to Newman, namely the difference between "a place and no place at all." What this means can be conveyed only by the exhibition itself, for it makes these important works by Newman immediately perceptible—visually, mentally, and physically. This exhibition is not a place where we are meant to become oblivious of everything around us. On the contrary, it is a place which makes us even more aware of ourselves—a place of self-reassurance, as it were. Whether in today's context the exhibition will still be able to generate impulses which extend beyond the esthetic to the ethical remains to be seen; that question cannot be answered until we actually stand in front of the works themselves. Thanks to enormous support from so many sides, it is now possible for us to do so. Each individual work by Barnett Newman has found a temporary place of residence in the rooms of the Kunstsammlung Nordrhein-Westfalen. What long seemed unhoped-for, indeed impossible, has suddenly become an overwhelming, astonishing, moving, inspiring reality—in other words, a wonderful stroke of luck of the kind which occurs rarely, if at all.

I

It was not until the late fifties that Barnett Newman's paintings, with their vast, radiant expanses of subtly nuanced color, their verticality, their voids, and their no less intense stripes of color, began to attract an audience of connoisseurs, albeit an extremely limited one. Indeed, his native city of New York had approached his work with particular reserve and skepticism for a very long time. Even as late as 1970, Donald Judd was still able to astonish the art world with an opinion he had already formed in 1964: "Barnett Newman's paintings are some of the best done in the United States in the last fifteen years. [. . .] despite [. . .] the excellence of the work of Rothko, Noland, and Stella, it's not so rash to say that Newman is the best painter in this country. [Comparisons with other artists] still leave Newman one of the world's best artists—and the best make a short list."[1] The visual austerity of Newman's works and their overwhelming effect on the viewer, the extreme ambitiousness of his art, and the limitation of his renown as an artist for many years to a small circle of connoisseurs could not be easily reduced to a common denominator. There simply did not seem to be a code which could render these succinctly structured works understandable. Art critics would remain literally speechless, or shift the discussion to questions of priority, or think up historical contexts which were only to prove untenable after a very short time. Positively minded critics, on the other hand, would seek refuge all too often in abstract concepts and religious metaphors, thus only partially coming to terms with the vividness of Newman's painting, with its holistic impulses and its emotional aspects.

Newman himself was aware of this discrepancy between his far-reaching intentions and a reception which, nourished on misunderstanding, was far from enthusiastic and sometimes interspersed with demonstrations of hostility, albeit veiled. Thus Newman made a point of commenting in detail on all questions concerning art, both in interviews and in his own writings. These statements, which were first published in collected form in 1990[2], today constitute the most important basic research material for anyone seeking a deeper understanding of Newman's oeuvre. In these writings, existential pathos provided the basis for ethical and esthetic views of a general nature, whilst individual works only seldom played a part in his reflections. For example, when Barnett Newman represented the United States at the eighth São Paulo Bienal in 1965 together with several younger artists, the statement he made in the catalog clearly formulated what he sought to achieve in his painting:

"The freedom of space, the emotion of human scale, the sanctity of place are what is moving—not size (I wish to overcome size), not colors (I wish to create color), not area (I wish to declare space), not absolutes (I wish to feel and to know at all risk).

"The fetish and the ornament, blind and mute, impress only those who cannot look at the terror of Self. The self, terrible and constant, is for me the subject matter of painting and sculpture."[3]

An ambitious goal indeed, and one which, if we consider his works, was not all that easily attained. Although his paintings impressed the viewer through their categorical purism and the immediacy of their effect, they seemed completely obscure, totally resistant to all attempts at interpretation. They could not—and cannot—be instrumentalized and turned to any non-esthetic use. Art critics were for a long time baffled by the works of this American painter, especially in Germany, where his works, and only a few of them at that, were shown quite late: in the fall of 1958 at the Berliner Hochschule für Bildende Künste (now the Berliner Hochschule der Künste) and, in the following summer, at *documenta* 2 in Kassel, where both "Tundra" (1950) and "Cathedra" (1951, Fig. 51) were shown. Nine years were to go by before Newman again exhibited in Germany, this time at *documenta* 4 in 1968, where he showed such significant works from the sixties as "Voice of Fire", "Who's Afraid of Red, Yellow and Blue II", and "Profile of Light" (Fig. 57). At the time, however, hardly any notice was taken of them, as the attention of the media was focused first and foremost on Pop art. This extraordinarily belated reception of Newman's work in Germany can still be felt today.

One of the first illuminating essays on Barnett Newman—later published in German during the sixties—was written, significantly, by an artist. In his analysis of Newman's "Vir Heroicus Sublimis" (Fig. 1), Allan Kaprow also touches upon the relationship between the viewer and the painting, which he saw as a confrontation, without any transition, between the minimum and the maximum: "The wide span between creates an intolerable tension, and it must finally break. The flood of utter chaos, of sheer color inundating us, of lines crashing into splinters and vanishing into the vibrating deluge, is the 'terror' Barnett Newman refers to when he speaks of his work, and the 'abstract-sublime' which Robert Rosenblum perceived. This terror and passion is as close to our marrow, as unsettling to us emotionally, as anything of Pollock's: it is the other side of the same coin, and they meet, both of them, at the middle. Pollock erupts with frenzy, only to burn into the heavens. Newman begins with the trial of a premise of a perfect vision in a calm, unruffled world, and ends with a cataclysm."[4]

One aspect of this early essay is particularly interesting. Kaprow speaks of the terror and passion of the subject who, in his distress, is aware of his own limitedness and finiteness. At the same time, says Kaprow, the subject does not, at the sight of Newman's paintings, allow himself to be overwhelmed by this distress but rather asserts himself against the flood of emotions which these paintings release. Painting and sculpture, Newman said, have the "terror of Self" as their theme. And the self, in order "to catch even the slightest glimpse beyond the prison that it itself is [. . .] requires not distraction but rather the utmost tension [. . .]".[5] The category of experiences here alluded to is that of the sublime. I shall be coming back to this point later.

Kaprow's essay had touched upon one of the key aspects of reception, namely the viewer's experience of his own self. Max Imdahl's elucidating and exemplary interpretation of Newman's painting "Who's Afraid of Red, Yellow and Blue III" picked up the thread here and combined a structural analysis with subtle attempts at transcending optical phenomena. This study, which was central to the reception of Newman's painting in German-speaking countries, was published in 1971, i.e. one year after Newman's death. The quintessence of Imdahl's argument was that the confrontation with the totality of a painting no longer limited by its format brings the viewer to himself. Here, however, Imdahl goes much further than Kaprow in that he maintains that the inner being of the viewer is set free and allowed to act against the conventional exterior, whereby the viewer is transformed into a moral being. Art should be ethics and not esthetics. "The demand made by Barnett Newman on abstract painting is extraordinary."[6]

The proclaimed transformation of Newman's esthetics into ethics, being in keeping with the spirit of the sixties, may have seemed necessary and logical at the time, but could not succeed, not least because the desired effect was possible only through direct confrontation with the works themselves, and these works were hardly accessible to the general public. There were no Newman paintings hanging in German museums or galleries and all the important exhibitions took place outside Germany anyway. Take, for example, the posthumous retrospective mounted by the Museum of Modern Art which traveled to Amsterdam, London,

1 *Vir Heroicus Sublimis,* 1950/51
Oil on canvas, 96 x 216 ins.
The Museum of Modern Art, New York
Gift of Mr. and Mrs. Ben Heller

and Paris in 1971/72. Moreover, the German art scene at that time was dominated by the iconography of Pop art, with its imagery of consumerism and advertising, which had totally ousted the Art informel of the fifties and, by the same token, had made any reception of American Abstract Expressionism equally difficult. And since Newman's oeuvre could not find a place in the spectrum of Abstract Expressionism, its reception in Germany was disadvantaged from the outset. Thus, in this scenario, the initial response in Germany to the monumental oeuvre of this outsider was limited to just a few connoisseurs and enthusiasts. These were, besides Max Imdahl, the art critics Bernhard Kerber and Julian Heynen. Heynen's study of the artist's writings, completed in 1976 and published three years later, is a work of particular significance.[7] Naturally, these publications did not have a very large audience. Moreover, during the eighties, reception was made even more difficult by acts of vandalism and, above all, was influenced in such a way that it became almost impossible to come to terms with Newman's work objectively and with due scholarship. On the contrary, it was a situation which fostered certain clichés.

The most important occurrences are briefly recapitulated below, firstly in order to show what reservations had to be reckoned with during the initial, and decisive, phase of preparations for the Düsseldorf exhibition and, secondly, to mark out, with just a few keywords, the terrain on which I shall be concentrating in the following chapters. The occasional overlap of content, and my use here and there of identical statements by the artist as the starting points for different trains of thought and argument, could not always be avoided.

In April 1982, a student attacked and seriously damaged Newman's huge painting "Who's Afraid of Red, Yellow and Blue IV", 1969/70, which had just been purchased by the Nationalgalerie, Berlin, with the dedicated help of artists and private individuals.[8] When interviewed, the student explained his hatred of the painting by stating that its apparent lack of artistic merit and its exorbitant price—which was being widely discussed in the media at the time, and also heavily criticized—seemed to him to be the quintessence of an upside-down world, the loss of all moral standards, and the idolatrous worship of money.[9]

Four years later, in March 1986, a visitor to the Stedelijk Museum in Amsterdam slashed the equally huge painting "Who's Afraid of Red, Yellow and Blue III", 1966/67, several times along its entire length. This attack, which virtually destroyed the painting, was declared as an "Ode to Carel Willink". Carel Willink, a Dutch exponent of Magic Realism, had expressed his anti-modernist ideas in a book published in 1950 which the perpetrator quoted in court.[10]

After another four years, in 1990, it was the turn of the National Gallery of Canada in Ottawa to make headlines. The museum had announced its acquisition of "Voice of Fire" (Fig. 2) dating from 1967. Most citizens saw in this painting, which was of narrow, vertical format measuring 214 by 96 inches, nothing but three vertical stripes of color—blue, red,

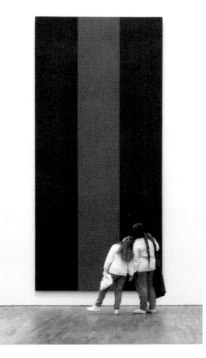

2 *Voice of Fire,* 1967
Acrylic on canvas, 214 × 96 ins.
National Gallery of Canada, Ottawa

20 blue—of equal width. The general impression, gained mainly from reproductions of the work, was that any housepainter could do the same in next to no time, and this sparked off a controversy lasting several months and culminating in the production of various sarcastically meant imitations and "fakes". As in Berlin, where the artist's widow's claim for damages amounting to 1.2 million U.S. dollars had been the talk of the town, so in Canada the price which had been paid for "Voice of Fire" triggered a heated discussion in the media. The ordinary tax-paying citizen, unfamiliar with modern art in general and with Newman's status in particular, that is to say, unable to differentiate between what is art and what is not, considered the price-performance ratio simply farcical. How could one spend so much money on something which was apparently so easy to copy and seemed to have nothing whatever to do with real painting as one knew it?

This question kept feelings running high for almost a year. Although, fortunately, no iconoclastic attack was made on "Voice of Fire" in Canada, there was one circumstance which seemed to confirm many a prejudice. In defense of its decision to purchase Newman's painting, the museum had published a brochure with a photograph on the front cover showing several visitors viewing the painting. As "Voice of Fire", like many other works by Newman, is strictly symmetrical and no distinction can be made in a photographic reproduction between right and left and top and bottom, the mistake which had been made in the brochure remained undetected for quite some time. It was a schoolboy who pointed out to the curators of the National Gallery that the image had been reversed, for one of the visitors shown in the photograph was wearing jeans with the manufacturer's label on the wrong back pocket![11]

In view of the alarming perspectives afforded by such dissimilarly motivated attacks on Newman's art and on the very system which engendered and sustained it, the unfortunate mistake of reproducing one of his paintings the wrong way round may perhaps be regarded merely as an ironic commentary on the situation. Nonetheless, several significant questions were raised at the time, though they rarely came up for public discussion in Berlin and Amsterdam, overshadowed as they were—and understandably so—by the scandals of wilful damage and destruction. The tabloids that, especially in Berlin, grasped every opportunity to voice so-called popular opinion under such headlines as "Any apprentice could have painted this", but made no contribution whatsoever to a better understanding of Newman's art, created a situation in which, here and there, people even sympathized with the perpetrators. In Canada, on the other hand, the entire nation—from the general public to the highest government circles—was preoccupied with questions of a completely different nature, questions which concerned not only Canada's cultural identity and her relationship with the United States[12] but also the esthetic objectives behind such a reductionist approach to form and

color. This discussion was to revive all those objections which had accompanied the debate on abstraction since the beginning of the century and which cast doubt not only on the esthetic value of abstract art but also on its claim to transcendentality. However, the discussion in Canada need not concern us further. More important in the present context is how the artist himself saw the relationship between the viewer and his work.

II

When Newman says: "The self, terrible and constant, is for me the subject matter of painting and sculpture", we cannot help feeling somewhat confused, for such subjectivism seems to bear little relation to his paintings with their impenetrable expanses of color and vertical elements. Their suggestion of overwhelmingness might possibly disturb us or alienate us, but are we shocked or shaken? Does one's own self, when confronted by these works, realize that self-assertion might here be called in question? Newman was fully aware of the problems which evocations of the sublime inevitably engendered. He himself was in constant search of valid answers, not just through the medium of painting but also through that of language, whereby he naturally presupposed that a painting can realize its subject matter only through the medium of painting, just as the subject matter of a poem can be realized only through the medium of language. Thus Newman rarely spoke about his individual works, and only in general terms at that. All the more prolix, on the other hand, were his commentaries on the medium of painting and on the aims which were bound up with it. Let me illustrate this point with an example.

In January 1968, Barnett Newman visited Paris at the invitation of the French critic Pierre Schneider. In a lecture which he delivered at a symposium on Charles Baudelaire as an art critic, Newman took the opportunity of denouncing contemporary criticism as impartial, boring, and "scientific". What Newman advocated in its place was the partial, passionate, and political approach to art taken by Baudelaire who, moreover, was also interested in fashion, dandyism, the madding crowd, the bizarre and the grotesque, in other words, modern life in all its many facets. Baudelaire would, Newman added, albeit with a touch of irony, undoubtedly have been the greatest Pop art critic of our time, and would also have appreciated Op art. Having the courage of his convictions and the passion to pursue everything that attracted his attention, everything he saw, everything he thought, and everything he felt, this French intellectual of the nineteenth century had, in Newman's view, the best qualifications for an understanding of the most fundamental of all the problems of a painter: the question "What to paint?"[13] Applied to an artist who, in the late sixties, was painting such works as "Who's Afraid of Red, Yellow and Blue" in four different versions, any question which placed such esthetic considerations in the foreground may seem surprising, for these works, with their

22 three adjacent areas of primary color, readily make one assume that the painter was more concerned with the question of how to paint than with the question of what to paint.

What Newman's question is getting at, however, is the difference between the representation of an object and the object of a representation. The representation of an object—the emphasis being on "object"—is always bound up in one way or another with reality, for at least associations with real objects are always possible. The same is not necessarily true of the object of a representation—the emphasis being on "representation"—for paintings and drawings which are completely dissociated from the real world are not, according to Newman, limited just to themselves, but have a subject matter.

Turned the other way round, the question "What to paint?" refers to the problem behind any kind of abstract art which seeks to be more than just a composition of shapes and colors or pure decoration. It is an old problem and one which has been troubling painters for a long time, and certainly since Kandinsky. In his *Über das Geistige in der Kunst* (Concerning the Spiritual in Art), a programmatic work published in Munich in 1911, Kandinsky wrote: "This 'What' is that content which only art can contain, and to which only art can give clear expression through the means available to it."[14] It would, at this juncture, be going too far to examine how Kandinsky's ideas may have lived on in Newman's work, though the differences would become noticeable very quickly: Newman replaced Kandinsky's spiritualism by the category of the sublime and reduced the Russian painter's vast repertoire of shapes and colors to monochromy and verticality, i.e. purist elementarism.

The views expressed by Newman in Paris in 1968 had preoccupied him all his life. In 1944/45, at a time when he had already begun to divorce himself from a Surrealist formal vocabulary, Newman saw in all art of the first half of the twentieth century "the search for something to paint".[15] In consequence of the semiotic revolution of modernism and the resulting autonomy of the medium, painters after Impressionism had—in Newman's view—been concerned first and foremost with questions of a technical nature and had lost sight of the actual purpose of art, a purpose which at all events ought never to limit itself to pure formalism.

As early as 1926, Newman had noted: "The artist emphatically does not create form. The artist expresses in a work of art an aesthetic idea which is innate and eternal."[16] Later, in 1944, Newman maintained that art was an expression of ideas, of meaningful truths: "Of course, modern art is abstract, intellectual! It is the expression of man's spirit."[17] The art of the future, wrote Newman, will be "an art that is abstract yet full of feeling, capable of expressing the most abstruse philosophic thought."[18] All statements made by Newman about this time start out from such or very similar premises.

It was during this phase in the mid-1940s that Newman's esthetic ideas began to take definite shape. He gradually developed, for example, the theories on which he was to base his arguments for the rest of his life, albeit with considerable modifications during the sixties. Abstract art, capable of abstract thought, must say something and defend human dignity.[19] A sense of the tragedy of life, for example, seemed to Newman to be the dominant theme of the paintings of Adolph Gottlieb[20], with whom Newman had been friends for many years. In another, more general context, Newman maintained that the contemporary painter was concerned not with individuality or subjectivity but rather with the "world-mystery". "His imagination is therefore attempting to dig into metaphysical secrets. [. . . and] it can be said that the artist like a true creator is delving into chaos."[21] After all, truth lies solely in the search for the hidden meanings of life. "Art must [therefore] become a metaphysical exercise."[22]

Newman's ideas in the middle of the forties seemed idealistic, romantic, and not all that original. But this soon changed. When, for example, Clement Greenberg, the influential and loyal supporter of New York's Abstract Expressionists, reviewed an exhibition of Adolph Gottlieb's paintings in 1947 and criticized the painter's metaphysical aims as "half-baked" and "revivalist" and, as such, "familiarly American," Newman countered with a very sharp rejoinder.

Newman argued that American artists created a truly abstract world which could be discussed only in metaphysical terms. Their intention was to produce from the nonreal, from the chaos of ecstasy, something that evoked "a memory of the emotion of an experienced moment of total reality."[23] Since the purpose of Newman's reply to Greenberg's criticism was to demonstrate the originality of American painting, he drew attention to the differences between American and European art. Whilst the European was concerned with the transcendence of objects, the American would focus on the reality of the transcendental experience.[24] Mark Rothko argues in the same vein—though without touching upon the differences between America and Europe—when he says: "A painting is not about an experience, it is an experience."[25]

The painter's predilection for polarized situations can also be observed elsewhere. In 1948, Newman drew a clear line of demarcation between the beautiful and the sublime. When formal relationships alone are inadequate and the process of abstraction merely leads to mathematical formalisms, then—says Newman—there is only one way of visualizing the sublime: the painter must divorce himself from all that is anecdotal and create a work which is a self-evident work of revelation to "anyone who will look at it without the nostalgic glasses of history".[26] What must now be visualized is not beautiful forms but absolute feelings. What must now be embodied are not the esthetic and the harmonious but the tragedy of existence and the "terror of the unknowable".[27] The painter must now concern himself not

24 with indirect representation but with the evocation of directness and immediacy. The visual
sensation must yield to the emotional sensation. Here Newman drew an analogy with the
natural sciences, for there, too, "the necessity for understanding the unknowable comes
before any desire to discover the unknown." [28]

III

Newman's paintings are about the sublime. This keyword of modernism is central to
Newman's esthetic ideas, which means that I must discuss it at this early juncture and risk
repeating myself in other contexts later on.

 The distinction between the beautiful and the sublime had already been drawn by Burke
in 1757. Kant, too, differentiated between the beauty of nature, which was bounded by form,
and boundless sublimity. The sublime cannot be accorded to nature, for the sublime exists
purely in the mind "insofar as we are conscious of being superior to the nature that resides
within us, and hence also to the nature that resides without us." [29] Ernst Cassirer put it like
this: "The sublime destroys the bounds of finiteness, yet this phenomenon is seen by the self
not as an act of destruction but rather as a kind of elevation and liberation, for it is in the
feeling of infinitude, which it now discovers within itself, that it may enjoy a new experience
of its own boundlessness." [30] In the present context, the recognition that sublimity is an
emotional phenomenon, though one which cannot be conveyed directly, is of decisive
significance. That was Hegel's view anyway: "Indeed, the sublime is the attempt at expressing
the infinite without having found, in the realms of phenomena, any object which might prove
fitting for such a representation. Precisely because it is a meaning which is invisible and with-
out any outward form and thus stands apart from the entire complex of recognizable objects,
the infinite remains, by its very definition, indescribable and defies all expression through that
which is finite." [31] This is precisely the point with which Newman is concerned: the expres-
sion of the infinite as a meaning which is invisible and formless, but without resorting to the
use of physical phenomena.

 In the light of the above, Newman's question "What to paint?" has already been
answered, though this answer then gives rise to new questions: What is the sublime in
fact, if it cannot be represented by physical phenomena? Can the sublime be represented
artistically at all and, if so, how? The answers, however, were no longer put into words, for
Newman soon realized—and certainly not later than 1948—that his works owed their
authenticity not to the relevance of their content but solely to their form.

 Nineteen forty-eight was a decisive year, for it was the year in which Newman, on his
birthday at the end of January, painted his "Onement I" (Fig. 20), a work of relatively small
format, and one which Newman himself considered to be the work which marked the

beginning of his life as a painter.[32] What Newman, after 1948, was essentially able to express only through his art—in a series of impressive paintings—was also suddenly to play an important role in the philosophical esthetics of the sixties. Space does not permit me to deal with this subject in detail, so I shall have to content myself with a few brief references. The theme of the sublime is central to Theodor W. Adorno's reflections in his *Aesthetic Theory*, which was published posthumously in 1970 (Adorno died in the same year as Newman), wherein the emphasis was on moments of the incommensurable and incommunicable in art. "In the administered world, artworks are only adequately assimilated in the form of the communication of the uncommunicable, the breaking through of reified consciousness. Works in which the aesthetic form, under pressure of the truth content, transcends itself occupy the position that was once held by the concept of the sublime."[33] Only thus can works of art form cells of resistance which "stand firm" against ubiquitous integration.[34]

There are of course no direct correlations between Newman's painting and Adorno's philosophy. On the contrary, many differences and contradictions become immediately obvious. These differences exist because, although both Newman and Adorno envision the sublime in terms of a structural matrix for a work of art, Adorno's basic starting point is the immanence of the sublime, that is to say, the sublime is incorporated in the formal principles of art from the outset, and this in turn implies that, for him, all transcendence is left out of account.[35] Newman, on the other hand, had argued that the contemporary painter's aim was to fathom the "world-mystery" and to dig into its "metaphysical secrets".

Newman's and Adorno's ideas also have points of contact and divergence in another respect. These are ideally exemplified by Newman's idea of "presence". The artist's problem here is to create a sense of place so that both the artist and the viewer learn where they are—which means, in the final analysis, who they are. "What matters to a true artist is that he distinguish between a place and no place at all; and the greater the work of art, the greater will be this feeling. And this feeling is the fundamental spiritual dimension. If this doesn't happen, nothing else can happen."[36] This presence, which Newman speaks of repeatedly, is not only bound up with place; it also has a temporal dimension, whereby the immediacy of the present constitutes a further structural device by which the sublime can again evoke transcendence. This transcendence is remote, occurs as a reflected event in the process of esthetic evocation and, in so doing, visualizes something that defies direct depiction.[37] In other words: the self, in Newman's case, is seized with a consciousness which shatters the esthetic illusion. In Adorno's case, it reads like this: "The subjective experience directed against the I is an element of the objective truth of art."[38] And, in another place, he writes: "The subject, convulsed by art, has real experiences; by the strength of insight into the artwork as artwork, these experiences are those in which the subject's petrification in his own subjectiv-

ity dissolves and the narrowness of his self-positedness is revealed."[39] There is no doubt about it, Adorno is here describing, albeit in his own characteristically philosophical diction, experiences which viewers of Newman's works may indeed have. Whether such a bold drawing of parallels is tenable would require further examination, though we could not of course expect Newman to have discoursed upon his works in a manner comparable, on a semantic level, with that of Adorno's observations.

Nevertheless, during the sixties, a change did take place in the painter's way of thinking, for he no longer spoke in terms of a world-mystery and metaphysical secrets but now addressed the task of visualizing "sensation[s] of wholeness and fulfillment"—or at least that is what he told Dorothy Gees Seckler in an interview published in *Art in America* in 1962. He went on to say, in the same interview, that he could readily talk about the transcendental, the self, and revelation in art, but would prefer to discuss the central significance of drawing in his paintings. "Instead of using outlines, instead of making shapes or setting off spaces, my drawing declares the space. Instead of working with the remnants of space, I work with the whole space."[40] In 1969, in *ARTnews*, Newman explained his intention of transforming a specific shape, in this case a triangle, "into a new kind of totality".[41] In the spring of 1965 he explained to David Sylvester what he sought to achieve through his art. For him it was important "that the onlooker in front of my painting knows that he's there. To me, the sense of place not only has a mystery but has that sense of metaphysical fact. [. . .] I hope that my painting has the impact of giving someone, as it did me, the feeling of his own totality, of his own separateness, of his own individuality, and at the same time of his connection to others, who are also separate."[42]

In such statements, including those concerning his artistic methods, Newman seems to be arguing more or less along the same lines as Adorno—especially in statements where Newman emphasizes the immanence of the experience of the sublime. Although the work of art does not depict a sublime object, the sublime object is always implied, always at the back of Newman's mind. When the viewer stands in front of the painting, the sublime forms part of the esthetic experience and may be graspable abstractly, though it cannot on any account be visualized directly. After all, Newman always alludes in his works to the undepictable, by evoking the non-depictability of transcendence. Put another way: "Spiritualization takes place not through ideas announced by art but by the force with which it penetrates layers that are intentionless and hostile to the conceptual."[43] One wonders whether Moses' Second Commandment, "Thou shalt not make unto thee any graven image etc.", saved Newman from attempting to illustrate transcendental content or whether it was the reduction inherent in the art of modernism which induced him to emphasize immanence, though without completely renouncing his transcendental goal. Newman's position here is strangely ambivalent.

This is also manifest elsewhere. In his attempts at—as he himself put it—"paint[ing] the impossible"[44], Newman seemed to be "too abstract for the abstract expressionists and too expressionist for the abstract purists".[45] What this seemingly superficial aporia was actually hinting at was the state of conflict between the representation of the unrepresentable on the one side and the refusal of presence to represent on the other.

Whichever way we look at it, Adorno's notion of the sublime is only of limited validity for our understanding of Newman's esthetic concept. Much more applicable is the notion put forward by Lyotard who maintains that, in the endeavor to express the sublime, transcendence cannot in the final analysis be depicted. "Whilst the sublime in Adorno's case consists solely in the inner, 'latent' force which drives the work of art apart into all its divergencies, the work of art in Lyotard's case becomes the place of a sublime relationship, with regard to which it [the work of art] functions as a non-depiction or as a depiction of non-depictability. Horizontality and strict immanence in Adorno's case, verticality and transcendence in Lyotard's."[46] Applied directly to Newman, Lyotard's argument goes as follows: "The space in which Newman's painting operates is no longer triadic in the sense that he requires a sender, an addressee and a reference. The message 'speaks' of nothing; it comes from nobody. It is not Newman who says or shows something through his painting. The message (the painting) is the messenger; it 'says': Here I am, i.e.: I belong to you, or: Belong to me. Two instances: you and I, not interchangeable, taking place only in the urgency of the moment. The reference (what the painting 'speaks' of), the sender (its 'author') contribute nothing, not even in a negative sense, and not even as an allusion to a possible presence. The message is the presentation, but of nothing, that is to say, of presence."[47]

Lyotard here aptly describes the situation of the viewer when standing in front of one of Newman's paintings. His description, albeit very brief, also points to where the true problem of their reception lies. What the painting conveys visually must serve as a means of conceptualizing what *de facto* cannot be seen. In other words, if we are not receptive to Newman's paintings, we shall learn nothing of this artist's intentions. Is this something specific to Newman's work, or is it generally applicable to abstract art? What is obviously special about Newman is that his paintings literally make our glances bounce back, that they both fascinate and repel, that they captivate us and at the same time fail to give us the sense of security we feel we need. Suggestion suffuses absolute coldness, the emphatic vehemence of the color is fractured by a formal rigor which is without parallel. The viewer searches for a standpoint in front of the work, finds it visually and forfeits it emotionally; having steadied himself in front of the canvas, he now witnesses an act of visual compulsion. Individual colors flare up; seen simultaneously, the resulting contrasts hurt the eye; the viewer must turn away, and then, as though spellbound, return. Newman's paintings are static objects, and yet the experience

they convey or trigger is a temporal phenomenon, and one which, in Newman's most powerful works, is bound up with the actual moment. Newman himself saw it more or less like that, too. When asked by a visitor how long it had taken him to paint "Vir Heroicus Sublimis"(Fig. 1), he answered: "It took a second but the second took a lifetime."[48]

IV

What does, however, seem to reveal ever new aspects of Newman's works is their titles. The titles, said Newman in an interview in 1965, should be seen as metaphors which somehow correspond to what he thought was "the feeling in them and the meaning of it. [. . .] and I try to give it [the painting] a title which for me evokes the emotional content, and I hope is a clue to others".[49] As Newman held this opinion all his life, his titles should be taken seriously and always be included in interpretations of his works, though we must of course bear in mind that many of his titles were not conceived until long after the respective works had been completed. Since such titles come very close to being interpretations by the artist himself, they must be reflected upon in each individual case. The famous "Stations of the Cross", a series of fourteen paintings of equal format, painted between 1958 and 1966, were evidently not given their ultimate title until after Newman had begun his preparations for their exhibition at the Solomon R. Guggenheim Museum from April to June 1966.[50] Considering that Newman was an artist who did not work according to any preconceived idea but allowed the idea to evolve during its execution—indeed, the idea and its execution were identical and thus impulse and control coincided—the question is still open as to whether the titles actually perform the function which Newman ascribed to them. One thing, however, is obvious: the titles dictate, qualify, and, in the final analysis, condition the viewer's reception of the painting and thus may also undermine the immediacy of his experience. The titles evoke an imagery which may either assist the phenomenology of the respective work or counteract it. The viewer cannot help asking himself, as he passes from one painting or sculpture to the next, how the visual character of a work relates to its title and vice versa. If one makes the title alone the starting point of one's reflections, one might slip all too easily into mere speculation. Several critics have already succumbed to this risk. Particular mention in this regard must be made of those publications by Thomas B. Hess which were long regarded as authoritative works on Newman's oeuvre, though Hess unthinkingly placed it in a kabbalistic context.[51]

The complexity of the questions provoked by Newman's oeuvre cannot possibly be discussed in detail here. Indeed, from the brief descriptions already given, it must be obvious to the reader that it would be virtually impossible to deal with Newman's art adequately without accurately analyzing the works themselves and considering them in the artistic context in which they were created or to which they were meant to respond. Even so, the

use of the term "deal" would perhaps be inappropriate, for how can one possibly "deal" with something which is meant to be experienced immediately and suddenly? How do esthetic experience and rational reflection relate to each other? How can "invisible, formless meaning"—in Hegel's sense—be conveyed verbally without referring to "physical phenomena"? The philosophical encoding or decoding of esthetic phenomena can of course be extremely important to us in our search for the answers. After all, esthetics is not an applied philosophy; it is, in itself, philosophical. But whether one must go as far as Hegel, for whom "the science of art was more of a necessity than art itself"[52], remains to be seen, though this statement does, in the light of growing theoretical interest in art, seem apt inasmuch as art cannot, in many cases, develop its content without the aid of philosophy. What is in fact being thematized here, though not explicitly, is the discrepancy between visual experience and abstract concept, which raises the question as to how we can assure ourselves of the visual phenomena of Newman's paintings, in other words, how we can make the incommensurable commensurable.

There is another aspect which ought not to go unmentioned. Like many artists, Barnett Newman was skeptical of impartial and detached art critics and historians, for they operated—in his view—in a "mirage", even though artists had proven again and again, through their works, that there was no such thing as art "history". Only art and anarchy were productive, surprising, creative, and innovative, whilst the art critics and the art historians, that is to say, the *Kunstwissenschaftler*—probably the only German word Newman ever used—offered nothing but substitutes, clichés, and obsessions, in other words, illusions which had nothing to do with the actual artistic process.[53] Whilst Newman was skeptical of every kind of theory outsiders ventured about his work, no matter what form it took, he himself liked nothing better than to theorize about art, and about timeless art in particular. Newman naturally placed his own paintings in this category, for his art had to appear in the right light, exactly in keeping with its proclaimed meaning. Belligerent as he was, Newman lived a life full of controversy, and that is precisely what makes our study of his oeuvre all the more interesting, though by no means easier.

We know, from statements made during the forties, that Newman's art had a manifold objective: absoluteness, exclusiveness, transcendence—indeed, the abolition of history altogether—universality, the vanquishing of all relativity and causality. But we must not fool ourselves: the belief that Western art transcends causality is rapidly on the wane, and its sense of mission, namely that of helping the world to attain new heights of spirituality, is likewise becoming a thing of the past. Art history as the history of salvation? With Yves Klein and Barnett Newman as its prophets? Does that exist? Is there such a thing as the crystallization of a time continuum into a single moment, or the transformation of indefinite space into the

30 here and now? Is it possible, through an esthetic act, to substantiate the subject, or even save it, when it seems to have become obsolete long since? Is all that conceivable, and can art accomplish it?[54] Such questions, too, are provoked by Newman's oeuvre today, and perhaps more than ever before.

1 Donald Judd, *Barnett Newman*, in: *Studio International*, February 1970, p. 67. Here quoted from: Donald Judd, *Complete Writings 1959–1975*. Halifax and New York, 1975, p. 200.

2 Cf. Note 3.

3 Newman, *Writings*, p. 186 f.

4 Allan Kaprow, "Impurity," *ARTnews* 61, No. 9 (January 1963), p. 55. German translation: Allan Kaprow, *Barnett Newman—Ein Klassiker?* in: Jürgen Claus, *Kunst heute. Personen, Analysen, Dokumente.* Reinbek, Hamburg, 1965 (rowohlts deutsche enzyklopädie Nr. 238/239).

5 Theodor W. Adorno, *Aesthetic Theory*, ed. by Gretel Adorno and Rolf Tiedemann, newly translated, edited, and with a translator's introduction by Robert Hullot-Kentor. Minneapolis, 1997 (Theory and History of Literature, Vol. 88), p. 245.

6 Max Imdahl, *Barnett Newman, Who's Afraid of Red, Yellow and Blue III.* Stuttgart, 1971 (= *Werkmonographien zur bildenden Kunst* in *Reclams Universal-Bibliothek Nr. 147*, edited by Manfred Wundram), p. 27. Reprinted in: Max Imdahl, *Zur Kunst der Moderne. Gesammelte Schriften, Bd. I*, edited by Angeli Janhsen-Vukićević. Frankfurt, 1996, p. 244 ff.

7 Julian Heynen, *Barnett Newmans Texte zur Kunst.* Hildesheim and New York, 1979 (= *Studien zur Kunstgeschichte, Bd. 10*).

8 Cf. *Hommage à Barnett Newman*, op. cit. This catalog, whose cover Wolf Vostell designed in imitation of the painting, is a remarkable document, not least because the following artists each donated one of his works as his contribution towards the purchase of "Who's Afraid of Red, Yellow and Blue IV": Frank Badur, Bodo Baumgarten, Ulrich Erben, Günter Fruhtrunk, Johannes Geccelli, Rupprecht Geiger, Raimund Girke, Kuno Gonschior, Gotthard Graubner, Erich Hauser, Erwin Heerich, Bernhard Heiliger, Leo Kornbrust, Norbert Kricke, Alf Lechner, Thomas Lenk, Heinz Mack, Georg Karl Pfahler, Gerhard Richter, Ulrich Rückriem, Alf Schuler, Heinz Trökes, Günter Uecker, Wolf Vostell, Franz Erhard Walther, and Ben Willikens.

9 Cf. Peter Moritz Pickshaus, *Kunstzerstörer. Fallstudien: Tatmotive und Psychogramme.* Reinbek, Hamburg, 1988, p. 65 ff.

10 Cf. in this connection Dario Gamboni, *The Destruction of Art. Iconoclasm and Vandalism since the French Revolution.* London, 1997, p. 207 ff.

11 Concerning this heated and vehement debate, which had many far-reaching political implications, see *Voices of Fire. Art, Rage, Power, and the State*, edited by Bruce Barber, Serge Guilbaut, John O'Brian. Toronto, Buffalo, London, 1996, p. 32.

12 John O'Brian, *Who's Afraid of Barnett Newman?* in: *Voices of Fire*, op. cit., p. 133.

13 Newman, *Writings*, p. 135.

14 Wassily Kandinsky, *Über das Geistige in der Kunst, 5. Aufl.* Bern-Bümpliz, 1956, p. 34. (English translations appeared in 1914, 1946, and 1947.) Here quoted from: Wassily Kandinsky, *On the Spiritual in Art*, in: Kandinsky, *Complete Writings on Art*, Vol. 1, edited by Kenneth C. Lindsay and Peter Vergo. London, 1982, p. 138. The rejection of the world of phenomena in favour of an inner, spiritual world, as implied in Kandinsky's work, has its origin in Romanticism and is based on the notion that the human being and the cosmos have a common root or are, in principle, even identical. See Sixten Ringbom, *The Sounding Cosmos. A Study in the Spiritualism of Kandinsky and the Genesis of Abstract Art.* Abo, 1970 (Acta Academiae Aboensis, Ser. A, Vol. 38, No. 2), p. 114 ff.

15 Newman, *Writings*, p. 80.

16 Ibid., p. 58.

17 Ibid., p. 67.

18 Ibid., p. 69.

19 Ibid., p. 105.

20 Ibid., p. 76.

21 Ibid., p. 140.

22 Ibid., p. 145.

23 Ibid., p. 163.

32

24 Ibid., p. 164.

25 Lawrence Alloway, *The Rothko Chapel*, in: *Nation*, No. 212, March 15, 1971, p. 349 f. Here quoted from: Dore Ashton, *About Rothko*. New York, 1996, p. 135 (originally published in 1983).

26 Newman, *Writings*, p. 173.

27 Ibid., p. 108.

28 Ibid., p. 158.

29 Cf. Georg Wilhelm Friedrich Hegel, *Ästhetik, Bd. I* (quoted from 2nd edition, H. G. Hothos, 1842). Frankfurt, n.d., p. 353.

30 Here quoted from: Bernhard Kerber, *Die Ökumenische Kapelle in Houston*, in: *Gegenwart Ewigkeit. Spuren des Transzendenten in der Kunst unserer Zeit*, edited by Wieland Schmied in collaboration with Jürgen Schilling. Berlin, 1990, p. 65.

31 Hegel, op. cit., p. 353.

32 Newman, *Writings*, p. 306.

33 Adorno, op. cit., p. 196.

34 Ibid., p. 31.

35 Cf. Wolfgang Welsch, *Adornos Ästhetik des Erhabenen*, in: Wolfgang Welsch, *Ästhetisches Denken*, 2nd edition. Stuttgart, 1991, p. 146.

36 Newman, *Writings*, p. 289.

37 Karl Heinz Bohrer, *Das "Erhabene" als ungelöstes Problem der Moderne. Martin Heideggers und Theodor W. Adornos Ästhetik*, in: Karl Heinz Bohrer, *Das absolute Präsens. Die Semantik ästhetischer Zeit*. Frankfurt, 1994, p. 103.

38 Adorno, op. cit., p. 246.

39 Ibid., p. 269.

40 Newman, *Writings*, p. 251.

41 Ibid., p. 194.

42 Ibid., p. 257 f.

43 Adorno, op. cit., p. 93.

44 Newman, *Writings*, p. 279.

45 Ibid., p. 180.

46 Welsch, op. cit., p. 147.

47 Jean-François Lyotard, *Der Augenblick. Newman*, in: *Zeit. Die vierte Dimension in der Kunst*, edited by Michel Baudson, Palais des Beaux-Arts de Bruxelles, 1984, p. 100.

48 Newman, *Writings*, p. 248.

49 Ibid., p. 258 f.

50 Cf. Lawrence Alloway, *The Stations of the Cross and the Subjects of the Artists*, in: *Barnett Newman. The Stations of the Cross, Lema Sabachthani*, Solomon R. Guggenheim Museum, New York, 1966, p. 11. Newman at one time wanted to entitle the two first paintings, completed in 1958, so that they would make a pair, such as "Adam" and "Eve". In 1961, the first painting of the series was exhibited with the title "Station" and reproduced in the magazine *Art in America* with the title "The Series, I", (Vol. 49, No. 4, 1961, p. 94). Thomas M. Messer, on the other hand, recalls that in all the many discussions leading up to the first exhibition of the series, Barnett Newman, who had long hesitated before agreeing to the museum exhibit, never once mentioned the title "Stations of the Cross". Not until Alloway had written his introductory essay for the catalog did Newman finally decide on the title "The Stations of the Cross: Lema Sabachthani". Interview with Thomas M. Messer, July 3, 1997.

51 Thomas B. Hess, *Barnett Newman*. New York, 1969. Undoubtedly more influential were the chapters published in the catalog of the Museum of Modern Art: *"Not Here—There", "L'Errance", "Onement", "The Stations of the Cross"* and *"Be"*, cf. Preface, Note 5.

52 Hermann Lotze, *Geschichte der Ästhetik in Deutschland*. Munich, 1868, p. 190. Here quoted from Adorno, op. cit., p. 140 f.

53 Newman, *Writings*, p. 52.

54 Thomas McEvilley, *Kunstgeschichte oder Heilsgeschichte*, in: *Kunst und Unbehagen. Theorie am Ende des 20. Jahrhunderts*. Munich, 1993, p. 133.

1 "Irascible"?

On January 15, 1951, a photograph taken by Nina Leen (Fig. 3) appeared in *LIFE* with the caption: "Irascible group of advanced artists led fight against show". As the magazine devoted several pages to these "Irascibles", something quite unusual must have happened. The background was, briefly, as follows: In the spring of 1950, the Metropolitan Museum began preparations for a large exhibition entitled "American Painting Today. A National Competitive Exhibition", which was to be shown in December of the same year. As its title intimated, the exhibition was to be a competition, and various juries had been formed in the main regional

3 The "Irascibles", 1951
Back row, from left: Willem de Kooning, Adolph Gottlieb, Ad Reinhardt, and Hedda Sterne; middle row: Richard Pousette-Dart, William Baziotes, Jackson Pollock, Clyfford Still, Robert Motherwell, and Bradley Walker Tomlin; front row: Theodoros Stamos, Jimmy Ernst, Barnett Newman, James Brooks, and Mark Rothko

centers of America, such as Santa Barbara, Dallas, Chicago, Richmond, and New York. Of the 6,248 works entered for the competition, 761 were selected for exhibition, 421 coming from New York alone. Only one work from each artist was shown.

The prize-winning works were not all that exciting. Karl Knaths won the first prize— a check for 3,500 dollars—for his "Basket Bouquet". The runner-up—"Centurion's Horse" by Rico Lebrun—was followed by "Fish Kite" by Yasuo Kuniyoshi, and "Nine Men", a genre scene by Joseph Hirsch. All of them, without exception, were stylized representations with only slightly abstracted and easily recognizable motifs, and considerable borrowings from late Cubism.

Altogether a rather depressing result, and one which seemed to bear out the prejudiced view that American art was indeed provincial. Those artists who considered themselves to be avant-garde objected both to the unlimited admission of entries and to the two-stage method of adjudication, first by a conservative, provincial jury and then by a more open-minded body of adjudicators. This method could in their view only further amateurism and mediocrity and in no way bring about an improvement in American art and culture. Moreover, the protesting artists criticized the Metropolitan Museum for its seemingly total lack of enthusiasm for avant-garde art. Their anger was further inflamed by the director of the museum who, in public, compared them with "flat-chested" pelicans "strutting upon the intellectual wastelands."[1]

The opening of the exhibition at the end of December 1950 was an opportunity for *LIFE* to draw public attention to these "Irascibles" and their protest. Indeed, the magazine accorded them a place of honor in the heroic tradition of dissidence, placing them on a par with the Impressionists and the Ash-can School. The published photograph was subsequently featured in virtually all accounts of Abstract Expressionism and has thus decisively influenced our mental picture of this movement. In this regard I am grateful to Maria Müller for having drawn my attention to another photograph of the group in which Pollock and Newman are standing well behind the others. But let us return to the photograph which appeared in *LIFE*. Although it does not, regrettably, show all eighteen artists, most of them are there: back row, from left to right: De Kooning, Gottlieb, Reinhardt, Sterne; center row: Pousette-Dart, Baziotes, Pollock, Still, Motherwell, Tomlin; at the front, seated: Stamos, Jimmy Ernst, Newman, Brooks, and Rothko.

Clearly, this group photograph is much too well arranged for it to be a spontaneous snapshot. And in the middle of this gathering of worthies, who have obviously put on their Sunday best for this appointment with the photographer, is Barnett Newman. But why? Is it because he was the dominant spokesman of a group united by much more than this one protest? Hardly. Is it because he was particularly renowned and revered as an artist? Cer-

tainly not. On the contrary, his first exhibition, which had been at Betty Parsons exactly a year before (January 23–February 11, 1950), had been only moderately successful, whilst his second exhibition would not take place for another few months. Or perhaps the arrangement was, as Sylvester assumes[2], a purely formal one conceived by the photographer, with the two baldest men, Newman and Pollock, in the middle, and the men with the richest moustaches forming a triangle—Stamos on the left, Rothko on the right, and Newman in the middle. Could that be it? Since we know nothing about the circumstances in which the picture was taken, we can only guess.

In insider circles, Newman had undoubtedly made a name for himself as a critic and an orator, and also as an essayist and exhibition organizer, but hardly as a painter. When Motherwell delivered a lecture on "The New York School" at a conference of the College Art

4 The Surrealists, early 1940s
Back row, from left: Jimmy Ernst, Peggy Guggenheim, Pavel Tchelitchew, Marcel Duchamp, and Piet Mondrian; middle row: Max Ernst, Amédée Ozenfant, André Breton, Fernand Léger, and Berenice Abbott; front row: Stanley W. Hayter, Leonora Carrington, Frederick Kiesler, and Kurt Seligmann

36 Association on October 27, 1950, he mentioned seventeen artists by name, but not Barnett Newman.[3] Whether Newman was regarded as a "dud" as an artist—which is Sylvester's view—cannot be said for sure. It was Pollock's work which at that time was attracting the greatest interest, as was clearly evidenced by *LIFE*'s presentation of him in August 1949 as America's greatest living painter. And, in 1950, the *Saturday Review* proclaimed de Kooning, Rothko, and Pollock as the leading minds of the new movement in abstraction.[4] Evidently Barnett Newman was not somebody to be looked upon as an artist.

Group portraits play an important role in the process of self-reflection, especially where artistic movements are concerned, for here propaganda and self-portrayal are their primary purpose. This can be best illustrated by way of a comparison with a similar photograph. Taken in New York at the beginning of the forties, this photograph (Fig. 4) shows those artists who moved in the social circle around Peggy Guggenheim, most of them European wartime expatriates: at the front, from left to right: Stanley W. Hayter, Leonora Carrington, Frederick Kiesler, Kurt Seligmann; in the middle: Max Ernst, Amédée Ozenfant, André Breton, Fernand Léger, and Berenice Abbott; at the back: Jimmy Ernst, Peggy Guggenheim, Pavel Tchelitchew, Marcel Duchamp, and Piet Mondrian. Here, too, a certain compositional principle has been adopted, although it is not so centralized—a symmetrical group at the front and, behind them, two straight rows, the one looking to the right, the other to the left, with the exception of Berenice Abbott. What cannot be overlooked here is that Breton is seated in the middle, although he is not given the prominence enjoyed by Newman amid the "Irascibles". Breton's presence in this photograph is that of a writer, of the author of the Surrealist Manifesto, of an organizer of exhibitions, not of an artist. It would certainly be going too far to suggest that Newman's role among the New Yorkers was similar to that played by Breton among the Europeans. There is another possibility, however: in view of the scramble for superiority, that is to say, for the leading position in the movement, among Pollock, de Kooning, Rothko, and Still, the most important place in the photograph was given to someone who could not possibly lay claim to such a position, to someone who, before then, i.e. before the end of 1950, had hardly made an appearance as a painter, but who, by virtue of his educational and cultural background and his acknowledged keenness of intellect, certainly occupied an important place in the group and, presumably, had a significant and influential part to play in the protest. Indeed, the photograph furnishes us with the very evidence we need for this assumption, for Newman's prominent position in the photograph can hardly be explained otherwise. This can be demonstrated in detail, albeit only indirectly.

Firstly, we must bear in mind that the artists in the photograph cannot be regarded as a homogeneous group. On the contrary, they belonged to two completely different camps,

as Hess has pointed out. On the one side there were the "bohemians" who, like de Kooning, Pollock, and Kline, lived in Greenwich Village, wore workmen's clothes, earned their livelihood doing odd jobs, and slept in their studios. De Kooning and Kline exhibited mainly at the Egan Gallery. On the other side there were the "intellectuals", such as Gottlieb, Rothko, Newman, Still, and Reinhardt, whose social life was uptown, where they lived in apartments. These artists exhibited mostly with Betty Parsons, though Pollock also exhibited in her gallery on several occasions. Situated half-way between these two galleries, as it were, was Samuel Kootz who mainly handled Robert Motherwell, Hans Hofmann, William Baziotes, and Adolph Gottlieb. That the bohemians, with the exception of Pollock, rejected Newman is not really surprising, but he did not have an easy time of it with the intellectuals either, for many of them regarded him as a parvenu.[5]

Moreover, although Newman might on occasion have been something of a public champion for the cause of American art—for he coined terminology applicable both to his own work and to that of his friends—he does not seem to have played an outstanding role at this early stage as a theorist either.

There is other evidence of Newman's status. For example, at the private art school which Baziotes, Motherwell, Rothko, and Hare founded in the fall of 1948 and to which Newman, who joined the school shortly after, gave the name Subjects of the Artist, Newman attended the lectures and discussions which took place regularly on Friday evenings. When, in the fall of the following year, the discussion forum of Subjects of the Artist was handled by Studio 35—which took its name from its address: 35 East 8th Street—Newman again took part. The extraordinarily lively activities of this forum were capped by a three-day discussion among the artists. They discussed questions of a general nature, while deliberately avoiding all possible references to their own works. These discussions—Artists' Sessions—took place in 1950, from April 21 to April 23, and were moderated by Robert Motherwell, Richard Lippold, and—the only non-artist—Alfred H. Barr. If we study Robert Goodnough's published account of the Artists' Sessions[6], we find that Newman did not play a prominent part: he neither formulated interesting theories nor made inspiring remarks. Newman spoke much less frequently during these discussions than did Reinhardt, Motherwell, Lippold, and the others. Although Newman was evidently accepted by New York artists, he certainly did not enjoy a status comparable with that of André Breton.

Thus, if Newman was specially chosen to occupy a prominent position in the *LIFE* photograph, the reasons could not have been bound up with his modest reputation as a painter and theorist. Although we shall never know exactly what prompted the "Irascibles" to give Newman the place of honor in their midst, we can posit that it was because he was one of the key figures of the protest, perhaps even its initiator. Whether all of the protago-

nists saw it that way cannot be said for sure. Rothko's rather strained expression might be a sign of disagreement with the honor accorded Newman. Of greater consequence, however, are Newman's natural posture and the very impressive way his person fills and commands the center of the picture. It is a posture which manifests Newman's positive and optimistic conception of himself, but there is nothing arrogant about it, nor do we have the impression that he was laying any claim to leadership. But even though he had thus far not had spectacular success as a painter—unlike Pollock, de Kooning, Reinhardt, Still, and Rothko—he had, nonetheless, published several works of criticism, catalog contributions, and essays and had, in all of them, formulated concepts which not only stemmed from, and illuminated, his own personal approach to art but also were in circulation among other artists. It is this and other related aspects of Newman's activity which I shall be dealing with in the following chapters, in order to form a more accurate picture of Newman's intellectual make-up.

II Finding His Bearings

Even though, in the final analysis, there are really only two aspects of Newman's work which enable us to gain an impression of what motivated him during those early years, namely the practical and the theoretical, we shall for the time being concentrate on testimonies furnished by word of mouth, especially as there is no pictorial evidence dating back further than 1944. Newman destroyed everything that had existed prior to that year. Let us therefore briefly recapitulate the most important moments in Newman's artistic career.

In 1922, his last year at high school, Newman received permission from his mother to enroll at the Art Students League where he attended a class in drawing from casts. His frequent visits to the Metropolitan Museum had already awakened his interest in art, but now, after considerable success in the drawing class, Newman wanted nothing else but to become an artist. That was—he confided in Thomas Hess much later—"the highest role a man could achieve—it was a dream."[7] Newman's interest in art became even keener during his attendance at the City College of New York, where he also developed an interest in philosophy.

In 1926, Newman had an experience which, for his career, was not without consequences. Wishing to view the Barnes Collection in Merion, he was told that, as the collection of a private art school, it was accessible only to those enrolled in the school, whose teachers subscribed to the formalistic doctrine of Roger Fry. Newman's indignation found expression in a brief diatribe where he stated a conviction he was to maintain all his life: "Our critics [. . .] tell us in true nominalistic style that the artist creates form. This is a falsehood that has created much mischief, to say the least. The artist emphatically does not create form. The artist expresses in a work of art an aesthetic idea which is innate and eternal."[8]

Newman's idealistic view had been shaped by his reading of Spinoza. According to Spinoza, intuition was the key to esthetic experience, though this experience was not to be understood as a "sensory intuition in space and time", or as a "psychic, emotional experience", but rather as an "asensory, luminous intuition in timeless presence".[9] A significant change in Newman's approach was already beginning to suggest itself: one does not have intuitions, they are bestowed upon one, one is distinguished by them. What is interesting in this connection is that, whilst still at school, Newman added to his first name, Barnett—a transliterated approximation of Baruch (Blessed One)—a second name, Benedict (the Latin equivalent of Baruch). Newman retained this pleonasm of forenames until the mid-forties.[10]

Among the people whose acquaintance Newman made outside the college during the late twenties was Adolph Gottlieb who had likewise been a student at the Art Students League and, moreover, had studied under such renowned artists as John Sloan and Robert Henri. Two years older than Newman, Gottlieb had already been to Paris and had studied there at the Académie de la Grande Chaumière before returning to New York where he attended various other art schools from 1923 onwards. Thus he was already leading the unrestricted life of an artist, a circumstance which very much impressed Newman and reinforced his own intention to do the same.[11]

But nothing was to come of it, for Newman's father asked him to work for him in his clothing factory after graduating from college. In two years' time, said his father, Newman would have earned enough money to be able to devote himself entirely to his art without any financial hardship. But then came the Depression and his father's business went bankrupt. Refusing to acknowledge defeat, Abraham Newman pressed ahead with an ever growing pile of debts. It was not until 1937, when his father fell ill and retired, that Barnett Newman finally succeeded in liquidating the company.[12]

These circumstances were undoubtedly an impediment to Newman's artistic development. Living the life of an artist was out of the question. In order to gain a certain degree of financial independence, Newman decided to become an art teacher, but failed the qualifying examination, as did Gottlieb. Managing in the meantime to eke out a modest living as a substitute teacher, Newman took the examination a second time in 1938. Again he failed. This time Newman was outraged and showed the examination papers to the famous American mural painter Thomas Benton, who admitted in writing that he, too, would never have been able to pass such a test. The scandal was already brewing. Under the title "Can We Draw? The Board of Examiners Says—No!" Newman promptly organized an exhibition of the works of those artists who had failed the examination, including no less a celebrity than Max Weber. In an angrily worded catalog foreword, Newman cast doubt on

the validity of the selection process. But it was all of no avail. Newman and his comrades-in-arms were allowed to retake the examination, but failed on this attempt, too. Thus it was that Newman earned a mere $7.50 a day between 1931 and 1935, and from 1936 to 1939. During the war years he taught painting, drawing, design, and silk screen printing two days a week at the Washington Irving Adult Center, for $15 per week.[13]

In leading the protest against the procedure for examining and selecting art teachers, Newman was not acting purely in his own interest. On the contrary, he was responding—as he would respond time and time again—as a committed citizen who took social, ethical, and political problems seriously. In fact, in 1933, that is to say, when the Depression was at its worst, Newman had stood as a candidate for the office of Mayor of New York, knowing full well that he did not stand a chance of winning even a respectable number of votes. The campaign manifesto which he published emphasized education and culture and called for the establishment of free, municipally funded institutions, such as art schools, a city conservatory, a city university, an educational movie house, an opera house, an art gallery, and street cafés. The city could, Newman maintained, finance these institutions with income from public services (such as buses and subways), its own insurance company, and other profit-making municipal activities.[14] Newman, who had here construed economic facts and figures to support his own way of thinking, pleaded for "open forms and free situations", taking a stance which was at once rebellious and socially committed. And he even learned to read Yiddish "so I could follow the anarchist newspaper."[15]

It was about this time that Newman seriously thought of writing a book on the civil service in America. Surprising though this may be, it makes sense when we consider Newman's personal situation as a substitute teacher and the measures that had been initiated in the New Deal, particularly to provide government work for impoverished artists. In order to be able to research and write this book, Newman applied for a fellowship. In the proposal accompanying his application—which was ultimately rejected—Newman announced his aim of offering the world, a world which in his opinion was "sick of crackpot utopias", a "real, practical, American solution for our present social chaos."[16] An ambitious aim indeed, and one which, whilst testifying to Newman's political commitment, showed that there were other things, besides painting, which were important to him.

In view of the hopelessness of his situation and the impossibility of making a living by his painting, Newman took up various studies about the beginning of the forties. He devoted a great deal of time to the study of botany, geology, and ornithology and developed a theory of esthetic taxonomy according to which the loon, having the most monotonous of songs, perched on the very bottom rung of the evolutionary ladder, whilst the sparrow, by virtue of its complicated sequence of notes, perched on the very

highest.[17] As late as 1945, Newman was still not sure which way he would go. Influenced by Joyce, he had begun to write an "erotic" novel, but this soon bored him and he dropped the idea. He then concentrated more on his painting, which he had taken up again in 1944 after a break of several years.[18]

If we survey the period from about 1930 until the early forties, we gain the following impression: Newman had many and, in some respects, extremely diverse interests. He was forever commencing new projects, though they often remained unfinished. He committed himself politically, and he fought not only for his own interests but also for those of his fellow artists. The job with which he actually earned his bread and butter was both irksome and without any artistic or intellectual prospects, let alone financial ones. This situation was further aggravated by his involvement, for too long a time, in his father's bankrupt business, and clearly led to an overwhelming feeling of insecurity during the Depression, the New Deal, and the Second World War. Newman seemed to call all traditions into question and, in particular, refused to recognize any binding artistic criteria. It was, all told, a period of complete disorientation. Nonetheless, Newman constantly endeavored to put an end to this hopeless and totally disheartening situation. He desperately needed to know what way of life could promise him a fruitful future. At the beginning of the forties he familiarized himself with the prevailing artistic tendencies; the conclusions he drew from them were to play a decisive role in his personal development from then on. Thanks to the posthumous publication of his writings, this development is more easily surveyable today than it was just a decade ago.

III Against Isolationism

Even though we do not know what Newman painted prior to this period, or indeed whether he painted anything at all, we can be sure that it did not escape his notice that many different tendencies had begun to establish themselves in American art. At that time, for example, much publicity was being given to the Mexican mural painters, and this undoubtedly had a direct influence on the programs of the Works Progress Administration, which commissioned artists to adorn many public buildings with cycles of murals. The aim was to further the acceptance and efficacy of art, and to advance a more rational relation of the artist to his work, and of the viewer to works of art. Art was frequently used as a means of furthering educational aims and also served other purposes which had little or nothing to do with esthetics.

Much more significant, however, was the widespread striving for an autonomous, genuinely American art. This movement was essentially isolationist and, as such, angered Barnett Newman who, whilst being American through and through, was definitely cos-

mopolitan in his outlook. Several exhibitions which he considered chauvinistic and reactionary prompted him to rise up in protest and to seek the support of other artists. In an essay begun in 1942 but never published, Newman exposed those xenophobic sentiments which, in his view, served to disguise the furtherance of "simple-minded, sentimental, salable art"[19]—and at a time, moreover, when the bombing of Pearl Harbor had shocked America out of her isolationism and forced her to enter the war. Newman polemicized against art which depicted and glorified the simple way of life in the (American) countryside, the kind of art produced by Grant Wood and by the commercially minded artists of the so-called American Renaissance. Newman attacked reactionary philistinism and all those corrupt artists who knowingly jumped on the bandwagon. According to Newman, America was culturally and esthetically immature, and he asked himself whether his country, suffering from an inferiority complex on this account, might fall victim to Nazi ideology. Newman closed his essay with the following demands: "It is time for artists to wake up and reexamine their aesthetic foundations, to rid themselves of the millstone that has made art in America an expensive picture-postcard factory. It is time they understood the political foundation of their art, cleaned house, and went back to the study of art where they belong. It is time artists refused isolationist money, repudiated the art dealers, the favor of museum directors. It is time artists forgot about success and made clear to the art public that the deaths of Grant Wood and Gertrude Whitney were as strong a symbol as Pearl Harbor for the end of an isolationist era."[20]

Newman expressed himself in a similar vein in his catalog foreword for the first annual exhibition of the American Modern Artists. This exhibition was held at the Riverside Museum in New York at the beginning of 1943. It had been organized as a protest against a juried exhibition of contemporary art at the Metropolitan Museum which had deliberately excluded modernist jurors and contributors and had been arranged by a consortium of various artists' groups called Artists for Victory. Newman had clearly stated the modern artists' position in a letter to the director of the Metropolitan Museum: "In these crucial times, when all our cultural values are at stake, no cultural enterprise can stand that excludes the vital, creative forces of modern artists and builds on the feeble support of noncreative elements."[21] In the catalog of the exhibition, in which he himself did not take part, Newman wrote: "We, who dedicated our lives to art—to modern art—to modern art in America, at a time when men found easy success crying 'To hell with art, let's have pictures of the old oaken bucket'—we mean to make manifest by our work, in our studios and in our galleries, the requirements for a culture in a new America.

"America has the opportunity of becoming the art center of the world."[22]

This awareness of living in crucial times also conditioned the actions of other artists. Whilst they wished to reject isolationist tendencies and to welcome modernism with open arms, they had no wish to succumb to the influence of those European artists who, during the war, had sought refuge in America in ever increasing numbers. Thus they had to seek and establish their own unmistakable positions and be able to underpin them with sound theory and convincing argument.

IV Reinventing Painting

It was about this time that Newman took up painting again, after a lapse of several years. It was a beginning from scratch, and it was a beginning which seemed to release new, undreamt-off energies. After a devastating depression and a fierce world war, one could not simply pick up where one had left off: "It was impossible to paint [. . .] flowers, reclining nudes, and people playing the cello. At the same time one could not move into the situation of a pure world of unorganized shapes and forms, or color relations [. . .] And I would say that for some of us, this was our moral crisis in relation to what to paint."[23] Newman put it even more bleakly: "In 1940, some of us woke up to find ourselves without hope—to find that painting did not really exist. Or to coin a modern phrase, painting, a quarter of a century before it happened to God, was dead."[24] And this new beginning had something revolutionary about it: "It was that awakening that inspired the aspiration—the high purpose—quite a different thing from ambition—to start from scratch, to paint as if painting never existed before. It was that naked revolutionary moment that made painters out of painters."[25] Other artists spoke along much the same lines—Robert Motherwell, for example, when at a symposium on "French Art vrs. U.S. Art Today" in Provincetown in August 1949, said that all modern painters in America at that time felt the necessity to reinvent painting.[26]

There was a hunger for inspiration. Newman, Gottlieb, and Rothko moved in a circle of young painters whose curiosity and enthusiasm drove them incessantly forward in their search for ever new possibilities of artistic expression. Opportunities to become informed were everywhere—at Peggy Guggenheim's gallery Art of This Century, for example, where Pollock, Baziotes, and Motherwell had already had an opportunity to show some of their works in an exhibition of collages in early 1943. And, in November of 1943, Peggy Guggenheim mounted Pollock's first solo show, which was enthusiastically reviewed by Clement Greenberg and Robert Motherwell. Further exhibitions of young New York artists followed in rapid succession between October 1944 and January 1945, including solo shows of Baziotes, Motherwell, and Rothko. These exhibitions fostered a lively scene of encounters and exchanges among the young artists, and of mutual support and motivation.

44 Rothko and Gottlieb had by now given up their partially pseudorealist, partially surrealist styles. In Rothko's case, this change was so drastic that he even abbreviated his name from Marcus Rothkowitz to Mark Rothko. On June 7, 1943, Rothko and Gottlieb wrote a letter to the *New York Times* in response to a negative review in that newspaper. The letter was a statement of their objectives, and it is possible that Newman—by virtue of his skill as a writer—was involved in the drafting of it. However, as he had not taken part in the third annual exhibition of the Federation of Modern Painters and Sculptors, which had occasioned the review and rejoinder, there was no reason for him to have been mentioned by name. Parts of the letter were published in the *New York Times* on June 13, 1943. The essence of the statement is as follows:

"1. To us art is an adventure into an unknown world, which can be explored only by those willing to take the risks.

"2. This world of the imagination is fancy-free and violently opposed to common sense.

"3. It is our function as artists to make the spectator see the world our way—not his way.

"4. We favor the simple expression of the complex thought. We are for the large shape because it has the impact of the unequivocal. We wish to reassert the picture plane. We are for flat forms because they destroy illusion and reveal truth.

"5. It is a widely accepted notion among painters that it does not matter what one paints as long as it is well painted. This is the essence of academicism. There is no such thing as good painting about nothing. We assert that the subject is crucial and only that subject-matter is valid which is tragic and timeless. That is why we profess spiritual kinship with primitive and archaic art."[27]

Several elements of this manifesto were to prove fruitful during the years that followed. Firstly, there is the assertion of the artist's own approach, his willingness to take risks, his imagination, his directness of expression, and his insistence on his own subjective standpoint. Secondly, there is the insistence on the medium of expression, that is to say, large, unequivocal shapes that emphasize the picture plane and destroy the illusion of space and depth. Thirdly, and most importantly, there is the definition of subject matter—the unknown, irrational world, the tragic and the timeless—from which the spiritual kinship of modern painting with primitive art derives.

Newman's recognition of the war's consequences is manifest in an essay which he wrote for *Tiger's Eye*, but which on account of its length could not be included in the March issue of 1948 (nor was it published at any later date during his lifetime). In this essay, Newman again deals with the relationship between Surrealism and primitive art: "Surrealist art under its realistic and ideal surfaces contains all the weird subject matter of the primitive world of terror.

"But that time is over. The war the surrealists predicted has robbed us of our hidden terror, as terror can exist only if the forces of tragedy are unknown. We now know the terror to expect. Hiroshima showed it to us. We are no longer, then, in the face of a mystery. After all, wasn't it an American boy who did it? The terror has indeed become as real as life. What we have now is a tragic rather than a terrifying situation."[44] And in another essay Newman maintains that, after the Second World War, Surrealism as an artistic credo is dead, for the infernal realities of the battlefields and the concentration camps have made all the prophecies of this movement obsolete.[45]

Newman's expression "the terror of the unknowable" seems to hark back to an older esthetic concept of terror which had for centuries dominated the discussion of the sublime. Perhaps we can also detect the—albeit indirect—influence of Nietzsche's suggestion that in view of the world's intellectual decline the human being should, "in his deep and lasting distress, grasp the ungraspable as the sublime".[46] Whilst he is not specific about it, Newman dimly senses the impossibility of stepping out of his own time. Against the backdrop of the Second World War, any reflection on primitive cultures that arises out of existential *angst* is dubious. Newman's construct of a relationship between so-called primitive art and contemporary art which transcends space and time does not forfeit its power of suggestion, but the problem shifts to a different level, namely that of representation. The unimaginable had now become the object of reflection and, in its esthetic evocation, had to be something that was beyond all grasp. Truth which could not be understood could only be shown in a veiled form. This reasoning was prominent in Newman's writings whenever contemporary art movements were the topic, though he now obviously realized that his reflections on the ideographic picture could neither substantiate nor justify a workable vocabulary of form. The "totemic affinity" between all living creatures and the "noumenistic mystery" of the equality of man and nature which he had recognized in Stamos's paintings[47] were now becoming more and more dubious. Stamos's paintings were full of symbols, but they were not really abstract.

VII Abstraction

In such a situation, it was almost inevitable that Newman, besides being preoccupied with primitivism, Surrealism, and American art, should concern himself with genuine abstract art as well, though a definite line of demarkation cannot always be drawn between these individual schools. Surrealism and abstraction were indeed prevalent in New York during the forties, firstly through the European expatriates who had fled from Europe before the war and, secondly, through the activities of the Museum of Modern Art, the Gallatin Collection—although in 1943 this collection had passed from New York University to the Philadelphia Museum of Art—and the Museum of Non-Objective Painting, which was later to become the Solomon R. Guggenheim Museum. Nor must it be forgotten that both Kandinsky and Mondrian, shortly before the end of the war, had been honored—almost simultaneously—with posthumous retrospectives in New York, exhibitions which made a great impression.[48] There can be no doubt that Newman's lifelong preoccupation with Mondrian was largely ascribable to this circumstance.

In 1944, Newman speaks of Mondrian as the protagonist of pure abstraction, an abstraction which completely denies the world around us and "insists on a purist world of pure forms and color".[49] In the spring of 1945, Newman was working on his essay "The Plasmic Image" (unpublished during his life) which, for long stretches, reads like a refutation of Mondrian's essay "Plastic Art and Pure Plastic Art" which had appeared in *Circle* in 1937. Newman's artist is concerned with the penetration into the world-mystery; Mondrian, on the other hand, is concerned with the discovery of universal beauty. Newman's artist seeks the sublime; Mondrian seeks direct reference to life. Whilst Newman's artist strives to catch the basic truth of life, Mondrian searches for that fundamental law of equivalence which creates dynamic equilibrium and reveals the true content of reality.[50] Newman called the new painting "plasmic", because "the plastic elements of the art have been converted into mental plasma". For Mondrian, on the other hand, art was an expression of true reality and true life which, whilst not being definable, were nevertheless realizable in plastic form.[51] For Newman, art was a language through which important visual ideas could be projected, whilst in Mondrian's eyes non-figurative painting represented an art in which form and content were one and the same.[52] Newman's project was bound up with intellectual content. Mondrian's project was bound up with line and color and with the way they related to each other, whereby the whole emotional and intellectual spectrum was brought into play, only not the subject matter.[53] The most decisive difference, however, was that Newman understood art as a metaphysical exercise, whereas Mondrian saw the purpose of art as being the creation of a new plastic reality which embraced everything—architecture, sculpture, painting, and applied art.[54]

The rejection of Mondrian's art was widespread among American artists. For de Kooning, who strongly criticized Neo-Plasticism, Mondrian was a merciless artist who left nothing undone and whose ideas were a little crazy.[55] As early as 1942, Motherwell had criticized Mondrian's abstraction as being too bare. It was not, he said, concrete and specific enough fully to involve the observer mentally and emotionally. On the other hand, it manifested a "poetry of constructiveness" and an "implacable honesty" which made one think of Seurat and Cézanne. "Beside Mondrian the other abstractionists seem dull and grey."[56] Thus, in his opinion of Mondrian, Newman was very much in agreement with other artists. One is struck, however, by Newman's intense and lifelong preoccupation with Mondrian. Whilst in 1945 Newman maintains that Mondrian's concept is based "on bad philosophy and on faulty logic"[57], in 1948 he writes: "Even Mondrian [. . .] succeeded only in raising the white plane and the right angle into a realm of sublimity, where the sublime paradoxically becomes an absolute of perfect sensations. The geometry (perfection) swallowed up his metaphysics (his exaltation)."[58] With this—in Newman's own eyes—devastating criticism, a significant artist had been utterly condemned. Indeed, this criticism could not have been anything but harsh, for Newman had himself felt challenged and his ideas called into question by Mondrian's conception of art. As late as 1965, Newman still spoke disparagingly of Mondrian. While he respected Mondrian highly, he felt he had to confront his dogmatism and his "systematic theology"[59], for in truth Mondrian had destroyed what really mattered in art, namely the subject matter.[60]

VIII The Reality of the Transcendental Experience

But let us return to the immediate post-war years. In 1945, Newman gave serious thought to an essay by Joseph Frank in the *Sewanee Review* entitled "Spatial Forms in Modern Literature" which drew parallels between modern art and literature. In his criticism of Frank's observations, Newman defines painting as a medium which permits pure expression: "Modern painting is an attempt to change painting into a poetic language, to make pigment expressive rather than representational."[61] In the course of his reflections, Newman weighs tribal art against abstraction and clearly states, for the very first time, what art must seek to achieve—namely a solution to the problem of subject matter: "The abstract art of the Northwest Coast Indian and the archaic Greek, like the archaic epic, used subject matter. The fact that they were able to transcend appearance and make contact with absolutes was based on the particular *kind* of subject matter they used rather than on the complete avoidance of apparential [sic] subject matter. That is a truth which has become very evident to the new painters who, although dissatisfied with realistic subject matter, are equally dissatisfied with the abstract and nonobjective art of the last

thirty years. These painters feel that Picasso, Arp, Kandinsky, and Mondrian have made revealing statements, but that essentially they are negative statements. None of them discovered a new subject matter or recreated an old one; these men took the easy way out and destroyed subject matter. [. . .] What has to be done is to discover the proper theme that will make contact with reality; what has to be discovered is a new subject matter."[62]

Newman's categorical rejection of abstraction as represented by Kandinsky and Mondrian and his equally uncompromising refusal to accept Surrealism, not to mention his contempt of isolationist genre painting, were indeed conducive to his defense of so-called primitive art—especially since he considered it to be the only art which transcended the ephemeral and expressed the absolute. Moreover, if we take a closer look at Newman's historical construct, the strategy behind it becomes obvious. Just as Kandinsky spoke out against the "Salons" and in defense of the creative potential of folk painting on glass, or Klee against academicism and in defense of children's drawings and their power of unsophisticated expression, so Newman turns to tribal art in his search for a means of resisting abstraction and Surrealism. Abstraction, Surrealism, and isolationism are, for Newman, the equivalents of academicism and the "Salons". They must at all events be countered. Radical renewal is his concern, just as it was Kandinsky's and Klee's, but Newman's aim is not the discovery of primitive, unsophisticated expression but the visualization of eternal truths, truths which can be readily discovered in early civilizations and their art and which, even today, in a completely new context, are still binding.

Thus Newman calls abstraction and Surrealism into question, two European movements to which, time and time again, he opposes indigenous American art. A completely different approach was adopted by Rothko. For him, Surrealism and abstraction are like one's mother and father, since they are the cause of one's own existence. But one then breaks away from the parental home. "I, being both they, and an integral completely independent of them."[63] Motherwell, on the other hand, whilst owing more to Surrealism—and its automatist techniques—than any other American painter of his generation, realized, like Newman, that "a young movement in painting [. . .] will only be important to the degree that we try to advance beyond the great Parisian painters."[64]

But if Surrealism was not to be the origin of the American tradition of painting, what else was there to build on? Wherein lay the specific character of an independent American art form? Newman, like many others, sought answers to these questions. The following example may serve to illustrate the situation: Towards the end of 1947, Clement Greenberg criticized the symbolic and metaphysical aims of such young painters as Rothko, Still, Gottlieb, and Newman as "half-baked and revivalist, in a familiar Ameri-

can way". This criticism was countered emphatically by Barnett Newman, whose positive appraisal of the work of his fellow American artists reads: "The American painters under discussion create an entirely different reality to arrive at new unsuspected images. They start with the chaos of pure fantasy and feeling, with nothing that has any known physical, visual, or mathematical counterpart, and they bring out of this chaos of emotion images that give these intangibles reality. There is no struggle to go to the fantastic through the real or to the abstract through the real. Instead, the struggle is to bring out from the nonreal, from the chaos of ecstasy something that evokes a memory of the emotion of an experienced moment of total reality."[65] "The Americans evoke their world of emotion and fantasy by a kind of personal writing without the props of any known shape. This is a metaphysical act. With the European abstract painters we are led into their spiritual world through already known images. This is a transcendental act. To put it philosophically, the European is concerned with the transcendence of objects while the American is concerned with the reality of the transcendental experience."[66]

Newman continued to use such oversimplifications in order to make as clear as possible the essential difference between European and American art. In March 1948, in a short piece published in *Tiger's Eye*, Newman saw the European artist as one nostalgic for ancient forms, "hoping to achieve tragedy by depicting his self-pity over the loss of the elegant column and the beautiful profile," whereas "the artist in America is, by comparison, like a barbarian. He does not have the superfine sensibility toward the object that dominates European feeling. He does not even have the objects.

"This is, then, our opportunity, free of the ancient paraphernalia, to come closer to the sources of the tragic emotion. Shall we not, as artists, search out the new objects for its image?"[67] Newman was not alone in his opinions. Motherwell, too, stressed that a conscious abandoning of the past was the essentially American creative act, though only if American painters were then able to create a world of their own.[68]

IX The Experience of Presence

No matter what Newman talks and writes about at this time, whether it is his dislike for the still young movements of Surrealism and abstraction, his admiration of tribal art, his plea for a new and independent American art and his categorical rejection of European art, his evocation of great mysteries, the chaos of ecstasy, mystical truths, transcendental experiences, the world-mystery, metaphysical exercises, and the memory of the emotion of an experienced moment of total reality—that is to say, for all his talking and writing, we still cannot really say what, for Newman, the new subject matter of art

should be. We know—from what he says and writes—what he is rejecting, but it is extremely difficult to make out exactly what he is striving for. Newman attempted to give an answer to this burning question in what must be his most famous essay, "The Sublime Is Now". In this essay, which appeared in *Tiger's Eye* in December 1948, Newman discussed the problem of achieving the sublime through art in an age which had no exalted myths or legends and, moreover, was dominated by a dubious form of abstraction: "We are reasserting man's natural desire for the exalted, for a concern with our relationship to the absolute emotions. We do not need the obsolete props of an outmoded and antiquated legend. We are creating images whose reality is self-evident and which are devoid of the props and crutches that evoke associations with outmoded images, both sublime and beautiful. We are freeing ourselves of the impediments of memory, association, nostalgia, legend, myth, or what have you, that have been the devices of Western European painting. Instead of making *cathedrals* out of Christ, man, or 'life,' we are making [them] out of ourselves, out of our own feelings. The image we produce is the self-evident one of revelation, real and concrete, that can be understood by anyone who will look at it without the nostalgic glasses of history."[69]

Thus painting, for Newman, must seek to visualize the sublime. Moreover, Newman repeatedly links his notion of the sublime with such phrases as "world-mystery", "metaphysical secrets", "basic truth of life" etc.[70] In a review of an exhibition at the Museum of Modern Art in 1944, Newman writes: "The art of the future will, it seems, be an art that is abstract yet full of feeling, capable of expressing the most abstruse philosophic thought."[71] Modernism, wrote Newman in this same review, had taught us that "art is an expression of thought, of important truths, not of a sentimental and artificial 'beauty'." Since modernism, the artist had become "a creator and a searcher" rather than "a copyist or a maker of candy". Of course, writes Newman, "modern art is abstract, intellectual!"[72]

Here, too, Newman is full of words and phrases, but they lead us nowhere. His notion of the new American painting and its subject matter still seems vague and indecisive. We cannot of course reproach him for this. On the contrary, we can only assume that the answer cannot be readily expressed in words. Newman knew exactly what he did not want, but he had only an inkling of the direction in which his ideas were taking him. And so perhaps the solution to the problem was to be found purely in the actual medium of painting—visual and wordless—and nowhere else.

What we *do* know, however, is that the new American painter will be concerned with the sublime, with abstruse philosophic thought, with important truths, and will be creating his art out of himself, i.e. out of his own feelings. This is an ahistorical view, a view

which reflects not the linear course of time but rather time's standstill experienced, as it were, in an instant of fulfilment, as an existential moment. When in 1949 Newman visited the Indian mounds in the Ohio Valley, he suddenly realized that his art, the art he was seeking, was ultimately concerned essentially with the phenomenon of presence.[73] All revolves around the idea that man is present; the sensation is not a physical one of space—and this is important inasmuch as all historical definitions of the sublime proceed from the terror of natural phenomena—but one of time. "The concern with space bores me. I insist on my experiences of sensations in time—not the *sense* of time but the physical *sensation* of time."[74]

This last statement, with which Newman concludes his description of his excursion to the Indian earthworks in Ohio, expresses his realization succinctly. The change from the principle of "space" to the principle of "time" may be seen, in inverted analogy to Richard Wagner's Parsifal ("Thou seest, my son, here time doth space become"), as a process of metamorphosis or transubstantiation. Moreover, it becomes clear that the sublime has to do not with abstract symbols but rather with an experience of self at that moment when the two phenomena that determine human existence—space and time—merge. The incommensurable, which is central to Newman's theme, reveals itself as an esthetically evoked phenomenon which, in its sublimity, can no longer be experienced, only spiritualized. Thus thrown back upon himself, the observer experiences one thing above all else—himself as another.

All this means, if we think it through to the very end, that the notion of the sublime, as understood by Longinus, Kant, Hegel, Burke, and others, serves Newman primarily as a backdrop for the development of his own ideas. Newman no longer sees the sublime as "the imagination of the infinite in the finite" (Schelling) or as "applied infinity" (Jean Paul), nor does he mean Kant's "supersensible realm" or "negative desire". Rather, Newman has brought the notion of the sublime into play only in order to modify or replace it. For Schiller, the sentiment of the sublime consisted "on the one hand, of that overwhelming feeling of powerlessness and limitation which we experience in our endeavor to grasp an object, and, on the other, of our feeling of superior strength that fears no bounds and enables the mind to overcome that to which our sensory powers are subject"[75]—in other words, the sublime has its origin in the discrepancy between sensory perception and abstract notion. By comparison, Newman's definitions of the sublime remain strangely vague. But this can be explained: the dichotomy between passive sensory subjection and active mental penetration—which since Schiller has been regarded as fundamental to the definition of the sublime—had yielded in Newman's theoretical reflections to the notion of presence. Underlying New-

man's thinking was his awareness of the inadequacy of metaphysics. Newman would naturally have liked to retain metaphysics, for it would have substantiated art's claim to transcendence. However, metaphysics not only had long since served its purpose—certainly since Marx, Kierkegaard, and Nietzsche—but also had, in the light of horrific political events, proved once more to be obsolete, and this was a fact which Newman could not ignore. For him, the sublime in tribal art had hitherto manifested itself in the "terror of the unknowable", but the unknowable had now metamorphosed into the concrete, incommensurable horror of Hiroshima and the Holocaust. This could not of course be thematized; it could not serve as the subject matter of depiction. This "exit from the world of the senses", as Schiller put it[76], was closed for ever more. Newman's dilemma was that, for the sake of art, he was holding on to something which, in view of the violation of civilization by the atomic bomb and the concentration camps, forbade every form of esthetic evocation.

X The Terror of the Esthetic

Newman's theories on esthetics, as formulated, quite unsystematically, in his essays and statements between the middle and the end of the forties, are based on two premisses: a radical negation of all art-historical tradition coupled with a leaning towards so-called primitivism; and a definition of art which culminates in the notion of the sublime, albeit radically modified by Newman. When Newman speaks, for example, of the "reality of the transcendental experience" or the "memory of the emotion of an experienced moment of total reality" and claims that painting can achieve them, he is shifting the emphasis to the subject's experience of presence. The esthetic of terror has suddenly turned into the terror of the esthetic. As I shall be dealing with this matter in greater detail later, I wish at this juncture merely to point out that Newman's meandering thoughts were not synthesized into their antithesis; rather, the emphasis on the subject's self-experience was placed within the sensation of the sublime as a whole. Seen this way, art changes from a metaphysical exercise into a transcendental act. It is not the work itself which is sublime but, if at all, the sensation of the incommensurable which the viewer experiences when viewing the work. What is critical here, of course, is the question, What prerequisites must a painting meet in order to trigger this experience? It is a central question, and one which was to preoccupy Newman for the rest of his life. Let us, for the moment, look twenty years ahead, to January 1968, when, at the Baudelaire symposium in Paris, Newman remarked on what Baudelaire had understood as the most fundamental of all a painter's problems, namely "What to paint?"[77] It is a problem which implicitly differentiates between the representation of a theme, and

the theme of a representation. In our present context, the problem implies the difference between the representation of the sublime, and the sublime of the representation—with the sublime of the representation able to reveal itself only in the subject's own experience of presence, namely as an experience of identity in the non-identical.

Whichever way we look at Newman's attempts to free himself from a specifically idealistic tradition, a tradition linked with such names as Malevich, Kandinsky, and Mondrian, we inevitably find ourselves confronted by what can only be described as a "salvation-history of art" which asserts its claim to absoluteness, intellectualizes all that is natural and insists on transcendental experience as the ultimate goal. The question of the subject matter of pure painting, that is to say, of painting which is free from all that is symbolic, anecdotal, formalistic, and thematic, has perhaps resolved itself of its own accord—historically—and in complete contradiction to what Newman himself pursued, considered, hoped for, and sought to achieve through the medium of painting, and through this medium alone, for it could be achieved through no other. Permit me to recapitulate: It is not the suggestion of the sublime in Newman's oeuvre which fascinates us, but rather the reflection of the pole diametrically opposed to the sublime. Admittedly, the experience of presence in Newman's case—and here he follows a traditional approach—is the reverse side of the experience of the sublime, and hence they are closely linked, though when we stand in front of his works we experience only one side with any intensity, namely presence, for an experience of the sublime is no longer possible. Our loss of that category of meaning in which eternal truths are presumed to reside strengthens our skepticism about what we see in Newman's oeuvre and at the same time confirms the extraordinary artistry of his esthetic act, the foundations of which survive only in our memory.

Newman's ideas found a generally sympathetic echo among New York artists, though they were contested now and again. For example, the December 1948 issue of Tiger's Eye, in which Newman's essay "The Sublime Is Now" appeared, also featured an essay by Robert Motherwell, whose original title was "Against the Sublime". In this essay, Motherwell maintained that the Impressionists led the decisive attack on the sublime. To revalidate it would be completely unthinkable, Motherwell writes, not least because modernism had proven to be a progressive and irreversible process of elimination and/or reduction.[78] This was a superficial approach and, as such, had nothing to do with the problems raised by Newman, problems which have preoccupied artists right up to the present day and, in some cases, have led to inventions which are, quite literally, breathtaking. One has only to think of the work of Richard Serra, James Turrell, Walter de Maria, and Gerhard Merz, among others.

On the whole, however, Newman's theoretical reflections during the immediate post-war years fell on fertile ground; the prevailing feeling among artists at that time was that theorizing on art should no longer be the prerogative of the universities and museums but should, as in France during the nineteenth century, be left to painters and poets.[79] Here Newman found himself in a dilemma: on the one hand he must lead the normal life of a human being and, on the other, make progress as an artist—indeed, the artist must lead a double life, a life which keeps art and society separate. A great many American artists suffered such a life of isolation. Their alienation syndrome was further aggravated by the lack of collectors and the concomitant financial difficulties, by the enormous attraction of the European artists, and by their own painstaking search for a new way in art. De Kooning, for example, felt that he belonged nowhere: " [. . .] we have no position in the world—absolutely no position except that we just insist on being around."[80] Others saw themselves as being in opposition to society, like all avant-garde artists since the nineteenth century.[81] Thus the idea of the sublime—or, more correctly, presence—might also be understood, albeit in an oversimplified sense, as the sublimation of the isolation of the creative individual.

This brief survey of Newman's beginnings and his esthetic ideas of that time will have sufficed to show that, during those early years, Newman had laid the theoretical foundations for everything that was to preoccupy him in the future.[82] From our reading of the manuscripts referred to here—many of which had not, at the time, been published, or had appeared in magazines which did not have large circulations, or had been published in foreign magazines, such as *La Revista Belga*—we gain the impression that Barnett Newman was a man of strong character who left no stone unturned in his quest to be an artist after Hiroshima and Auschwitz. Although he was a far less productive and successful writer than Robert Motherwell, for example, Newman's ideas opened up new and unusual perspectives. He insisted on the autonomy of American art. He was enlightened. He was concerned about the needs of the community. He involved himself in social and political matters and spoke out about things he considered wrong or in dire need of reform. Intelligence, perseverance, unusual polemical talent, and social competence joined forces in Barnett Newman with a strong sense of political responsibility and enormous strategic ability. Although he was still an unknown quantity as a painter, little noticed as an orator, scarcely ever properly appreciated as a theorist, it would seem that Barnett Newman was, in those immediate post-war years when everything was still in flux and standpoints had yet to find their own level, something of an *éminence grise* on whom many artists in New York were pinning great hopes and expectations, whilst others adopted a more reserved attitude. This may explain why Barnett Newman occupies such

a prominent position in that historically significant photograph which appeared in *LIFE*. The question yet to be answered, however, concerns Barnett Newman's own painting and its reception.

60

1 As reported in *LIFE,* January 15, 1951.

2 Cf. David Sylvester, *The Ugly Duckling*, in: *Abstract Expressionism. The Critical Developments*, exh. organized by Michael Auping, Albright-Knox Art Gallery, September 19– November 29, 1987, p. 139.

3 Cf. *The Collected Writings of Robert Motherwell*, ed. by Stephanie Terenzio, New York and Oxford, 1992, p. 76.

4 Cf. Beryl Wright's chronology in: *Abstract Expressionism*, op. cit., pp. 267, 269.

5 Hess, 1969, pp. 42–43.

6 *Artists' Sessions at Studio 35 (1950)*, ed. by Robert Goodnough, in: *Modern Artists in America,* cf. n. 28, p. 103, ed. by Robert Motherwell and Ad Reinhardt, New York, [1951], p. 9 ff.

7 Hess, 1969, p. 11.

8 Newman, *Writings*, p. 58.

9 Hess, 1969, p. 7. Here Hess quotes Karl Jaspers's description of Spinoza's "third kind of knowledge".

10 Ibid., p. 11.

11 Ibid., p. 14.

12 Ibid., p. 15.

13 Ibid., p. 16.

14 Cf. Newman, *Writings*, p. 7.

15 Hess, 1969, p. 18.

16 Newman, *Writings*, p. 14.

17 Hess, 1969, p. 20.

18 Ibid., p. 25.

19 Commentary in Newman, *Writings*, p. 20.

20 Newman, *Writings*, p. 28 ff.

21 Ibid., p. 29.

22 Ibid., p. 30.

23 Ibid., p. 287.

24 Newman at the Pollock Symposium in New York in April 1967. Cf. Newman, *Writings*, p. 191.

25 Newman, *Writings*, pp. 191–92.

26 Cf. *The Collected Writings of Robert Motherwell*, op. cit., p. 67.

27 Quoted from: *Mark Rothko*, The Tate Gallery, London, 1987, p. 69.

28 Newman, *Writings*, p. 60.

29 Ibid., p. 61 f.

30 Newman was of course not the only painter interested in primitivism. Rothko, Pollock, Gottlieb, Baziotes, and many others all borrowed from it, though they were concerned less with direct appropriation than with expressing something essential using their own forms, often with dubious results. Artists showed no particular preferences; they were interested in everything exotic and archaic. In a lecture delivered in 1951, Motherwell named the affinities of the New York School with the art of other cultures—Egypt, Africa, the South Seas, and above all the Orient— but maintained that the energy, substantiality, sexuality, and heaviness of Occidental art still persisted in the New York School artists' work. Cf. *The Collected Writings of Robert Motherwell*, op. cit., p. 80.

31 Newman, *Writings*, p. 65.

32 Ibid., p. 89.

33 Ibid., p. 101.

34 Ibid., p. 102.

35 Ibid.

36 Ibid., p. 106.

37 Ibid., p. 140.

38 Ibid., p. 145.

39 Ibid., p. 163.

40 Ibid., pp. 106–107.

41 Cf. Robert Goldwater, *Primitivism in Modern Art*, 3rd, enlarged edition, Cambridge, Mass., and London, 1986, p. 161.

42 Newman, *Writings*, p. 108.

43 Ibid., pp. 75, 142.

44 Ibid., p. 169.

45 Ibid., p. 96.

46 Cf. Friedrich Nietzsche, *Vom Nutzen und Nachteil der Historie für das Leben*, in: *Sämtliche Werke*, ed. by G. Colli and M. Montinari, Vol. I, Munich, 1980, p. 280.

47 Newman, *Writings*, p. 109.

48 *Piet Mondrian. Memorial Retrospective*, Museum of Modern Art, New York, March 20 –May 13, 1945; *Kandinsky Memorial Retrospective*, Museum of Non-Objective Painting, New York, March 15– May 15, 1945.

49 Newman, *Writings*, p. 69.

50 Newman, *Writings*, p. 140, and Piet
Mondrian, *Plastic Art and Pure Plastic Art
(Figurative Art and Non-Figurative Art)*, in:
Circle. International Survey of Constructive Art,
ed. by J. L. Martin, Ben Nicholson,
N. Gabo, London, 1937, pp. 43, 45.
51 Newman, *Writings*, p. 141, and Mon-
drian, op. cit., p. 53.
52 Newman, *Writings*, p. 141, and Mon-
drian, op. cit., p. 55.
53 Newman, *Writings*, p. 155, and Mon-
drian, op. cit., p. 52.
54 Newman, *Writings*, p. 145, and Mon-
drian, op. cit., p. 56.
55 Willem de Kooning, *What Abstract Art
Means to Me*, Symposium, February 5,
1951, Museum of Modern Art, New York.
Quoted here from: Harold Rosenberg,
Willem de Kooning, New York, n.d. [1974],
p. 143 f., and *Willem de Kooning*, interview
with David Sylvester (1963), quoted from
Rosenberg, op. cit., p. 205.
56 *The Collected Writings of Robert
Motherwell*, op. cit., p. 22.
57 Newman, *Writings*, p. 141.
58 Ibid., p. 173.
59 Ibid., p. 256 f.
60 Ibid., p. 91.
61 Ibid., p. 88.
62 Ibid., p. 91.
63 Mark Rothko, *Personal Statement*
(1945). Quoted here from: Diane Wald-
man, *Mark Rothko*, Solomon R. Guggen-
heim Museum, New York, 1978, pp. 48, 49.
64 Letter from Motherwell to Samuel
Kootz dated January 21, 1947. Cf. *The
Collected Writings of Robert Motherwell*,
op. cit., p. 42.
65 Newman, *Writings*, p. 163.
66 Ibid., p. 164.
67 Ibid., p. 170.
68 Cf. *The Collected Writings of Robert
Motherwell*, op. cit., p. 48.

69 Newman, *Writings*, p. 173.
70 Ibid., p. 140.
71 Ibid., p. 69.
72 Ibid., p. 67.
73 Ibid., p. 174.
74 Ibid., p. 175.
75 Friedrich Schiller, *Werke, National-
Ausgabe*, 1943 ff., Vol. 20, p. 137.
76 Friedrich Schiller, *Über das Erhabene*,
in: *Sämtliche Werke*, Vol. 5, Munich, 1975,
p. 799.
77 Newman, *Writings*, p. 135.
78 Cf. *The Collected Writings of Robert
Motherwell*, op. cit., p. 53.
79 Ibid., p. 59.
80 De Kooning on April 22, 1950. Cf.
Artists' Sessions at Studio 35, op. cit., p. 16.
81 Lecture by Motherwell in August
1944. Cf. *The Collected Writings of Robert
Motherwell*, op. cit., p. 34 f. In 1949 this
view was even more pronounced: "The
abstractness of modern art has to do with
how much an enlightened mind rejects of
the contemporary social order. It also has
to do with an effort to find a more ade-
quate expression of subjective experience
than what one sees in the street, or on
the table." Ibid., p. 61.
82 See in this connection: Jeremy Strick,
Enacting Origins, in: *The Sublime is Now:
The Early Work of Barnett Newman. Paintings
and Drawings 1944–1949*, exhibition cata-
log, Walker Art Center, Minneapolis, 1994,
p. 27: "But it was through continually
reassessing and re-enacting his own artis-
tic origins that Newman moved his art
forward. For Newman, the search for the
subject about which he wrote was ulti-
mately just that: the search for himself as a
maker of art. Newman's art of the future
was located through an intensely focused
process of rediscovery and artistic re-
enactment of his own recent past."

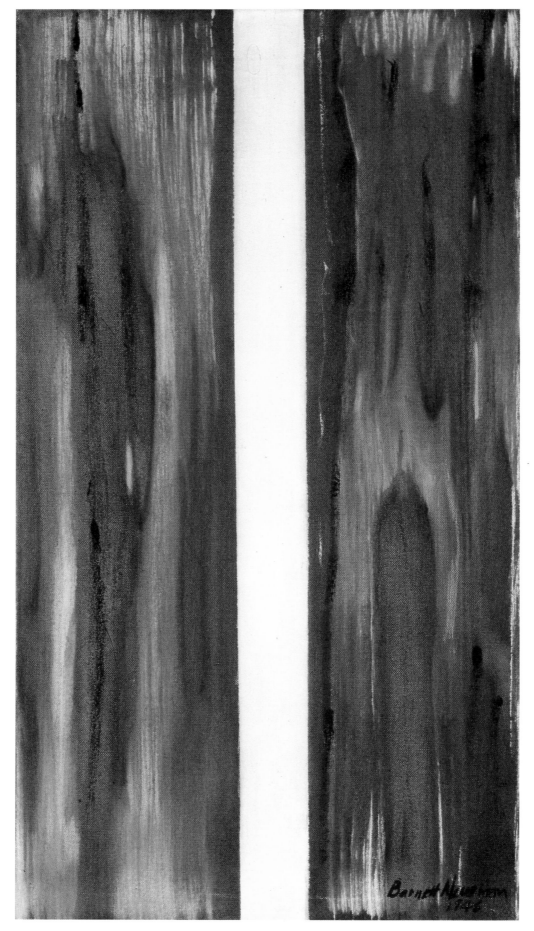

5 *Moment,* 1946 (Cat. No. 1)
Tate Gallery, London. Presented by Mrs. Annalee Newman, the artist's widow, in honor of the
Directorship of Sir Alan Bowness, 1988

In his profound study of Newman's artistic beginnings, Jeremy Strick points out that Barnett Newman wrote the larger part of his theoretical and critical texts between 1944 and 1949 and that the artistic works which he produced between 1944 and 1946 were mainly works on paper. Indeed, in 1944 and 1945, Newman wrote twelve essays, made some thirty works on paper, and painted one small picture.[1] Among these works is a mixed-media drawing—dated by Richardson to 1944[2]—which depicts, in stylized manner, a blue, winged insect approaching a red blossom against a background of brown earth and a pale yellow sky (Fig. 6). The drawing is evidence of the attempt by Barnett Newman, who by this time was almost forty years old, to convert his knowledge of biology into esthetic metaphor. The result appeals through its brilliance of color and the sure way in which the details have been placed on the picture plane, though the drawing is, on the whole, somewhat labored and lacks the grandeur one might have expected. Newman's drawing can be compared with the early work of Rothko who at that time was likewise searching for an adequate artistic means of expressing his ideas. Newman before Newman—like Rothko before Rothko, or Pollock before Pollock—is a subject of such extreme interest, and to art historians in particular, that researchers are concentrating on the early works of these New York painters to an ever increasing extent.[3]

Other works produced by Barnett Newman during the mid-1940s have titles which, directly or indirectly, refer to such themes as genesis, beginning, birth, and creation, and thus associate depictions of natural phenomena with the mythical and the cosmic. Although they are not always original and convincing, these works are interesting inasmuch as they reveal the prerequisites of Newman's radical pictorial conception, a conception which he did not ultimately realize until 1948. An examination of a few of these early works would therefore be apt.

I

In 1945, Newman produced a painting entitled "Gea" (Fig. 7). This symbolic representation of the earth goddess is executed in oil and oil crayon on cardboard measuring 28 by 22 inches. According to Hesiod's "Theogony", the Earth (Gea) was born of chaos and herself gave birth to the sky, the mountains, and the oceans. Knowing this, we are able to understand Newman's painting: slightly to the right and just below the center is an empty, clearly outlined circle. Sprouting from it are biomorphic shapes reminiscent of plants, blossoms, and cells. Newman uses shades of brown on a deep red ground broken only by a sand-colored area on the left. Referring to this painting years later, Newman explained the white, empty circle as "a kind of void from which and around which life emanated—as in the original Creation."[4] This void is the most curious feature of the work, for it clashes with the other-

wise organic structure of the composition and, in its abstract negativity, would hardly seem interpretable as the source of life. A similar void appears in an untitled drawing from 1946 (Fig. 65). Here, however, all zoomorphic elements have been eliminated. This reductionist treatment of the theme makes the drawing considerably more consistent than Newman's painting "Pagan Void" (Fig. 8)—completed a short time later—which is full of references to form. The black circle in the center of the painting has been interpreted as a symbol of the unconscious enclosing a ritualistic spear and a tiny flagellum, with the whole work seen as a "biomorphic conflation of primitive archetypes with the fecundity of sexual imagery."[5] "Genesis—The Break" (Fig. 9) must be viewed in the same context. Here, too, is a round, isolated, darkly colored element, surrounded by a translucent space, creating the impression of a cell or a sinister celestial body. Newman used this motif in several drawings[6], but in his paintings soon began combining it with vertical stripes which were, sometimes, angled ("Death of Euclid", 1947) or sprouted growths ("Genetic Moment", 1947). Essentially, however, Newman was endeavoring to purify his imagery, to rid it of such rounded and excrescent elements in favor of cosmic paraphrase and, ultimately, a completely abstract style ("Euclidean Abyss", 1946/47).

7 *Gea,* 1944/45
Oil and oil crayon on cardboard,
28 x 22 ins.
The Art Institute of Chicago
Through prior gift of the Charles H. and
Mary F. S. Worcester Collection, 1990.64

In the context of the American art of the times, these first few works by Newman hardly convey the impression of being autonomous. Indeed, many of Newman's works of this period manifest a definite Surrealist influence. As is well known, many Surrealists had fled from fascism and the war to New York, where some of them had tried to gain a foothold. Their work was well received. Dalí and Miró, for example, had large solo exhibitions at the Museum of Modern Art. However, the Surrealists' presence in New York and the

66

8 *Pagan Void*, 1946
Oil on canvas, 33 x 38 ins.
National Gallery of Art, Washington, D.C.
Gift of Annalee Newman in honor of the
fiftieth anniversary of the National Gallery
of Art

personal contacts between American and European artists—cultivated chiefly by Mother-well—were perhaps less decisive in the fruitful reception of Surrealism in America than was the awareness that the works of the Surrealists furnished an apocalyptic diagnosis of the state of civilization and, in their convulsive confusions of life and death, of destruction and regeneration, in their visions of violence, cannibalism, insanity, and sexual abnormality, visualized the total collapse of civilization culminating in the Second World War. Whilst being able to embrace some of its aspects, Newman, Rothko, Gottlieb, and other American artists rejected Surrealism on the grounds that it not only lacked transcendence but also failed to concentrate on the human psyche. The dream worlds and phantasmagoria of the Surrealists seemed increasingly suspicious to them. Their skepticism may have been influenced, if not prompted, by Wolfgang Paalen who broke with the Surrealists shortly after having mounted, in 1941, a comprehensive Surrealist exhibition in Mexico, where he lived in exile. Surrealism's literary associations seemed to him to be becoming more and more dubious. Moreover, Paalen suspected that the Surrealists were reopening the door to realistic depiction, which

9 *Genesis – The Break*, 1946
Oil on canvas, 24 x 27 ins.
Dia Center for the Arts, Courtesy of
The Menil Collection, Houston

had been considered defunct ever since the inception of Cubism.[7] It was not least on account of such reservations that an interest in the anthropological-cum-mystical dimensions of art was rapidly gaining in significance during the forties. Preoccupation with tribal art, and with Indian art in particular, was the logical consequence, as this seemed to be the only way of preserving art's claim to absoluteness and of representing the "metaphysical patterns of life". Surrealism was becoming increasingly obsolete.

If Newman oriented himself by any other painter during this period, that painter was Miró. Unlike the other Surrealists—to whom he belonged, albeit only partially—Miró was seen by Newman as the only one "who carried on the modern-art tradition of using paint expressively, as an artistic language, instead of pictorially [. . .]. That is why the movement in painting looks to him as leader."[8] However, by 1947, i.e. two years later, Newman had changed his mind. He criticized Miró's use of the physical world as the starting point for his images: " [. . .] so that Miró when he produces his fantasies, [. . .] always takes off from the factual image to stretch it into the chaos of mystery. [. . .] The American painters under dis-

68 cussion [. . .] start with the chaos of pure fantasy and feeling [. . .] and they bring out of this chaos of emotion images that give these intangibles reality."9

But let us leave Newman's changed opinion of Miró at that. His argument is not all that convincing and doubtless served him merely as a pretext for finally breaking with Surrealism and reinforcing the originality of his own position. But there may also have been other factors. We cannot exclude the possibility, for instance, that during this period a genuinely American tradition had become relevant to Newman's thinking. Much of Newman's work from that time is reminiscent, for example, of the works of Arthur Dove (1880–1946). One is reminded in particular of Dove's abstractions based on natural forms which he painted during the thirties (Fig. 10). If American affinities are to be sought, they will be found in that circle of artists whom Alfred Stieglitz exhibited at his 291 Gallery and whose artistic approach to nature had been more or less influenced by Henry David Thoreau (1817–1862), whom Newman likewise revered, as could be seen just by browsing through his library. Arthur Dove, like Georgia O'Keeffe (1887–1986), belonged to this circle, and it is likely that Newman was familiar with their work despite his never once mentioning it in his essays.[10]

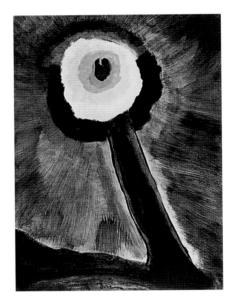

10 Arthur M. Dove, *Moon,* 1935
Oil on canvas, 35 x 25 ins.
Collection Zurier

And this was not without good reason, for he had always adopted a reserved approach to American art and considered it to be provincial and lacking in autonomy. But no matter what had inspired him, whether it was Surrealism or the American tradition, Newman was at that time chiefly concerned with using visual symbols as a means of expression, and since this was in his eyes the only legitimate function of the artist, he was forever in search of reasons which would justify it: "Just as we get a vision of the cosmos through the symbols of a mathematical equation, just as we get a vision of truth in terms of abstract metaphysical concepts, so we get from the artist today a vision of the world of truth in terms of visual symbols."[11] Thus the new painting was seen by Newman as analogous to science and philosophy. And just as we accept that the new mathematics, the new symbolic logic, and the new physics represent a new concept of the world—Newman argues—so must we accept the new painting as "the beginning of a new concept of beauty."[12]

Attempts to underpin one's theories with more or less apt references to comparable phenomena in other spheres, and in scientific ones in particular, are a tradition which goes back to the nineteenth century. Such references were central to Kandinsky's defense of abstraction. And the same, moreover, went for its intentions. What seemed to be so revolutionary about the classic avant-garde—and this applied to Kandinsky in particular—turned out to be something old, namely eternal truth which, long since buried under the negative influence of materialism and positivism, now had to be dug free again. The skepticism of the avant-garde of the early twentieth century towards modern civilization still prevailed after

the Second World War; indeed, it grew even stronger in the face of the horror and suffer-
ing which the war had caused, and, in some artists, developed into a categorical rejection of
the kind of pragmatism which, in the last resort, was responsible for the Holocaust and
Hiroshima. Redemption would often be projected into another world, a world of the imag-
ination, a world of transcendence. "Art is a realm of pure thought," Newman wrote in 1945[13]
and, in another essay written in the same year: "His [the contemporary painter's] imagina-
tion is therefore attempting to dig into metaphysical secrets. To that extent his art is con-
cerned with the sublime. It is a religious art which through symbols will catch the basic truth
of life, which is its sense of tragedy."[14]

Newman's intentions embraced both the new—inasmuch as this promised a peaceful
future—and the primitive and the archaic. The process of building a bridge from the present
to the past, and from the past to the present, was art's way of overcoming the historical
experience of disaster. Rejection of the immediate past and the ominous present was moti-
vated by a force akin to that "terror of the unknowable" which, for Newman, was manifest
in the art of archaic cultures. Even before viable conceptions began to emerge in his work,
Newman knew what goal his art would strive to achieve. He was concerned with visual
symbols which embodied comprehensive truths, symbols which had to be at once abstract
and visual, purist and suggestive. And, more important, they had to be valid both for the dis-
tant past and for the present day, and also for the future. This move away from history
towards pure intellect was possible, artistically, only through rigorous reduction and con-
centration. And these were soon very much in evidence in Newman's paintings.

II

Besides his central motif of the circle or oval, Newman began to occupy himself, to the
growing exclusion of everything else, with a vertical element which took the form of a nar-
row wedge or stripe. Initially hesitant, and then increasingly decisive, this element traversed
the entire picture plane from top to bottom. The very first of Newman's surviving paintings
from 1945 ("Untitled") features such elements, though Newman here combines them with
vegetal details. Graceful curves and the atmospheric transparence of the colors give this
painting a touch of serenity and playfulness. In "The Word I" (1946), Newman places—to the
right of the centerline—a vertical, extremely thin wedge which touches the bottom edge of
the painting with its pointed tip and broadens towards the top of the painting, seemingly
reaching beyond the picture plane.[15] Among the luminous brown and gray tones opened up
by this light-filled gap, we find a round area of dense color which is like the oval of ink
featured in a drawing produced in the same year[16] (Fig. 11). This combination of vertical and
circular or oval elements appears in a series of works (cf. Fig. 64) and one cannot help

11 Untitled, 1946
Brush and ink on paper, 24 × 18 ins.
The Museum of Modern Art, New York
Gift of The Drawings Committee in honor
of Richard E. Oldenburg

70

wondering, in view of Newman's preoccupation with the Creation and its mythology, whether there are any sexual connotations—albeit abstracted or stylized—at play here.[17]

Painted in the same year, "The Beginning" is another work of small format measuring 40 by 29¾ inches (Fig. 12). Standing out against the transparent blue and gray tones which dominate the ground are three vertical and/or slightly inclined stripes and wedges. The narrow, ocher-colored wedge on the left points downwards and slightly towards the center. Its tip penetrates a green, amorphous shape which seems to be forcing its way into the picture from the bottom edge. Out of the center of this shape rises a light yellow band of light which divides the entire picture plane from bottom to top. Placed close to the right edge of the picture is a light-colored wedge which is similar in shape to the ocher-colored one, but upright. The composition does not seem to be based on any clearly defined concept, as atmospheric and vegetal elements are combined and, moreover, broken by paths of light.

Thomas B. Hess has compared Newman's painting with Jonas Lie's "The Conquerors: Culebra Cut, Panama Canal". Painted in 1913, this work depicts a huge construction site from above. Rising from this site are several plumes of smoke, two of which broaden, wedgelike, towards the top of the picture. As a schoolboy, Newman saw this painting on visits to the Metropolitan Museum. Hess suggests that "The Beginning" and similar works were subconsciously influenced by such childhood experiences.[18]

This is not of course improbable, although a comparison with a work by Georgia O'Keeffe—"Abstraction Blue", 1927 (Fig. 13)—would have been closer to the mark. Whether Newman was familiar with this painting cannot be said. The parallels between it and his own work are so obvious, however, that knowledge of O'Keeffe's painting cannot be excluded. The obvious formal affinities are less relevant than the resemblance of content, for both "The Beginning" and "Abstraction Blue" manifest a turning away from the world as perceived through the senses towards a spiritualized world. In O'Keeffe's case, the break with the real world has already been effected, and harshly, too. A vertical gash cuts, like a knife, through the graceful, ornamental curves of a blue sphere in which clouds and waves gently merge. Newman, however, seeks—at least during this early phase—to achieve a compromise between abstract figuration and the ground. This is manifest in the way the delicate veils of color become denser near the bands and repeat the vertical structures of the stripes, thus taking the edge off their harshness.

Such observations permit one to assume that Newman, contrary to his declarations at the time, did not start from "the chaos of pure fantasy and feeling" but rather drew his imagery from impressions of the real world, subjecting what he saw about him to a radical process of reduction. The wedge-shaped vertical or inclined elements are reminiscent, for

14 Georgia O'Keeffe, *Street, New York
No. 1,* 1926
Oil on canvas, 48 x 30 ins.
Private collection

15 Untitled, 1946 (Cat. No. 24)
Constance R. Caplan, Baltimore

◁ 12 *The Beginning,* 1946
Oil on canvas, 40 x 29¾ ins.
The Art Institute of Chicago
Through prior gift of Mr. and Mrs. Carter
H. Harrison, 1989

◁ 13 Georgia O'Keeffe, *Abstraction Blue,*
1927, oil on canvas, 40 x 30 ins.
The Museum of Modern Art, New York
Acquired through the Helen Acheson
Bequest, 1979

example, of the beams of searchlights. But are we not also reminded of the streets of New York with their buildings' steep, converging lines? Georgia O'Keeffe springs to mind yet again. Her painting "Street, New York No. 1" (Fig. 14) dating from 1926 converts the metropolis into a bottomless, hence inaccessible chasm. Only the streetlamp rising from the invisible vanishing point tells us that what appears to be a crystalline formation of dead matter is in fact a city, a menacing Moloch more dreadful and inhumane than we can possibly imagine. Those of Newman's paintings which bear a structural resemblance (Figs. 15, 68) to O'Keeffe's painting do not convey the same message, although their features are indeed conducive to such associations and interpretations. Newman had a completely different relationship to New York. He loved this city, as his essay on the lower tip of Manhattan, written in 1943 or 1944, proves beyond doubt.[19] Drawings such as Figure 15 have a generalized dramatic effect, defy all concrete allusion, and refrain from making any comment. Nonetheless, Newman must have sensed that his shallow wedge, which so sharply cleaves the menacing blackness, might indeed be interpreted as the patch of sky between the buildings of a New York street or as the beam of a searchlight. And this is undoubtedly why Newman soon decided to replace the wedge by a stripe of uniform thickness or thinness.

This decision is already evidenced by "Moment", from 1946 (Fig. 5). The narrow, vertical canvas is divided down the center by a pale yellow stripe, whilst the broader, brownish stripes on either side create a wood-grain effect.

Making its very first appearance here was an element which Newman was soon to refer to as a "zip". This onomatopoeic word describes the whizzing sound made by an object moving fast through the air, or the sound of cloth being torn. In a figurative sense, it denotes life, energy, dynamism, and power. In prosaic usage, it means what we might readily think it means—a zip-fastener.[20] Indeed, we must be absolutely clear about the word's scope of meaning—from banality to abstraction—before we can realize how deliberately Newman chose it to describe something which was to become the most important pictorial element of his entire oeuvre—his leitmotif as it were.

Newman's "Moment" is a painting of an extraordinarily simple structure which, whilst emphasizing symmetry and verticality, does not create an effect of uniformity. Although the central stripe is flat and uniform, it relates to the adjacent, broader stripes of color in such a way that we feel we are looking through an opening at an exposed background. It is as though there are two picture planes, one behind the other, the front one having been torn apart to reveal the deeper and brighter one behind it. No sooner have we felt this, however, than the yellow stripe optically forces its way to the front and undermines the illusion of depth.[21] For a brief moment the two planes seem to be aligned, only to separate seconds later.

72 It is precisely in this latent to-and-fro motion that we recognize the changed function of the painting. It no longer operates as an object, as a picture merely to be looked at, but as a picture offering an optical experience. This optical experience is also manifest elsewhere. The alternation between the opaque and the transparent, between the warm and cool shades of brown, creates an ambiguous atmosphere. Rising and falling, pulsating and flowing, thickening and thinning—the impressions change rapidly. These active and living fields of color seem to have been not just abruptly torn apart but also modified in their effect inasmuch as—when the eye proceeds outwards from the pale yellow center—it is the material properties of the broad brown stripes which become particularly noticeable and not their atmospheric elements, for these now assume secondary importance in the viewer's consciousness. One registers not so much the effects themselves as the way they have been created. In this connection it should be mentioned that "Moment" is one of the very first examples of Newman's use of adhesive tape. Here it served to mask the middle stripe once Newman had painted the entire canvas a uniform shade of pale yellow. Newman could then continue to work without worrying about the homogeneity of the left and right hand sides. This was guaranteed, as were the straightness and neatness of the yellow stripe—which mattered—after removal of the masking tape.

"Moment" is a small work and not outstanding in the context of Newman's oeuvre. It does however come to terms, and much more clearly than any of the other works mentioned hitherto, with Newman's fundamental problem as a painter. Since Surrealist strategies were now obsolete, Newman must strive to separate evocation from illusion and seek to convey the symbolic, but without the use of visual symbols. The challenge was to reduce pictorial elements to an absolute minimum whilst at the same time increasing their power of expression. "Moment" points the way: the painter must seek to achieve more and more by less and less. And this was possible only if the painting operated no longer within a limited plane but as an integral part of a totality. In other words, the effect must not be depicted in the painting but evoked in the viewer.

In this respect, Newman seems to have taken a backward step in his painting "The Command", which he completed in the same year (Fig. 16). Here, a broad area of asphalt brown is balanced against a narrower, reddish one. Between them is a pale yellow stripe which leans slightly towards the left; it is impossible to say with certainty whether the stripe joins the two areas together or separates them. Moreover, any rigorousness of concept is undermined by the earthy shades of color and the subtly nuanced moiré effects. But both paintings clearly have one thing in common: Newman develops, within the painting, carefully textured and harmonized areas of color and then adds a radical, vertical incision which banishes anything that could stimulate illusion and fantasy. The paintings suggest—and permit—

16 *The Command,* 1946
Oil on canvas, 48 x 36 ins.
Öffentliche Kunstsammlung Basel
Kunstmuseum
Gift of Annalee Newman in honor of
Arnold Rüdlinger and Dr. Franz Meyer,
1988

a dual reading, depending on whether it is the vertical dividing element which comes to the fore in the viewer's perception or the areas of differentiated color which this element either separates or joins.

Newman's approach here can best be illustrated by comparing "Moment" and "The Command" with a painting by Mark Rothko dating from almost the same time. This untitled

74

17 Mark Rothko, Untitled, 1946/47
Oil on canvas, 95$^1/_2$ x 80 ins. Tate Gallery, London

painting (Fig. 17) depicts amorphous shapes of varying materiality, some longish and linear, others round or oval. The structure of the painting is predominantly vertical. Shades of milky brown, soft violet, green, and blue subtly harmonize to transform the canvas into something extremely atmospheric, for although the painting is kept two-dimensional, i.e. there is no illusion of depth, it has a latent illusionistic quality. Whilst the biomorphic elements—the longish, roundish, snakelike shapes—and the speckled areas and the gently blending colors of the painting operate superficially as non-objective pictorial elements, they also awaken a cornucopia of organic associations which, being altogether vague, stimulate the imagination.

Here Rothko concentrates his attention entirely on the situation within the painting. Whilst Newman also seeks to do this, he resorts at the same time to the most radically effective means of thwarting the illusion and destroying the unity inherent in the painting. Newman provokes two questions: What is a painting in the first place, and how can the viewer's relationship to this artificially produced object be determined and influenced? Such reflections were evidently foreign to Rothko at this time, and a comparison of "Moment" and Rothko's untitled painting points to already unbridgeable differences between the two artists. Newman was able to understand Rothko because he could fathom Rothko's problems, while Rothko regarded Newman's paintings as too intentional and hence unsuccessful. Thus the profound discord which was to exist between Newman and the other protagonists of the new American painting was already manifesting itself in 1946, although those concerned did not at the time realize its consequences, particularly as Newman was still considered first and foremost as an intellectual and very little notice was taken of his painting and drawing.

There is nonetheless something in the works of Newman and Rothko which unites the two artists. Although they were conscious of living and working in a period of radical change, the consequences of their artistic strategies were not always foreseeable. This was true not only of Newman but also of the other painters of his generation. In 1945, Rothko was still categorically refusing to paint abstract forms. He would "sooner confer anthropomorphic attributes upon a stone", he said, "than dehumanize the slightest possibility of consciousness."[22] By 1946, however, Rothko had obviously progressed beyond this standpoint, for his works of that time do not reveal even the slightest hint of the representational. And, in 1947/48, Rothko even declared that the unquestioning reconciliation of the representational world with itself must be shaken. "With us the disguise must be complete. The familiar identity of things has to be pulverized in order to destroy the finite associations with which our society increasingly enshrouds every aspect of our environment.

"Without monsters and gods, art cannot enact our drama [. . .]. It is really a matter of ending this silence and solitude, of breathing and stretching one's arms again."[23]

76 Here Rothko neither names nor adequately conceptualizes the artistic means necessary to deal with the great existential pathos of "overcoming solitude". Only one thing seems certain: without "monsters and gods" there is no chance of putting an end to the crippling silence. By 1949, however, Rothko makes no further mention of this. Now, he says, in order to achieve the greatest clarity in his work, the painter must eliminate all obstacles between himself and the idea, and between the idea and the observer.[24] And these obstacles include all representational elements. Rothko is in fact defining what had already been a characteristic feature of his painting for some time: soft-edged zones of color without any obtrusive geometrical shapes or realistic details. Thus, in Rothko's case, as in Newman's, reflections on the aims and possibilities of painting were bound up with the painting process itself. Indeed, this could be said of all the Abstract Expressionists, as examples below will show.

But first let us return to our starting point, to the formal aspect of Newman's work, and examine it in relation to a painting by Clyfford Still. About the mid-forties, Still was painting pictures whose formal vocabulary was limited to a very few elements. His painting entitled "July 1945—R" (Fig. 18) is of impressive size, 69 by 32 inches. The painting comprises shades of gray and brown which become denser towards the middle of the work and culminate in a dark, vertical, cloudlike structure of irregular width and contour, its black center forming the axis of the canvas and extending from the top to the bottom edge. This central field is split down the middle by a jagged white line which divides the entire composition, like a crack, into two halves. Two small red dots in the upper half of the painting delicately accentuate its heavy, lusterless coloration.

Whether Newman was familiar in the 1940s with Still's paintings cannot be said for sure, but it is possible. "July 1945—R" was shown in 1946 at the Art of This Century gallery and also, a year later, in a group exhibition at the Betty Parsons Gallery[25]. Still's "Quicksilver" and "Figure" appeared in the exhibition "The Ideographic Picture" which Newman organized in 1947. But even if Newman had seen "July 45—R", this contributes little or nothing to an understanding of Newman's intentions. Here, as in his entire later production, Still remained faithful, despite his work's strong contrasts and oppositions, to the principle of homogeneous composition, whereas Newman intended something else. He had set himself a task which, in the ultimate analysis, was impossible, namely to preserve the character of the painting and simultaneously call it into question, indeed, abolish it altogether. What Newman was aiming at was the totality of the work, and to this end he emphasized the irreconcilability of the totality with its parts. Newman's reflections on the problem of part and whole were central to his theorizing at that time and I can well imagine that his "zip", the name which he had coined for the vertical connecting/dividing lines in his paintings, is a concept

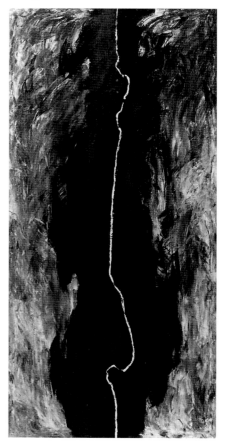

18 Clyfford Still, *July 1945—R*, 1945
Oil on canvas, 69 × 32 ins.
Albright-Knox Art Gallery, Buffalo

which grew from such reflections, for it resolves not only an esthetic problem but also an existential problem of enormous consequence.

An essay on the paintings of Tamayo and Gottlieb reveals the direction in which Newman's reflections were taking him. At one point in this critical study, which was published in *La Revista Belga* in April 1945, Newman writes: "Man is a tragic being, and the heart of this tragedy is the metaphysical problem of part and whole. This dichotomy of our nature, from which we can never escape and which because of its nature impels us helplessly to try to resolve it, motivates our struggle for perfection and seals our inevitable doom. For man is one, he is single, he is alone; and yet he belongs, he is part of another. This conflict is the greatest of our tragedies [. . .]"[26]

Newman's "zip" did not develop directly out of the tradition of abstract painting, although that is where—as an isolated element—it did in fact have its origin, as we shall see later. What Newman is aiming at can again be better understood by way of comparison with a work by another artist. Motherwell's "Little Spanish Prison" (Fig. 19), dating from the early forties, is composed of alternating yellow and whitish gray vertical stripes which cover the entire canvas. Rather vibrant and obviously painted freehand, these stripes are reminiscent more of an awning than of the prison bars suggested by the title. A short, horizontal, carmine stripe crosses three of the vertical stripes, like a doorbolt, in the top left-hand corner of the painting. Motherwell's atmospheric painting, like those of Rothko and Still, reveals a striving to achieve synthesis within the composition. Newman seeks his subject matter elsewhere. What he does share with his contemporaries is the desire to transcend the reality of the painting. But at the same time he strives to achieve the very opposite, namely to make the painting an object, that is to say, something which acquires presence through its physical reality.

Neither in 1946 nor in 1947 was Newman able to find a convincing solution. Whilst in 1946 he painted some nine pictures, only two resulted in 1947, namely "Genetic Moment" and "Death of Euclid", the latter being, in its formal vocabulary, a sequel to his "Euclidean Abyss" of 1946/47.[27] Compared with "Moment", these works seem to represent a step backwards. Although he had adopted such geometrical elements as straight and parallel lines, Newman had no intention of entering the sphere of pure abstraction and hence falling into a "Euclidean abyss". By referring—at least in the title—to the death of the Greek geometrician and, by implication, to the demise of his postulate about parallel lines, Newman states that, for him, the straight line is a natural element and not an abstract one. In "Euclidean Abyss", one yellow perpendicular curves outwards, while the other is bent at right angles. "Death of Euclid" features identical perpendicular bands, complemented on the right by a dark circle surrounded by a bright aura.

19 Robert Motherwell, *Little Spanish Prison*, 1941/44
Oil on canvas, 27¼ x 17 ins.
The Museum of Modern Art, New York
Gift of Renate Ponsold Motherwell

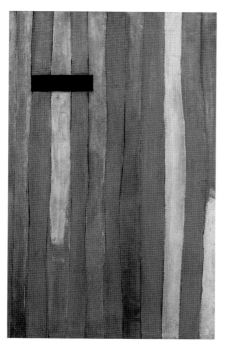

Newman's work of that time manifested a dual tendency: the reduction of its formal vocabulary to a minimum, and a simultaneous strengthening of its power of expression. It was in his ink drawings that Newman came closest to finding a solution, especially as in this medium color and its differentiating function do not play a role. Significantly, Newman's painting "Two Edges" (Fig. 46) harks back to a drawing done in 1946 (Fig. 62), as is evidenced by the similarity of the structural rhythm of the dark and light colored elements and the wedge forms. The painting's configuration is perhaps due to the limitation of its coloration to subtly differentiated shades of just one color, namely yellow ocher.

What is noticeable about Newman's paintings of this time is his endeavor to ascribe a specific quality of expression to straight lines, and to make these straight lines the decisive structural principle of his paintings. It is an endeavor of enormous consequence, for it is nothing less than an attempt to combine the most extreme possibilities of two genres of art—painting and drawing. It was a problem which, once it had been formulated, preoccupied Newman, and he was to return to it again and again throughout his life. When, for instance, the discussion during the Artists' Sessions at Studio 35 on April 23, 1950, turned to this question, de Kooning and Newman voiced completely different opinions. Let us take, as an example, their words about Mondrian's paintings. De Kooning: "About this idea of geometric shapes again: I think a straight line does not exist. There is no such thing as a straight line [. . .] Mondrian is not geometric, he does not paint straight lines [. . .] A picture to me is not geometric—it has a face."[28] Newman's reply: "Geometry can be organic. Straight lines do exist in nature. [. . .] A straight line is an organic thing that can contain feeling."[29]

Perhaps we ought to remind ourselves, in this context, that Kandinsky considered the line to be the greatest opposite of a painted area and saw the line as the result of the influence of a force, as the "most concise form," so to speak, "of the infinite possibility of movement." He regarded the vertical line as a warm element, whereas the horizontal was the cold, basic support of human existence. Moreover, Kandinsky associated the vertical line with white, the horizontal line with black.[30] Newman himself was later to stress that drawing was central to his whole concept, referring explicitly to the drawing that existed in his painting, i.e. his "zip": "[. . .] my drawing declares the space. Instead of working with the remnants of space, I work with the whole space."[31]

"Onement I" (Fig. 20) is generally considered to be the key work in Newman's development. Measuring only 27 by 16 inches, "Onement I" is not only a small painting but also an unassuming one. A semi-transparent, uniform layer of reddish brown paint covers the canvas. Dividing the canvas into two equal halves is a strip of dark brown adhesive tape painted over with a thick reddish orange paint so unevenly that the edges of the adhesive tape are partially visible along its entire length.

In an interview given in 1965, i.e. at a considerably later date, Newman remembered painting "Onement I" on his forty-third birthday, that is, on January 29, 1948. When David Sylvester asked what had led him to such an extreme kind of form, Newman said: "I don't paint in terms of preconceived systems, and what happened there was that I'd done this painting and stopped in order to find out what I had done, and I actually lived with that painting for almost a year trying to understand it. I realized that I'd made a statement which was affecting me and which was, I suppose, the beginning of my present life, because from then on I had to give up any relation to nature, as seen. That doesn't mean that I think my things are mathematical, or removed from life. By 'nature' I mean something very specific. I think that some abstractions—for example, Kandinsky's—are really nature paintings. The triangles and the spheres or circles could be bottles. They could be trees, or buildings. I think [. . .] I removed myself from nature, but I did not remove myself from life."[32]

What was also remarkable about this interview was Newman's subsequent comment: "The painting itself had a life of its own in a way that I don't think the others did, as much."[33] In his Newman monograph, Thomas B. Hess proceeded from 1950 Newman's statement on the usefulness of titles to identify the subject matter and help the viewer[34], and suggested— with the artist's approval, no doubt—several terms which might explain "Onement I". Hess spoke of "harmony" and "wholeness"[35]—terms which come very close to Newman's title.

"Onement", a now obsolete, late Middle English word, does indeed mean physical, emotional, and spiritual unity. Hardly ever used since the sixteenth century, it today lives on in the word "atonement" (from the Medieval Latin word "adunamentum") and especially in Day of Atonement, the name given to the most solemn feast of the Jewish year. By using a term which is no longer in common use, Newman not only flaunts his erudition but also mysticizes his painting and lends it an aura of sanctity. In the final resort, however, "onement" means nothing but "unity".[36]

Years later, in 1970, Newman again commented on the "zip" in this painting. He no longer saw it as a stripe or streak of light but as a stroke which made the painting come to life, united it, "got rid of atmosphere", and created a totality.[37] Newman now realized that, through his "zip", he had filled the surface, whereas hitherto he had thought he was empty-

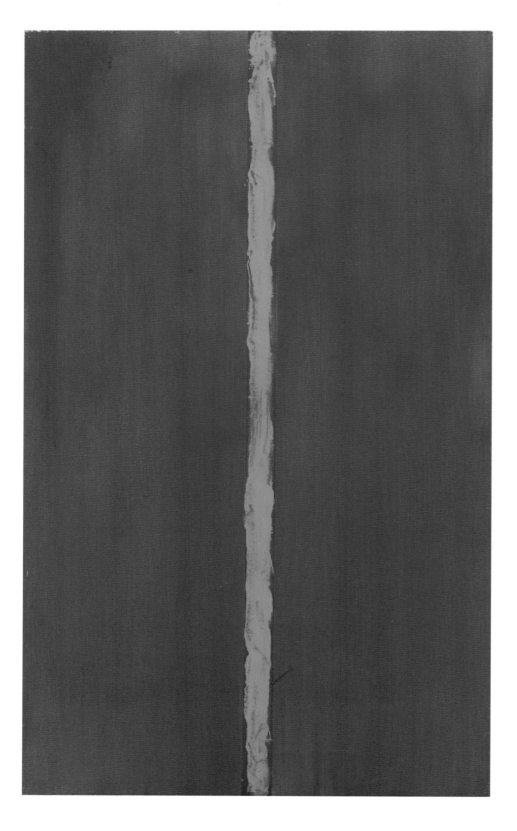

20 *Onement I*, 1948
Oil on canvas, 27 x 16 ins.
The Museum of Modern Art, New York
Gift of Annalee Newman

ing the canvas.[38] Newman was not being inconsistent, not contradicting himself, for he obviously meant that, in this particular painting, the stripe of orange over the adhesive tape destroyed the illusion of depth, or, to be more correct, did not allow such an illusion to occur in the first place. There was to be no suggestion of a spatial effect. On the contrary, all the elements of the painting appear to occupy just one optical plane. The surface is literally filled solidly. Our experience tells us that anything that is optically two-dimensional cannot be perceived spatially, and, conversely, that anything that suggests staggered picture planes cannot be perceived two-dimensionally. Newman's comments, however, do not imply an either/or or a neither/nor situation, but rather a potentiality: any illusion of spatiality is undermined the moment it is sensed, and any illusion of flatness is banished as soon as the viewer accommodates it. "Onement I" does not of course provoke a stark advancing and receding effect comparable with that of a normal figure-ground relationship; indeed, no forwards and backwards optical movement is even noticeable. The latent differentiation of impressions which Newman refers to concerns not the relationship between depth and surface but the relationship between part and whole. Newman already touched upon this problem in "Moment", but there it was forced into the background by the prevailing dichotomy of surface and space. In "Onement I", however, the emphasis has shifted.

Now, in "Onement I", the central stripe simultaneously divides the brown rectangle and joins its two halves together again. Both halves are identical, interchangeable, visually unappealing; the emphasis is thus on uniformity, symmetry, anonymity, and aloofness. Quite the reverse is true of the central stripe. Newman seems to have invested all his vitality into the thickly applied, partially raised, hesitantly executed stripe of orange paint which traverses the entire painting from top to bottom. The orange band was not done with rapid strokes, nor is it a streak or a stream, a tear or a crack. On the contrary, it communicates itself to the viewer as a deliberately slow flow of color, and it does so in such a way that the viewer cannot help tracing its vertical course, reconstructing the movement of Newman's hand.

What do we have before us? Is it "a sum of the painting's independent units"[39] or an integral whole? "Onement I" is certainly not perceivable as a work divided down its middle and suggesting spatiality. The "zip", placed in an area of neutral resonance, operates neither as a motif in its own right nor as a sharp dividing line, but rather performs a dual function. It holds the two halves of the reddish brown rectangle together and pushes them apart[40]; and it darkens the brown of the adjacent halves through the high content of red in its orange.

No matter how unremarkable "Onement I" might seem, this painting represents Newman's first success in visualizing several dualities simultaneously and resolving them in a single work: part and whole, light and dark, surface and space, element and structure, trans-

82

parence and opacity, in which connection the contrasts between individuality and neutrality, spontaneity and control in the actual application of the paint must not go unmentioned. More important than everything else, however, are the extreme reduction of the pictorial language and, above all, the absolute dominance of the vertical axis of symmetry. The latter lends the painting a vividness which draws our attention away from any slight nuances of color, ensuring that our perception of "Onement I" does not go further than a mere registration of actual facts: a "zip" is a stripe, a line, an axis—it is vertical and creates symmetry, and so on.

As in "Moment", the traditional notion of composition as an arrangement of different parts forming a whole is negated in "Onement I". In this respect, Newman differs radically from Mondrian.[41] Moreover, the vertical stripe not only mirrors the axis of the viewer's body but also divides the viewer's field of vision into two halves—although it is not Newman's intention to thematize the axiality of the viewer's body. By eliminating all illusion of space and depth in "Onement I", and by reifying the painting to a greater degree than ever before, Newman completely changes the function of the painting. The extremely reduced repertoire of forms and colors of "Onement I" not only underlines its character as an object but also makes the process of perception itself the object of esthetic reflection.[42]

It is in this respect, too, that Newman's "Onement I" also differs from Olga Rozanova's "Green Stripe" (Fig. 21), dated 1917; the version reproduced here[43] measuring 28 by 20$\frac{1}{2}$ inches is not much bigger than "Onement I" (27 by 16 inches). The formal similarity is quite astonishing, especially if we consider the altogether different premises of Newman and Rozanova. What was merely a formal experiment in the Russian painter's case and, moreover, constituted an exception within her oeuvre, was in Newman's case the result of systematic research over many years and the foundation of all his future work. From what we know today, the answer to the obvious question—Was Newman familiar with Rozanova's work?—is definitely in the negative. Indeed, a closer examination reveals such striking differences that the structural affinities of the two works cease to seduce us further. The Russian painter's vertical, light-green stripe against a whitish gray ground is far less significant than the painting's uniform, harmonious, painterly structure, whilst Newman's "zip", with its adhesive tape and its thickly applied paint, clearly differentiates between the elements of the painting and at the same time seems to bring them—in terms of color—closer together.[44] Despite all their surprising similarities, Rozanova strives for visual appeal, whilst Newman completely undermines such an effect, accentuates the character of the painting as an object, and makes the process of perception itself the subject matter. If we were to go back slightly further in time, past this Russian Constructivist, we might be reminded of Matisse's "Porte-Fenêtre à Collioure" of 1914 (Fig. 22). Here, however, the solid, dark vertical mass which

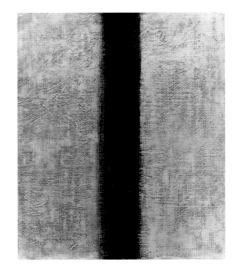

21 Olga Rozanova, *Green Stripe,* 1917
Oil on canvas, 28 x 20$\frac{1}{2}$ ins.
The George Costakis Collection

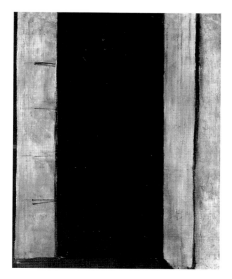

22 Henri Matisse, *Porte-Fenêtre à Collioure,* 1914
Oil on canvas, 46½ x 35 ins.
Musée national d'art moderne
Centre Georges Pompidou, Paris

dominates the painting is illusionistically transfigured by the surrounding elements, clearly demonstrating how radical Newman's break with such traditions was. All the same, Rozanova's paintings in this style were very probably unknown to Newman, and this painting by Matisse was not shown publicly until the nineteen-sixties.

"Onement I" is a small painting which can be perceived as an aloof, manageable, and easily surveyable object. On a much larger scale, "Onement III" (Fig. 23) makes a greater demand on the viewer's power of perception, for not only sensuous and spiritual presence is evoked, but also physical presence.[45] Thus Newman's paintings have something of a mirror about them, inasmuch as the viewer's glance is reflected back upon himself and he, the viewer, is prompted to reflect not only on the painting but also on the process of looking at the painting and on the person who is looking at it, and also on the process by which the subject and the object interrelate. For a painting to exist for the viewer, it is not enough for the viewer to see and register it with his eyes; he must also be conscious of his seeing and registering, and be aware of himself as a seeing and registering subject. For Merleau-Ponty, the process of perception involves both the body and the senses; the body and the senses are nothing but our habitual knowledge of the world. Objects such as "Onement I" seem inexhaustible and we easily become entangled in expansive discourse on a variety of aspects. But that is only because, between the painting and the viewer, "there is this latent knowledge which our gaze uses—the possibility of its rational development being a mere matter of presumption on our part—and which remains forever anterior to our perception."[46]

This process of reflection is identical with the process of painting and does not occur beforehand or independently of a painting's execution. Thus we can understand Newman when he says that it took him several months after completing "Onement I" to realize what a decisive turn his painting had taken.

The disparity which now existed between Newman and other artists was evidenced particularly by Clyfford Still's "July 1945—R" (Fig. 18), and perhaps it was this circumstance which made Newman feel obliged to justify his artistic work, especially as he knew that the others, whilst appreciating him as an orator and organizer, hardly considered him a painter.[47] And once he had grasped what was radically new about "Onement I", Newman's productivity increased rapidly. Indeed, no less than seventeen paintings were produced within twelve months. This was in fact Newman's most prolific phase ever. "Onement II" was painted in 1948. "Onement III" and "Onement IV" followed in 1949.

Measuring 71⅞ by 33½ inches, "Onement III" (Fig. 23) is a painting of considerable size. Painted in reddish brown and carmine, this work creates an altogether different impression from "Onement I", primarily on account of its larger dimensions. The dark "zip" with its

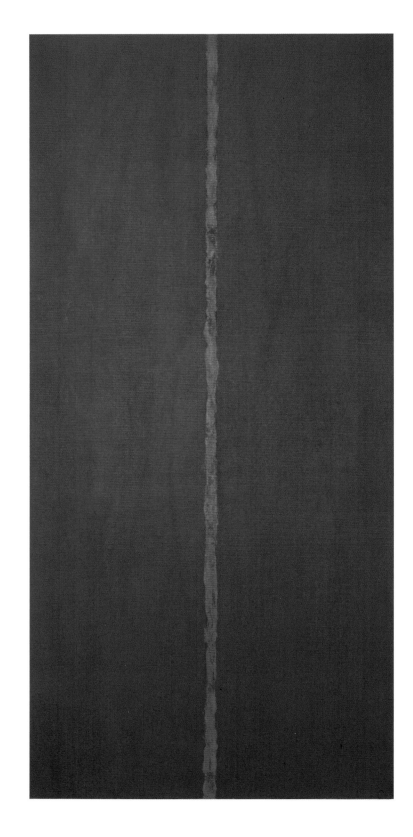

23 *Onement III*, 1949
Oil on canvas, 71⁷/₈ x 33¹/₂ ins.
The Museum of Modern Art, New York
Gift of Mr. and Mrs. Joseph Slifka

24 *Be I*, 1949
Oil on canvas, 94 x 76 ins.
The Menil Collection, Houston
Gift of Annalee Newman

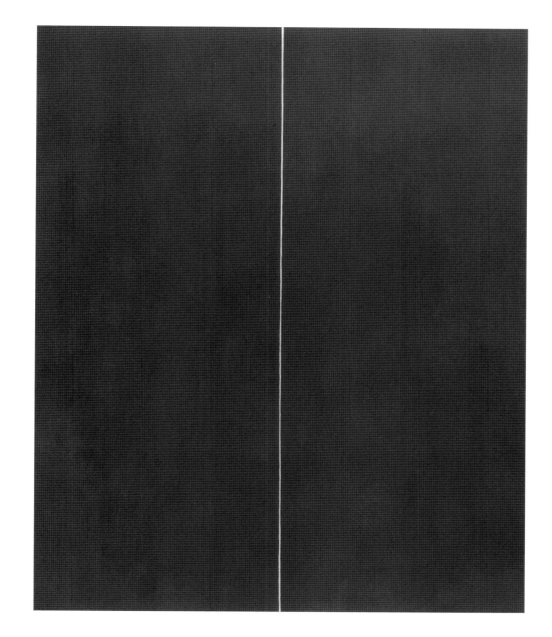

much more precise edges is also different. The bright red paint was evidently not applied by brush, as in the case of "Onement I", but by some semi-mechanical means. This is apparent both from the empty areas within the red stripe and from the red paint's having bled, in several places, beyond the sharp edges of the "zip" into the adjacent areas of reddish brown.

The "zip" could have more than one function. Besides introducing the vertical, thickly painted stripe with its uneven edges as a positive element, Newman used it with a negating effect. In "Be I" (Fig. 24), for example, an extremely narrow "zip" divides a large mono-

chrome surface measuring 94 by 76 inches. Here the viewer searches unconsciously for a point where the axis of his body corresponds with the "zip". What is perceived, above all else, is the verticality of the painting, with the viewer unable to decide whether the grayish "zip" lies on top of the red, or whether it is embedded in it or recedes behind it. Although "Be I" is quite effective from a distance, it cannot properly be experienced until the viewer moves closer to the painting and its edges begin to move out of his angle of vision, and little else can be seen but this precise line of demarkation which, being thin and sharp, does not really separate the two halves of the canvas or push them apart. This concept was so important to Newman that he repeated it in 1970, albeit on a larger scale (111 1/2 by 84 inches) and with a more pronounced verticality.

IV

After the hermetic and radical solutions featured by the works discussed above, "Concord" from 1949 (Fig. 25) would seem to represent a step backwards. It is considered by some to be unfinished[48], as Newman had left the masking tapes—the "zips"—on the canvas, where over the years they have gradually turned brown ocher. It is an unusually painterly work, for the ground clearly shows the strokes and movements of the brush, with the greenish gray assuming an almost translucent quality, an effect with which Newman had already experimented several years previously, and in 1946 in particular. Concord is the name of a small township near Boston where the influential American naturalist and transcendentalist Henry David Thoreau once lived. While on their honeymoon in 1936, Newman and his wife, Annalee, visited Concord[49], and we may assume that the title of this work was not only meant to be taken at its semantic face value—i.e. concord in the sense of harmony—but was also intended to evoke memories of Thoreau, whose writings Newman had avidly consumed. Indeed, it was during the forties, when he developed a profound interest in the study of ornithology and botany, that Newman had become fascinated by Thoreau's way of combining mysticism with exact observation of nature. Moreover, Newman was doubtless highly impressed by Thoreau's social criticism and his radical non-conformism (Thoreau's essay "Civil Disobedience" was first published in 1849).

Very probably, Newman decided to discontinue work on this painting because the double stripe was posing a problem. Although the center is emphasized in this painting, the viewer wonders whether he is looking at a "double zip" or at three contiguous vertical stripes; the space between the two tapes corresponds roughly to the taped areas' widths. Since the central stripe is of the same color and composition as the ground, the two strips of masking tape are set off optically from the background, creating a spatial effect. The two verticals seem to come forwards, away from the ground. This effect is enhanced by the

25 *Concord,* 1949
Oil and masking tape on canvas,
90 x 54 ins.
The Metropolitan Museum of Art,
New York. George A. Hearn Fund, 1968

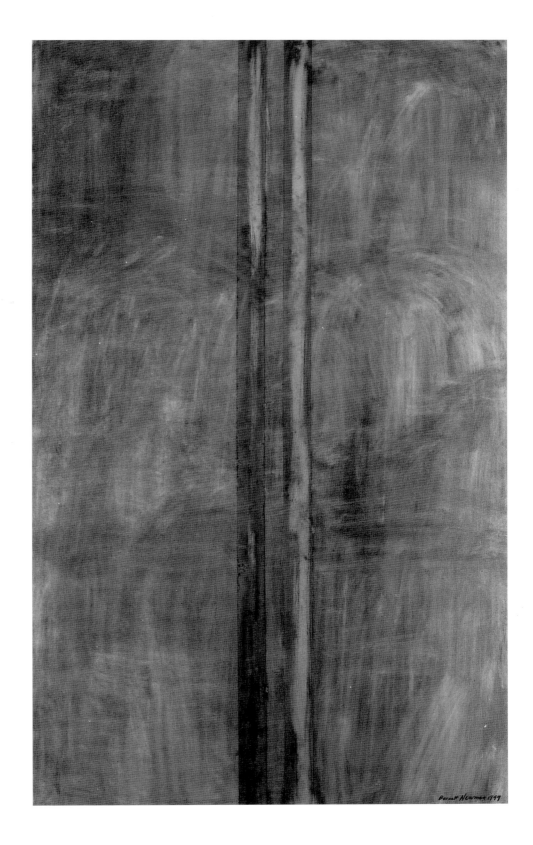

brushstrokes which move alternately in horizontal and vertical directions; an oblique stroke in the bottom right-hand part of the painting responds to two arch-shaped strokes in the top third of the painting, the right-hand one more prominent than its counterpart on the left. This differentiation between the two segments harks back to those strategies which Newman thought he had at last succeeded in abandoning in "Onement I"[50].

The idea of a "double zip" might have come to Newman through his realization that the possibilities of variation afforded by his "Onement" paintings in terms of format, coloration, and paint application were far too limited.

Thus it was that other paintings produced during this phase likewise featured a double vertical stripe. Typical examples are "By Two's", "Galaxy", and "The Promise"[51]. The most interesting solution is undoubtedly the one offered by "Covenant" (Fig. 47). Executed in landscape format, this painting has two very differently colored "zips" against a dark maroon ground. The black "zip" is approximately 1 inch wide and positioned left of center, whilst the pale yellow "zip" is of varying thickness (between ⅝ and ¾ inches) and is positioned right of center. The light-colored, narrower strip is more prominent and leans towards the left. The narrower masking tape for this "zip" had been applied prior to application of the maroon paint and then removed. The resulting hollow was then filled by Newman with yellow paint, commencing at the top; the paint spread beyond the width of the masking tape, evenly at first, just a fraction of an inch on both sides, but, further down, the paint began to spread more to the right than to the left. As a consequence the distance between the right-hand edge of the "zip" and the right-hand edge of the canvas is almost an inch—¹¹/₁₆ inch, to be exact—greater at the top than at the bottom.

This deviation is significant inasmuch as it tells us that Newman, whilst having placed the masking tape absolutely vertically, was happy to paint free-hand after the tape's removal and thus make do with a certain degree of inaccuracy. In this way he avoided the sterility typical of many a Constructivist painting. Newman's approach reflects a mixture of precision and intuition, of deliberation and restrained gesture.

This approach becomes obvious when we consider the surface of the painting as a whole and the way it is divided up. The yellow "zip" divides it roughly according to the golden section. According to strict mathematics, the yellow "zip" should be positioned 1¾ inches further to the left, but Newman has taken into account that the area to the left of the yellow "zip" is in turn divided by the black "zip" and thus appears smaller than it actually is. Here, too, we realize how ingeniously Newman achieves an effect which, in the final analysis, has not been dictated by a measuring tape.

The dark vertical line—which by optical illusion seems to occupy a deeper plane—divides the remaining area between the yellow "zip" and the left-hand edge of the canvas

according to the same principle of proportion, but with more evident precision, since the pale yellow "zip" makes the right-hand part of the painting stand out in relation to the entire surface of the canvas.

Thus the harmony residing in the order created by what seem to be arbitrarily placed stripes cannot develop properly until the viewer begins to consider the painting abstractly and first relates the light-colored "zip" to the entire surface of the painting and then the left-hand, larger area to the dark-colored "zip". The maroon ground is divided into three fields, the narrowest field flanked by two others of different width. The "zips" serve here to establish a moment of equilibrium between these differently weighted fields. The narrower field on the right is set off by the light-colored "zip" and hence seems to be more promi-nent than the slightly wider, left-hand field whose inner boundary is formed by the dark-colored "zip".

However logical and consistent all this may seem, there is still one matter that has to be resolved, namely the problem posed by the widths of the stripes. When considering the compositional structure of the painting, do we proceed from the centers of the stripes or from their edges, and, if from the edges, from which ones? Such a simple composition can give rise to an array of problems. Indeed, "Covenant" challenges the viewer's powers of rea-soning and perception, making him realize the wealth of associations that reside in the paint-ing's plain and simple composition. But for all its conceptual lucidity, the painting refuses to answer the most crucial question: Where is the center of the painting? We can guess that it is not exactly in the middle of the field formed by the two "zips"; it seems obvious that it must be slightly closer to the dark-colored "zip", but exactly where we cannot say simply by looking at the painting. Although it may seem irrelevant to ask where the optical center of gravity is, this question arises automatically, for the viewer relates the "zips" to the entire surface of the painting, analyzes their colors, their widths, and the execution of their edges, reflects upon their relationship to each other and, in so doing, seeks, without thinking, to determine his own position in front of the painting which, whilst seemingly divided up into separate parts by the vertical stripes, creates the impression of being an integral whole. In analyzing the relationship of the individual parts to one another, the viewer unconsciously searches for the center of the painting. The optical center of the painting need not coincide with its apparent or arithmetical center.

"Abraham" (Figs. 26, 48) was also painted in 1949. Whether the title alludes to the biblical character—whom Newman, from all accounts, revered as a god-like artist—or to Newman's own father, who had died on June 30, 1947[52], need not be discussed here. What is more important is that, with this painting, Newman had taken a further step forwards. Although he again divides the canvas vertically with a "zip", this time it is an unusually broad

90 one. As Hess remarked, the right-hand edge of this stripe marks the center of the painting, while its left-hand edge divides the left half of the painting in the a ratio of 1:2. Thus the width of the vertical stripe corresponds to one-sixth of the entire width of the canvas.[53]

Bois saw this painting as an important breakthrough, for Newman had divided the canvas symmetrically and at the same time called this symmetry into question and undermined it[54]. Again, the process of perception is the theme, and the way Newman deals with it is unusually sensitive. The coloration is dark, approaching black. Depending on the lighting conditions, the viewer can make out a greenish hue in the larger fields, and a bluish black within the "zip". The outer edges of the "zip" are slightly reflective—possibly on account of the varnish—creating the effect of a delicate aura. This extraordinarily subtle differentiation in valence and luminescence lends the "zip" a uniform character. Bois, however, saw this completely differently. In his opinion, Newman had realized while painting "Abraham" that the interaction of figure and ground within the picture would not allow the viewer a moment of repose and that "the only factual certitude which [the viewer] will be able to grasp will be the lateral expanse of the canvas." The basis of Newman's sense of scale, Bois says, was not realized until "Abraham"[55], for here each of the two edges of the vertical stripe functioned— or at least tended to function—as a "zip" in its own right and thus undermined the homogeneity of the vertical stripe as a whole. The subtle gradations of black are perhaps conducive to such claims, although the overall visual impression contradicts them inasmuch as the slight luminescence along the outer edges of the "zip" consolidates the "zip" and sets it off, subtly but clearly, from the fields on either side. Indeed, it is my opinion that in "Abraham" Newman was concerned with completely different questions and had scarcely given any thought to the problem of scale.

Bois's assertions about "Abraham" are more applicable to other works by Newman— for example, to a drawing in the National Gallery of Art, Washington, D.C., which was produced in the same year (Fig. 27). The white empty stripe in the center of the drawing is as wide as the black field on the left, and both are considerably narrower than the black field on the right. One cannot help asking oneself whether the composition comprises three vertical elements, or whether an extremely broad white "zip" divides the black ground and forces it apart, or whether two black verticals are moving towards each other and gradually narrowing the space between them. None of these questions can be answered unequivocally, for the white underlies the black and thus confuses the figure-ground relationship. Paintings in this category include "Covenant" (Fig. 47). In those cases where Newman uses several "zips" it is not the symmetry of our field of vision which is challenged but rather its lateral extension. Indeed, this was the problem which Newman encountered with his large formats.

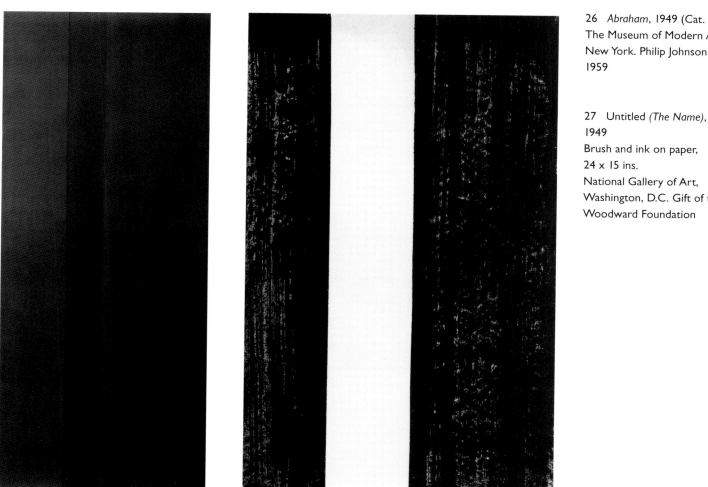

26 *Abraham*, 1949 (Cat. No. 3)
The Museum of Modern Art,
New York. Philip Johnson Fund,
1959

27 Untitled *(The Name)*,
1949
Brush and ink on paper,
24 x 15 ins.
National Gallery of Art,
Washington, D.C. Gift of the
Woodward Foundation

But first let us turn to the other extreme. After finishing "Vir Heroicus Sublimis" (Fig. 1), perhaps his most important work of this early period[56], Newman produced several paintings of extremely narrow, vertical format. The question whether Newman had begun to paint such narrow paintings as "The Wild" (95³/₄ by 1⁵/₈ inches) because he had "felt intoxicated with scale" after completing the large "Vir Heroicus Sublimis" will be ignored here, as will the question whether these works had been painted to rebut a museum curator's assertion that Newman was concerned with formal relationships along Bauhaus lines.[57]

"Untitled (Number 2)" (Fig. 52), a painting of exaggeratedly vertical format measuring 48 by 5¹/₄ inches, employs two contrasting colors, with the deep black stripe on the right measuring only one third of the width of the red stripe. The vertical demarkation line has

been executed with considerable accuracy, although here and there the black paint has bled, creating a fringed effect. It is precisely this effect, however, which Newman sought to achieve. The viewer focuses his attention on this phenomenon, for it alone seems to hold the answer to the questions of how the colors relate to each other, of which color is on top and which beneath, etc. He also asks himself whether he is looking at two stripes or just one stripe which occupies only a part of the canvas. And is the line of demarkation to be considered as a "zip"? And how can such contrasting colors be reconciled in terms of tonality? And is this still a painting, or must it be viewed rather as a wall object or sculpture? Such questions are not elicited by "Eve" (Fig. 49), one of Newman's clearest and most impressive paintings of this period. The dark violet stripe on the right not only brings out the warm glow of the red but establishes a correspondence with the vertical axis, which has a tendency to move towards the right.

"The Wild" (Fig. 50) provokes questions similar to those invited by "Untitled (Number 2)", but to an even greater degree. What do we see? First of all, there is the extremely elongated vertical support over which the canvas has been stretched. The entire canvas has been painted with a ground of bluish gray. Running down the center is a red stripe approximately ¾ inch wide which, for its part, has been overpainted with the same red, though this time with greater spontaneity, i.e. more "untidily". In some places, the first, more precisely executed stripe is still visible, while in others the subsequently applied layer of cadmium red runs over onto the bluish gray ground, obliterating the edges of the first stripe. Basing our judgement on what we have observed hitherto, we cannot readily place this work in a particular category: Are we looking at a bluish gray ground with a red "zip"? Are there two "zips", one on top of the other, the one executed with extreme care, the other spontaneously? Does the painting in fact thematize the problem of figure and ground? The answer to these questions is not made any easier by the narrow, shadowy gap that is visible between the aluminium frame and the canvas, and decisively influences the visual quality of the painting. "The Wild" does in fact leave much unanswered and seems to be more an interesting case than a successful painting. Perhaps Newman was indeed "just" attempting to isolate a "zip" from its painted context, thus ridding it of its illusory character and quite literally materializing it. "The Wild" has the appearance of a painted rod and yet it is definitely a painting in the traditional sense, i.e. it comprises a stretcher, a stretched canvas, a coat of primer, a frame, etc. Here Newman seems to have wanted to demonstrate, once and for all, that a "zip" does not simply represent a vertical space, gap, or crack in the painting but has qualities all its own, qualities which extend beyond the context of his supposed reflections on the problem of figure-ground relationships.[58] The indirect message is that Newman's paintings are concerned first and foremost with the "zip" and only secondarily with what the

"zip" joins or separates, overlies or underlies, limits or opens, heightens or reduces. But whichever way we look at it, "The Wild" is a work clearly related to "Here I" (Figs. 79, 87)[59], the first sculpture that Newman produced—likewise in 1950.

V

Works which seem to be antithetical to "The Wild" and Newman's other extremely narrow vertical formats are the two paintings "Vir Heroicus Sublimis" and "Cathedra" (Fig. 51). Both works are 96 inches high and of almost the same width—216 and 213 inches respectively; "Cathedra" is thus only slightly narrower than "Vir Heroicus Sublimis". Contrary to what might first seem to be the case, the enormousness of these paintings is not all that surprising in an American context. In retrospect, Motherwell felt that one of America's most important contributions to modern art was the hugeness of American paintings.[60] Indeed, in 1947, the Museum of Modern Art had mounted the exhibition "Large-Scale Modern Paintings" which included not only works by classic modernists—Matisse, Léger, Picasso, and Miró—and by such contemporaries as Matta, Lam, and Siqueiros but also Jackson Pollock's "Mural" of 1943, which had been specially created for Peggy Guggenheim's townhouse. Pollock's enormous painting measures 7 feet 11 3/4 inches by 19 feet 9 1/2 inches.

Pollock does in fact seem to have played a leading role in the process of applying mural-painting strategies to easel painting. In principle, Pollock was concerned with transferring the ambitiousness and effectiveness of mural painting from the public to the private sphere, replacing narration by feeling, the social context by the individual one, but without waiving the mural's overwhelming force through sheer size—which was particularly effective when the rooms in which the oversized paintings were to hang were relatively small. In his application for a Guggenheim Fellowship in 1947, Pollock described his artistic objectives thus: "I believe the easel picture to be a dying form, and the tendency of modern feeling is towards the wall picture or mural. I believe the time is not yet ripe for a *full* transition from easel to mural."[61] In *Possibilities*, a magazine edited by Motherwell and Rosenberg which appeared only once, in 1947/48, Pollock wrote his famous statement that his painting "does not come from the easel" and that he preferred "to tack the unstretched canvas to the hard wall or the floor [. . . and] work from the four sides and literally be *in* the painting."[62]

Three years later, Rothko spoke in a similar vein: "I paint very large pictures. I realize that historically the function of painting large pictures is painting something very grandiose and pompous. The reason I paint them, however—I think it applies to other painters I know—is precisely because I want to be very intimate and human. To paint a small picture is to place yourself outside your experience, to look upon an experience as a stereopticon

94

view or with a reducing glass. [. . .] However you paint the larger picture, you are in it. It isn't something you command."[63]

The large format had a magical attraction for virtually all the Abstract Expressionists. Their own statements tell us their intention in using this format, namely to draw the viewer in and to keep him there. If you try to free yourself, says Hess, it is as if to shake off a spell, "to reassure yourself that you are merely yourself, in a room, faced by an object. Then the object draws you back in to focus on the color, on the surface, to a communion with the colored plane."[64] But Hess also draws our attention to another, more down-to-earth aspect: "Ambition, too, was a motive for increasing the scale of the paintings, for pushing beyond the practical sizes that fit living rooms [. . .]"[65] The paintings were intended, from the outset, for a specific public, namely the kind that frequented art galleries and museums. In this context, the oversized canvases had the effect of emphasizing that they were meant primarily for exhibition.

Although before 1950 Newman had worked only in a small or medium-sized format, he was conversant with the problems of large-scale painting, and certainly had been so since he made the acquaintance of Thomas Hart Benton. In the late 1930s, after having twice failed the qualifying examination for New York City art teachers, Newman sought the advice of this famous muralist, who happened to be his summer neighbor on Martha's Vineyard. They discussed the difficulty of passing an examination which required the candidate to design, in an hour and a half, a mural for a wall of given dimensions.[66] Benton, who in 1930 had painted "America Today" at the New School for Social Research in New York, a work which was central to the mural movement, clearly stated in his interview with Newman—which was published in the *New York Times* on September 19, 1938—that it was impossible to design a large-scale painting under the prevailing examination conditions.

Twelve years were to go by before Newman began to experiment, like Pollock, Still, and Rothko, with large-scale painting. When he had his first solo exhibition at the Betty Parsons Gallery, from January 23 to February 11, 1950, Newman declared his paintings to be "embodiments of feeling", each one to be experienced for itself: "Full of restrained passion, their poignancy is revealed in each concentrated image."[67] For his second solo exhibition at the same gallery, from April 23 to May 12, 1951, Newman wrote brief instructions on how to view his work: "There is a tendency to look at large pictures from a distance.

"The large pictures in this exhibition are intended to be seen from a short distance."[68]

With a title slightly reminiscent of Pollock's "Cathedral" of 1947, "Cathedra" (Fig. 51) is one of Newman's largest and undoubtedly most significant works. The viewer is immediately overwhelmed by its intensity of color. A deep ultramarine blue covers the entire canvas, though not uniformly as reproductions suggest. The color iridesces, becoming darker

here and lighter there; effects of light and shadow seem to interact with nuances of cobalt blue and black, creating a latent horizontal movement within the color, as though the light of the painting has been set in motion. What we feel is the Romantic impulse which overcomes us when we stand in front of a painting by Caspar David Friedrich and lose ourselves in it.[69]

"Cathedra" means "seat" or "throne", and Hess says that, according to Newman, the title referred to Isaiah 6:1: "[. . .] and I saw also the Lord sitting on a throne, high and lifted up, and the train of His mantle filled the temple."[70] Hess's own comments in this connection may be disregarded, for his biblical exegesis scarcely contributes to an understanding of the painting. On the contrary, his mystical and religious speculations allow no scope for further, more precise analysis. Despite Newman's assertion to Hess, Newman had always said that a title served as a metaphor to identify the emotional content or meaning of a painting, thus helping the viewer to understand it.[71] On the other hand, Newman was, like the other New York painters, averse to all literary implications in painting. Any—no matter how subliminal—relationship between word and image was highly suspect.[72] Hess's interpretation is refutable not least because nothing was further from Newman's mind than the "abstract" illustration or embodiment, in whatever form, of so-called pure ideas. This was the domain of the "ideographic picture"; the dictionary definitions of the term "ideograph" and "ideographic" which prefaced Newman's 1947 exhibition catalog foreword on this theme all refer to the representation of ideas purely by means of symbols, figures, or hieroglyphics and without using language to express their names.[73] Symbols and figures, however, are missing from "Cathedra". The vast expanse of ultramarine blue initially prompts a vague feeling of infinity. The title is meant to steer this feeling in a certain direction, but without associating it with a definite object. If we approach the painting with the idea of a "cathedra" or a "throne" fixed in our minds, we shall never be able to understand it. The painting will always remain an enigma. But perhaps this much can be said: a throne is an upright piece of furniture used by persons of high rank. The feeling of transcendence evoked by the horizontal expanse of blue is associated vaguely with verticality, for the title "Cathedra" brings something into play which is higher than we ourselves. Whether we immediately think of an invisible God is another matter. These aspects of the painting cannot of course be dismissed, but they remain indecisive and, for the most part, arbitrary. Moreover, all further reflections in this direction come to an immediate standstill once we focus our attention on the purely visual aspect of the painting instead of on a possible semantic content.

Any latent sensation of the sublime is thwarted by Newman's decisive, not to say radical, intervention. The white "zip" not only divides the painting but also destroys every illusion to which the viewer might have been willing to abandon himself. The second "zip", on

the right-hand side and unevenly overpainted in pale cobalt blue, undermines any visual effect which might capture the viewer's imagination. Thus Newman first builds up a mood in the painting and then completely destroys it. The painting fails to keep its promise, as it were. Once we become conscious of the "zips", we no longer experience the expanse of blue as an echo chamber for our feelings, but merely as a color which is transparent in some places, opaque in others. The "zips" render obsolete what Newman had been constantly reflecting upon in his statements and writings at that time: the experience of the sublime. "Cathedra" is such a grandiose work precisely because it brings together two levels which are seemingly incompatible: Romantic feeling and rational analysis, emphasis and control. The moment we lose ourselves in the painting we are thrown out of it again head over heels. We experience two things at the same time: fascination and repulsion. And then, all of a sudden, we are conscious of the calculation behind the painting. The narrow, right-hand field takes up exactly one eleventh of the entire area of the canvas and it is ten times the width of the white "zip" which, for its part, is twice the width of the right-hand one. The fields defined by the "zips" measure approximately $95^1/_2$ by $95^1/_2$ inches, although the right-hand one is slightly wider. This small deviation, optically insignificant, again shows that Newman worked by intuition and not by geometrical precision, though the latter might seem to be the case.

When the painting is viewed in this perspective, its title, too, assumes a different significance. It may indeed be taken literally, we may indeed think of the vision of Isaiah, but then we immediately reject all intellectual and literary associations, for we realize that any religious allusions become stranded, as it were, in the physical presence of the color. Both Rothko and Newman seek to evoke the spiritual, but Newman is not so naive as Rothko. Newman's paintings have always—contrary to his statements—acknowledged the identity of the non-identical. Never has there been a thesis without an antithesis. Never the irrational without rational, disciplined form. Never the severely geometrical without a hint of jaggedness or unpredictable overspills of color. Always the oscillation between the painting as a painting and the painting as an object. "Cathedra" operates, if you like, on several levels at the same time, and it is this circumstance which makes our appreciation of this work problematical, for no matter which of the painting's aspects we pick out, we do so at the expense of all the others.

All in all, "Cathedra" is a work which at once overwhelms us and keeps us at a distance. What takes place in the painting—the alternation between vague suggestion and abrupt realization—forces the viewer, again and again, to verify his own categories of perception. All associations which might have been evoked by the dominant expanse of blue seem to be thwarted by the "zips". And this has a rebound effect on the viewer himself, for

any questions which he may have wanted to ask of the painting are now thrown back at him, though only for as long as this inverted process of reflection lasts before it again turns outwards and concentrates once again on the object.

Newman's "Prometheus Bound" (Fig. 54) is a painting which can be interpreted in a similar way.[74] Measuring 132 by 50 inches, "Prometheus Bound" belongs to a group of four paintings which Newman produced in 1951/52 and which all feature the same exaggeratedly vertical format; the other three are "Day Before One", "Day One", and "Ulysses". According to the ancient Greek myth, Prometheus had stolen fire from heaven to help mankind and had thus angered Zeus who then punished him by having him chained naked to a rock in the Caucasus. Every day an eagle fed on his liver. The pain was unbearable, for Prometheus's liver would grow again during the terrible cold of the night only to be torn apart and eaten again by the eagle the following morning.

Whilst in essence—according to Nietzsche's[75] interpretation of this myth[76]—the titanically striving individual must inevitably commit a wicked deed, there is nothing in Newman's painting which even intimates this. All we can see is a vast expanse of black, dull and cloudy, without a hint of transparence or luster, covering almost the entire canvas with the exception of a narrow white stripe at the bottom. Its painterly quality lies in the easily discernible brushing and wiping strokes—broad and expansive, circular and contractive in the black; short and fierce in the white. Whilst in the bottom right-hand corner of the painting the horizontal line is still relatively neat, the rest of this demarkation between light and dark is quite turbulent. In places, the white forces its way into the black, where it has been dabbed and made to leave small spots here and there, whilst in other places it is the black which penetrates the white. As the black was obviously still wet when Newman applied the white, there are slight touches of gray here and there, but they do not detract from the hardness of the contrast. The painting is reminiscent of a snow-covered landscape beneath an immeasurable, starless firmament; the several horizontal streaks of white over the black strengthen this impression.

And so, in order to fathom this painting, we seek refuge, albeit unconsciously, in metaphorical imagery, seeing—with the Greek myth at the back of our minds—the vast expanse of black as the cold night which enshrouds Prometheus. Moreover, since we have a tendency to transcend such narrative aspects, we recall, almost involuntarily, that Prometheus, according to another source, had also created human beings, that he had assisted at the "birth" of Athena as she sprang from the head of Zeus and, as a token of her thanks, had been endowed with the gift of various scientific and artistic skills which he later bequeathed to mankind. Prometheus, the creative individual who has to atone for his deeds on behalf of mankind through endless suffering and, enveloped in the terrible yet regenerat-

ing darkness of night, is relieved of his pain only to be exposed to fresh torment each new day—is that the message behind this painting?

Such associations might be taken still further. In his *Gay Science*, Nietzsche intimated that magic and alchemy had preceded the natural sciences in the cognitive process. They had awakened the desire for hidden and forbidden powers and had promised more than they could fulfill. Nietzsche concluded by asking: "Did Prometheus first have to believe that he had stolen light and then atone for this deed before he discovered that he himself had created light by coveting it, and that not only mankind but God, too, was all his own work and had been but clay in his hands?"[77]

Viewed in this perspective, the expanse of black in Newman's painting takes on a different meaning. It refers not, or at least not only, to the cold night of the myth but to that impenetrable dark chaos which the yearning for the light of knowledge creates. Imagination not only precedes the deed but also anticipates reality. For Newman this meant two things: the magician came before the scientist; and artistic imagination came before scientific knowledge.

Indeed, this was the very point made by Newman in his essay "The First Man Was an Artist" which was published in the October 1947 issue of *Tiger's Eye*. This essay was virtually a declaration of Newman's artistic creed. "The necessity for dream," he writes, "is stronger than any utilitarian need"; "the necessity for understanding the unknowable comes before any desire to discover the unknown"; the "poetic outcry" is older than the "demand for communication"; the esthetic act always precedes the social act. "The artistic act is man's personal birthright. [. . .] For the artists are the first men."[78]

Here Newman is proclaiming the priority of art over all other disciplines. He justifies this claim by partially identifying the primitive artist with the modern artist. The notion that contemporary experience in art was bound up with that of original man was widespread among New York artists after the Second World War. Nietzsche, Jung, and Worringer had, through their writings, set the stage for this belief.[79] "Painting is still a primitive business," said Newman only two months before his death.[80]

Such regressive ideas were ubiquitous during the late forties. This turning towards myth—by Newman and others—resulted from the doubts that had come to prevail in the face of the dominance of science, rationality, and technology in all spheres of life. Artists were against every kind of materialism, believing that myths and mysteries represented forms of knowledge in which truth manifested itself openly and genuinely. These beliefs were metaphysical projections aimed primarily at bolstering the status of art, at ensuring and/or reinstating its position of supremacy. Viewed in this light, the spiritualization of art meant less a transcendence of reality, although that is precisely what many artists strove to achieve, than a total rejection and/or negation of reality and the creation of a different, spiritual reality.

The expression of terror and violence, albeit indirect, in "Prometheus Bound" is thus the reverse side of the artist's yearning for that spirituality and community which, according to Newman and other mythologizers, governed so-called primitive societies.[81] The terrible darkness of the night evokes the longing for the light of truth, as intimated by the narrow band of white at the bottom of Newman's painting.

But Newman's claim goes further. Out of opposition to the work and techniques of the craftsman, which in his eyes were inartistic, Newman accords absolute priority to the artist. Only the artist, he says, is able to invent human reality—naturally a spiritual one. In the summer of 1952, close to the time the paintings under discussion were completed, Newman spoke at the Fourth Annual Woodstock Art Conference on "Aesthetics and the Artist". Asked about the artist's relationship to nature, Newman answered: "[. . .] what I think the artist does is to create reality, and that what seems to be reality is really an imitation of art, of what the artist has made. By 'reality,' I mean human reality. The artist does not make the hills and the rivers, but whatever reality we have as human beings has been created by the artist and only by the artist. It seems to me that by identifying art or reality with nature, the aesthetician has reduced the artist [. . .] to a performer."[82]

Such hopes of realizing imagined reality in his painting were of course vain, but what distinguished Newman from all others was his constant reflection on the doubts which he had in this regard. The fragility of his esthetic concept as a guarantor of his modernity has its roots here. The ideas he so vividly evokes again and again in his essays are forever besieged by questions concerning their artistic feasibility. Newman's theories and esthetic reflections apply to his paintings only up to a point. Esthetic theory and artistic practice are not always congruent, indeed, the one sometimes seems to negate the other.

From the outset Newman was conscious that his work as an artist was not for practical use.[83] As an opponent of practicality and rationality in art, he was pained by the futility of his actions. The absence of any direct social relationship between the modern painter and his public was felt by most Abstract Expressionists[84], and Newman, like many others, saw himself as "outside society".[85] There is of course nothing unusual about this, indeed it is the topos of artistic self-conception in our modern age. Newman, however, gives the painter's role as an outsider a particular twist. When Arshile Gorky committed suicide on July 21, 1948, Newman wrote a memorial tribute, though it was not published at the time. In America, he says sarcastically, the artist "has the special privilege of being told and reminded every minute of his state of futility." Newman ended the tribute with the words: "When he [Gorky] walked into his barn to perform his private Passion, he made clear to each of us the nature of our own act and our destiny: that no matter how violent the artist's will may be against the world, his real target is the artist-man himself—that the moral act is an act

of self-destruction. In showing us the morality of the moral act, Gorky saved us from the drastic violence he himself assumed."[86]

Considerably more significant than Newman's portrayal of Gorky as a martyr and redeemer, and his blasphemous implication that Gorky died to save us all, are certain other statements which Newman makes in this tribute. He sees the esthetic act as one of self-destruction, for it is performed against a background of total lack of acceptance, foundation, and perspective. Whilst the opposite is forever being proclaimed, says Newman, painting is in the final analysis not only an act of self-discovery and self-invention—as some artists like to see their work[87]—but also one of self-destruction. At any rate, this is what Newman felt at that time. Much later, in 1965, Newman was to speak of the "terror of Self": "The self, terrible and constant, is for me the subject matter of painting and sculpture."[88]

The irritation which such notions may cause results from the implication that the paintings thematize something that is impossible to show, that they suggest something that cannot be verified. In a highly rationalized world, art becomes the only non-conceptual language in which the possibility of divine creation is reflected —"qualified by the paradox that what is reflected is blocked."[89] "Day Before One" and "Day One"—and Newman's other works whose titles allude to the origin of the world—all owe their metaphorical presence to the discrepancy between the evocation of transcendence and its immediate revocation. Indeed, that gives them their strength. Even though Newman might have wished to create a kind of art which would heal the wounds of modernism, free it from its constraints, and release it from its suffering, and even if this wish were the basis of his concept of the sublime[90], every esthetic appraisal of his works contradicts the "relief function" such hypotheses imply. What Newman did achieve in such paintings as "Cathedra", "Prometheus Bound", and several others was something unique, all the same. Newman had now reached the first peak of his career, and the tragic thing was that other painters did not notice—nor, probably, were they able to. Newman's crisis during the fifties was that not all of his works were able to meet the standard he had set, for he did not always succeed in combining inherent opposites and contradictions into an esthetically convincing whole.

Adorno's *Aesthetic Theory* was published in 1970, the year of Newman's death, and contains a passage which is quite remarkable: "To survive reality at its most extreme and grim, artworks that do not want to sell themselves as consolation must equate themselves with reality. Radical art today is synonymous with dark art; its primary color is black. [. . .] The ideal of blackness with regard to content is one of the deepest impulses of abstraction. [. . .] The radically darkened art [. . .] which aesthetic hedonism [. . .] defamed for the perversity of expecting that the dark should give something like pleasure, is in essence nothing

but the postulate that art and a true consciousness of it can today find happiness only in the capacity of standing firm."[91]

This reference to Adorno in the context of Barnett Newman's works may seem a little far-fetched, not to say dubious, but the idea that such an extraordinarily impressive and hermetic painting as "Prometheus Bound" manifests the "capacity of standing firm" is irresistible. This immense expanse of black above a low white horizon seems to be the quintessence of artistic existence. The reality of the transcendental experience which, for Newman, forms the basis of American art, and hence of his own art[92], seems here to have lost its magic, to have faded away. It is not the "emotion of an experienced moment of total reality" which these paintings evoke, but merely the memory of it, as Newman points out[93]. Memory is bound up with the subject of the viewer; it is not direct but the result of reflection, triggered visually by the "zip" or, as in this case, by the discrepancy between black and white. "Artworks become appearances, in the pregnant sense of the term—that is, as the appearance of an other—when the accent falls on the unreality of their own reality."[94] The unreality of their own reality—this is manifest in "Prometheus Bound", "Cathedra", "Abraham", "Eve", and other works. They are the highlights of the oeuvre of an artist whose paintings not only surpass his writings but also, in many respects, render them obsolete.

102

1 Jeremy Strick, *Enacting Origins*, in: *The Sublime is Now: The Early Work of Barnett Newman. Paintings and Drawings 1944–1949*, exhibition catalog, Walker Art Center, Minneapolis, 1994, p. 10.

2 Richardson, No. 2.

3 Representative of several studies is the one published by Michael Leja who examined the works of the Abstract Expressionists—particularly Pollock, Rothko, Still, Newman, and Gottlieb—within a very broad framework of references. Cf. Michael Leja, *Reframing Abstract Expressionism. Subjectivity and Painting in the 1940s*, New Haven and London 1993.

4 Cf. Dorothy Gees Seckler, *Frontiers of Space*, in: *Art in America*, Vol. 50, Summer 1962, p. 86. Cf. Richardson, No. 13.

5 Robert Carleton Hobbs, *Early Abstract Expressionsm: A Concern with the Unknown Within*, in: *Abstract Expressionism. The Formative Years*, by Robert Carleton Hobbs and Gail Levin, Herbert F. Johnson Museum of Art, Ithaca, N.Y., 1978, p. 11.

6 Cf. Richardson, Nos. 14, 15, 16, and 41.

7 Wolfgang Paalen, *On the Meaning of Cubism Today*, in: Wolfgang Paalen, *Form and Sense*, New York, 1945 (*Problems of Contemporary Art*, No. 1), p. 30.

8 Newman, *Writings*, p. 152.

9 Ibid., p. 163.

10 Concerning the parallels between the work of O'Keeffe and that of Rothko cf. Robert Rosenblum, *Modern Painting and the Northern Romantic Tradition. Friedrich to Rothko*, London, 1975, p. 214.

11 Newman, *Writings*, p. 147.

12 Ibid., p. 147. Wolfgang Paalen deals with this problem in his essay "Art and Science" and comes to the conclusion that art and science are complementary. Their respective spheres are quality and quantity, he writes, but reality is indivisible, meaning that all empty abstractions based on terms like "the absolute" and "the void" have no bearing on human reality. Cf. Wolfgang Paalen, *Form and Sense*, op. cit., p. 63.

Paalen's eloquent and informed essay does full justice to the then current discussion of the problems of quantum mechanics, whereas Newman employs only very vague notions.

13 Newman, *Writings*, p. 72.

14 Ibid., p. 140.

15 "Untitled", 1945, and "The Word I", 1946. Illustrations cf. Rosenberg, No. 21 and No. 44.

16 Richardson, No. 38.

17 Hess, 1969, p. 27.

18 Hess, p. 49. See also the small illustration of Lie's painting on the same page.

19 Newman, *Writings*, p. 30 ff.

20 Cf. *The New Shorter Oxford English Dictionary on Historical Principles*, ed. by Lesley Brown, Vol. 2, Oxford, 1993, p. 3762.

21 Cf. Yve-Alain Bois, *Perceiving Newman*, in: *Barnett Newman/Paintings*, The Pace Gallery, New York, April 8–May 7, 1988, p. ii, who sees the yellow stripe rather as a repoussoir. This important essay was reprinted in: Yve-Alain Bois, *Painting as Model*, Cambridge, Mass., and London, 1990, p. 187 ff.

22 Personal Statement 1945, here quoted from: *Mark Rothko 1903–1970*. The Tate Gallery, London, 1987, p. 82.

23 Statement in: *Possibilities*, No. 1, 1947/48, p. 84.

24 Statement in *Tiger's Eye*, No. 9, October 1949, p. 114. Here quoted from: *Mark Rothko 1903–1970*. The Tate Gallery, London, 1987, p. 85.

25 Cf. Patricia Still, *Clyfford Stills Biographie*, in: *Clyfford Still (1904–1980). Die Sammlungen der Albright-Knox Art Gallery, Buffalo, und des San Francisco Museum of Modern Art*, ed. by Thomas Kellein, Kunsthalle Basel, January 26–March 22, 1992, p. 146; p. 147 shows Still's solo exhibition at Peggy Guggenheim's gallery at the beginning of 1946; "July 1945—R" can be seen on the right.

26 Newman, *Writings*, p. 76.

27 Rosenberg, Figs. 19, 15, and 14.

28 *Artists' Sessions at Studio 35 (1950),* ed. by Robert Goodnough, in: *Modern Artists in America,* ed. by Robert Motherwell and Ad Reinhardt, New York, [1951], pp. 19, 20.
29 Ibid., p. 20.
30 Wassily Kandinsky, *Point and Line to Plane. A Contribution to the Analysis of Pictorial Elements* (1926). Here quoted from: Kandinsky, *Complete Writings on Art,* ed. by Kenneth C. Lindsay and Peter Vergo, Vol. II, London, 1982, p. 592. The first translation of Kandinsky's essay (*Point and Line to Plane*) by Howard Dearstyne and Hilla Rebay was published by the Museum of Non-Objective Painting, New York, in 1947.
31 Interview with Dorothy Gees Seckler in 1962. Cf. Newman, *Writings,* p. 251.
32 Newman, *Writings,* p. 255.
33 Ibid., p. 256.
34 *Artists' Sessions at Studio 35,* op. cit., p. 15.
35 Hess, 1969, p. 54.
36 Polcari went much further, proceeding from the etymological meaning of the word "onement", and claimed that the painting heralded "a new life, a new harmony, which fills the abyss of social and historical chaos with the power of the first new color/spirit of the postwar world." Cf. Stephen Polcari, *Abstract Expressionism and the Modern Experience,* Cambridge, New York etc., 1991, p. 197.
37 Newman, *Writings,* p. 306.
38 Hess, 1969, p. 53.
39 Ibid.
40 Cf. ibid., p. 31.
41 Cf. Yve-Alain Bois, op. cit., p. iv.
42 Ibid., p. v. To other painters the painting even seemed to have a presence all its own, for the more one looked at it the more it would assert its autonomy. An interesting statement in this connection was made by Still in a letter written in 1951: "When I expose a painting I would have it say: 'Here am I; this is my presence, my feeling, myself. Here I stand implacable,

proud, alive, naked, unafraid. If one does not like it he should turn away because I am looking at him. I am asking for nothing. I am simply asserting that the totality of my being can stand stripped of its cultural camouflage and look on the factional people who pass before me and see them without rancor, desire, or fear.'" Cf. Patricia Still, op. cit., p. 151. Here quoted from: *Clyfford Still,* San Francisco Museum of Modern Art, 1976, p. 119.
43 The version illustrated here (28 by 20½ inches) belongs to the Costakis Collection. Cf. *The George Costakis Collection. Russian Avantgarde Art,* ed. by Angelica Zander Rudenstine, New York, 1981, No. 1067 (color illustr.), in which reference is made to another version with a pink stripe owned by a museum in the former Soviet Union. Yet another version with a green stripe (28 by 19¼ inches) hangs in the Architectural-Artistic Museum Reserve, Rostov-Yaroslavski, cf. *Die Epoche der Moderne. Kunst im 20. Jahrhundert,* ed. by Christos M. Joachimides and Norman Rosenthal, Martin-Gropius-Bau, Berlin, May 7–July 27, 1997, Fig. 141.
44 Rosenberg, p. 52, went so far as to recognize in "Onement I" a synthesis of the two diametrically opposed trends of Abstract Expressionism, the evenly painted surfaces of such artists as Rothko, Reinhardt, and Gottlieb at the one extreme, and the gestural painting of such artists as Pollock, Hofmann, and de Kooning at the other.
45 "Without this human scale relation, 'Onement I' reads more as an idea about artistic scale than as a painting generating empathy with its own vitality through externally directed scale." Cf. Barbara Reise, *The Stance of Barnett Newman,* in: *Studio International,* 179, No. 919, February 1970, p. 51.
46 Maurice Merleau-Ponty, *Phenomenology of Perception,* translated by Colin Smith (1962), London and New York, 1996, p. 238.

104

47 In December 1948, Rothko wrote to
Clyfford Still informing him that Robert
Motherwell had engaged Newman for his
Subjects of the Artist school. Newman's
duties were however to consist solely in
advertising and in organizing lectures and
so on, but not in teaching, for he was not
a professional artist. Cf. Patricia Still,
op. cit., p. 150.

48 Hess, p. 65.

49 Thomas B. Hess, *Some Postcards from
Barnett Newman. A Photographic Footnote*,
in: *Art in America*, January/February 1976,
p. 80 f.

50 Cf. Yve-Alain Bois, op. cit., p. vii, who,
for reasons similar to those given here,
considers "Concord" to be one of New-
man's most seductive paintings and notes
that the impression of unity conveyed by
"Onement I" was not achieved in this
painting, and it was therefore a "failure"
(Bois himself put the word inside quote
marks).

51 Illustrations in Rosenberg, Nos. 53,
58, and 62.

52 Hess, p. 61.

53 Ibid., p. 59.

54 Bois, op. cit., p. vi.

55 Ibid., p. viii.

56 This important painting cannot be
dealt with in greater detail here, especially
as it is not being shown in this exhibition.
The controversy which arose between
Newman and Panofsky concerning its
title—or rather the spelling of it—has
been described in detail in recent litera-
ture. Cf. Beat Wyss, *Ein Druckfehler. Panof-
sky versus Newman—Verpaßte Chancen
eines Dialogs*, Cologne, 1993. Pages 25 ff.
contain a facsimile of the original pages of
the magazine *ARTnews*, February 1961,
showing the essay "The Abstract Sublime"
by Robert Rosenblum, and the letters to
the editor from Newman and Panofsky.

57 Cf. Hess, p. 71.

58 Cf. Barbara Reise, op. cit., p. 53.

59 Rosenberg, p. 75.

60 Robert Motherwell, *Concerning the*

*Beginning of the New York School:
1939–1943*. Interview with Sidney Simon,
in: *Art International* (Summer 1967). Cf. *The
Collected Writings of Robert Motherwell*,
ed. by Stephanie Terenzio, New York and
Oxford, 1992, p. 166.

61 Francis V. O'Connor, *Jackson Pollock*,
The Museum of Modern Art, New York,
1967, p. 40.

62 Ibid.

63 *A Symposium on How to Combine Archi-
tecture, Painting and Sculpture*, in: *Interiors*,
Vol. 90, No. 10, May 1951, p. 104. Here
quoted from: Diane Waldman, *Mark
Rothko, 1930–1970*, New York, 1978, p. 62.

64 Hess 1969, p. 51.

65 Ibid., p. 52.

66 Newman, *Writings*, p. 15 ff.

67 Ibid., p. 178.

68 Ibid., p. 178.

69 Rosenblum, op. cit., p. 212.

70 Hess, p. 82.

71 In a discussion with his artist friends,
for example, on April 22, 1950. Cf. *Artists'
Sessions at Studio 35*, op. cit., p. 14. New-
man also spoke in a similar vein in an
interview in 1970: "[. . .] the title could act
as a metaphor to identify the emotional
content or the emotional complex that I
was in when I was doing the painting [. . .]".
Cf. Newman, *Writings*, p. 305.

72 Cf. Ann Gibson, *Abstract Expression-
ism's Evasion of Language*, in: *Art Journal*,
Vol. 47, No. 3, Fall 1988, p. 208 ff.

73 Cf. Newman, *Writings*, p. 107.

74 Cf. Zdenek Felix, *"Prometheus Bound"
von Barnett Newman*, in: Museum
Folkwang Essen, *Mitteilungen 1976/77*,
Vol. 10/11, n.p.

75 On Newman's reaction to Nietzsche
cf. W. Jackson Rushing, *The Impact of
Nietzsche and Northwest Coast Indian Art on
Barnett Newman's Idea of Redemption in the
Abstract Sublime*, in: *Art Journal*, Vol. 47,
No. 3, Fall 1988, p. 188 ff.

76 Friedrich Nietzsche, *Die Geburt der
Tragödie*, in: *Werke in drei Bänden*, ed. by
Karl Schlechta, Vol. 1, Munich, 1966, p. 60.

77 Friedrich Nietzsche, *Die fröhliche Wissenschaft*, in: *Werke*, op. cit., Vol. 2, p. 176.

78 Newman, *Writings*, pp. 158, 159, and 160.

79 Cf. W. Jackson Rushing, op. cit., p. 192.

80 Newman, *Writings*, p. 307.

81 Cf. Michael Leja, *Reframing Abstract Expressionism*, p. 82 ff.

82 Newman, *Writings*, p. 245. Newman had made a similar statement in 1950. Cf. *Artists' Sessions at Studio 35*, op. cit., p. 16.

83 Newman had already spoken along similar lines in 1933 when reflecting on the relationship between the worker and the artist and demanding absolute freedom for the latter. Cf. Newman, *Writings*, p. 8.

84 Motherwell, for example, expressed this view in an essay published in *Perspectives USA* in the fall of 1954. Cf. *The Collected Writings of Robert Motherwell*, op. cit., p. 106.

85 In an interview in 1966, Newman felt that the artist lived in "a kind of exile in a so-called utopia, in a so-called paradise. That was the artist in New York at that time—people talked about him as if he were an underground man. He was outside society." Newman, *Writings*, p. 275.

86 Ibid., p. 112.

87 As Motherwell did, for example, in a lecture entitled "Reflections on Painting Now" in August 1949: "No one now creates with joy; on the contrary, with anguish; but there are a few selves that are willing to pay; it is this payment, wherever one lives, that one really undertakes in choosing to become an artist. The rest one endures, in France or America. In so doing, one discovers who one is, or, more exactly, invents oneself. If no one did this, we would scarcely imagine of what a man is capable." *The Collected Writings of Robert Motherwell*, op. cit., p. 68. And Tworkov, too, in 1962, recalled having experienced painting during the forties as an "inner search for one's own self", and he had not been the only one to see painting in this way either. Cf. Michael Leja, *Reframing Abstract Expressionism*, op. cit., p. 37. And Newman himself had written, in 1948: "Instead of making *cathedrals* out of Christ, man, or 'life,' we are making [them] out of ourselves, out of our own feelings." Newman, *Writings*, p. 173.

88 Newman, *Writings*, p. 187.

89 Theodor W. Adorno, *Aesthetic Theory*, ed. by Gretel Adorno and Rolf Tiedemann, newly translated, edited, and with a translator's introduction by Robert Hullot-Kentor, Minneapolis, 1997 (Theory and History of Literature, Vol. 88), p. 78.

90 This was the view of W. Jackson Rushing, op. cit., p. 193.

91 Adorno, op. cit., pp. 39, 40.

92 Newman, *Writings*, p. 164.

93 Ibid., p. 163.

94 Adorno, op. cit., p. 79.

His second exhibition at the Betty Parsons Gallery, which ended on May 12, 1951, brought Newman no success, only criticism or the meaningful silence of fellow artists. It was not least on account of this negative response, which for him was tantamount to a devastating defeat, that Newman suddenly found himself in a serious crisis which was to last a good ten years; by the end of the crisis, the movement to which he subscribed would long since have passed its zenith. Clement Greenberg, however, reacted positively to the exhibition, albeit belatedly. In January 1952, more than six months after the exhibition, he published a lengthy article in which he spoke well of Newman, though he concluded with an endorsement of Pollock as "in a class by himself." Greenberg expressed regret about the exhibition's having been boycotted by the very people from whom he had expected—justifiably—greater discernment. Both of the exhibitions at the Betty Parsons Gallery had been dominated by such strength and such striving for truth that Newman had to be regarded as a "very important and original artist." Greenberg argued—contrary to the common, prejudiced "view—that Newman's work had little to do with Mondrian. Indeed, the disparaging reaction of most of the New York "avant-garde" reflected upon their own credibility, contributing nothing to an understanding of Newman's art or an appreciation of its value.[1]

For all Greenberg's enormous influence, it is difficult to say what would have happened if his article had been published during the exhibition or immediately after it. But that was not to be, and so it was a very disappointed Barnett Newman who took back his paintings from Betty Parsons in the summer of 1951. Only the gallery-owner herself and Newman's friend Tony Smith had each purchased a work. Depressed and probably plagued with self-doubt, Newman now painted very little. Whereas between 1949 and 1951 Newman had completed as many as thirty-five paintings, he painted only twelve between 1952 and 1955, and none in 1956 or 1957. One might conclude that this drop in output was due to Newman's inspirational crisis, but if we consider those paintings which he produced after his second exhibition, we must draw a different conclusion. In 1952, for example, Newman produced such significant works as "Achilles" (Fig. 53), "Ulysses" (Fig. 28), and "Prometheus Bound" (Fig. 54). These were followed, in 1953, by "Onement VI" and "L'Errance", and then, in 1954, by "The Word II", "White Fire I", "The Gate" (Fig. 29), "Primordial Light" (Fig. 30), and "Right Here". And in the following year, 1955, Newman painted "Uriel" (Fig. 31), one of his most important paintings. But this painting signified a new problem and, in spite of its size, was symptomatic of the difficult situation in which the painter now found himself.

What must have discouraged Newman more than anything else was the lack of exhibition opportunities. This situation was aggravated by the absence of collectors interested in his work. It was not until December 1955, that is to say, after a lapse of four and a half years,

that Newman exhibited again, in a group show at the Betty Parsons Gallery. This was followed, in the summer of 1957, by his participation in a comprehensive showing, in Minneapolis, of American painting from 1945 to 1957. Newman had to wait longer for his next solo show, exactly seven years. Compared with the exhibition activities of the other exponents of the so-called New York School, Newman's public appearances as a painter had virtually ceased. This situation was particularly serious inasmuch as the mid-fifties were a period of economic upswing in America receptive to modern art. People who had hitherto merely taken an interest in art were now collecting it. The art market was developing appreciably and putting some artists, for the first time ever, on a more or less firm economic footing. Newman, however, was excluded. No other important painter of his generation had to wait so long for success and recognition as he.

If we ask ourselves why Newman had largely disappeared from public view, we cannot hold back the suspicion that, whilst he was taken seriously as a critical analyst, his works were considered only illustrations of his esthetic theories. Newman's paintings seemed much too simple to many. Others saw in his "zips" merely a Neo-Dada gesture, or they felt provoked by the empty expanse of canvas. Newman's status as an outsider within the New York School—this is how Newman himself saw his situation—was perhaps also a consequence of Newman's not having been involved, during the late thirties and early forties, in any of the programs of the Works Progress Administration, as Pollock, Rothko, Reinhardt, and others had been. Newman told Hess years later: "I paid a severe price for not being on the [government arts] project with the other guys; in their eyes I wasn't a painter; I didn't have the label."[2]

Although Newman painted only a few large paintings during this time—a circumstance which was no doubt partly due to his not having the money to buy the necessary materials—he still tried to play a public role. He did not wish to give up after so many set-backs. He continued to voice his opinion on art matters with his customary causticness, and never shied at controversy. Since the publication, in 1990, of his essays, statements, interviews, and selected letters, we know much more about Newman's moral commitment, his critical attitude, and his contradictoriness.[3] We must however bear in mind that these writings do not provide a complete picture of his personality or the full range and development of his ideas. They offer only an outline. Much was discussed in conversations, either in person or by phone, and none of them was recorded. All the same, we can draw a great many conclusions from Newman's surviving writings. Indeed, these writings become particularly vivid whenever we are able to reconstruct their respective contexts. Unfortunately, lack of space forces me to concentrate on just a few of those incidents which seem particularly relevant to the fifties.

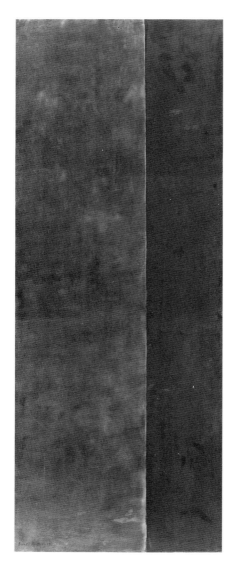

28 *Ulysses,* 1952
Oil on canvas, 132 x 50 ins.
The Menil Collection, Houston
Partial gift of Adelaide de Menil Carpenter

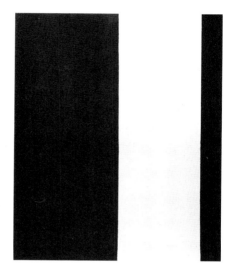

29 *The Gate*, 1954
Oil on canvas, 93 × 76 ins.
Stedelijk Museum, Amsterdam

On August 22 and 23, 1952, Newman took part, together with poets, philosophers, architects, and designers, in a panel discussion at the Fourth Annual Woodstock Art Conference on "Aesthetics and the Artist". Newman's remarks about the relationship between theory and practice in art[4] were later to be condensed into a witty saying: "Aesthetics is for the artist as ornithology is for the birds." Newman's statement is important not for its rejection of the philosophy of art claimed by Woodstock panelist Susanne K. Langer in her book *Philosophy in a New Key*, but because it showed him again reflecting on his status as a painter and defending the artist's autonomy. Painting for Newman is "an art which is an end in itself", but he dissociates himself from the art-for-art's-sake approach, seeing the artist rather as a demiurge: "This position is really saying that the world is created by the artist. Reality is what the artist makes it. [. . .] Life is an imitation of the reality set up by the painter."[5]

It was through such views that Newman essentially differed from his New York contemporaries. A few examples may serve to illustrate this point. Esthetic projections are often influenced by romantic notions. When asked, in 1951, what abstract art meant to him, Robert Motherwell replied that it helped one "to unify oneself through union. [. . .] Abstract art [. . .] grew up [. . .] from a primary sense of gulf, an abyss, a void between one's lonely self and the world. Abstract art is an effort to close the void that modern men feel."[6] Other painters reflected upon existential problems in their art. Replying to the same question— the meaning of abstraction—Willem de Kooning said that art never seemed to make him peaceful or pure: "I always seem to be wrapped in the melodrama of vulgarity. [. . .] Some painters, including myself, [. . .] have found that painting—any kind of painting, any style of painting—to be painting at all, in fact—is a way of living today, a style of living, so to speak. That is where the form of it lies."[7] Jackson Pollock evaded the issue with a tautology: "Abstract painting is abstract. It confronts you."[8] And, several years later: "Painting is self-discovery. Every good painter paints what he is."[9] By comparison, Rothko was idealistic. In October 1949 he had declared that the progression of a painter's work lay in a striving for clarity, that is to say, in eliminating "all obstacles between the painter and the idea and between the idea and the observer". Such obstacles, said Rothko, included "memory, history or geometry, which are swamps of generalization from which one might pull out parodies of ideas (which are ghosts) but never an idea in itself."[10] A statement by Newman, written at the time of his first solo exhibition, at the Betty Parsons Gallery early in 1950, reads like a direct answer to Rothko: "These paintings are not 'abstractions,' nor do they depict some 'pure' idea. They are specific and separate embodiments of feeling, to be experienced, each picture for itself. They contain no depictive allusions. Full of restrained passion, their poignancy is revealed in each concentrated image."[11] Newman dismisses Rothko's "pure ideas" in favor of feeling and passion. Ad Reinhardt, on the other hand,

rejected Newman's approach, though without making any direct reference to him. During the Artists' Sessions at Studio 35 on April 22, 1950, he expressed the view that paintings should manifest no emotions whatsoever, unless such emotions referred directly to painting as painting.[12]

These statements show Newman's place on the spectrum of romantic, idealistic, and existential ideas, and his points of contact with the art-for-art's-sake position which Ad Reinhardt was at that time defending more and more vehemently. Newman did however go much further in the statement he delivered at Woodstock, and on several critical points. Newman illustrated his view that "reality is what the artist makes it" with an offhand example: "I have noticed that most girls today look like Picasso faces. Picasso had a fantastic sense of the lip, and if you walk the streets, you will see that the girls of today are now using lipstick so that the reality of the mouth is really Picasso's. Life is an imitation of the reality set up by the painter."[13] Newman obviously substitutes cultural codes and patterns of behavior for the notion of reality. In truth, art does not dictate reality, at best it inspires fashion, i.e. provides guidelines for our second nature, so to speak. But we need not occupy ourselves further with this irrational statement by Newman. Essentially, Newman was concerned with making his ideas about so-called primitive art relevant to the present day. "Undoubtedly the first man was an artist," he had written in 1947[14], and this idea was still uppermost in his mind at Woodstock. Curiously, Newman made his point by referring to a contemporary European artist, and not to a mythical figure.

What these hypertrophic statements on art reveal, perhaps more than anything else, is Newman's need to compensate for his deeply felt social inconsequence, his disadvantaged position as an artist, and the trauma of rejection and isolation. "I insist that I'm an artist. [. . .] I'm not interpreting nature or reality—I'm making it [. . .]"[15]

Considering the situation immediately following his exhibition at the Betty Parsons Gallery in May 1951, it is hardly surprising that Newman's friendships with other artists cooled and even became strained. This estrangement sometimes manifested itself in unusual, not to say grotesque ways. On June 22, 1953, for example, Newman asked the painter Alfonso Ossorio to give him back one of his small, narrow paintings ("Untitled [Number 1]"), his reason being that such a small work would convey a wrong impression of his intentions if it were shown apart from his large-format works. He had therefore decided to withdraw all such "small" canvases from public view, and was not prepared to make an exception of the one he had sold to Ossorio.[16] A weak argument indeed, for there was no question of a public presentation of Newman's work at that time. The actual reasons lay elsewhere. Ossorio, who was not without money, had gradually built up a collection of paintings which included large-format works by Still, Pollock, and others. Knowing this, we can readily decipher the

30 *Primordial Light*, 1954
Egg tempera and oil on canvas,
96 × 50 ins.
The Menil Collection, Houston

message of Newman's letter: If you, Ossorio, do not purchase a large painting from me, then give me back my small one, for I wish to be suitably represented in your private, yet much frequented, collection, as indeed I ought to be—or not at all.

Even Newman's relationship with Thomas B. Hess, who was later to become one of the painter's most influential apologists, was not without complications. Hess, who was the managing editor of *ARTnews*, had in 1951 published a book entitled *Abstract Painting: Background and American Phase*, which Newman had been asked to review by the editors of *Partisan Review*. Although Newman's devastating critique was not published, its tenor must have gradually become known, for Newman was obliged, four years later, to write a letter to Hess explaining the situation, although he now presented things in a completely different light. Newman insisted that his review, had it been published, would have been the best review Hess's book received, saying that it had been "fair, unbiased, and written with dignity and grace, seriously examining the book's aesthetic and philosophic content." Indeed, Newman would have liked to have known Hess's opinion of his review, insisting that he would have written the same review even if he, Hess, had been "highly complimentary to [him] in [his] book, instead of indifferent." Much to his regret, the review never appeared. Very prudently, Newman omitted to offer or send Hess a copy of his manuscript.[17]

On June 7, 1954, Newman wrote a letter to the editor of *The New York Times Magazine*. It had been occasioned by the appointment of a new director at the Museum of Non-Objective Painting, which had meanwhile been renamed the Solomon R. Guggenheim Museum. The new director, James Johnson Sweeney, had announced certain changes which became the target of Newman's polemical talents. Newman's main complaint was that Sweeney had decided to exhibit the museum's paintings without frames. Newman argued that Sweeney, in stripping these great pictures of their frames, distorted their historical meaning. It is probable that Newman, who had meanwhile become touchier than ever, felt that his own claim to originality was being challenged. After all, he, Newman, had been "one of the first painters to reject the frame".[18] Newman's letter was not published at the time.

Newman's quarrel with Ad Reinhardt was a foregone conclusion. Although Reinhardt had exhibited two paintings ("Dark Symbol" and "Cosmic Sign") in "The Ideographic Picture", an exhibition which Newman had organized at the Betty Parsons Gallery in 1947, hardly another year had gone by before Reinhardt was attacking "transcendental nonsense, and the picturing of a 'reality behind reality' " and calling for a "pure painting [which] is no degree of illustration, distortion, illusion, allusion or delusion."[19] In 1954, Reinhardt published one of his notorious polemics[20], in which he mercilessly satirized his contemporaries. No matter whom he picked on—whether Pollock, de Kooning, Motherwell, Rothko, or Still—Reinhardt was anything but flattering, though none of them actually seemed to take offence.

Only Newman, whom Reinhardt classed (with others) as an "Art-Digest-philosopher-poet and Bauhaus-exerciser, [an] avant-garde-huckster-handicraftsman and educational-shop-keeper, [a] holy-roller-explainer-entertainer-in-residence", did not find his portrayal at all funny and overreacted. He sued Reinhardt for libel—the sum sought was $100,000—but failed to convince the court, especially as Newman's wife, Annalee, had been his only witness after Clyfford Still backed out.[21]

The controversy between Newman and Reinhardt did not end at that. Their opposition to each other continued, finding expression particularly in their art-theoretical statements. Let me offer an example. In 1962, Newman spoke with Dorothy Gees Seckler in an insightful interview, again describing himself as a painter who follows his intuitions: "My concern is with the fullness that comes from emotion, not with its initial explosion, or its emotional fallout, or the glow of its expenditure. The fact is, I am an intuitive painter, a direct painter. I have never worked from sketches, never planned a painting, never 'thought out' a painting. I start each painting as if I had never painted before. I present no dogma, no system, no demonstrations. I have no formal solutions. I have no interest in the 'finished' painting. I work only out of high passion."[22] Only a few months later, Ad Reinhardt published his essay "Art-as-Art", in which he wrote: "Art is art-as-art and everything else is everything else." The object of "art-as-art", wrote Reinhardt, was to make art "purer and emptier, more absolute and more exclusive—non-objective, non-representational, non-figurative, non-imagist, non-expressionist, non-subjective. The only and one way to say what abstract art or art-as-art is, is to say what it is not."[23]

A comparison of these two statements by Newman and Reinhardt reveals an interesting blend of congruence and contradiction. Both artists' negative definitions are basically in agreement. The difference lies in Newman's operating on the basis of emotion and experience and Reinhardt's refusing to accept such a basis. Devoid of anything positive, Reinhardt's approach verges on artistic anemia. His radicalness outdoes itself and undermines the very basis from which he operates. Art which is understood purely as "art-as-art" becomes something else—namely the occasion for, and object of, meditation. Newman never went this way. He was never concerned with diffusion of the subject. On the contrary, the confirmation of the subject's presence was his constant endeavor.

By the time Newman was fifty, the symptoms of his crisis had become even stronger. During that year, 1955, he painted only one picture. "Uriel" (Fig. 31) is a large painting, whose dimensions—96 by 216 inches—are the same as those of "Vir Heroicus Sublimis". Its size alone implies a claim to greatness, and the quality of the painting indeed does justice to this claim. The contrast of lucid turquoise and earthy brown, of homogeneity and transparence, of expansion and concentration, creates an effect of tension which seems to

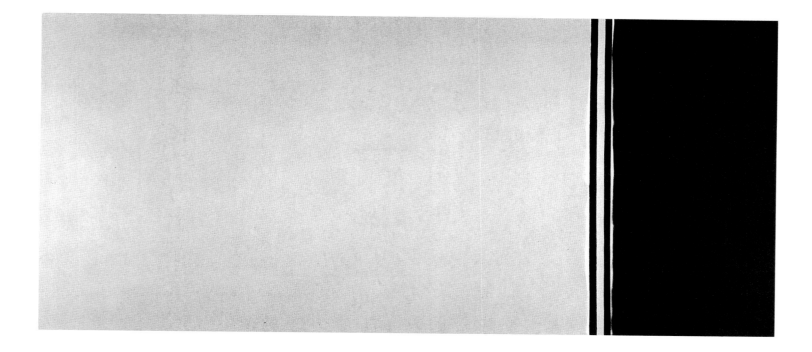

31 *Uriel*, 1955
Oil on canvas, 96 x 216 ins.
Reinhard Onnasch Collection, Berlin

have a will all its own, for one has the impression that it would optically tear the painting apart if not for the black vertical line which prevents the pale greenish blue from becoming even stronger and undermining the brown on a broader front, or forcing it further to the right. The vertical division turns everything on its head, as it were: one senses a latent dynamism in the larger, uniform field of light greenish blue, whilst the richly nuanced field of brown, with its modulated edge, appears calmed, with the result that, despite the unequal sizes of the two color fields, one experiences a state of equilibrium, though only if one stands exactly in front of the "zips" and brings the axis of one's body into line with the three vertical stripes.

"Uriel" deserves detailed examination, for this painting is the sum of all the immediately preceding paintings which feature the same cold, indifferent, pale yet bright turquoise. "Right Here", "White Fire I", "The Word II", "Primordial Light", and "The Gate" were all painted in 1954. "Uriel", the last and artistically most demanding painting of this series, is the only one in which Newman uses a rich, warm brown—partially opaque, partially transparent—for one of the dominant areas of the canvas. Earth colors, wrote Newman in a 1945 essay on the paintings of Tamayo and Gottlieb, help the artist to express "the majestic force of our earthly ties and natures."[24] Admittedly, it is wrong to quote Newman out of context, especially when his statement antedated "Uriel" by ten years, but the visual effect created by

"Uriel" reveals Newman's intention to contrast coldness with warmth, indifference with animation. It is difficult to say whether Newman saw in this painting the embodiment of a more fundamental contrast, such as that between mind and nature, or between spirituality and materiality, or whether the pale luminescence of the turquoise on the left represents hermetic detachment, while the dark, pulsating brown on the right is meant to visualize emotional presence, but Newman's naming this painting after an archangel whose name means "Light is God" certainly points us in this direction and seems to imply that Newman was striving to achieve two things at the same time: the immediacy of esthetic presence and the transcendence of perceived reality. For all its grandeur, "Uriel" instills in us an ever growing feeling of unease the longer or more frequently we look at it. The reason for this lies in the unresolvable contradiction of Newman's endeavor to bring together two things which in principle are mutually exclusive. On the one side he accentuates the artistic autonomy of forms and the self-referentiality of colors, on the other he emphasizes the associative functions of the painting, its title—the name of the archangel—being one such function. The synthesis of the incompatible—immanence versus transcendence—which Newman sought to achieve had become a problem. The suggestion of transcendence which Newman had so impressively conveyed in "Cathedra" (Fig. 51) no longer seemed possible, or was no longer worth striving for. "Uriel" was paving the way for Newman's central theme of the sixties, the simultaneous affirmation and questioning of scale. Painting as a totality—this can already be experienced in "Uriel", though not to the full. Thus "Uriel" is a key work in Newman's oeuvre, for it manifests a problem which Newman was not able to resolve until much later. "Uriel" also reflects Newman's external circumstances, that is to say, the desperate situation in which he found himself, for it is a work which barely conceals its own fragility—a discrepancy which, in the final analysis, is the product of indecision.

It is not known whether Newman worked on other paintings in 1955, or, if he did, whether he scrapped them or merely left them unfinished. What is remarkable, however, is that no paintings were produced in the following two years. There may have been external causes for this. Indeed, it is clear that the path Newman had taken, the path which had led him to "Uriel", could not be continued, nor did it offer any perspectives. And perhaps Newman himself realized this. Judging by the obvious aporia, Newman was in a blind alley from which there was no immediate escape. Whilst I do not wish to overemphasize symptoms of Newman's crisis, his not painting any pictures in 1956 and 1957 calls for an explanation which takes all causes into account, and not only the external ones.

Newman had no opportunity of exhibiting his work at that time. No serious collector seemed interested in his paintings, let alone prepared to pay an appropriate price for even one of them. Forever in financial straits, he would occasionally try his luck at the races,

though he could count himself lucky if he won back his stakes. He gradually lost contact with his old friends. Indeed, Newman had become so embittered that, in a letter to Sidney Janis dated April 9, 1955, he belittled Rothko as a "salon painter", accusing him of a shameless lack of integrity and dissociating himself from him. Newman reproaches Rothko—for reasons which seem totally unfounded—for having "looked" at his, Newman's, paintings solely for the purpose of being inspired by what he "saw" in them, just as he had "looked" at the work of other artists for the same purpose. "[Rothko . . .] fights," writes Newman, "to submit to the philistine world. My struggle against bourgeois society has involved the total rejection of it."[25] Newman's polemic against an artist whom he had known for over fifteen years and with whom he had at one time been close friends becomes all the more puzzling when we realize the triviality of what sparked it off. Janis had merely invited Newman to the opening of the first Rothko exhibition at his gallery. Newman, however, may have shied at initiating what would have meant the ultimate break with his friend Rothko: it is not known if Newman mailed the letter.

In May 1955, the Whitney Museum of American Art mounted an exhibition entitled "The New Decade: 35 American Painters and Sculptors". Organized by the director of the museum, John I. H. Baur, the exhibition focused on artists influential on the New York art scene since the end of the Second World War, including William Baziotes, James Brooks, Willem de Kooning, Herbert Ferber, Adolph Gottlieb, Franz Kline, Ibram Lassaw, Richard Lippold, Robert Motherwell, Jackson Pollock, Richard Pousette-Dart, Ad Reinhardt, Theodoros Stamos, and Bradley Walker Tomlin. Added to these were another twenty-one artists who are largely unknown today. Barnett Newman was not invited to take part. Feeling ignored, not to say scorned, Newman wrote Baur on August 11, i.e. almost four months after the opening of the exhibition, reproaching him for excluding him, Newman, in favor of so many second-rate artists who had "dipped their brushes into my work".[26] What had actually triggered his protest, however, was something else. The only mention of Newman's name in the catalog had been made in Motherwell's biography, and it was this circumstance which had angered him. While his not having been invited to take part in this traveling exhibition, which would be stopping at San Francisco, Los Angeles, Colorado Springs, and St. Louis, had certainly injured his pride, Newman was much more furious at having been assigned the role of a peripheral figure in the biography of another artist whom, moreover, he did not hold in particularly high regard. Newman's reaction had been prompted not so much by his wounded vanity as by his—undoubtedly correct—recognition that one of New York's leading museums did not consider his work significant in the context of post-war American art.

There was just one bright moment in these dark times: Clement Greenberg paid tribute to Newman in an essay entitled " 'American-Type' Painting", stressing Newman's special

position, though drawing parallels with Clyfford Still who, wrote Greenberg, was "almost the only abstract expressionist to 'make' a school." The painters in Still's "school", however, did not imitate him but had been able to establish "strong and independent styles of their own." Greenberg continued: "Barnett Newman, who is one of these artists, has replaced Pollock as the enfant terrible of abstract expressionism. He rules vertical bands of dimly contrasting color or value on warm flat backgrounds—and that's all. But he is not in the least related to Mondrian or anyone else in the geometrical abstract school. Though Still led the way in opening the picture down the middle and in bringing large, uninterrupted areas of uniform color into subtle and yet spectacular opposition, Newman studied late Impressionism for himself, and has drawn its consequences more radically. The powers of color he employs to make a picture are conceived with an ultimate strictness: color is to function as hue and nothing else, and contrasts are to be sought with the least possible help of differences in value, saturation, or warmth.

"The easel picture will hardly survive such an approach, and Newman's huge, calmly and evenly burning canvases amount to the most direct attack upon it so far. And it is all the more effective an attack because the art behind it is deep and honest, and carries a feeling for color without its like in recent painting."[27] All in all, Greenberg counted Pollock and Newman among the outstanding exponents of the new painting. Although their works were still considered the *reductio ad absurdum* of modern art, Pollock was now a famous name. All the same, wrote Greenberg, Pollock's art had still "not been fundamentally accepted where one would expect it to be", for "few of his fellow artists can yet tell the difference between his good and his bad work."[28] In such remarks one detects a certain skepticism, not to say detachment. Indeed, it is not so much Pollock as Clyfford Still who plays the central role in this essay. Greenberg considers Still to be "one of the most important and original painters of our time [. . .], if not the best."[29]

Newman felt that he had been comparatively well treated and suitably contextualized in Greenberg's essay, which had endeavored to characterize the respective styles and concepts of Hans Hofmann, Motherwell, de Kooning, Gottlieb, Rothko, Pollock, and Still against the background of the avant-garde of the first half of the century, for which Picasso and Kandinsky served Greenberg as typical exponents. But no matter how positive Greenberg's appraisal of Newman, Newman felt obliged to contradict him and draw his attention to what he considered to be serious errors. What had annoyed him most of all was the critic's suggestion that Newman had derived his style from Still. Feeling that Greenberg not only had cast doubt upon his originality but also had misunderstood him, Newman wrote Greenberg a letter to set things straight: "When I did see Still and his work, my concept and style had already been formed."[30] Newman also put Greenberg right on several other points, but

these were not equally significant. Nonetheless, Greenberg heeded many of Newman's objections when he revised the essay, reprinted in his book *Art and Culture* in 1961.

Newman's letter to Greenberg had been written on August 9, 1955, that is, two days before he wrote his letter of protest to the Whitney Museum. The connection is obvious: America's most important art critic discusses Newman's work within the context of the twentieth-century avant-garde, while the Whitney Museum ignores Newman and gives preference to a horde of insignificant artists. In either case a reaction was called for, if only out of self-respect.

Newman's reactions and strategies may seem hypercritical to the reader of today, but we must make allowance for Newman's difficult, not to say precarious, situation. Nothing could illustrate this more clearly than a particularly incredible episode which took place in December 1955. Betty Parsons, who was far more interested in the work and studios of her artists than in the commercial success of her "artist's—and critic's—gallery"[31], as Greenberg called it, had organized a group exhibition celebrating the tenth anniversary of her gallery. Newman was one of the artists invited to participate. Three weeks prior to the December 19 opening, Newman sent Betty Parsons his 1949 painting "Horizon Light", together with an explanatory note. Except for the reviewers, no one was to see his painting before the opening, and this went for artists and their friends in particular. Why that? Because Newman was afraid they would steal his idea? This is indeed the impression we gain, especially if we consider his objection to being typecast as "a maker of straight-line, vertical-line pictures." Newman wanted to show that he had been doing "horizontal pictures with horizontal lines" as early as 1949, long before all the others: "It ['Horizon Light'] was seen and known by artists and others at that time [1949] for what it was, and one of the reasons I am showing it is to disengage myself from this attempt to label and typecast me and my work. I wish to assert my freedom, to say that I am a painter who paints pictures—not lines—and here is one that I did in 1949."[32]

What must go on inside an artist who writes such letters, who is so bent on asserting his own historical status? Newman's attitude cannot be understood unless we can envision his situation. An artist could not live off a few well-meant remarks in a review, and if he did not have the opportunity to exhibit his work, it would never be seen. Indeed, in the consciousness of that public which was so important to the art world, his work did not exist. A painting's value as an exhibit had long since reduced virtually all its other values to insignificance. Newman and his contemporaries knew this. Only a painter who exhibited had any hope of recognition. Only a painter who exhibited had an identity.

All this can be viewed objectively. From what we know from his correspondence, Newman had experienced his greatest difficulties in 1955. But this was also the year in which

he painted "Uriel". Whether there is a connection, and, if so, what, I cannot say, nor do I wish to risk a conjecture.

Let us therefore stick to the known facts. Newman's next adversary was Robert Motherwell. An essay written by Motherwell for the catalog of the memorial exhibition of Bradley Walker Tomlin at the Whitney Museum had appalled Newman, not so much because he considered the essay to have mischaracterized Tomlin, but because Motherwell had self-servingly laid claim to the role of "transmission agent" between the Surrealists and the Abstract Expressionists. This could not fail to annoy Newman, for he saw the autonomy of the New York painters, the autonomy which not least he, Newman, had so energetically proclaimed and defended, called into question. In a letter to the director of the museum, written on October 20, 1957, Newman attacks Motherwell's "self-seeking and self-elevating" assertion that he had played—and was still playing—a leading role in the new American painting. He pokes fun at Motherwell's declared affinity with Duchamp and Surrealism, and derides him as the inventor of such labels as "Ecole de New York", remarking that, according to some rumors he has heard, Motherwell is "the best painter in the Ecole de Staten Island."[33] Newman and Motherwell did not exchange a word for years to come.

A great many other instances of Newman's embittered and determined struggle for recognition could be cited, but they would scarcely alter the general picture already given. If we survey the period of Newman's increasing isolation, loss of esteem, and aggressive resistance, two things stand out. Firstly, Newman rarely reacts directly. When he finds fault with Rothko, he writes to Janis. His opinion of Motherwell finds expression in a letter to the director of the Whitney Museum. What displeases him about Sweeney prompts a letter to a newspaper, and so on. Secondly, Newman seems to be aiming at a larger audience, or a particular addressee, and yet he hesitates, again and again, to send off what he has written. However great his disappointment may have been in each individual instance, he often shies at making the ultimate break. Only in Ad Reinhardt's case was Newman so adamant that he took him to court, only to be further humiliated by the court's dismissal of his complaint as a trivial matter.

Our *tour d'horizon* permits us to say with absolute certainty that, after 1951 and within just a few years, the painter Barnett Newman had become an outsider whose work was largely ignored. Whilst from the mid-fifties onwards other exponents of Abstract Expressionism were benefiting from the economic upswing in America and steadily attaining financial security through the sale of their work, Newman was being pushed even further out into the cold—and to such an extent that he decided to give up painting altogether and get a job as a fitter with a tailor. Annalee Newman, who supported them both from her earnings as a teacher, was against this idea and managed to dissuade him.[34] The crisis reached its climax

on November 30, 1957: Barnett Newman, now fifty-two years old, suffered a heart attack. Although he survived it, Newman took many months to recover. In 1958, after an interval of two years, Newman began to paint again, first "Outcry" and then, still in 1958, the first two works of his series "Stations of the Cross". These titles are revelatory.

Deep though Newman's crisis was, it was during these years of intense isolation that Newman made the acquaintance of a young collector—a meeting which was not without consequences. Newman met Ben Heller in 1956. A year later Heller bought two paintings, "Queen of the Night I" and "Adam" (Fig. 32). Heller also brought Arnold Rüdlinger and Alfred H. Barr, Jr., to Newman's studio, which eventually led to purchases of Newman's works for the Kunstmuseum Basel and for the Museum of Modern Art, New York.[35]

There was another sign of improvement, too. When the Minneapolis Institute of Arts mounted its exhibition "American Paintings 1945–1957: 146 Pictures Representing Outstanding Achievement or Promise by American Artists of the Post-War Era" (June 18–September 1, 1957), three of Newman's paintings were shown: "Onement III" (listed simply as "Onement" in the catalog), "Abraham", and "Vir Heroicus Sublimis". It was the first public showing of Newman's work since Betty Parsons's tenth-anniversary exhibition eighteen months earlier. Instead of receiving the recognition he had long been hoping for, however, Newman was again the target for atrocious criticism. In his review for *The New Republic*, Frank Getlein dismissed "Vir Heroicus Sublimis" as "the most asinine thing" in the exhibition and relegated it to the "Design Division". Getlein reported a viewer's opinion that the museum could have saved a lot of money "by getting the plan and having the thing run off by the janitors with rollers." Even more astonishing, however, is Newman's reaction: he allowed himself to be drawn into this non-intellectual, cliché-ridden argument and wrote a letter to the editor of *The New Republic* explaining why his paintings in fact constituted "the strongest threat to the 'Design' painters."[36] Newman's letter was published one month before his heart attack.

In May 1958, Newman had a solo exhibition, his first in seven years. It was a glimmer of hope after the deep emotional and physical crisis he had suffered during the past several months. The retrospective exhibition at Bennington College, Vermont, had been initiated by Tony Smith and Paul Feeley. In his introduction to the exhibition catalog, Clement Greenberg linked Newman's oeuvre with Impressionism, thus contradicting the widespread condemnation of Newman as a puffed-up Mondrian disciple. Greenberg also recalled his first encounter with the painter's work at the Betty Parsons Gallery in 1950 and his puzzlement at Newman's ability to achieve "such a maximum effect with such a minimum of means." Greenberg was equally exhilarated by Newman's second show in 1951, but no longer puzzled: "Seeing the same and new pictures of his over the years since, I became increasingly

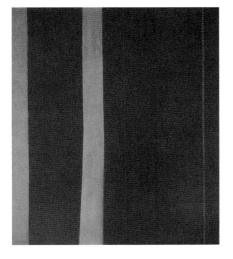

32 *Adam*, 1951/52
Oil on canvas, 95⁵/₈ x 79⁵/₈ ins.
Tate Gallery, London

aware of how complex they were in their exploration of the tensions between different light values of the same color and between colors of the same light value. Such tensions form an almost entirely new area of interest for our tradition of painting, and it is part of Newman's originality that he should lead our sensibility toward it. Thereby he has enlarged our sense of the capacities of color and of the capacities of the art of painting in general. No wonder I consider this first retrospective exhibition of his art an historic occasion."[37]

The eighteen paintings exhibited at Bennington ranged from "Pagan Void" (1946) and "Onement I" (1948) to "Vir Heroicus Sublimis" (1950/51) and "Day One" (1951/52). They were shown in the New Gallery of the college from May 4 through May 24. Bennington College had a short yet extremely important tradition of art exhibitions. Pollock's first retrospective—comprising just eight paintings done between 1943 and 1951—had taken place here in 1952. It was followed, in 1954 and 1955, by exhibitions of Adolph Gottlieb and Hans Hofmann, several years prior to their respective exhibitions at the Jewish Museum in New York and the Whitney Museum of American Art. Bennington had thus made a name for itself in the art world. And with Clement Greenberg's imprimatur, Newman's exhibition could not fail to attract enormous attention.

Moreover, as the artistic consultant of the short-lived though highly influential French & Company gallery, Clement Greenberg showed twenty-nine of Newman's paintings in New York a year later, in a solo show which took place from March 11 through April 5. What was remarkable about this selection was the absence of the works, including "Uriel", which Newman had painted between 1953 and 1955. Although nothing was sold, the exhibitions themselves met with a positive response. The climate had evidently changed. And as Greenberg also exhibited Kenneth Noland and Morris Louis at French & Company, Newman's oeuvre suddenly found itself in a new environment, so to speak.

The assertion that Newman had changed from "an outcast or a crank into the father figure of two generations"[38] may seem exaggerated, but there can be no doubt that he was now enjoying increasing recognition. This was evidenced not least by Newman's participation, with four paintings, in the Museum of Modern Art's traveling exhibition "The New American Painting" which, from April 1958 onwards, toured eight European cities—Basel, Milan, Madrid, Berlin, Amsterdam, Brussels, Paris, and London—ending back at the Museum of Modern Art in the spring of 1959. Taking part in this exhibition, which was so important for the European reception of American art, were almost all of the artists whom Newman had known since the forties: William Baziotes, James Brooks, Sam Francis, Arshile Gorky, Adolph Gottlieb, Philip Guston, Grace Hartigan, Franz Kline, Willem de Kooning, Robert Motherwell, Jackson Pollock, Mark Rothko, Theodoros Stamos, Clyfford Still, Bradley Walker Tomlin, and Jack Tworkov.[39]

Each of the artists wrote a statement for the catalog, which was translated into the languages of the countries visited by the exhibition. For the American edition, Newman wrote a preface to his statement, but decided to withdraw it at the last minute, an understandable decision, for in it he again fired off broadsides against the critics who had done him wrong for so many years and, whether out of pure ignorance or with intention, had misinterpreted or, even worse, ignored him. "They say", Newman concludes, "that I have advanced abstract painting to its extreme, when it is obvious to me that I have made only a new beginning. In short, they find me too abstract for the abstract expressionists and too expressionist for the abstract purists."[40]

In his catalog statement Newman again underlined the special role which he played in the history of American art, once more asserting his independence of all European traditions: "I realize that my paintings have no link with, nor any basis in, the art of World War I with its principles of geometry that tie it into the nineteenth century. To reject cubism or purism, whether it is Picasso's or Mondrian's, only to end up with the collage scheme of free-associated forms, whether it is Miró's or Malevich's, is to be caught in the same geometric trap. Only an art free from any kind of the geometry principles of World War I, only an art of no geometry, can be a new beginning.

"Nor can I find it by building a wall of lights; nor in the dead infinity of silence; nor in the painting performance, as if it were an instrument of pure energy full of a hollow biologic rhetoric."[41]

In the light of his own paintings, we must consider Newman's plea for an "art of no geometry" to be double-edged, and we can perhaps comprehend it only in the context of his endeavor to make us see the specific strength of his painting in his negation of all tradition. In order to lend weight to his argument, Newman adopts a moralizing tone: "[. . .] It is precisely this death image, the grip of geometry, that has to be confronted.

"In a world of geometry, geometry itself has become our moral crisis. And it will not be resolved by jazzed-up kicks but only by the answer of no geometry of any kind."[42] The cultural criticism behind Newman's statement need not concern us here. More interesting and relevant is that Newman, in opposing the principles of geometry in art, argues along the same lines as the Abstract Expressionists—to whom he himself claimed no allegiance—whilst vehemently rejecting their essential strategies and tendencies. Such formulations as "the dead infinity of silence", "a wall of lights", or "an instrument of pure energy full of a hollow biologic rhetoric" may be understood as hidden invectives against Still, Rothko, Baziotes, Gottlieb, and all the others. As was so often the case, Newman's statements were ambiguous, subtle, and full of deliberate assertions about artistic politics which were also meant to be understood as such.

122

"The New American Painting" was also revealing inasmuch as Newman, Pollock, and Still showed only works from the late forties and/or early fifties—Newman's contribution comprised "Abraham", "Concord", "Horizon Light" (all dating from 1949), and "Adam" from 1951/52—whilst all the other living artists represented showed at least one more recent work, too. Newman could not of course exhibit any current works. For some obscure reason, his paintings from 1954 and 1955 had not been submitted for exhibition, and there was nothing from the following two years which he could have exhibited anyway.

In spite of the positive reception of both Newman's Bennington and French & Company exhibitions and his participation in group exhibitions from the summer of 1957 onwards, there was no immediate increase in his productivity. As we have seen, Newman produced just three pictures in 1958, and in 1959 evidently not a single painting, but only three drawings which essentially harked back to earlier concepts.[43] In 1960 he completed two further works in the "Stations of the Cross" series as well as the significant painting "White Fire II" (Fig. 33). These were followed, in 1961, by "Black Fire I", "Noon Light", "Shining Forth (To George)" (Fig. 104), and "Be II" (1961/64). Newman was gradually finding his rhythm, painting at least four and at the most six paintings per year, as well as making prints (after 1961), drawings (mainly in 1960), and sculptures (all but one after 1962).

All in all, Newman's production was not only extremely concentrated but also limited to works of exemplary quality. Newman worked with deliberateness and refused to pander to the demand of the art market, whose receptivity to his work was limited in any event. He was now able to ensure a modest income for his wife and himself. By the end of the fifties, Newman's crisis seemed to be at an end, and the next decade was to bring forth many significant works. Newman continued his sharp-tongued criticism, though his relationships with other painters, especially those of the younger generation, became more relaxed as his own success increased.

Looking back over these critical years, we cannot reproach Newman for egocentricity, injured pride, or weakness of character. His reactions, no matter how astonishing they might be individually, were the result of the social isolation which in one way or another also affected other painters of his generation. Each single one of them, moreover, considered himself the greatest artist of his time. All of them owed their success to this or that device or strategy—an inspired form, a technical trick, a specific color combination—and yet precisely such originality, as the yardstick of esthetic quality, was at the center of many heated quarrels. Newman's statements considered in this chapter bear this out. Such quarrels were ultimately concerned with the survival of one's own oeuvre in the past of the future, that is to say, with one's work's legitimacy and historical significance. This relentless competition tore apart painters who had acted in solidarity and had pursued common interests during

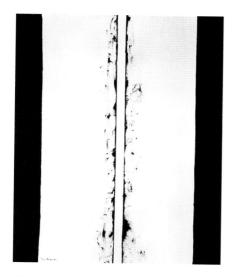

33 *White Fire II*, 1960
Oil on canvas, 96 x 80 ins.
Öffentliche Kunstsammlung Basel
Kunstmuseum

the early years when hardly anyone had showed an interest in their work. Against this back-drop of particularism and ever increasing jealousy Newman's verbal gibes are only too understandable. Newman's writings provide us with an inkling of how difficult and desperate his situation must have been during the fifties.

124

1 Clement Greenberg, "*Feeling Is All*", in: *Partisan Review*, January–February, 1952. Reprinted in: *The Collected Essays and Criticism*, Vol. 3, *Affirmations and Refusals 1950–1956*, ed. by John O'Brian, Chicago and London, 1993, p. 103 f.

2 Hess, 1969, p. 42.

3 Newman, *Writings*. Cf. Yve-Alain Bois's critical appraisal of this edition, *Artist and Critic*, in: *Art in America*, 79, No. 4, April 1991, p. 37 ff.

4 Rosenberg, p. 235. Cf. also: Newman, *Writings*, p. 247. The esthetics/ornithology analogy was again used by Newman in 1970: "[. . .] aesthetics is for me like ornithology must be for the birds." Newman, *Writings*, p. 304.

5 Newman, *Writings*, p. 246.

6 In conjunction with the exhibition "Abstract Painting and Sculpture in America", Motherwell delivered a lecture on "What Abstract Art Means to Me" at the Museum of Modern Art on February 5, 1951. Cf. *The Collected Writings of Robert Motherwell*, ed. by Stephanie Terenzio, New York and Oxford, 1992, p. 86.

7 Statement made by de Kooning during the symposium at the Museum of Modern Art (cf. Note 6). Here quoted from: *Die neue amerikanische Malerei* (*The New American Painting*), German-English edition of exhibition catalog, organized by the Museum of Modern Art, New York, Hochschule für bildende Künste, Berlin, September 3–October 1, 1958, n. p.

8 *The Talk of the Town*, in: *The New Yorker*, August 5, 1950. Here quoted from: Francis V. O'Connor, *Jackson Pollock*, The Museum of Modern Art, New York, 1967, p. 51.

9 Interview with Selden Rodman, *Conversations with Artists*, New York, 1957. Here quoted from: O'Connor, op. cit., p. 73.

10 *Tiger's Eye*, Vol. 1, No. 9, October 1949, p. 114. Here quoted from: Diane Waldman, *Mark Rothko, 1903–1970. A Retrospective*, New York, 1978, p. 61.

11 Newman, *Writings*, p. 178.

12 "I don't understand, in a painting, the love of anything except the love of painting itself." *Artists' Sessions at Studio 35 (1950)*, ed. by Robert Goodnough, in: *Modern Artists in America,* ed. by Robert Motherwell and Ad Reinhardt, New York, [1951], p. 15.

13 Newman, *Writings*, p. 246.

14 Ibid., p. 158.

15 Ibid., p. 246.

16 Ibid., p. 198.

17 Ibid., p. 118 f. The edition of Newman's *Writings* does not disclose whether Newman actually had the chutzpa to mail this letter. It seems improbable, for Hess was much too important for Newman to risk getting on the influential critic's wrong side.

18 Ibid., p. 40 f.

19 Ad Reinhardt, statement in the catalog of his exhibition at the Betty Parsons Gallery, 1948, n. p., here quoted from: Irving Sandler, *The Triumph of American Painting*, New York, 1970, p. 221.

20 *The Artist in Search of an Academy. Part Two: Who Are the Artists?* in: *College Art Journal*, New York, Vol. XIII, No. 4, Summer 1954, p. 314 ff. Here quoted from: *Art-as-Art. The Selected Writings of Ad Reinhardt*, edited and with an introduction by Barbara Rose, New York, 1975, p. 202.

21 Cf. Ad Reinhardt, *Schriften und Gespräche*, ed. by Thomas Kellein, Munich, 1984, p. 189. Also: Mary Fuller, *An Ad Reinhardt Monologue*, in: *Artforum*, October 1970, p. 36 ff.

22 *Art in America*, 50, No. 2, Summer 1962, p. 83; here quoted from: Newman, *Writings*, p. 248.

23 Ad Reinhardt, *Art-as-Art*, in: *Art International*, Vol. VI, No. 10, December 1962, p. 36 f. Here quoted from: *Art-as-Art. The Selected Writings of Ad Reinhardt*, op. cit., p. 53.

24 Newman, *Writings*, p. 77.

25 Ibid., p. 201 f.

26 Ibid., p. 205.

27 Clement Greenberg, "American-Type" Painting, in: Partisan Review, Spring 1955. Reprinted in: The Collected Essays, Vol. 3, op. cit., p. 231 f.

28 Ibid., p. 226.

29 Ibid., p. 228.

30 Newman, Writings, p. 204.

31 Cf. Clement Greenberg, Foreword to the Tenth Anniversary Exhibition of the Betty Parsons Gallery, in: The Collected Essays, Vol. 3, op. cit., p. 256.

32 Newman, Writings, p. 206.

33 Ibid., p. 209.

34 Hess, 1969, p. 57 f.

35 Hess, p. 92.

36 Newman, Writings, p. 209 f., including an extract from Getlein's review.

37 Clement Greenberg, Introduction to an Exhibition of Barnett Newman, in: The Collected Essays, Vol. 4, op. cit., p. 55.

38 Hess, 1969, p. 61.

39 The exhibition was one of a series of six exhibitions organized between 1942 and 1963 by Dorothy Miller, curator at the Museum of Modern Art. These exhibitions each presented a limited selection of American artists who were considered important. Dorothy Miller and Alfred Barr, Jr., did not hold Newman in particularly high esteem. The credit for his inclusion in the exhibition must evidently be given to the collector Ben Heller who, at very short notice, arranged several paintings in Newman's studio to show to Barr and Miller. Cf. Lynn Zelevansky, Dorothy Miller's "Americans", 1942–1963, in: The Museum of Modern Art at Mid-Century. At Home and Abroad (Studies in Modern Art, 4), New York, 1994, pp. 87, 92.

40 Newman, Writings, p. 180.

41 Ibid., p. 179.

42 Ibid.

43 Richardson, Nos. 58–60.

"In response to World War II and the intellectual climate generated by it, the future Abstract Expressionists came to believe that they faced a crisis in subject matter. Prevailing ideologies—socialist, nationalist, and Utopian—and the styles identified with them—Social Realism, Regionalism, and geometric abstraction—lost credibility in their eyes. Unwilling to continue known directions or to accept any other dogma, the Abstract Expressionists turned to their own private visions and insights in an anxious search for new values. The urgent need for meanings that felt truer to their experience gave rise to new ways of seeing—to formal innovations."[1] This is how Irving Sandler set the scene in his book *The Triumph of American Painting*, published in 1970. No matter how arduous their way out of anonymity was, no matter how desperate their financial situation, the Abstract Expressionists—in all their diversity—were furnishing proof of individual freedom, and their movement was even considered in some instances as the cultural alternative to the collectivism embodied by communist systems. It was also a movement which drew a clear line of demarcation between the United States and Europe. New York versus Paris—this was the antagonism that was heating the debate at the beginning of the fifties. As we have seen, Barnett Newman had, with many an art-political statement, played a significant role in this polarizing process. "American violence, roughness, and subjectivity against French rationality, decoration, and gloss"[2]—this was the challenge. The aggressive struggle for hegemony, not just political and military but also cultural, was furthered by developments which took place in America itself. The more Americans saw themselves as a leading world power, and the more their economic growth made them forget the Great Depression and the consequences of the Second World War, the more they were able to rid themselves of their proverbial inferiority complex in matters cultural. Indeed, culture became fashionable and it was now the vogue to take an interest in music, theater, and art, and, wherever possible, to acquire the appropriate status symbols. Out of the "lonely crowd" (to use David Riesman's famous phrase) of America's affluent society had developed a mass of "culture consumers"[3], and the "devotees of art [had] grown from a lonely handful to an army."[4] "Americans [had] now become a nation of museum-goers."[5] The artist was no longer the outcast of an uninformed society. The cultural climate had produced a new stratum of individuals and institutions that served as disseminators between the creators and the consumers.[6] Art had evidently become a tool of Public Relations and could be exploited accordingly.[7] Thus acceptance of contemporary art gradually spread during the fifties, although it was the stars of Pop Art who were the first to achieve popularity in the true sense, if this may be deemed an appropriate criterion for a movement which, despite its commonplace imagery, was based on elitist codes.

The leveling of differences now taking place in American society was only superficial, for the deeply rooted dissension that existed between artists and the public was only con-

cealed, not resolved. The social process of valuation and discrimination had long since turned its attention to art, indeed, it had converted it into a special discipline, the performance of which, whether active or passive, demanded not only appropriate skills but also considerable knowledge. There was of course a genuine interest in art, and this interest grew rapidly during the fifties, but it also gave cause for suspicion: Did the esthetic criteria which these works of art laid down have a validity reaching beyond outward appearance, beyond face value, or were they being too easily exploited for purposes which the artists themselves would never have envisioned?

1 Opposition to Communication

Such questions concerning the function of Abstract Expressionism were examined by Meyer Schapiro in his lecture on "The Liberating Quality of Avant-Garde Art", delivered at the annual congress of the American Federation of Arts in 1957. This art historian, who was renowned as much for his publications on Byzantine, early Christian, and Romanesque art as for those on the artists of the nineteenth and early twentieth century—Courbet, Seurat, and Cézanne, for example—had now turned to the work of contemporary artists. For a professor at a prestigious university like Columbia to show an interest in current movements in art, even in American art, was unusual. Born in Lithuania in 1904, and living in America since the twenties, Meyer Schapiro belonged to the same generation as Gorky, Newman, Rothko, de Kooning, and Still. He knew many of them personally, just as he knew many of the younger artists—Pollock, Reinhardt, Motherwell, and Guston—and he was fully conversant with their works. Thus Meyer Schapiro's lecture was based on a direct knowledge of contemporary art, and it was particularly noteworthy inasmuch as he attempted to describe the social role of the new painting at a time when it had reached the peak of its development and was enjoying growing public esteem. What interested Schapiro above all was the inconsistency between current developments in painting and sculpture and current developments in other artistic media. Communication arts, for example, were developing at breakneck speed, while painting, despite drastic changes in form and content, was still clinging to traditional techniques and maxims. It was this discrepancy which Schapiro emphasized in his lecture. Modern communication sought to achieve maximum efficiency, conveying its message with the aid of constant repetition and easily understandable stimuli. Painting, however, seemed the antithesis of communication. Messages in abstract paintings—insofar as they are incorporated in, and not projected into, the works—are not tied to any specific vocabulary or to any specific rules. Every artist develops his own idiom, and this idiom changes from time to time, sometimes even from one work to the next. Indeed, there is no code that could be applied to the works of all artists

and make the deciphering of them easy, or even possible. "The experience of the work of art, like the creation of the work of art itself, is a process ultimately opposed to communication as it is understood now."[8] Nothing is perfectly reproducible in painting, no statement is conveyable, nothing can be reduced to communicable impulses. Contemplation has taken the place of communication. Schapiro sees abstract art's noncommunication as being for many "an equivalent of what is regarded as part of religious life: a sincere and humble submission to a spiritual object, an experience which is not given automatically, but requires preparation and purity of spirit."[9]

Meyer Schapiro's justification of the abstract art of his time was possible only by replacing the esthetic issue by a moral one and rewriting the criteria of evaluation accordingly. If there are no longer any ideals worthy of artistic embodiment, the artist must turn to his own self as his only reliable source. Although he exercises no influence on practical life, the artist is central to the life of culture. After all, says Schapiro, artists are among the most moral and idealistic human beings able, by virtue of their "inner freedom and inventiveness", and by their "mastery of the formless and accidental", to "maintain the critical spirit and the ideals of creativeness, sincerity and self-reliance."[10]

All in all, Meyer Schapiro's treatise is an apologia of abstract painting. The incommensurableness of its messages and its diversity of processes, shapes, and colors—defying objective evaluation—were seen in a positive light by Schapiro, not least as the ultimate alternative to the manifestations of absolute pragmatism which were increasingly pervading all walks of life. That abstract painting thereby radically dissociated itself from the stratum of society which, paradoxically, guaranteed its survival is not directly addressed by Schapiro. But Schapiro was a Marxist, and he would not be one if he did not tell us what enabled this noncommunicative movement to survive in an increasingly communicative world: it was the artists' speculation—albeit in a spiritual guise—on the survival of their works in the past of the future, or, to put it more bluntly, their expectation of an increase in the material value of their works. The Abstract Expressionists, all of them concerned in one way or another with the spiritualization of reality and the evocation of transcendence, were vaguely aware of this circumstance, but did not own up to it. Whilst they were, without exception, selfless, idealistic, and high-minded, they were creating works for a market—represented by critics, collectors, dealers, and public institutions—which was not averse to capitalizing on them. Although it cannot be said that the artists were oblivious to what was happening, their attitude toward the rationalized world was one of regression and refusal; they emphasized the autonomy of the subject and the immanence of creative reflection. Meaning and obligation remained focused on the individual work, were integrated into its structure, and could not be separated from it. Universal validity, which every artist sought to achieve, remained an

insurmountable challenge in the background, an unrealizable wish in the face of reality. Whilst one aspired to fulfill a universal obligation, one knew that it was an illusion, that there was, in the end, only the obligation which one had towards one's self, towards one's work. The problem was to find a way of bringing truth and intention into line now that the so-called eternal truths—the truths that have their origin in our myths and legends—had proved obsolete and invalid, and even the terror of the unknowable had forfeited its enigma since Hiroshima. Although Schapiro himself would not have admitted it, his approach proceeds from the notion that what justifies art in society is art's state of isolation in society. A seemingly paradoxical situation results: In order to be integrated into their cultural context, authentic works of art must be free from every hint of superficial integration and remembered reconciliation. In other words, only because the works refuse to communicate are they communicable in a world of communication as embodiments of something of special value.

Barnett Newman was well aware of the dichotomy described by Schapiro in his 1957 lecture. Newman never voiced this awareness, possibly out of some self-protective instinct, but it was clear to him that, in a world of ever spreading and ever faster flowing information, painting must oppose unimpeded communication, whilst at the same time not waiving the need to communicate and thereby robbing painting of its foundations. A difficult situation indeed: on the one hand painting must express what could no longer be expressed, and, on the other, furnish historical justification for thematizing the incommensurable. This problem had preoccupied Newman from the outset. Moreover, Newman found himself in a double dilemma which was to plague him for the rest of his life: firstly, he realized that resistance to what Adorno called the "total domination of social totality"[11] was possible only where the spirit can survive and live on in its most advanced form; secondly, he was aware that his painting had only one recipient capable of reacting to it appropriately—and that was Newman himself.

This dilemma is reflected in the loneliness of the creative act itself. The Abstract Expressionists felt this keenly. Motherwell, for example, described the situation in 1949 thus: "One enters the studio as one would an arena. One's entire character is revealed in the action, one's style, as we say, which differs from individual to individual, and from tradition to tradition. Of course, everyone undergoes risks just by living. From one point of view, the artist's function is to give each risk its proper style. In this sense everyone should be an artist."[12] Compared with this plea by Motherwell for the kind of absolute individuality which had to be defended day after day in the "arena" of the studio, Newman took an unemotional stance in response to a *Tiger's Eye* inquiry in 1947 inscrutably entitled "The Ides of Art: The Attitudes of Ten Artists on their Art and Contemporaneousness". The "Ides of March" anal-

130 ogy doubtless implied the abolition and/or vanquishing of (the tyranny of) art, i.e. the Euro-
pean and regionalist art prevailing in New York after 1945. Newman responded thus: "An
artist paints so that he will have something to look at; at times he must write so that he will
also have something to read"[13]—an egocentric refusal to communicate which could hardly
have been more terse or more pronounced.

II Doing and Reflecting

Since almost twenty years went by before Newman talked again about the interaction of
conception and execution in the creative act, it has not been possible for me to deal with
this process, for chronological reasons, until the present chapter. Newman gave a detailed
account in an interview with Thomas B. Hess in 1966. Compared with a young painter, New-
man felt that he was at a disadvantage because he was burdened by his existing work. Should
he do yet another "Newman", as might be expected of him? A work bearing his trademark?
A problem indeed. "I move into the painting and my feeling is that there is something going
on that is different, that I didn't know, or that I thought maybe I achieved in another paint-
ing but didn't, and now I'm carrying it through in this particular painting. When I stop work,
I look at the painting, and in that sense having removed myself from the doing, [I question],
Does it say something to me? And either it does, and I feel it isn't all said and I have to fight
the painting again, or else, if I feel it has said something which I hoped for in a vague way but
didn't really expect, or if it moves into a new area that is a surprise to me, I live with that
painting until I understand it and then go on. [. . .] If by 'intellectual' you mean that it is also
emotional, I think that this is the process [you go through] as you move into the blank area,
and the terror of that blank area is the whole issue. What is the most difficult thing about
painting? The most difficult thing is sitting in that room by yourself. You have to sit there by
yourself; it's not like sitting at a place with a desk, where other people are talking to you and
the phones are ringing. You are there all alone with that empty space. [. . .]"[14]

What stands out here is a topos of artistic self-conception, namely the artist's fear of
the empty canvas. As Newman never worked from sketches, the challenge is twice as great,
the risk incalculable, and the result unpredictable. Newman states that it is not until he
reflects upon the result that he either rejects the work, makes it the starting point of fur-
ther efforts, or accepts it as valid. Each new act of painting, Newman suggests, justifies itself
self-evidently. This does not happen in a detached or arbitrary way, but requires historical
justification in each individual instance. If we think back to Schapiro's remarks on the artist's
refusal to communicate in a world of ever accelerating communication, it becomes clear that
Newman and the other artists of his generation were not concerned with withholding from
the viewer anything which he might have been able to experience in or through their works.

After all, the artist was not in a position to refuse the viewer something which was evidently just as inaccessible to the artist himself. Here we must not associate the creative act with romantic inspiration, nor should we see it as an unconscious act, with the painter as the instrument of a transcendent force. Newman describes a dual act of creation. What was traditionally regarded as a single process, wherein preconceived intention and intended realization interact, disintegrates here into two different processes. Work with canvas and paints, etc., continues to the point where everything has taken shape. Only then, says Newman, does he reflect on the esthetic result and determine its theme and meaning, and give the work its title. Reflection after the event only reveals what is manifest in the work anyway. But even the artist—if we are to understand Newman correctly—is not immediately clear about what he has created. On the contrary, he must make every effort to understand its essence. Viewed in this light, abstract painting, whilst not refusing communication, calls into question the conditions governing the possibility of communication, yet without negating them entirely.

The work thus created runs the risk of being doubly misunderstood: it may seem to say absolutely nothing, or absolutely everything. Literature on Abstract Expressionism is often full of either meaningless eloquence or metaphorical fantasy. Both had to be avoided. The painter, steering a perilous course between the Scylla of banality and tautology and the Charybdis of incomprehensibility and arbitrariness, had to find a way of evoking significant feelings and revealing truth. Whilst abstract painting operated on the level of visual immanence (indeed, no other level was possible), its interpretation could not be based on phenomenology alone, yet it was clear that, without phenomenology, there was nothing to understand. The transcendence of the painter's own work could succeed only by comparison with other artistic standpoints, historical as well as current, as this—confrontation and criticism—was the only way of clarifying, and indirectly defining, one's intentions. One of abstract painting's fundamental problems, that of self-justification, prompted Newman to concern himself theoretically with the genesis of abstract art in order to be able to adopt a clear position of his own.

III Wiping Out Impressionism

Thomas B. Hess's first monograph on Newman contains a very revealing anecdote. In 1959, Meyer Schapiro invited Newman to talk to his students at Columbia University about his work. Following Newman's lecture, Schapiro drew four rectangles on the blackboard representing four art movements. The object outlined in the first rectangle stood for Realism, the dots in the second one for Impressionism, the interwoven shapes in the third one for Cubism, and the dissociated elements in the fourth one for Surrealism. Schapiro then asked

132 Newman where he himself fit in, whereupon Newman walked to the blackboard, rubbed out the dots in the second rectangle and drew a "zip" down the edge. "I wiped out Impressionism!," said Newman afterwards. It was his only comment.[15] The point of the story lies in Newman's surprising reaction to Impressionism. If he had reacted in this way to Surrealism, we would not have been so taken aback, especially in view of his declared rejection of this movement in the circle of the initiated, to whom Schapiro doubtless belonged. But why this reaction to Impressionism? And what did it mean? In order to answer these questions, we must first know something about the notions which Newman associated with this movement. During the forties, Newman had taken a deep interest in the writings of Jules Laforgue, and had even translated his essay on Impressionism.[16] In his essay "The Problem of Subject Matter", written in 1944/45, Newman had—in keeping with the French critic's own theory—identified the beginning of modernism with Impressionism. "Modern painting begins with the impressionists precisely because for the first time in history, a group of artists repudiated the role of the great personal message with its attendant doctrine of the immaculate conception and decided to devote themselves exclusively to solving a technical problem in painting—color."[17] The Impressionists had solved the problem of color for every painter since. "They set the artist's palette free of its prison."[18] They did not, however, provide a solution to the problem of subject matter. Anything, says Newman, could now be subject matter, and the result was a chaotic, "laissez-faire eclecticism". The Postimpressionists, with Cézanne at their head, brought form back into the foreground and, through the use of distortion, not only denied perspective but also "made possible the emancipation of the artist from nature."[19]

It was also in 1944 that Newman reviewed a comprehensive exhibition at the Museum of Modern Art. Using the same arguments advanced in "The Problem of Subject Matter", he criticized the museum's presentation of the history of modern art as beginning with the Postimpressionists rather than with the Impressionists.[20] In an open letter to the president of the Museum of Modern Art, written in July 1953, Newman took up the theme again (he also took it up much later, in January 1957). What had triggered Newman's reaction this time was the museum's acquisition of Monet's "Poplars at Giverny" (1888). He asked whether the museum was now prepared to "stop taking sides, stop slanting art history, and become simply a repository for art treasures?

"Is the museum ready to abdicate the authority that has established Cézanne as the father of modern art, Marcel Duchamp as his self-appointed heir, and the Bauhaus screwdriver designers who have proclaimed the millennium with their offerings of modernistic furniture and bric-a-brac under the slogan 'Function and form on earth, good design for all men,' [in order] to fight for a new concept of art?

"In short, does the acquisition of this picture by Monet mean that the museum is giving up its history, its theories of art, its popularizing role of entertainment?"[21]

Newman's emphatic defense of the historical significance of Impressionism cannot be ascribed to his reading of Laforgue alone. We must also remind ourselves of Newman's shock when, in 1926, he discovered that the treasures of the Barnes Foundation in Merion were accessible only to those students of art history whose teachers subscribed to the theories of Roger Fry, Clive Bell, and others. It was the "mediocre if not a poor"[22] painter Fry whose exhibition had been the subject of Newman's very first review a year earlier, in 1925. Fry held the view that modernism began with the Postimpressionists, for they—Fry names Picasso and Matisse in the main—"do not seek to imitate form, but to create form; not to imitate life, but to find an equivalent for life"[23].

Newman's deep disappointment at not being able to view the works of the Barnes Foundation was certainly justified, and it may be seen as one of the two biographical elements which led to Newman's revaluation of Impressionism. The other element was Newman's notion of the history of art: "The impressionists studied color; the postimpressionists, shape; the cubists, the picture plane; the abstractionists and surrealists, subject matter. [. . .] truth [for the new painter] is a search for the hidden meanings of life"[24]—a simplistic notion which, for the sake of effectiveness, takes neither exceptions nor complexities into account. When Newman, in 1959, literally wiped out Impressionism and usurped its place, he was claiming the role of the Impressionists for himself: if Monet, Pissarro, and others had laid the foundations of modernism, he, Newman, was now laying the foundations of a new, forward-looking art. Newman never formulated this claim in so many words, but his conception of himself and his work, conveyed through his writings, corroborates the view that by his surprising gesture in Meyer Schapiro's seminar Newman was indeed staking such a claim.

IV An Inert Material

It was not only his historical role which Newman saw in the context of Impressionism, but also the significance which he attached to color: "When I started moving into my present concern or attitude in the mid-forties," said Newman in an interview in 1962, "I discovered that one does not destroy the void by building patterns or manipulating space or creating new organisms. A canvas full of rhetorical strokes may be full, but the fullness may be just hollow energy, just as a scintillating wall of colors may be full of colors but have no *color*. My canvases are full not because they are full of colors but because color makes the fullness. The *fullness thereof* is what I am involved in. It is interesting to me to notice how difficult it is for people to take the intense heat and blaze of my color. If my paintings were empty they could

take them with ease. I have always worked with color without regard for existing rules concerning intensity, value or nonvalue. Also, I have never manipulated colors—I have tried to create *color*."[25]

"Color makes the fullness"—this a central aspect of Newman's paintings during the sixties. He spoke in the same vein in another interview in 1966: "It seems to me that one has to go beyond the sensation of colors to make color."[26] What is surprising is that Newman, who could be so eloquent and enthusiastic, should speak so reservedly about such an important aspect of his work, an aspect which enabled him to establish a link with Impressionism and justified his claim to having laid the foundations of a radically new kind of painting. His reflections on color are general and vague. "Color makes the fullness" is a reserved statement indeed, if we recall the emphatic proclamations of the intrinsic value of color when the road to abstraction was beset with different hazards earlier in the century. Kandinsky, for example, saw color as a means of exercising a direct influence on the soul. "Color is the keyboard. The eye is the hammer. The soul is the piano, with its many strings. The artist is the hand that purposefully sets the soul vibrating by means of this or that key. Thus it is clear that the harmony of colors can only be based upon the principle of purposefully touching the human soul. This basic tenet we shall call the principle of internal necessity."[27]

Newman does not speak of the harmony of colors, of the purposeful touching of the human soul, of internal necessity; indeed, he dismisses that which Kandinsky describes and analyzes at great length in his essay—the effects of individual colors on human feelings. In none of Newman's statements is there any mention of the psychological effects of colors, of the way colors relate to each other, or mutually influence each other, etc. But there is a good reason for Newman's restraint.

In a television interview with Frank O'Hara in 1964, Newman describes color as an "inert material". He does not choose color, he says, for its symbolic value or its specific qualities. On the contrary, he uses it freely, so that only when he begins to paint does color become a factor in the "emotional feeling of scale".[28] Newman basically rejects all historical or conventionally accepted definitions of the properties of color. No matter what color he chooses, it does not become the vehicle of the painter's emotions until he starts to use it on the canvas. Not until the process of painting takes place does the color become charged with emotion and begin to take on meaning. And since the creative act is of necessity an act of self-reassurance, the material with which the artist works must be devoid of properties, an inert material, as Newman puts it. Only in this state is the material able to absorb the artist's emotional impulses and make the painting a transcendental experience. And only in this way can the artist be sure of evoking an experience of self in the beholder.

Newman defies color. It is as though he were afraid of succumbing to its charm and beauty and, in so doing, relinquishing his quest for the sublime. Evidently, none of the utensils necessary for painting was allowed to possess an emotional value of its own. This may seem difficult to understand, but it is precisely what Newman meant when he described, in a television interview with Lane Slate at the end of 1963, his way of working: "[…] it happens that I am starting on some new canvases. I am preparing about half a dozen in a variety of sizes. I begin work by shrinking the canvases. I then stretch them to get them tighter, then shrink them again and restretch them several times. I find that this is important for me to do because I need to make the fabric inert. Raw canvas has a kind of allure that is captivating, a sense of false mystery that is very sentimental. By shrinking it and stretching it, I destroy this sentimental quality. For me, the material, whether canvas or paint, has to be inert, so that I myself can create the sense of life. Otherwise there is the danger that I may fall in love with the material. I think that happens to many painters, and the result must inevitably be aesthetic, so that instead of creating a work of art one makes, at best, only a beautiful thing, an art object. I hope I'm not doing that. I hope I'm making a viable work, and for that I need inert materials. After all, legend tells us that man was made out of mud, not out of amethyst."[29]

Newman's references to the scale or size of his paintings proceed along similar lines. In the aforementioned interview with O'Hara, he emphasizes the inner relationship between color, emotion, scale, and the painting process itself: "The color I make out of colors is what creates the emotional feeling of scale. Because in the end scale I think is a felt thing. [. . .] It's my scale based on actually doing it."[30]

What Newman is saying reflects a central aspect of his creativity, though his subjectivism makes it difficult to understand what he is getting at. Newman's description of the creative process is cryptic: whilst conveying through a simple choice of words the impression of conclusive reasoning, he leaves unsaid what ought to be said. Newman's words revolve round the point, but never come to it. He says what he, as the painter, intends to do; he tells us how his way of working with canvases, colors, and brushes is art; he seeks to express verbally what his paintings express visually. But his words describe only the vast field within whose boundaries the creative process takes place. How he actually visualizes the subject matter remains—like the subject matter itself—a secret. Conscious of the inadequacy of words when it comes to describing the creative act itself, Newman avoids the issue and, significantly, resorts to an analogy based on the various parts of speech: "The empty canvas is a grammatical object—a predicate. I am the subject who paints it. The process of painting is the verb. The finished painting is the entire sentence, and that's what I'm involved in."[31] What Newman is saying, in effect, is that color, scale, canvas, etc., were nothing but materials

136 before they became essential features of the form, and now manifest themselves in the form as "messages" to be qualified in terms of content. All emotions and meanings embodied by Newman's paintings remain bound up with the form, this being preconceived in some cases, newly conceived in others. Only when it is worked upon by the painter does it become a special form and experienceable as such. The question "How can anything which Newman calls 'inert' have expression and meaning in the finished work?" is at the heart of Newman's oeuvre.

Let us try to shed a little light on this darkness. As we have seen, Newman does not consider color to have a representational function. Since the late forties, Newman has ceased using color as a means of characterizing an object or evoking a mood. In principle, Newman's painting is based on the intrinsic value of color, though this statement must be qualified inasmuch as this intrinsic value is not recognized by Newman where color still serves him as an "inert" material. What this means is that color, as a material, is radically diminished, whilst color in the painting has that inherent quality on which the presence of the painting relies, as Newman's statement "Color makes the fullness" suggests. Although he himself does not say so, Newman might be differentiating between what Josef Albers called "factual fact" and "actual fact". "Factual fact" refers to purely objective fact, that is to say, to the substance on the canvas, whilst "actual fact" embraces the subject's experience as he contemplates the work.[32] For Newman, "factual fact" would be the inert, characterless substance which—here he differs from Albers—has not yet been applied to the canvas, whilst "actual fact" would be what turns the painting into a work of art, but in terms of expression, not contemplation (another variation from Albers). Whether Newman had Albers's differentiation in mind or not, one thing is clear: Newman's exaltation of the subject. It is the painter who has the final say. It is the painter who instills in the inert materials—canvas and color—that emotional impulse which transforms the flat, colored object into a work of art. No matter how unusual Newman's reflections may seem, at bottom they express a traditional notion of the creative act.

Everything that makes a work of art a work of art results from the painter's emotion, for the materials with which he works are characterless, emotionless, devoid of properties. This is what Newman's repeated utterances—inert fabric, inert color, inert canvas, inert materials, etc.—imply. Such statements become even easier to understand when we recall that Newman was at that time working on his series "Stations of the Cross", fourteen paintings of identical dimensions and based essentially on two elements: raw canvas and just one color—black.

Newman's preoccupation with the inertness of materials, and especially the inertness of color, is not consistent, however. There are statements by Newman in which drawing

takes precedence over color. "Drawing is central to my whole concept," said Newman in 1962, for example. "I don't mean making *drawings*, although I have always done a lot of them. I mean the drawing that exists in my painting. Yet no writer on art has ever confronted that issue. I am always referred to in relation to my color. Yet I know that if I have made a contribution, it is primarily in my drawing. The impressionists changed the way of seeing the world through their kind of drawing; the cubists saw the world anew in their drawing; and I hope that I have contributed a new way of seeing through drawing. Instead of using outlines, instead of making shapes or setting off spaces, my drawing declares the space. Instead of working with the remnants of space, I work with the whole space."[33]

That Newman contradicts himself when he diminishes color in relation to drawing is not relevant here. Such inconsistencies only reconfirm Newman's aloofness from the esthetics of materials and the unique, absolute position which he allocates to the ego in the creative process. It is Newman who fills the void, makes color out of colors, declares the space, converts metaphysics into presence, and transforms the spiritual into experience—in short: fills dead material with life. This is an enormous claim: the artist, half-way through the twentieth century, once more assumes divine qualities.

There is another aspect which must be considered in this context. The canvas has not only a certain material quality and surface texture but also a certain size. As in the case of color, the more or less fortuitous dimensions and shape of the canvas are in themselves meaningless. It is the painter's "involvement" which turns them into something specific: "For me, the shape and the size of a canvas must also be inert," Newman said in 1963. "I am not involved in size for itself. I do small paintings, and I do large ones. I choose the sizes in a haphazard way. For me, the size is a challenge. It is the challenge of its finiteness that I have to contend with and to overcome. [. . .] I pick up shapes and areas in a haphazard way, but once I've picked one up I feel I've made my first commitment to the piece. [. . .] Size is only a means to me to involve myself in what I think is a painter's problem—that is, a sense of scale [. . .]"[34] Three years later, Newman said, "The real problem of a painting lies in the painter's sense of scale."[35] "Scale", for Newman, always means "human scale".[36] Again, Newman contrasts simple alternatives. Reflection on the size of a canvas produces an esthetic object, whilst measuring and cropping the canvas in order to relate the content to the size merely produce a work of art. Occasionally, Newman takes such hair-splitting too far, differentiating, for example, between "pictures" and "paintings", a distinction which, whilst hardly contributing to an understanding of his intentions, is an effective underpinning for his prejudiced appraisals of the works of others. Newman's paintings must distinguish themselves from every object and every art object. "I have helped elevate painting," says Newman towards the end of his 1963 interview with Lane Slate, "into a new grand vision.

138

[. . .] To create a work of art means, to me, to express something that is deep in one. It's not acting out one's neurosis, it's not expressing one's sensations; but it is an attempt to put down what you really believe and what you really are concerned with or what really moves you and interests you. [. . .]"37

Newman's statements during the sixties seem at first glance to be quite lucid, and they are indeed so for long stretches. It is only when he comes to talk about the essence of the creative act that his reasoning seems to lose its power of persuasion. This is virtually inevitable, for not even the painter is able, in the final analysis, to say what it is that makes a work of art a work of art. The conceptual apparatus which Newman employs in his statements and interviews does little to clarify this point. All the same, we note that Newman no longer speaks of his metaphysical aspirations ("art must become a metaphysical exercise") or of "penetration into the world-mystery". He remarks now mainly on such concrete concerns as materials, color, size, and scale, albeit with the implicit understanding that the work embodies subjective feeling, that it embraces a fundamental spiritual dimension, that it successfully distinguishes between a place and no place, and that presence can be experienced in both its local and temporal dimension.

Newman's position can be defined with greater clarity by referring to his opposite, Ad Reinhardt. The two painters' fundamental differences are obvious when we look at Reinhardt's "Abstract Painting, Red" (Fig. 34), from 1952. Whilst Reinhardt's famous statement "Art is art. Everything else is everything else"38 would have met with Newman's approval, his plea in his essay "Timeless in Asia" for "only blankness, complete awareness, disinterestedness" in art39 would definitely have not. The differences between these two artists must have seemed irreconcilable once Reinhardt published his famous article "Art-as-Art" in a prominent art magazine in 1962. Consider the following passage, for example: "The one work for the fine artist, the one painting, is the painting of the one-size canvas, the single scheme, one formal device, one color-monochrome, one linear-division in each direction, one symmetry, one texture, one free-hand brushing, one rhythm, one working everything into one dissolution and one indivisibility, each painting into one overall uniformity and non-irregularity."40

Reinhardt sees painting as a ritual which repeats the same structure over and over again; it has no meaning; it is timeless, absolute, and pure. The subject—the artist—is totally negated, entirely absorbed in the meditative routine of painting, a routine in which everything seems to be predetermined. By way of contrast, let us recall what Newman wrote in his statement in the catalog of the 1965 São Paulo Bienal: "The self, terrible and constant, is for me the subject matter of painting and sculpture."41 It is this contradiction, irresolvable though it may be, which drives Newman to seek valid formulations, no matter how difficult

this is under the conditions he himself imposes. The challenge is to achieve a maximum of expression with an extremely reduced formal vocabulary (canvas format and "zip") and an extremely limited number of colors, all the while not only identifying himself with his work but also conveying this absolute presence to the viewer. It is testimony to Newman's depth that he makes no attempt to conceal these divergences, but rather makes all contradictions, unresolved as they are, repeated components of his works.

V A Few Examples: Overcoming and Asserting the Format

"Tertia" (Fig. 55) was painted in 1964. Although it bears a resemblance—the same colors, a similar structure—to "The Third" (Fig. 35), which Newman painted in 1962, the two paintings are hardly comparable in effect.

Let us concentrate on "Tertia" (shown in this exhibition), a painting of slender, vertical format measuring 78 by 35⅛ inches. It is dominated by a field of vivid orange bounded, on the right, by a narrow yellow stripe and divided, on the left, by a one-inch-wide yellow "zip". Beyond the "zip", towards the left-hand edge of the canvas where the white ground has been left visible, the orange field "frays". Several opposites are played off against each other: expressivity against homogeneity, broadness against narrowness, tightness against looseness, concentration against eccentricity, and so on. What irritates the viewer is the figure-ground relationship. What is the figure? What is the ground? Whilst reproductions suggest that the dominant orange is bordered, asymmetrically, by the yellow, this is not the case, for the yellow is different on either side: on the left it is cool, on the right it has been warmed slightly by the addition of reddish-brown. Neither the stripe nor the "zip" is in front of, or behind, the field of orange. Indeed, we gain the impression that the painting operates against, and spreads across, the white ground of the canvas, whose boundary is perceived as what first catches the eye. The broad, short brush-strokes which drive the orange into the white void on the left-hand side of the canvas suggest incompletion. It is as though the process of covering the entire canvas with orange was interrupted just prior to completion. Painting presents itself as painting. Newman's painting "Triad", 1965, works in a similar way. Here, too, a field of reddish-orange spills over into the white left-hand edge of the canvas, but not so far as to mask the presence of a vertical line, whilst on the right a dark-colored "zip" holds the painting together.

Such divisions, overlappings, and penetrations of adjacent zones of color are typical of Newman's painting of the early sixties, and it is the "Stations of the Cross" in particular which are distinguished by the tendency to break open solid areas of color and emphasize certain zones by an expressive yet restrained use of color. "The Third", "Tertia", and "Triad" all make use of the same three elements: white ground, orange field, and "zip".

140

What is also striking about Newman's paintings of this period is his occasional harking back to earlier paintings. "The Moment I" of 1962 is similar in several respects to "The Name II" of 1950. "Right Here" of 1954 (Fig. 36) is echoed in "Not There—Here" of 1962 (Fig. 37). Although they differ in format, these last two paintings are comparable in ways which reach beyond the similarity of their titles. The earlier painting features an irregularly edged blue stripe on the left-hand side of the canvas, whereas the later painting has a sharply contoured yellow stripe on the right-hand side. Newman corresponds with himself, as it were. It is as though "Not There—Here" is to be understood not only as an answer to, but also as a correction of, "Right Here".

"Profile of Light" (Fig. 57), a painting of extremely succinct structure, must be considered as one of Newman's major works of the sixties. This impressively large, vertical painting measuring 120 by 75 inches is divided vertically into three broad zones, dominated left and right by a dark ultramarine, whilst the center shines in pure white. Even such a simple structure invites questions. Does the white cover the blue? Does the blue open to reveal the white? Or are both colors on the same plane? This fluctuation between figure and ground, between light and dark, between color and non-color, has been observed again and again. As Elizabeth C. Baker puts it, "neither dark nor light can be held in the mind or the eye, either as foreground or background."[42] The painting at once disintegrates and integrates. Regrettably, however, the frame in which "Profile of Light" has been mounted detracts from the to-and-fro, back-and-forth, up-and-down effect Newman intended, and may entirely rob the painting of its meaning.

The heraldic effect suggested by the simple tripartite structure—Alloway even spoke of Newman's "retrieval of iconographic potential"[43] when he saw this painting—is undermined by the extreme elongation of the vertical format. Almost twice as high as it is wide, "Profile of Light" is hardly perceptible as a symmetrically divided field. The emphasis on the vertical generates a dynamic, upward thrust. This is experienced by the viewer particularly when he is standing close to the middle of the canvas. Congruence with the axis of the viewer's own body and also with the *axis mundi*—perhaps this is how we might describe, in extremely simple terms, one of the powerful effects this painting creates.

Verticality is further implied by the title—"Profile of Light"—for light in this sense moves in only one direction, from top to bottom, like a sunbeam, like a flash of lightning, like a "zip". But the white band is not perceived as a "zip". It is too broad, although the "bleeding" of the blue into the white, which is particularly noticeable on the right-hand side, certainly awakens these associations.

Genetically, "Profile of Light" derives from such works as "The Way I" of 1951 (though this work is primarily the predecessor of "The Way II" of 1969), "Onement VI" of 1953, and

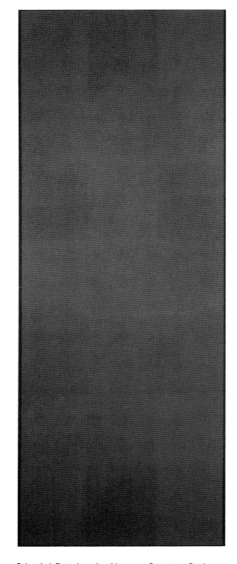

34 Ad Reinhardt, *Abstract Painting, Red,* 1952
Oil on canvas, 107¹/₂ x 40 ins.
The Museum of Modern Art, New York
Gift of Mr. and Mrs. Gifford Phillips

35 *The Third*, 1962
Oil on canvas, 101¼ x 120⅜ ins.
Walker Art Center, Minneapolis
Gift of Judy and Kenneth Dayton, 1978

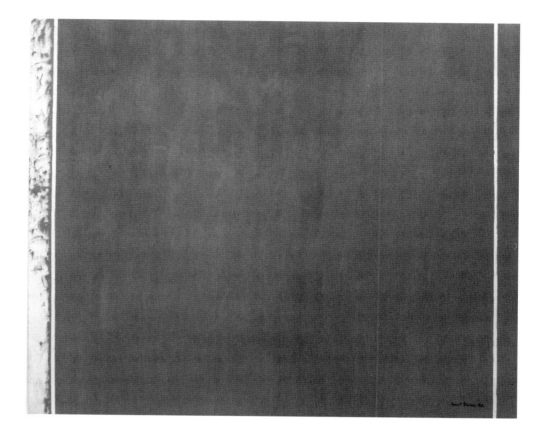

also "Now I" of 1965. Although "Now I", "Now II" (Fig. 38), and "White Fire IV" (Fig. 39) likewise feature a vertical, tripartite structure, their center stripes are, to a greater or lesser extent, emphasized over the outer ones. These rigid concepts were synthesized by Newman in his monumental work "Voice of Fire" (Fig. 2), which was also painted in 1967 and fully exploits the blue-red-blue contrast. Although this is one of Newman's most important paintings, it takes second place to "Profile of Light" in one respect: through the similar degrees of color saturation and the virtually identical luminescence of red and blue, "Voice of Fire" seems more consolidated, more homogeneous, thus eliminating the divergence which, in "Profile of Light", makes the unity of the painting so fragile and the symmetry so ambivalent. It is an intentional divergence, however, and has nothing to do with the quality of execution.

Symmetrical, hierarchical structures, such as those featured in the paintings just described, are the exception rather than the rule in Newman's oeuvre. Mostly he prefers asymmetrical structures which not only tend to transcend the format in a vertical direction but also incorporate a potentially disturbable order. A representative example is "Shimmer

142 Bright" (Fig. 56), painted in 1968. This painting features a light-gray ground accentuated on the left by two bright blue "zips". The exposed stripes of ground color between the "zips" and to the left of them are the same width as the "zips" themselves, this being three inches. Thus the viewer cannot be sure whether he is looking at just two or as many as four "zips", especially as the large, unfilled space to the right of the "zips" forms a perfect square measuring 72 by 72 inches.[44] Newman had already experimented with this principle in 1950.[45] "The Voice" (96⅛ by 105½ inches) has a yellowish "zip" on the right which divides off one eleventh of the entire area of the canvas, leaving a square of 96⅛ by 96⅛ inches as a painting within a painting, or as a painting next to a painting, or as a painting taken from a painting, depending on the way we read the uniquely balanced configuration of this work— whether as a synthesis, an addition, or a subtraction. "Shimmer Bright" is without question the more venturesome, and hence the more impressive, work, not only on account of the bright, steely blues but also, and primarily, because its unity seems at once endangered and strengthened. Whilst the canvas seems on the one hand to be divided into pieces, it seems unified on the other. One suspects—though one cannot prove it—that the balancing act succeeds only because the square, though it does not immediately appear to be a square, works subliminally as a resting-point within the configuration as a whole. Unfortunately, this painting, too, has been mounted in a highly unsuitable frame, with the gap between canvas and frame so deep and shadowy that it seems to form part of the picture—an effect certainly not in keeping with Newman's intentions.

A special place in Newman's oeuvre is occupied by the two triangular paintings "Jericho" and "Chartres" (Figs. 58 and 59) which Newman painted in 1968/69. These two paintings are directly related to the pyramid of Newman's "Broken Obelisk" (Fig. 113). When the steel plates were being cut for this sculpture, Newman envisioned triangular paintings the size and shape of the faces of the pyramid. He noticed, however, that the triangular faces appeared lower when they were inclined towards the apex of the pyramid. Thus he ordered canvases of reduced altitude. Said Hess: "He figured that by lowering the altitude, he would approximate the perspective effect of a plate leaning away from him, into the pyramid."[46] Consequently, a triangle having a height of 120 inches and a base of 114 inches (the dimensions of "Chartres") could be transformed, optically, into a triangle measuring 106 by 114 inches (the dimensions of "Jericho").

Both of these works belong to the category of "shaped canvases" which had been central to the work of such artists as Frank Stella since the mid-sixties, if not before. Whilst the question preoccupying these artists was whether or not the individual parts bore any relation to the whole, Newman's concern lay elsewhere. It was not structure, serial arrangement, or the contrast of hypotaxis and parataxis which aroused Newman's curiosity, but

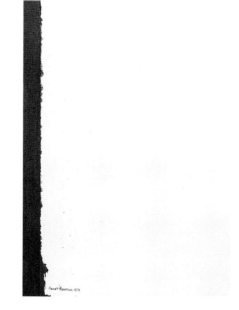

36 *Right Here,* 1954
Oil on canvas, 51 × 36 ins.
Stedelijk Museum, Amsterdam

37 *Not There—Here*, 1962
Oil and casein on canvas, 78 × 35 ins.
Musée national d'art moderne
Centre Georges Pompidou, Paris
Gift of Annalee Newman, 1988

rather the question of how to relate the subject matter to the unusual, non-rectangular format, or, as Hess quotes him, how to "break the format".[47]

Although they are both triangles, these two works differ considerably. By virtue of its dimensions alone, "Jericho" (106 by 114 inches) seems squat and sturdy, whilst "Chartres" (120 by 114 inches) creates a dynamic and forceful impression. This effect is essentially ascribable to color, and not to size or shape. The deep-black triangle of "Jericho" is divided vertically by a deep-red "zip" whose left-hand edge lies at the exact center. By comparison, "Chartres" is extremely vivid: bright yellow and red, and two different shades of blue. Its three "zips", each three inches wide, are arranged in strict symmetry: ultramarine in the middle, cobalt blue on either side. At the base of the triangle, the two red edges are the same length (28¼ inches), and the lengths of the inner yellow edges likewise match (24¼ inches).

These paintings, which were possibly Newman's response to the works of such younger artists as Kenneth Noland[48], posed a problem which was so important to Newman that he wrote a short essay on "Jericho" and "Chartres" which was published in the magazine *ARTnews* in April 1969. A "historico-iconographical footnote" was contributed by the editor of the magazine, Thomas B. Hess. Newman described the problem and its solution thus: "Could I do a painting on the triangle that would overcome the format and at the same time assert it? Could it become a work of art and not a thing?

"[. . .] I had to transform the shape into a new kind of totality.

"[. . .] How to do a painting without getting trapped by its shape or by the perspective was the challenge here.

"It was only when I realized that the triangle is just a truncated rectangle that I was able to get away from its vanishing points. I knew that I must assert its shape, but in doing so I must make the shape invisible or shape-less. I realized that, after all, it is nothing more than a slice of space, a 'space vehicle,' which the painter gets into and then has to get out of. It was this drama, my involvement in the existence of the triangle as an object and my need to destroy it as an object, that made it possible for me to begin painting them."[49]

Newman's reference to the triangle as a truncated rectangle is extremely revealing, for we now realize that he had conceived these two triangular paintings as extracts, as fragments of an unlimited vertical symmetry which, by reason of the given format, could not be rendered in its entirety. But was Newman still able to escape the danger of producing a painted object rather than a painting? This question preoccupied Newman at that time, though today it seems academic, not to say irrelevant. It was a sign of its time and must be considered in the same context as the discussion of Jasper Johns's flag paintings ("Is it a flag or is it a painting?").

144 A more significant difficulty is deciding whether the "zips" and the color fields poten-
tially reach beyond the sides of the triangle, or whether they operate only within it. This
problem, too, cannot be resolved. Whilst the bottom edge of the painting functions as an
uncrossable base-line, the two other edges interrupt the upward movement of the verticals.
Immanence and transcendence remain irreconcilable, as they did for de Chirico on a differ-
ent level when, in 1914, he painted his "L'Énigme de la fatalité" (Fig. 40), a triangular painting
which Newman may have seen during his visits to Basel in 1964 and 1968. Whilst the picto-
rial problems may seem comparable, the formal solutions are not. And it goes without saying
that Newman was not directly influenced by de Chirico when he conceived his triangular
paintings.

Concerning the meaning of these two paintings, Newman says very little: "I called one
painting *Chartres* because of the strong assertion of my inner structure in contrast with the
outside format and because of the even light in the painting, which has for me the evenness
of northern light—a light without shadows.

"The title *Jericho* explains itself." [50]

Does it really? Hess, at any rate, sees the need for an explanation. Quoting Meyer
Schapiro, he points out that the name of Géricault was, during the painter's lifetime, often
spelled "Jéricho". "Raft of the Medusa", Géricault's most famous work, made an enormous
impression on Newman when he visited the Louvre with the French art critic Pierre Schnei-
der in January 1968 [51], though it seems to be going too far to suggest, as Hess does, that the
triangular composition of "Raft of the Medusa", topped by the figure of a Negro sailor,
inspired the black triangle of "Jericho". [52]

In 1968, Barnett Newman painted "Anna's Light" (Fig. 60), which Yve-Alain Bois con-
sidered to be "the last major step Newman took in order to achieve the wholeness he
wanted to achieve." [53] Measuring 108 by 240 inches, this painting is the largest in Newman's
oeuvre. Dominating the canvas is a continuum of cadmium red which seems to generate an
intense field of energy. It fills almost the entire canvas, leaving only a band of white at each
end—three inches wide on the left, twenty inches wide on the right. What we cannot see,
but only measure and calculate, is that the area covered by the red is almost a double square.
This may seem irrelevant, but it explains why the painting gives the impression of a unified
whole despite its extreme lateral extension, and is not perceived simply as an uncontrollable
monochromatic expanse with a differently colored zone arbitrarily attached at each end.
The basic geometrical element—the double square—performs a conditioning function inas-
much as it controls our perception and prevents our eye from wandering beyond the bound-
ary of the red zone and, possibly, beyond the edges of the painting. This geometrical restraint
of our horizontal range of vision takes place without our being aware of it. The asymmetry

38 *Now II*, 1967
Acrylic on canvas, 132 x 50 ins.
The Menil Collection, Houston

39 *White Fire IV*, 1968
Acrylic and oil on canvas, 132 x 50 ins.
Öffentliche Kunstsammlung Basel
Kunstmuseum

of the painting, too, has a considerable part to play in this effect. That the white zone on the right is broader than the one on the left counteracts the habitual way we read a picture, from left to right. The broader zone of white acts as a buffer, restrains the latent dynamism suggested by the painting's lack of accentuation, and makes it even more difficult for us to bring the center of the painting and the center of the red zone into harmony with each other, indeed, to locate them at all.

The vast expanse of red is characterized by a subdued intensity, due primarily to its high degree of color saturation and low luminescence. The paint has obviously been applied in several coats, the first coat with a roller, the subsequent ones with a brush, resulting in variations in density and modulations in color which, depending on the lighting conditions, are noticeable to a greater or lesser extent. Whilst they denote a concentration of pent-up energy, these variations and modulations are so negligible, however, that they do not catch our eye as, say, a "zip" would have done. And even the partially sharp, partially uneven demarcation lines between the red and the white[54] hold our attention for only a short while. Indeed, they are barely noticeable when we view the expanse of red from a roughly central position. Our eye wanders, vainly seeking a substantial hold in a color experienced as a complex totality, a barely definable finitude, a saturated plenitude—a color which affords every scope and latitude whilst neither overpowering nor intimidating us. The size of the painting and the expanse of red are so calculated that the limits of our comprehension are reached but not exceeded.

A year earlier, in 1967, Newman had painted "White and Hot" (Fig. 41). Measuring 84 by 72 inches, this painting is considerably smaller than "Anna's Light", but is similar in structure: a red field in the center, vertical stripes of white on either side, the left-hand one narrower than the right-hand one. If we compare these two paintings, we realize that the figure-ground relationship is central to "White and Hot", whilst for "Anna's Light" it is of no relevance. Both paintings convey the impression of visual totality, but in different ways: immediately in the case of "White and Hot", for we can take in the painting at a single glance; gradually in the case of "Anna's Light", for the painting—after our initial shock—opens itself up to us bit by bit and only slowly solidifies our sensation of totality as we perceive the painting. We, the viewers, move towards the painting, then away from it, then to the right, and then back to the middle, letting our gaze wander. The painting addresses us not only mentally and emotionally but physically, too. We instinctively search for an optimum place to stand; we come to rest; we begin to move again: motion resides in our motionlessness, and vice versa. Overwhelmed by this deluge of red, we try to stem it. Once we feel we are in control, the urge to move overcomes us again: subjective states subliminally alternate between distraction and contraction, canceling each other out, coming to rest in perfect

146

equilibrium. Possibly no other work by Newman makes one sense the indivisibility of one's own body so intensively as does this painting[55], whose title, moreover, is biographical: just as "Abraham" refers to Newman's father, so "Anna's Light" refers to the artist's mother.

Ideomotor movements join forces with our experience of seeing to make us aware of how we view that something on the wall which is both a color field and a painting, which activates a spatial continuum beyond the sides of the canvas, that is to say, horizontally, but which clearly remains restricted vertically. And because "Anna's Light" blends the dynamic with the static, the exuberant with the restrained in a way which is at once simple and complex, we are again made to realize the peculiarity of visual perception which is not an autonomous mental process but one dependent on certain external conditions. These are described by Merleau-Ponty thus: "The enigma is that my body simultaneously sees and is seen. That which looks at all things can also look at itself and recognize, in what it sees, the 'other side' of its power of looking. It sees itself seeing; it touches itself touching; it is visible and sensitive for itself. It is not a self through transparence, like thought, which only thinks its object by assimilating it, by constituting it, by transforming it into thought. It is a self through confusion, narcissism, through inherence of the one who sees in that which he sees, and through inherence of sensing in the sensed—a self, therefore, that is caught up in things, that has a front and a back, a past and a future [. . .]"[56] It is this narcissistic bond which enables the painting to open itself up and make itself accessible to the viewer's subjective experience, and in such a way that its amorphous character exempts it from all specific functions which may detract from this experience.

Several parallels may be drawn between "Anna's Light" and "Who's Afraid of Red, Yellow and Blue III" (Fig. 42). Measuring 96 by 214 inches, this painting is somewhat smaller than "Anna's Light" and was completed slightly earlier. Whilst the painting is, like "Anna's Light", dominated by a broad expanse of red, the left-hand vertical stripe is blue, and the narrower, right-hand stripe, yellow. Here, too, the stripes have a retaining function, inhibiting the tendency of the red to extend beyond the edges of the canvas. Although the expanse of red results from the enormous size of the canvas, it is not congruent with it. The red defines the painting, but it is not joined to it like a skin or coating which covers the rectangular frame of the canvas and reduces the painting to a monochrome object. The color is experienced rather as something autonomous, self-generating, that is to say, something totally liberated from the formal dictates of the support.[57] Newman has here radicalized the form which he first put to the test in his "Who's Afraid of Red, Yellow and Blue I" of 1966 (Fig. 43). We can now recognize Newman's systematic approach: "Who's Afraid . . . III" is Newman's reply to "Who's Afraid . . . I". Similarly, "Anna's Light" is a reaction to "White and Hot". In "Who's Afraid . . . II" (Fig. 44), however, Newman follows a different course. He interrupts the red

40 Giorgio de Chirico
L'Énigme de la fatalité, 1914
Oil on canvas, 54 1/3 x 37 1/2 ins.
Emanuel Hoffmann Foundation
On permanent loan to the Kunstmuseum Basel

continuum with three "zips", a blue one in the middle and a yellow one at each side. This symmetry of form and color has its counterpart in Newman's last monumental work, which is also the last painting in this series: "Who's Afraid of Red, Yellow and Blue IV" (Fig. 61), 1969/70. Here Newman strikes a perfect balance between the symmetry of the forms and the asymmetry of the colors, with the intensity of the primary colors undermining the rigidity of the format. It is a painting which no longer seeks to reconcile Newman's two conflicting principles, i.e. the simultaneous overcoming and assertion of the format. On the contrary, "Who's Afraid of Red, Yellow and Blue IV" makes the divergence particularly evident.

When he exhibited his work in New York in the spring of 1969—his first solo exhibition of paintings in ten years—Newman made the "Who's Afraid of Red, Yellow and Blue" series the subject of a statement which is so revealing that I wish to quote it in full:

"I began this, my first painting in the series *Who's Afraid of Red, Yellow and Blue*, as a 'first' painting, unpremeditated. I did have the desire that the painting be asymmetrical and that it create a space different from any I had ever done, sort of—off balance. It was only after I had built up the main body of red that the problem of color became crucial, when the only colors that would work were yellow and blue.

"It was at this moment that I realized that I was now confronting the dogma that color must be reduced to the primaries, red, yellow and blue. Just as I had confronted other dogmatic positions of the purists, neoplasticists, and other formalists, I was now in confrontation with their dogma, which had reduced red, yellow and blue into an idea-didact, or at best had made them picturesque.

"Why give in to these purists and formalists who have put a mortgage on red, yellow and blue, transforming these colors into an idea that destroys them as colors?

"I had, therefore, the double incentive of using these colors to express what I wanted to do—of making these colors expressive rather than didactic and of freeing them from the mortgage.

"Why should anybody be afraid of red, yellow and blue?"[58]

Here Newman again makes an attack on Mondrian. The Dutch painter had posed a challenge to Newman for most of his creative life. Newman repeatedly criticized Mondrian's perfectionism, for it was, in his opinion, "founded on bad philosophy and on faulty logic"[59] and was nothing but a kind of "systematic theology"[60]. Mondrian—as he himself said—sought to reconcile the individual with the universal in order to rid art of everything tragic and to raise it to the highest level of purity[61], and it was precisely this nontragic aspect which Newman criticized.[62] Whereas for Mondrian "the color fields visualize[d], both through their position and size and through the respective strengths of their colors, only relationships and not forms", i.e. relationships which for Mondrian represented the "profoundest

41 *White and Hot,* 1967
Oil on canvas, 84 x 72 ins.
The Saint Louis Art Museum
Gift of Mr. and Mrs. Joseph Pulitzer Jr.

148

reality"[63], Newman had recognized, as early as 1948, the dangers of Mondrian's striving for perfection: "The geometry (perfection) swallowed up his metaphysics (his exaltation)."[64]

It is against this background that Newman's "Who's Afraid of Red, Yellow and Blue" series constitutes an answer to Mondrian's purist and formalist ideas. It is the final response in the art-theoretical dialog which had been taking place, indirectly, between Newman and Mondrian for many years. For all Newman's preoccupation with Mondrian, Mondrian's works hardly seem to have inspired or motivated Newman to demonstrate, through his own works, the absurdity of Mondrian's striving for harmony. Nonetheless, Mondrian's "Composition with Large Red Plane, Bluish Gray, Yellow, Black, and Blue" (Fig. 45), painted in 1922, ought not to go unmentioned, though not on account of its dominant red, but rather because this small painting—measuring 21¼ by 21 inches—embodied everything which Newman rejected. What Newman sought to achieve is most impressively demonstrated by the last painting in the "Who's Afraid of Red, Yellow and Blue" series.

Measuring 108 by 238 inches, "Who's Afraid of Red, Yellow and Blue IV" (Fig. 61) is only slightly smaller than "Anna's Light". The difference in width is only two inches. What Newman has done, if you like, is to take the two side stripes of "Anna's Light", which together measure 23 inches, join them in the middle, and reduce their width slightly. Indeed, the blue field in the middle is 22½ inches wide, with the result that the double

42 *Who's Afraid of Red, Yellow and Blue III,* 1966/67
Oil on canvas, 96 x 214 ins.
Stedelijk Museum, Amsterdam

43 *Who's Afraid of Red, Yellow and Blue I,* 1966
Oil on canvas, 75 x 48 ins.
Private collection, New York

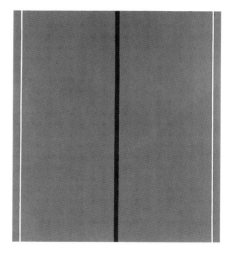

44 *Who's Afraid of Red, Yellow and Blue II,* 1967
Acrylic on canvas, 120 x 102 ins.
Staatsgalerie Stuttgart

square of "Anna's Light" has now been divided into two individual, virtually perfect squares measuring 108 by 107¾ inches.

Corresponding to Newman's succinct, symmetrical composition is the color sequence of red, blue, yellow. The effect created by these colors is extraordinarily difficult to evaluate. Their differing degrees of saturation, their divergent luminescence, and their barely comparable emotional values together strengthen the initial impression that these juxtaposed, contrasting color fields will never enter into a mutual relationship with one another. Above all, however, it is the simultaneous contrasts which seem to undermine this sturdy structure of symmetrically interrelating squares. If we stand in front of the painting and concentrate, for example, on the central blue field, the edges of the neighboring color fields begin to brighten and intensify, whilst the blue seems to deepen. This phenomenon of simultaneous contrast is an aspect of color theory that has been discussed for a good two hundred years, and certainly since Goethe. Light hues seem lighter when contrasted with dark hues; dark hues seem darker when contrasted with light hues. If we move our eyes away from the blue and towards the left, we apprehend an illusory light-red vertical stripe of the same width as the central blue stripe, flanked by a delicate shade of violet. If we move our eyes to the right, we perceive a light-yellow vertical stripe flanked by a pale greenish yellow. According to Michel Eugène Chevreul, who in his color theory of 1839 systematically described such simultaneous and complementary contrasts,[65] this effect should not in fact occur. If blue and yellow are placed side by side, Chevreul maintained, the yellow should appear orange when our gaze moves from the blue to the yellow, i.e. it is not the blue which superimposes itself visually on the yellow, but rather blue's complementary color, orange. If we do nonetheless experience the yellow in Newman's painting as a greenish yellow despite our relatively long concentration on the blue, it can only be because the red is so intense that it evokes its own complementary color—green—which merges optically with the yellow and produces the greenish yellow which we then perceive. In poor lighting conditions, the phenomenon of negative afterimage is less pronounced, meaning that we can experience the complementary contrasts more clearly, i.e. when our gaze moves from yellow to red, we see red plus the complementary color of yellow—violet —and these together create the impression of reddish violet; when our gaze moves from red to yellow we perceive, as already stated, a greenish yellow. Whilst it is hardly surprising that the bright yellow can produce this effect, for it is highly luminescent, it is astonishing that the comparatively subdued red is able to provoke no less powerful simultaneous and complementary contrasts.

It was not Newman's aim—and this is made clear in his statement—to achieve a harmony of contrasts, however. On the contrary, each color must, for the sake of expressiveness, carry an optimum of intensity. This was not a problem with yellow and blue. Conservator

150

Heinz Althöfer's examination of this painting showed just one layer of each color.[66] New-man's problem was to find a red which could hold its own in combination with this intensive contrast of yellow and blue. It was necessary to build up a red which had both an equalizing and an intensifying effect on the contrast, a red which at once linked the color fields together and forced them apart, a red which countered the enormous luminescence of the yellow and yet remained emotionally reticent, a red which enhanced the blue and yet masked its superiority as the all-important centre, the axis, the pivotal point of the painting. The red comprises no fewer than seventeen layers. This alone tells us how painstaking Newman's search for the solution was. And the result, I must add, is fascinating.

The extraordinary opportunity to show both paintings—"Anna's Light" and "Who's Afraid of Red, Yellow and Blue IV"—next to each other in the same exhibition makes one thing clear. Newman's works are acompositional. By this I mean that, although they utilize geometrical forms, they tend to neutralize the effectiveness of these forms. Newman's works evoke an immediate experience of totality inasmuch as the individual parts of a paint-ing do not appear as such. His aim was to overcome the given format on the one hand, and to assert it on the other, a dual strategy which had the purpose both of allowing the paint-ing to be perceived as a painting in the traditional sense, and not merely as a flat, painted object, and of transforming the painting into a totality which was not restricted by the for-mat. This synthesis has been achieved in these two paintings in a unique way, although New-man uses different methods in each case. "Anna's Light" negates the vertical and leaves it to the viewer to find his viewing position somewhere in the horizontal, thus setting in motion the viewer's psychophysical experience of his own self. "Who's Afraid of Red, Yellow and Blue IV", on the other hand, emphasizes the vertical and thus determines the viewer's exact position, thereby accentuating the symmetry, dramatizing the process of seeing, and setting in motion the viewer's psychic and emotional experience of his own self. The aim declared by Newman back in 1947—"to bring out from the nonreal, from the chaos of ecstasy some-thing that evokes a memory of the emotion of an experienced moment of total reality"[67] — has here been realized with the utmost ingenuity.

Newman always maintained that his paintings were not abstractions but "specific and separate embodiments of feeling, to be experienced, each picture for itself."[68] "The self, ter-rible and constant,"[69] was the central theme of his painting, with "human size for the human scale"[70] as a keynote. Newman saw the artist's task as the creation of reality—in the sense that paintings condition the way reality is perceived: "Life is an imitation of the reality set up by the painter."[71] It was Newman's constant aim to "give a sensation of wholeness or fulfill-ment"[72] through his painting, wherein a prime concern was to create "the sense of space. [. . .] that] should make one feel [. . .] full and alive in the spatial dome of 180 degrees going

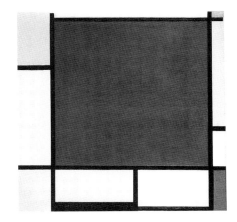

45 Piet Mondrian
Composition with Large Red Plane, Bluish Gray, Yellow, Black, and Blue, 1922
Oil on canvas, 21 1/4 x 21 ins.
Private collection, Monte Carlo

in all four directions."[73] Newman also sought to give the beholder "the feeling of his own totality, of his own separateness"[74] and to "create a sense of place, so that the artist and the beholder will know where they are."[75] And then there was the emphasis on scale: "The content and the form are inseparable: that's scale."[76] And, in another interview: "Size doesn't count. It's scale that counts. It's human scale that counts, and the only way you can achieve human scale is by content."[77] The sum of these statements is that Newman saw his works in correlation with himself and the beholder. This is of course only to be expected, but in Newman's case the experience of self warrants special mention, for it occurred on a much higher level, of greater complexity and intensity, than was the case with his contemporaries. The painting, Newman's painting, is inseparable from the beholder: "The thing is inseparable from a person perceiving it, and can never be actually *in itself* because it stands at the other end of our gaze or at the terminus of a sensory exploration which invests it with humanity."[78] Newman's paintings speak only when we look at them, and our act of looking becomes a part of the object of our reflection.

152

1 Irving Sandler, *The Triumph of American Painting. A History of Abstract Expressionism*, New York, Hagerston, San Francisco, London, 1970, p. 1.

2 Cf. Serge Guilbaut, *Postwar Painting Games: The Rough and the Slick*, in: *Reconstructing Modernism: Art in New York, Paris and Montreal 1945–1964*, ed. by Serge Guilbaut, Cambridge, Mass., and London, 1990, p. 61.

3 Cf. Alvin Toffler, *The Culture Consumers. Art and Affluence in America*, New York, 1964.

4 Ibid., p. 15.

5 Ibid., p. 25.

6 Ibid., p. 72.

7 Ibid., p. 113.

8 Meyer Schapiro, *The Liberating Quality of Avant-Garde Art*, in: *ARTnews*, Vol. 56, No. 4, Summer 1957, p. 36 ff. Here quoted from: Meyer Schapiro, *Modern Art. 19th & 20th Centuries*, London, 1978, p. 213 ff.

9 Ibid., p. 224.

10 Ibid., p. 226.

11 Theodor W. Adorno, *Aesthetic Theory*, ed. by Gretel Adorno and Rolf Tiedemann; newly translated, edited, and with a translator's introduction by Robert Hullot-Kentor, Minneapolis, 1997 (Theory and History of Literature, Vol. 88), p. 234.

12 *The Collected Writings of Robert Motherwell*, ed. by Stephanie Terenzio, New York and Oxford, 1992, p. 61.

13 Newman, *Writings*, p. 160.

14 Ibid., p. 282.

15 Hess, 1969, p. 54.

16 Jules Laforgue, *L'Impressionisme* (1883), in: *Œuvres complètes*, Vol. 3, Paris, 1913, p. 125 ff. Laforgue's essay may also have interested Newman in another respect. Laforgue saw the Impressionist painting not merely as a momentary depiction of reality but also as the artistic visualization of a relationship between the irretrievable momentariness of an outer reality and the irretrievable momentariness of an inner excitement within a see-ing individual. Laforgue's analysis relating to the viewer may have been particularly interesting to Newman, as it reflected his own ideas on presence and on the viewer's experience of self when confronted by a work of art. Cf. also Max Imdahl, *Farbe. Kunsttheoretische Reflexionen in Frankreich*, Munich, 1987, p. 29 f.

17 Newman, *Writings*, p. 81 f.

18 Ibid., p. 82.

19 Ibid., p. 83.

20 Ibid., p. 68.

21 Ibid., p. 39.

22 Ibid., p. 54 f.

23 Cf. Roger Fry, *The French Post-Impressionists*, in: Roger Fry, *Vision and Design*, ed. by J. B. Bullen, London, New York, Toronto, Melbourne, 1981, p. 167. The book was first published in 1920.

24 Newman, *Writings*, p. 144 f.

25 Ibid., p. 249.

26 Ibid., p. 273.

27 Wassily Kandinsky, *On the Spiritual in Art and Painting in Particular* (Munich, 1912). In: Kandinsky, *Complete Writings on Art*, Vol. I, ed. by Kenneth C. Lindsay and Peter Vergo, London, 1982, p. 160.

28 *Art New York: The Continuity of Vision. Barnett Newman*, directed by Bruce Minnix, Channel 13 / WNDT-TV, Newark, Educational Broadcasting Company, New York, 1964. Here quoted from Julian Heynen, *Barnett Newmans Texte zur Kunst*, Hildesheim and New York, 1979, p. 101.

29 Newman, *Writings*, p. 252.

30 Cf. Heynen, op. cit., p. 101.

31 Newman, *Writings*, p. 253.

32 Josef Albers, *Interaction of Color*, New Haven and London, 1963, p. 74.

33 Newman, *Writings*, p. 251.

34 Ibid., p. 252.

35 Ibid., p. 272.

36 Ibid., p. 186.

37 Ibid., p. 254.

38 Ad Reinhardt, *25 Lines of Words on Art. Statement*, in: *It is* (New York), No. 1, Spring 1958, p. 42. Here quoted from: *Art-as-Art: The Selected Writings of Ad Reinhardt*,

edited and with an introduction by Bar-
bara Rose, New York, 1975, p. 51.
39 Ad Reinhardt, *Timeless in Asia*, in: *ART-
news*, Vol. 58, No. 9, January 1960, p. 32 ff.
40 Ad Reinhardt, *Art-as-Art*, in: *Art Inter-
national* (Zürich), VI, No. 10, December
1962, p. 36 ff. Here quoted from: *Art-as-
Art: The Selected Writings of Ad Reinhardt*,
op. cit., p. 58.
41 Newman, *Writings*, p. 187.
42 Elizabeth C. Baker, *Barnett Newman in
a New Light*, in: *ARTnews*, 67, No. 16, 1969,
p. 60.
43 Lawrence Alloway, *Notes on Barnett
Newman*, in: *Art International*, Vol. 13, No. 6,
Summer 1969, p. 39.
44 Cf. Barbara Reise, *The Stance of
Barnett Newman*, in: *Studio International*,
Vol. 179, February 1970, p. 63. Cf. Hess,
p. 143.
45 Cf. Hess, p. 143.
46 Ibid., p. 136.
47 Ibid.
48 Cf. Reise, op. cit., p. 63.
49 Cf. Newman, *Writings*, p. 194.
50 Ibid., p. 194.
51 Ibid., p. 300.
52 Ibid., p. 193.
53 Yve-Alain Bois, *Perceiving Newman*, in:
Barnett Newman, Paintings, The Pace
Gallery, New York, April 8–May 7, 1988,
p. xi.
54 Cf. Ann Gibson, *Monochrome Malerei
in Amerika seit 1950*, in: *Kunstforum Interna-
tional*, Vol. 88, March/April 1987, p. 121 f.
55 Bois, op. cit., p. x f.
56 Maurice Merleau-Ponty, *Eye and Mind*
(1961), translated by Carleton Dallery,
quoted from: M. Merleau-Ponty, *The
Primacy of Perception and Other Essays*,
ed. by James M. Edie, 1964 (8th paperback
edition, 1989), p. 162 f.

57 Max Imdahl, *Barnett Newman, Who's
Afraid of Red, Yellow and Blue III*, Stuttgart,
1971 (*Werkmonographien zur bildenden
Kunst in Reclams Universal-Bibliothek*,
No. 147), p. 15.
58 Newman, *Writings*, p. 192.
59 Ibid., p. 141.
60 Ibid., p. 256.
61 Cf. Piet Mondrian, *Die neue Gestal-
tung*, Munich, 1925 (*Bauhausbücher*, No. 5),
p. 8.
62 Newman, *Writings*, p. 257.
63 Mondrian, op. cit., p. 11.
64 Newman, *Writings*, p. 173.
65 Cf. Max Imdahl, *Farbe, Kunsttheore-
tische Reflexionen in Frankreich*, Munich,
1987, p. 127 f.
66 The examination was carried out
prior to the restoration of Newman's
painting following the attack on it perpe-
trated in April 1982. I should like to take
this opportunity to thank Heinz Althöfer,
the long-standing director of the Restau-
rierungszentrum der Landeshaupstadt
Düsseldorf (Schenkung Henkel), for having
kindly placed the copious records of his
examination at my disposal.
67 Newman, *Writings*, p. 163.
68 Ibid, p. 178.
69 Ibid., p. 187.
70 Ibid., p. 190.
71 Ibid., p. 246.
72 Ibid., p. 250.
73 Ibid., p. 252.
74 Ibid., p. 257.
75 Ibid., p. 289.
76 Ibid., p. 292.
77 Ibid., p. 307.
78 Maurice Merleau-Ponty, *Phenomenol-
ogy of Perception*, translated by Colin Smith
(1962), London and New York, 1996,
p. 320.

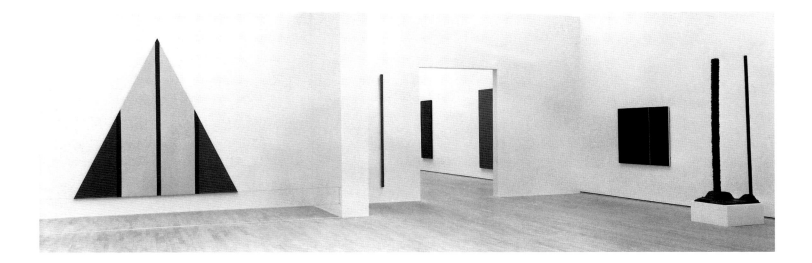

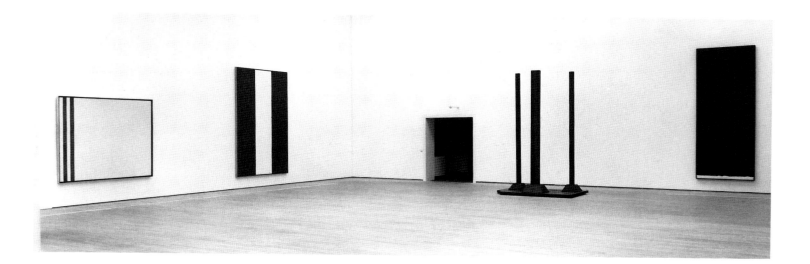

Barnett Newman Exhibition, Kunstsammlung Nordrhein-Westfalen,
Düsseldorf 1997; installation view

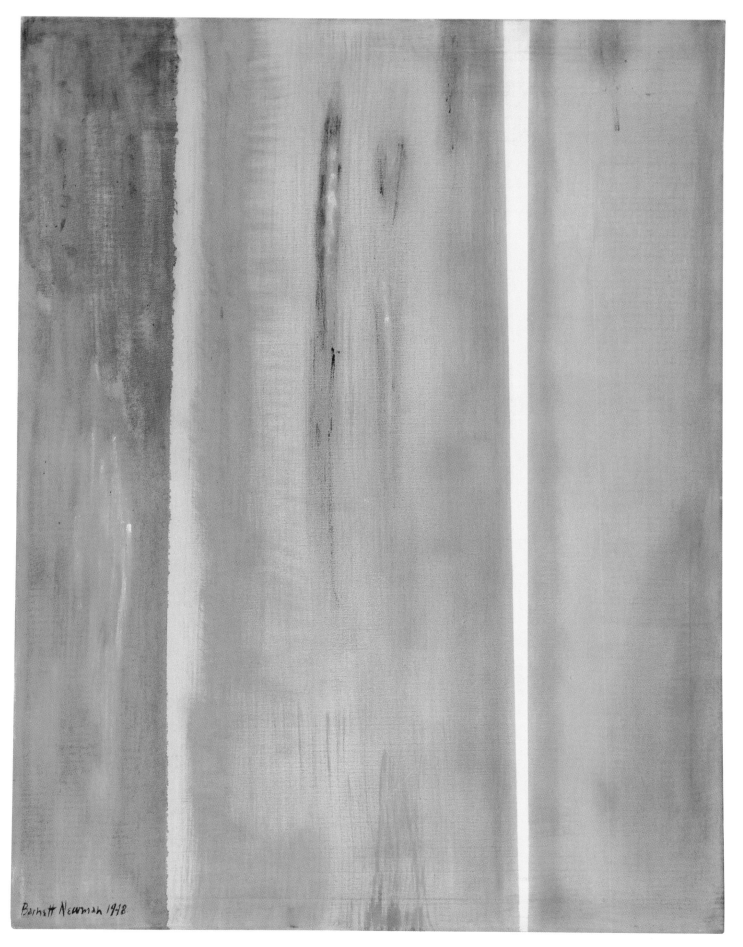

46 *Two Edges*, 1948 (Cat. No. 2)
The Museum of Modern Art, New York. Gift of Annalee Newman, 1990

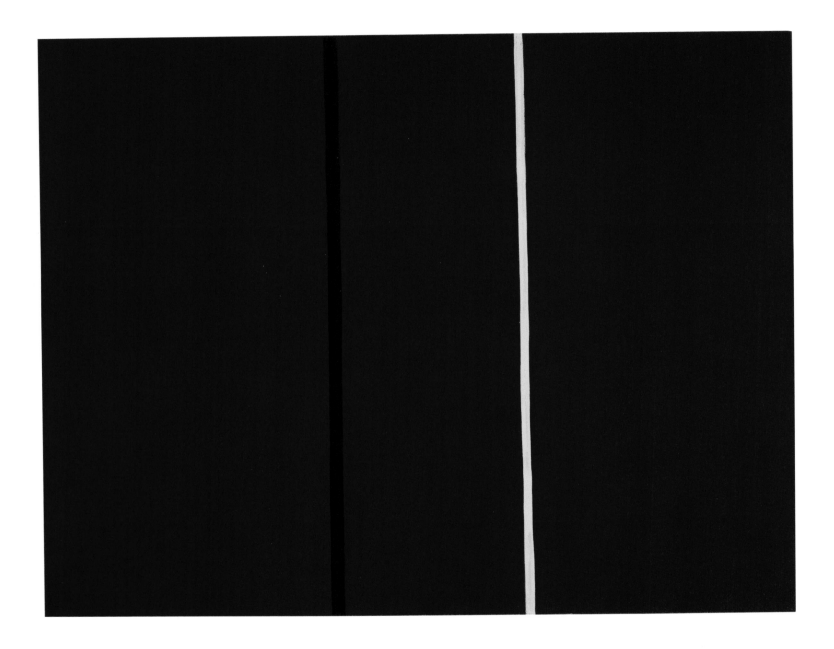

47 *Covenant*, 1949 (Cat. No. 4)
Hirshhorn Museum and Sculpture Garden, Smithsonian Institution, Washington, D.C.
Gift of Joseph H. Hirshhorn, 1972

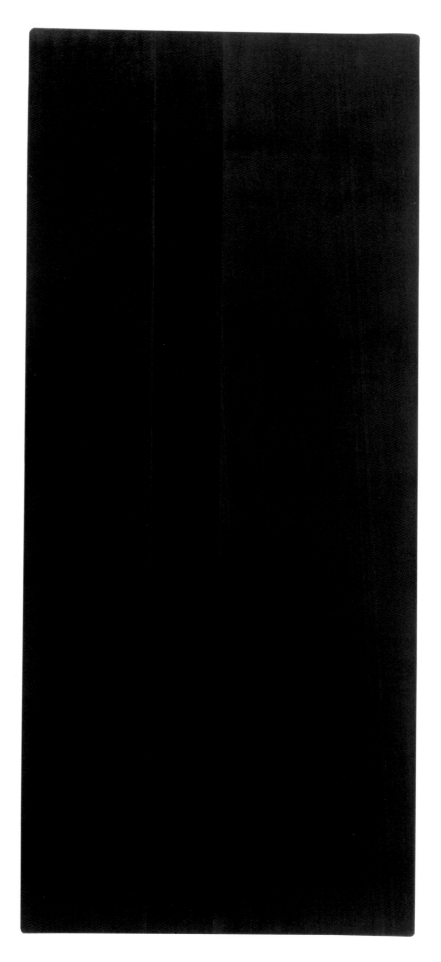

48 *Abraham*, 1949 (Cat. No. 3)
The Museum of Modern Art, New York. Philip Johnson Fund, 1959

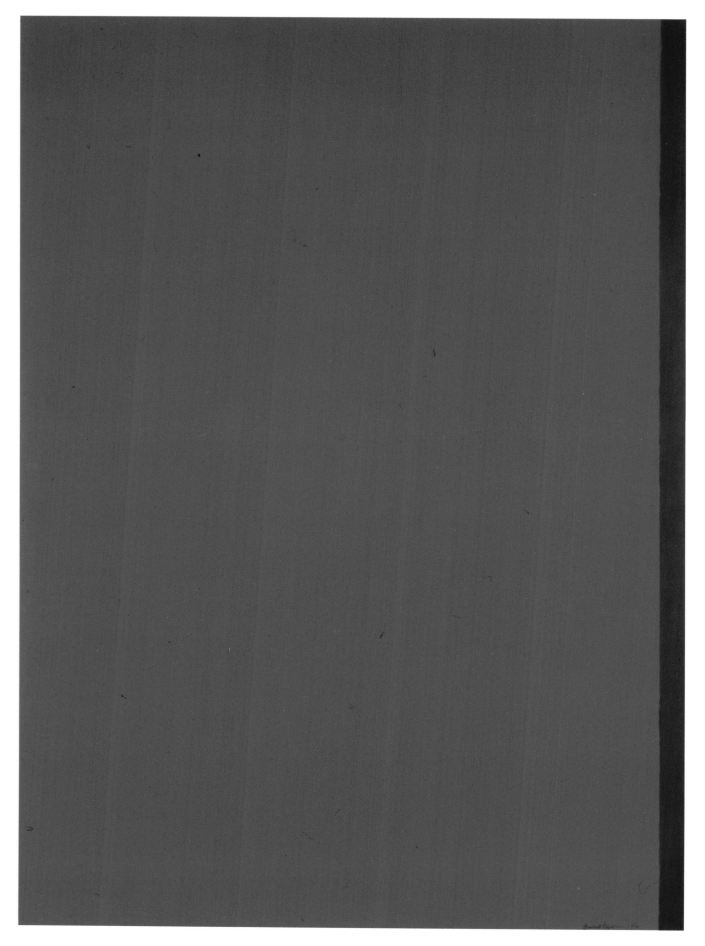

49 *Eve*, 1950 (Cat. No. 6)
Tate Gallery, London. Purchased 1980

50 *The Wild*, 1950 (Cat. No. 5)
The Museum of Modern Art, New York. Gift of the Kulicke Family, 1969

51 *Cathedra*, 1951 (Cat. No. 8)
Stedelijk Museum, Amsterdam

52 Untitled (Number 2), 1950 (Cat. No. 7)
The Menil Collection, Houston

53 *Achilles*, 1952 (Cat. No. 10)
National Gallery of Art, Washington, D.C. Gift of Annalee Newman
in honor of the fiftieth anniversary of the National Gallery of Art (1988.57.5)

54 *Prometheus Bound*, 1952 (Cat. No. 9)
Museum Folkwang, Essen

55 *Tertia*, 1964 (Cat. No. 11)
Moderna Museet, SKM, Stockholm

56 *Shimmer Bright*, 1968 (Cat. No. 14)
The Metropolitan Museum of Art, New York. Gift of Annalee Newman, 1991

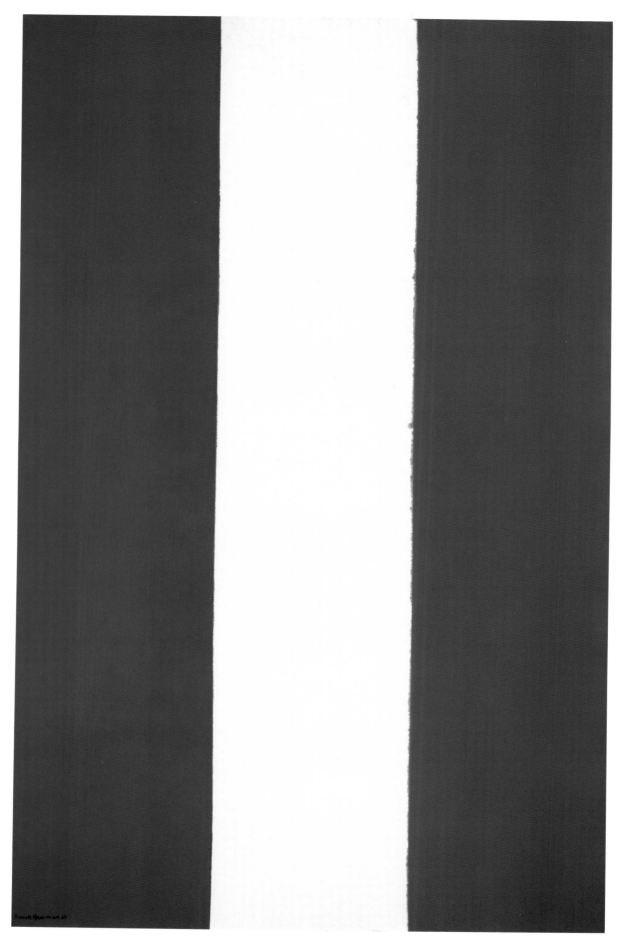

57 *Profile of Light*, 1967 (Cat. No. 12)
Museo Nacional Centro de Arte Reina Sofía, Madrid

58 *Jericho*, 1968/69 (Cat. No. 15)
Musée national d'art moderne, Centre Georges Pompidou, Paris
Joint purchase with B. and E. Goulandris (1986)

59 *Chartres*, 1969 (Cat. No. 16)
Daros Collection, Switzerland

60 *Anna's Light*, 1968 (Cat. No. 13)
Kawamura Memorial Museum of Art

61 *Who's Afraid of Red, Yellow and Blue IV*, 1969/70 (Cat. No. 17)
Staatliche Museen zu Berlin – Preußischer Kulturbesitz
Nationalgalerie und Verein der Freunde der Nationalgalerie

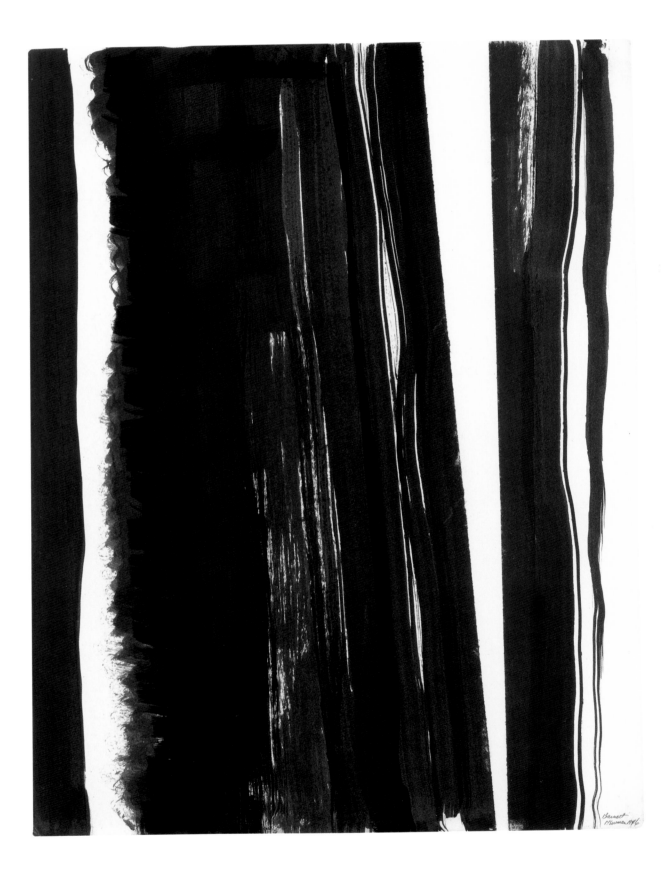

62 Untitled, 1946 (Cat. No. 20)
Mr. and Mrs. Stanley R. Gumberg

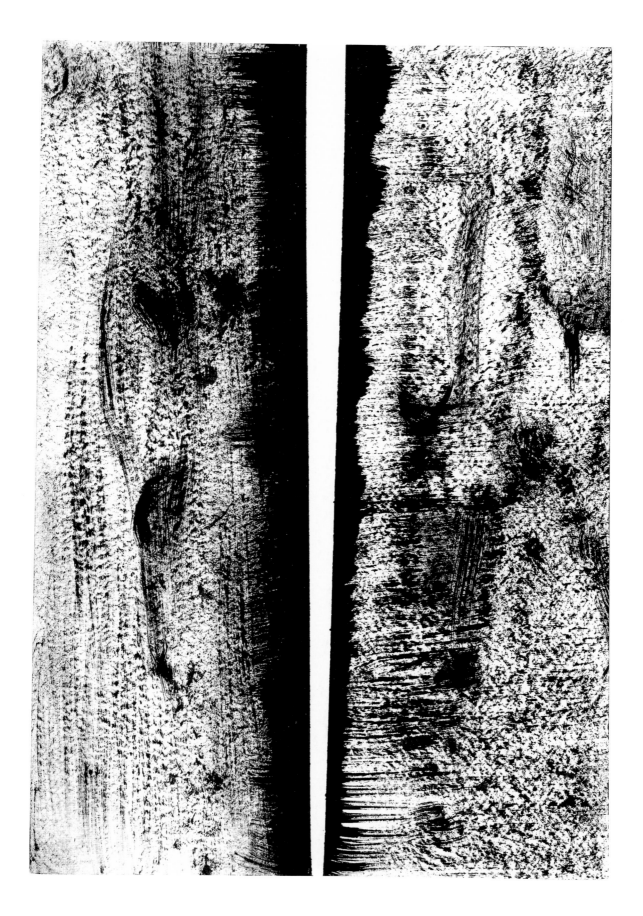

63 Untitled (*The Break*), 1946 (Cat. No. 21)
Musée national d'art moderne, Centre Georges Pompidou, Paris
Gift of Annalee Newman with the aid of Georges Pompidou Art and Culture Foundation, 1986

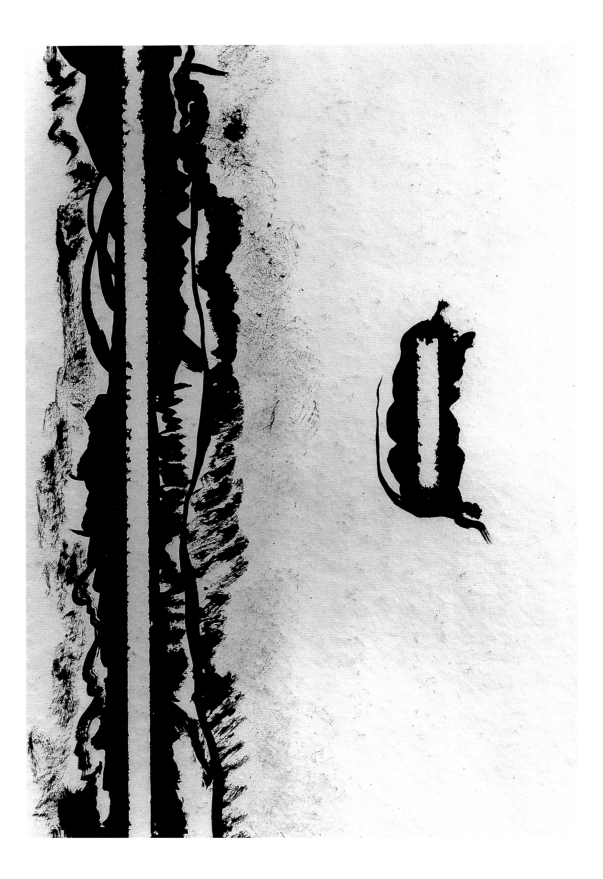

64 Untitled, 1946 (Cat. No. 22)
Collection Richard Serra and Clara Weyergraf-Serra

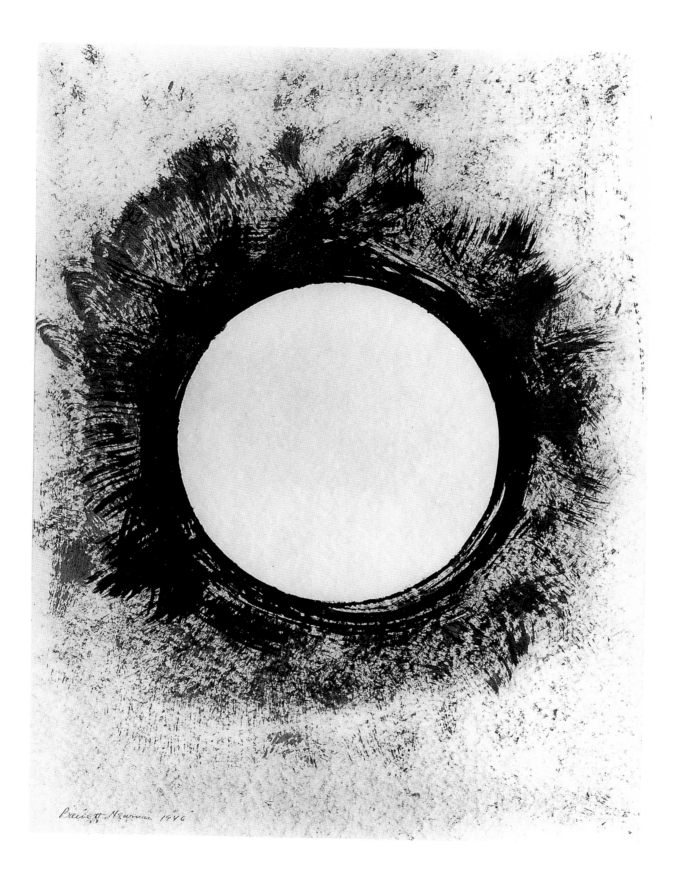

65 Untitled, 1946 (Cat. No. 23)
Louisiana Museum of Modern Art, Humlebaek. Gift of Annalee Newman

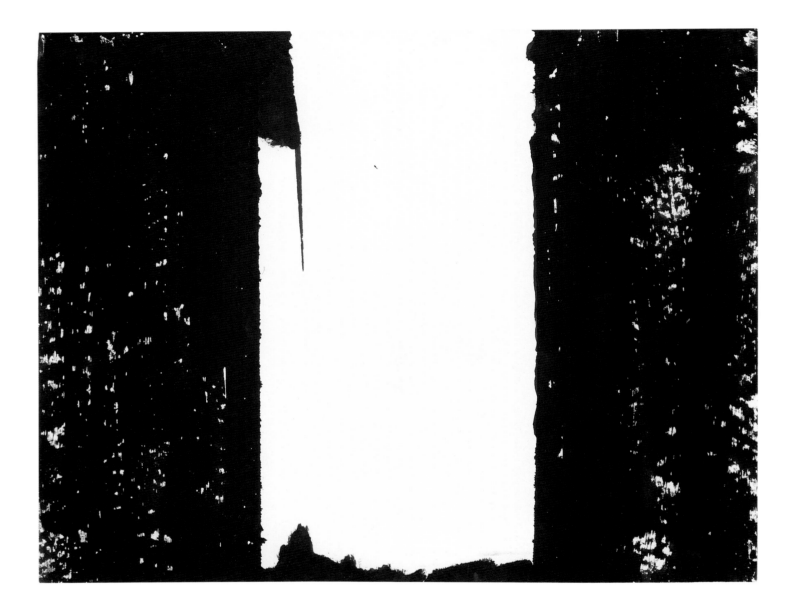

66 Untitled, 1949 (Cat. No. 25)
Courtesy Anthony d'Offay Gallery, London

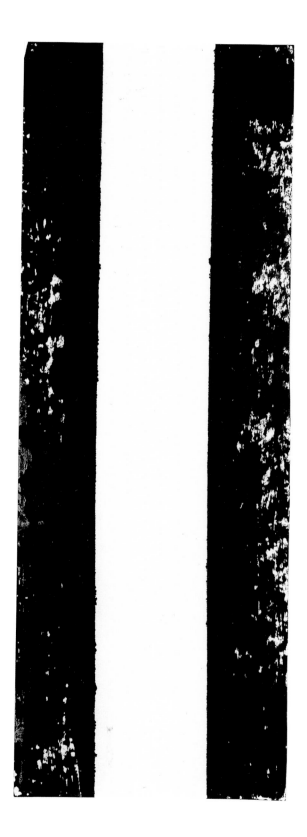

67 Untitled, 1949 (Cat. No. 26)
The Menil Collection, Houston

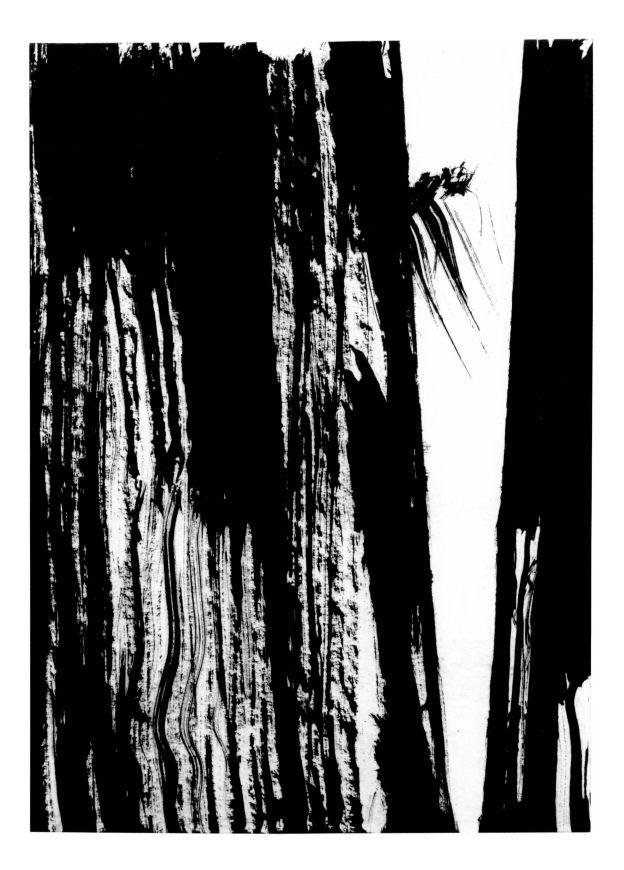

68 Untitled, 1946 (Cat. No. 24)
Constance R. Caplan, Baltimore

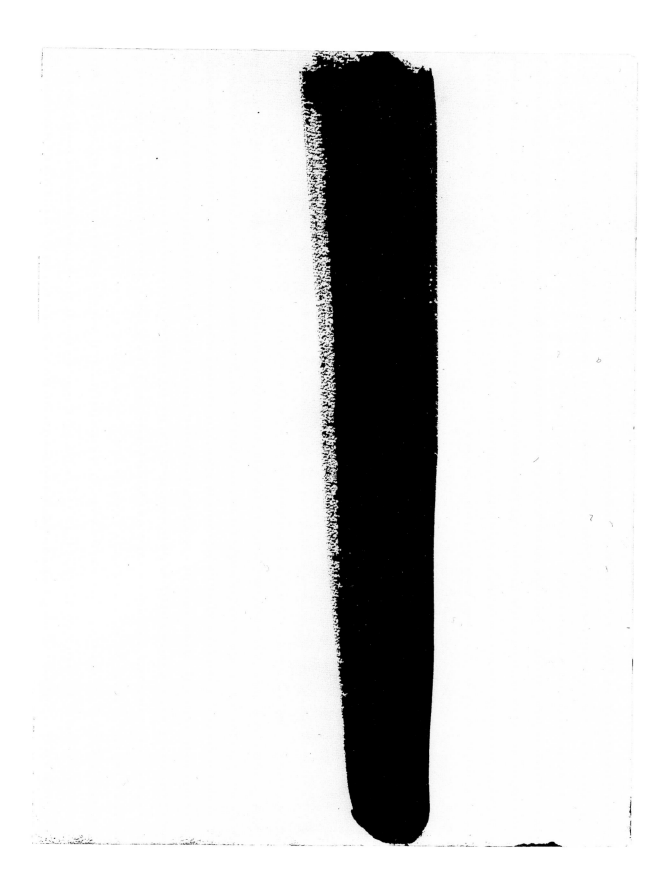

69 Untitled, 1960 (Cat. No. 27)
The Metropolitan Museum of Art, New York. Gift of Annalee Newman, 1992

70 Untitled, 1960 (Cat. No. 28)
The Art Institute of Chicago. Through prior gift of the Charles H. and Mary F. S. Worcester Collection

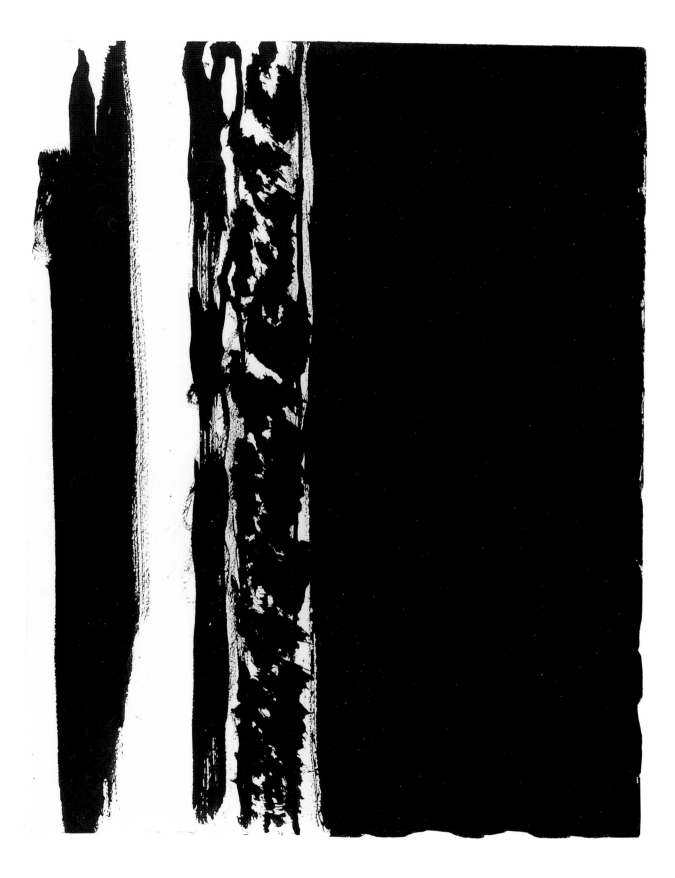

71 Untitled, 1960 (Cat. No. 31)
Louisiana Museum of Modern Art, Humlebaek. Gift of Annalee Newman

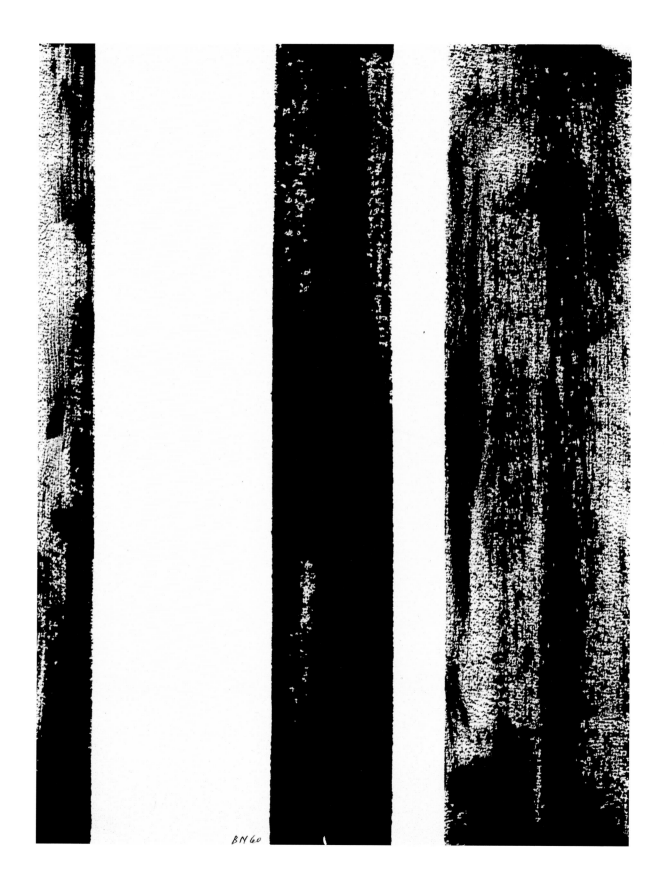

BN60

72 Untitled, 1960 (Cat. No. 30)
The Art Institute of Chicago. Through prior gift of Mrs. Arthur T. Aldis

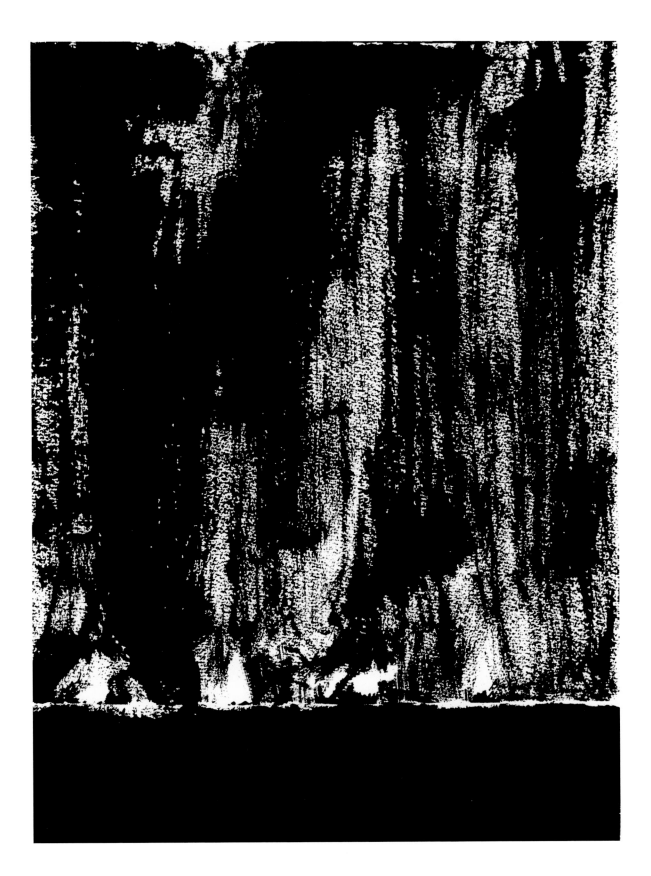

73 Untitled, 1960 (Cat. No. 29)
The Art Institute of Chicago. Through prior gift of the Charles H. and Mary F. S. Worcester Collection

74 *18 Cantos*, 1963/64 (Cat. No. 32)
Portfolio of 19 colored lithographs: 18 prints and title page
Original box (designed by the artist, hand-made by Caroline Horton)
With preface and dedication to Annalee Newman, and colophon page
Limited edition, No. 9/18
Staatliche Museen zu Berlin – Preußischer Kulturbesitz, Kupferstichkabinett

Title Page, 1964

BARNETT NEWMAN
"18 CANTOS"

A volume to be used as a book,
boxed, containing nineteen original lithographs,
consisting of 18 Cantos and a title page by
Barnett Newman,
together with a preface written by the artist and a colophon page,
and dedicated to Annalee Newman.
The edition consists of eighteen volumes of which this volume is
Number 9

The papers used are British, French Angoumois and Japanese hand-made papers.

The artist used American and French inks—straight, without mixing.
The lithographs were printed on a handpress by Zigmunds Priede in the studio of the
Universal Limited Art Editions, publisher, West Islip, Long Island, New York.
All the stones are effaced.

Each lithograph is signed and numbered by the artist and embossed with the seal of the publisher.

The box is hand-made by Mrs. Caroline Horton,
bound in vellum with the artist's initials drawn by him and embossed.

Typography and page-design of the preface and colophon are by Herbert Matter.

Publication was directed by Tatyana Grosman.

[ULAE]

Colophon Page, 1964

To Annalee

I should say that it was the margins made in printing a lithographic stone that magnetized the challenge that lithography has had for me from the very beginning. No matter what one does, no matter how completely one works the stone (and I have always worked the stone the same way I paint and draw—using the area—complete), the stone, as soon as it is printed, makes an imprint that is surrounded by inevitable white margins. I would create a totality only to find it change after it was printed—into another totality. Theoretically a lithograph consists of the separation between the imprint and the paper it is *on*. Unfortunately it never works that way for me. There is always the inevitable intrusion (in my lithograph at least) of the paper frame. To crop the extruding paper or to cover it with a mat or to eliminate all margins by "bleeding" (printing on papers smaller than the drawing on the stone) is an evasion of this fact. It is like cropping to make a painting. It is success by mutilation.

The struggle to overcome this intrusion—to give the imprint its necessary scale so that it could have its fullest expression, (and I feel that the matter of scale in a lithograph has usually not been considered)—so that it would not be crushed by the paper margin and still have a margin—that was the challenge for me. That is why each canto has its own personal margins. In some, they are small, in others large, still in others they are larger on one side and the other side is minimal. However, no formal rules apply. Each print and its paper had to be decided by me and in some cases the same print exists with two different sets of margins because each imprint means something different to me. In painting, I try to transcend the size for the sake of scale. So here I was faced with the problem of having each imprint transcend not only its size but also the white frame to achieve this sense of scale.

These eighteen cantos are then single, individual expressions, each with its unique difference. Yet since they grew one out of the other, they also form an organic whole—so that as they separate and as they join in their interplay, their symphonic mass lends additional clarity to each individual canto, and at the same time, each canto adds its song to the full chorus.

I must explain that I had no plan to make a portfolio of "prints". I am not a printmaker. Nor did I intend to make a "set" by introducing superficial variety. These cantos arose from a compelling necessity—the result of grappling with the instrument.

To me that is what lithography is. It *is* an instrument. It is not a "medium"; it is not a poor man's substitute for painting or for drawing. Nor do I consider it to be a kind of translation of something from one medium into another. For me, it is an instrument that one plays. It is like a piano or an orchestra, and as with an instrument, it *interprets*. And as in all the interpretive arts, so in lithography, creation is joined with the "playing"; in this case not of bow and string, but of stone and press. The definition of a lithograph is that it is writing on stone. But unlike Gertrude Stein's rose, the stone is not a stone. The stone is a piece of paper.

I have been captivated by the things that happen in playing this litho instrument; the choices that develop when changing a color or the paper-size. I have "played" hoping to evoke every possible instrumental lick. The prints really started as three, grew to seven, then eleven, then fourteen, and finished as eighteen. Here are the cantos, eighteen of them, each one different in form, mood, color, beat, scale and key. There are no cadenzas. Each is separate. Each can stand by itself. But its fullest meaning, it seems to me, is when it is seen together with the others.

It remains for me to thank Cleve Gray for bringing me to lithography, particularly at the time he did, Tatyana Grosman for her devotion and encouragement and patience in my behalf and to Zigmunds Priede for his sympathetic cooperation on the press.

Barnett Newman

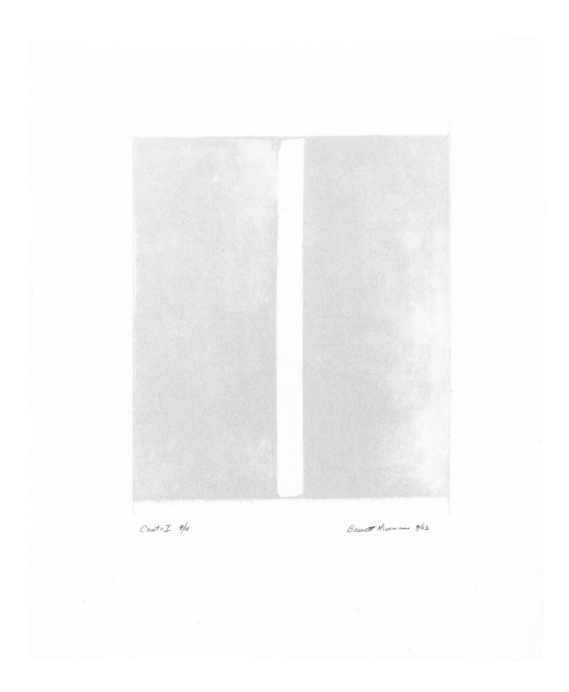

Canto I 9/18 Barnett Newman 9/63

Canto I, 1963

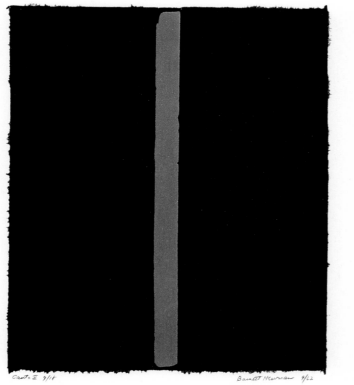

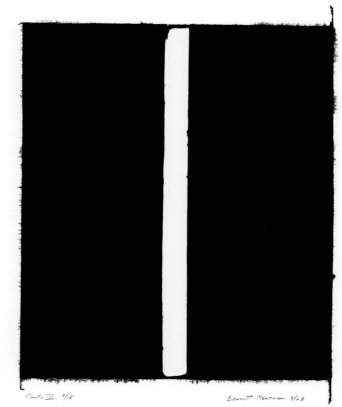

Canto II, 1963

Canto III, 1963

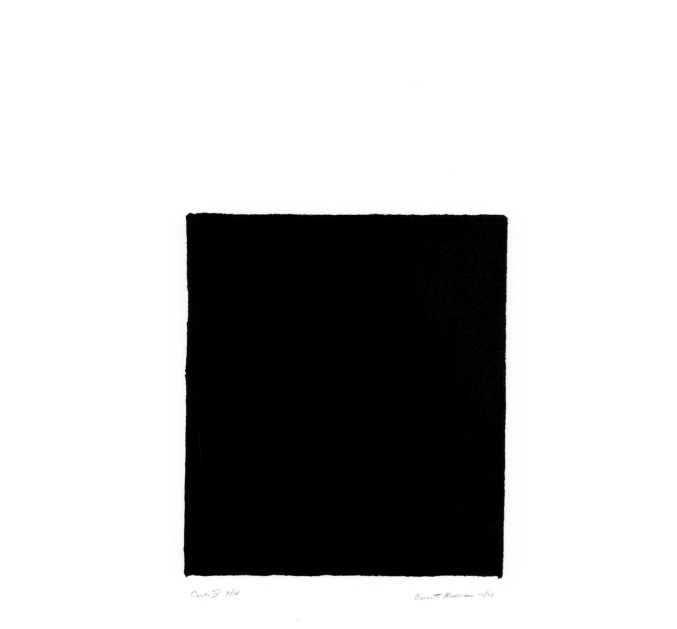

Canto IV 9/18 Barnett Newman 10/63

Canto IV, 1963

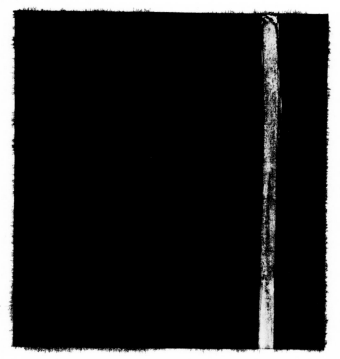

Canto V 9/18

Barnett Newman 11/63

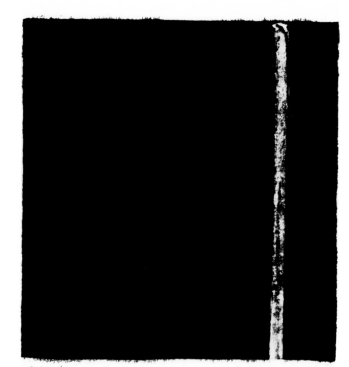

Canto VI 9/18

Barnett Newman 11/63

Canto V, 1963

Canto VI, 1963

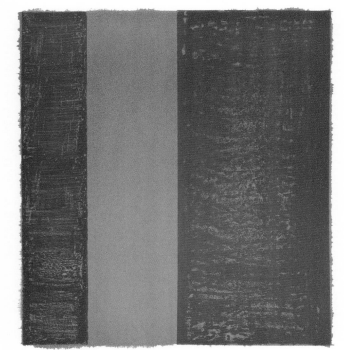

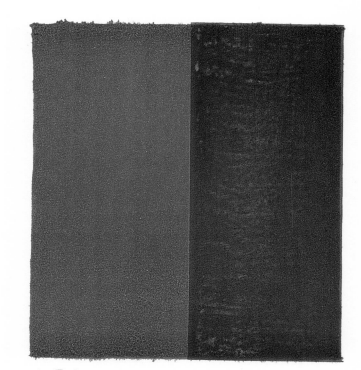

Canto VII, 1963 *Canto VIII, 1963*

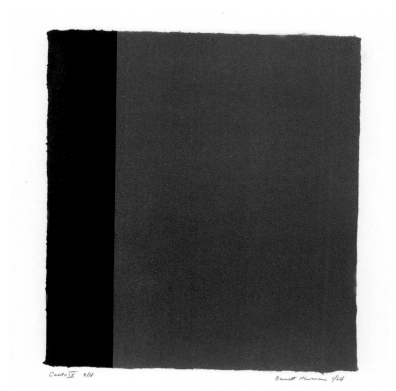

Canto IX, 1964

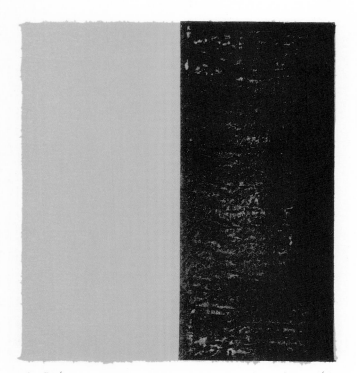

Canto X 9/18 Barnett Newman x/64

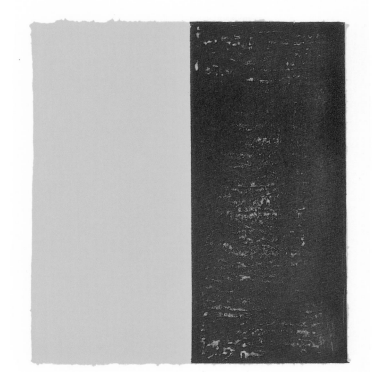

Canto XI 9/18 Barnett Newman x/64

Canto X, 1964

Canto XI, 1964

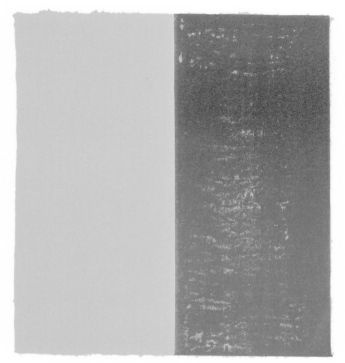

Canto XII 9/18 Barnett Newman 3/64

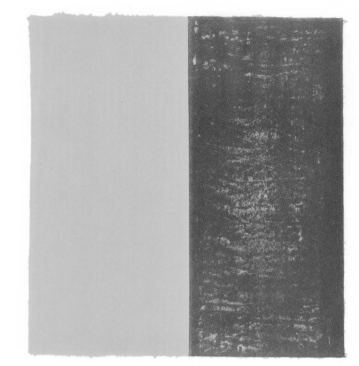

Canto XIII 9/18 Barnett Newman 3/64

Canto XII, 1964 *Canto XIII, 1964*

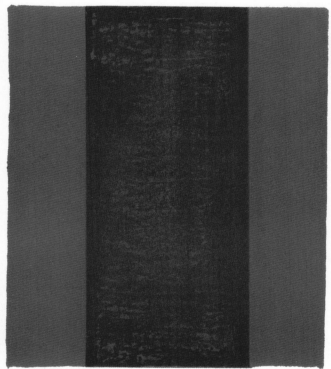

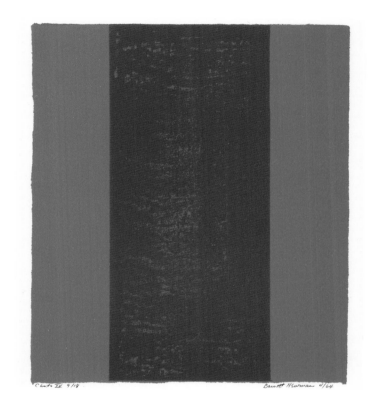

Canto XIV, 1964 Canto XV, 1964

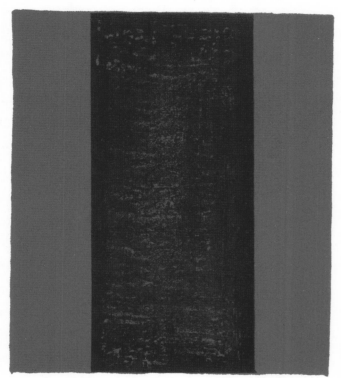

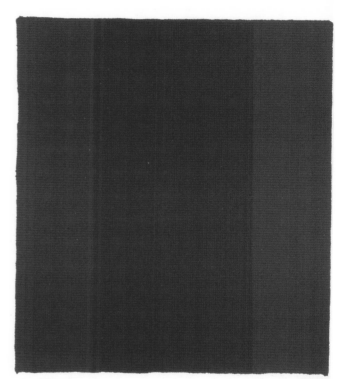

Canto XVI, 1964

Canto XVII, 1964

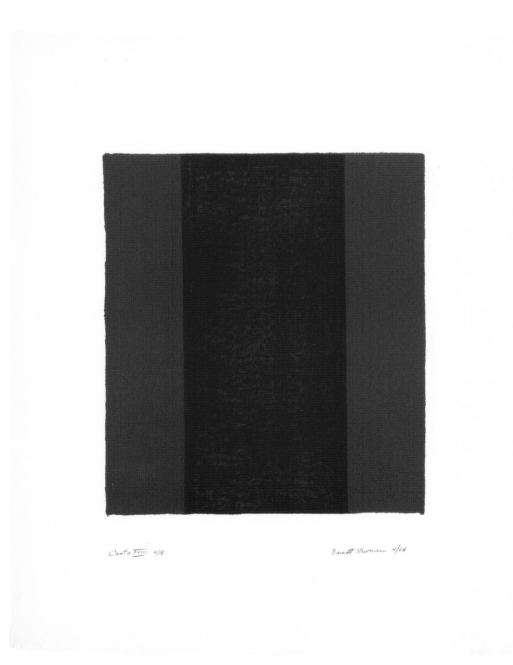

Canto *XVIII* 4/8 Barnett Newman 4/64

Canto XVIII, 1964

75 *Notes*, 1968 (I–XII) (Cat. No. 33)
18 etchings (limited edition, No. 4/7)
Öffentliche Kunstsammlung Basel, Kupferstichkabinett
Gift of Annalee Newman, the artist's widow, 1979

Note I, 1968 Note II, 1968

Note III, 1968

Note IV, 1968

Note V, 1968 Note VI, 1968

Note VII 1968
4/7

Note VII, 1968

Note VIII – State I 1968
4/7

Note VIII – State II 1968
4/7

Note VIII – State I, 1968

Note VIII – State II, 1968

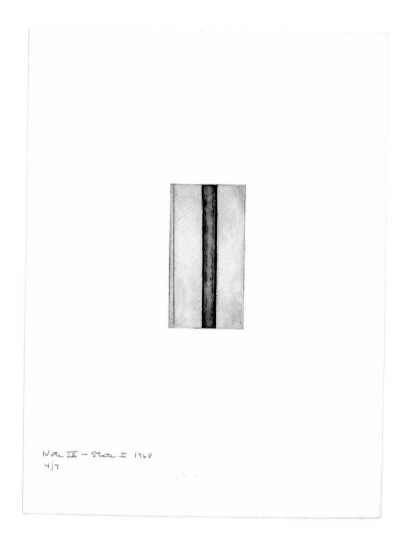

Note IX — State I 1968
4/7

Note IX – State I, 1968

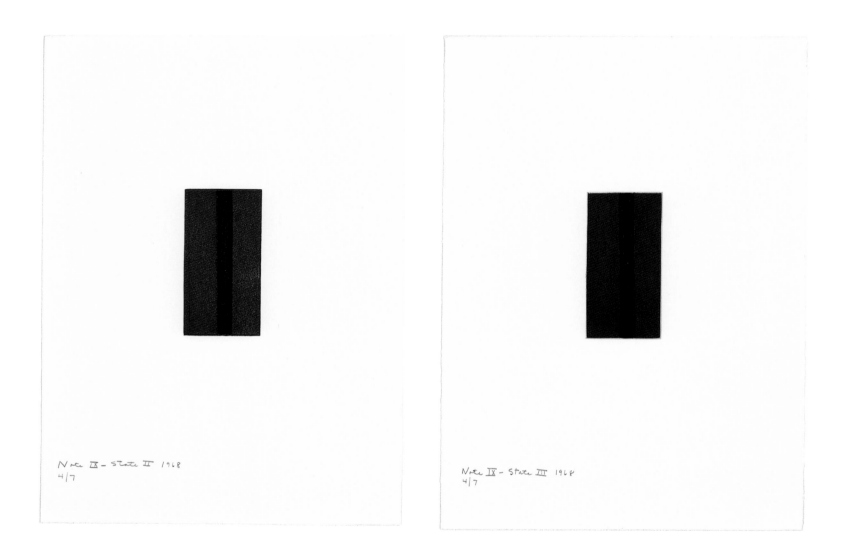

Note IX – State II, 1968

Note IX – State III, 1968

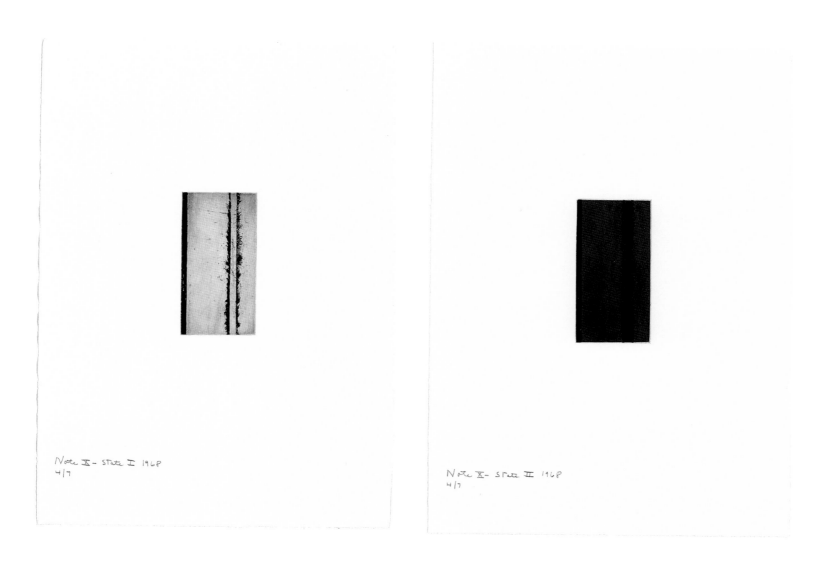

Note X – State I, 1968 *Note X – State II, 1968*

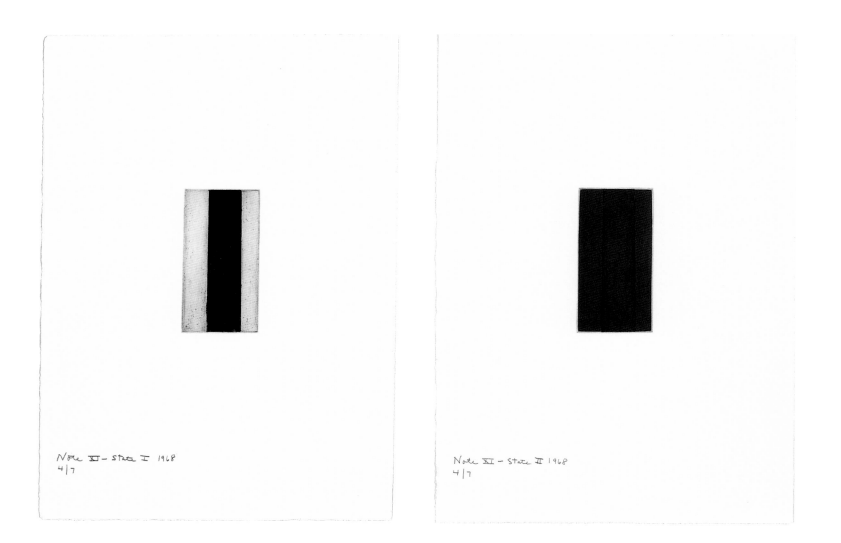

Note XI – State I, 1968 *Note XI* – State II, 1968

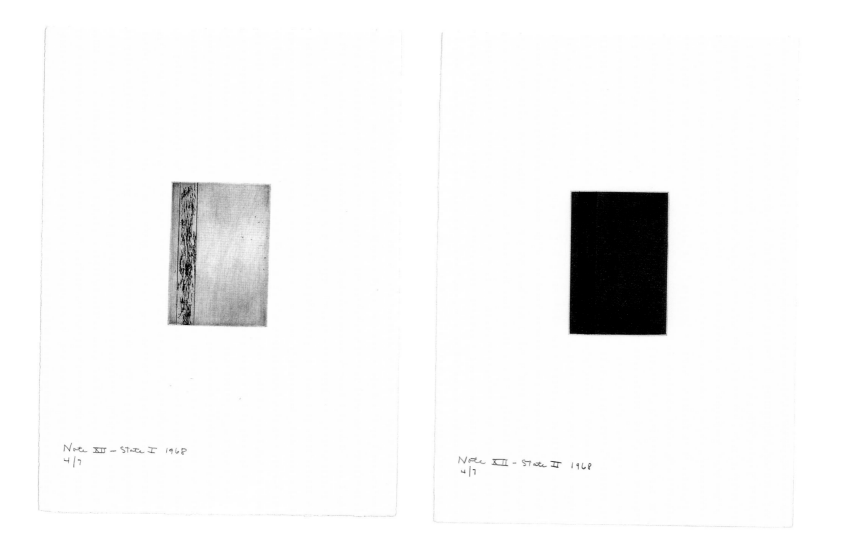

Note XII – State I, 1968
1968
4/7

Note XII – State II, 1968
1968
4/7

Note XII – State I, 1968

Note XII – State II, 1968

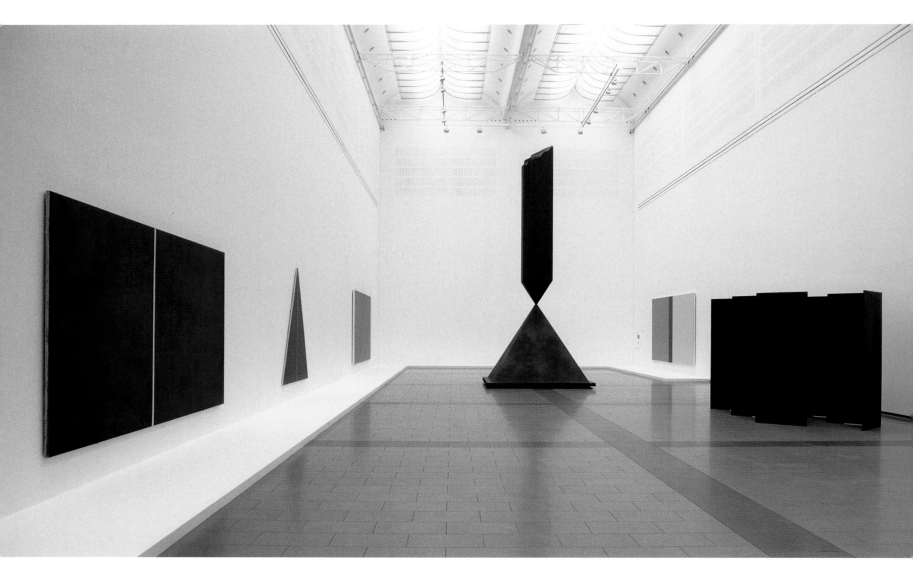

Installation view of ground-floor hall of the Kunstsammlung Nordrhein-Westfalen, Düsseldorf, 1997

Barnett Newman always saw himself as a painter, a view that is reflected in the volume of his production in other media. Besides approximately 110 paintings, Newman produced more than 80 drawings, 42 prints, only seven or eight sculptures (depending on whether the plaster and the bronze versions of "Here I" count as two separate sculptures or not), one architectural model, and one multiple. Moreover, the chronology of Newman's production[1] reveals the paucity of his oeuvre as a whole. Compared with that of other artists of his generation, Newman's production was rather modest in quantity. In their respective monographs, both Thomas B. Hess and Harold Rosenberg concentrate on Newman's paintings, paying only cursory attention to other aspects of his oeuvre, although in 1971 Rosenberg did devote an essay to Newman's sculptures. His index of Newman's sculptures, which included both technical details and exhibition and publication history, comes at the end of a small publication marking the dedication of one of the exemplars of "Broken Obelisk" on the campus of the University of Washington in Seattle.[2] Indeed, instead of adopting a comprehensive approach to Newman's work, art historians during the past twenty years have been concentrating on its individual aspects. Mention may be made here, for example, of Brenda Richardson's catalog of Newman's drawings[3], published in 1979; of Julian Heynen's study of Newman's writings on art[4], also published in 1979, and of the actual publication of these writings in 1990; of Jeremy Strick's analysis of Newman's early works, published in 1994[5]; and of Gabriele Schor's treatise on Newman's prints, published in 1996.[6] I shall, in the context of this exhibition, be dealing with Newman's sculptures and his architectural model quite exhaustively, not with the intention of preparing the ground for a catalogue raisonné, but with a view to describing and discussing the essential aspects of these works against the background of interpretations published since 1971, e.g. by Franz Meyer, Stephen Polcari, and Robert Murray, among others.

The plaster version of "Here I" was produced in 1950, followed by two versions in bronze in 1962. In 1965/66, Newman produced "Here II" and "Here III" from, respectively, COR-TEN steel and a combination of COR-TEN and stainless steel. The sense of isolation conveyed by the stele of "Here III" was heightened in 1967 in what must be Newman's best known work, "Broken Obelisk", an extraordinarily impressive work intended as a public sculpture. In all of his vertical structures, Newman was concerned with marking the place, emphasizing its presence, breaking the horizon, as he once said, and correlating the observer and the work in such a way that, in the observer's esthetic experience, the awareness of the object and the awareness of self partially overlap, even become synonymous.

Put more simply, the stelae of Newman's "Here I", "Here II", and "Here III" are the physical, three-dimensional equivalents of the vertical stripes—the so-called zips—of Newman's paintings, the material substrate, as it were, of their immateriality. Residing in all of

these hierarchical works is the esthetic experience central to their reception, namely our awareness that something is there, both for us, the beholders, and for the work itself. With "Broken Obelisk", however, Newman takes a completely different course, although the sculpture's verticality, which is particularly accentuated—and seemingly jeopardized at the same time—keeps this from being immediately obvious. The joining of a pyramid and an inverted obelisk visualizes two principles, a static one in the precarious balancing act, and a dynamic, compositional one in the combination of slanting and orthogonal lines. Here Newman embarks upon an esthetic strategy which is without parallel in his oeuvre of the fifties and sixties. His intention, however, is still the totality of experience and the creation of an overwhelming visual impression.

There was now another problem with which Newman had to concern himself, namely that of the relationship of space and time in a static structure. Newman first encountered the problem when working on his Model for a Synagogue in 1963. The outcome of this exercise (Newman was invited to exhibit among the established architectural fraternity of, among others, Philip Johnson, Frank Lloyd Wright, and Louis I. Kahn) is as unusual as the events leading up to it. The zigzag formation of the windows of his Synagogue Model anticipated two sculptures which were to mark Newman's radical change of position. "Zim Zum I", 1969, and the posthumously fabricated "Zim Zum II" are each without a base, consist of two parts, and are meant to be viewed not only from the outside but also from the inside. In other words, the viewer must walk both round the works and through them. They become comprehensible only through the immediate physical experience of their exteriors and, more important, their interiors. In both versions, which differ only in size, not structure, the emphasis has shifted from the optical to the physical, from the indirectness of the painting to the directness of perceived movement. The experience of space changes, as it were, into an experience of time. Thus the autonomy of the subject is confirmed in two ways, the intellectual and the psychophysical, with no firm boundaries between them. Whilst in the esthetic experience of the stelae the identity and autonomy of both the subject and the object are preserved, here it is the object, i.e. the sculpture, which defines the self through the viewer's own experience of self in the process of perception.

Compared with the subdued monumentality of "Zim Zum", the precarious balancing act of "Broken Obelisk" seems antiquated. Whilst I do not mean this in a derogatory way, it cannot be denied that "Broken Obelisk" brought a specific tradition of monumental sculpture to an impressive climax precisely at a time when American sculpture had long since begun to move in a completely different direction. Thus Newman's sculptural legacy lies, rather, in the two versions of "Zim Zum". Entirely unburdened by associations of the kind evoked by stelae, pyramids, and obelisks, "Zim Zum" is a rhythmic arrangement of iden-

BARNETT NEWMAN'S SCULPTURES

217

tical parts, i.e. a parallel repetition of plain rectangular shapes. As we shall see, however, Newman comes nowhere near to Minimal Art, nor to those configurations of extreme self-experience which were to herald a new turning point in sculpture in the seventies.

Barnett Newman's sculptures occupied a middle position: Newman dissociated himself from the movement which challenged the "pedestal tradition" and saw sculpture as a material collage of horizontal rather than vertical structure—David Smith was this movement's exemplar, and Anthony Caro its most important exegete; and Newman also kept his distance from younger sculptors, such as Stella, Judd, and Andre. Thus Newman was able to maintain his approach to art as something transcendental, as a "metaphysical exercise", categorically rejecting all non-relational principles. The notion of "form" was foreign to him, for his art was concerned primarily with the experience of presence, place, and identity. When we stand before and/or inside one of Newman's sculptures—and here I am thinking chiefly of "Zim Zum II"—two things happen simultaneously: the subject is both overwhelmed and confirmed, though not to an equal extent: whilst the sense of being overwhelmed is a relatively latent one, the sense of being confirmed is much stronger and virtually taken for granted. Indeed, in the final analysis it is the viewer who remains in command of the situation. Admittedly, even during Newman's lifetime, a number of artists were already beginning to undermine and call in question those basic principles which presupposed an unproblematic relationship between subject and object. Bruce Nauman and Richard Serra, to name but two of the most prominent exponents of this new approach, use experiences of "negative desire" (Kant) and develop works which are occasionally reminiscent of experimental set-ups. Virtually imprisoned by such constellations, the viewer finds himself in a situation which evokes unease, even apprehension. The esthetic experience is accompanied by a feeling of impotence, with the result that only a voluntaristic act of self-assertion can preserve the subject's autonomy. Whilst there is indeed a connection—albeit a loose one—between such works and Newman's posthumously fabricated sculpture "Zim Zum II", there is only an outward similarity between "Broken Obelisk" and, say, Serra's "Sight Point" of 1972/75—no analogies beyond those of verticality and balance can be drawn between these two works.

Newman's independence as a sculptor manifests itself not least in an astonishing work which must be viewed in the context of politically committed art. Whilst "Lace Curtain for Mayor Daley" has no parallels in Newman's oeuvre, it is a work which only Newman could have conceived and realized. Unwieldy yet pointed, "Lace Curtain for Mayor Daley" is a work through which the artist Barnett Newman speaks to us as an enlightened citizen, reflecting upon the interests of the community in a way which, in terms of abstract imagery, could not be more concrete.

"Here I" (in plaster), "Lace Curtain for Mayor Daley", the Synagogue Model, and the two versions of "Zim Zum" exist in only one copy, whilst "Here I" (in bronze) and "Here II" each exist in two exemplars, and there are three exemplars each of "Here III" and "Broken Obelisk". All told, a small oeuvre, but one which shows the precise and reflective way in which Newman worked. Nothing was further from his mind than the desire to decorate urban environments, or to satisfy art collectors' passions, or to help fulfill the encyclopedic purpose of the art museums. Each sculpture (including the Synagogue Model) is a work in its own right. Each is a convincing solution to a specific problem. Each is original, compelling, and impressive. For all its paucity, Newman's sculptural oeuvre operates on a very broad scale, reaching beyond existing horizons, and clearly and succinctly marking out new, exemplary positions. It is an oeuvre which not only significantly complements Newman's paintings[7] but also constitutes a substantially independent complex within his oeuvre as a whole. Unlike his paintings, Newman's sculptures do not invite analogy with the works of other artists. Although they do have a certain habitual and spiritual affinity with many of the works of Walter de Maria, any formal similarities are so slight that they are of no consequence. Newman's sculptures do, however, corroborate the view—a view particularly relevant to the first half of the twentieth century—that the credit for many an important innovative style in sculpture must be given to artists who were chiefly painters, not sculptors. The following chapters not only examine the specific qualities of Newman's sculptures but also place them in a larger context, thus defining Newman's position more clearly than has hitherto been the case. Rather than describe them in their entirety—no matter how systematic such a description might have been—I have preferred to analyze the works individually and in the chronological order of their making; the visual aspect of each work, not its title, has been the starting point of my reflections.

1 Richardson, p. 17.

2 Harold Rosenberg, *Barnett Newman: "Broken Obelisk" and Other Sculptures.* Index of Art in the Pacific Northwest, No. 2, Seattle and London, 1971.

3 Barnett Newman, *The Complete Drawings, 1944–1969*, ed. by Brenda Richardson, The Baltimore Museum of Art, 1979.

4 Julian Heynen, *Barnett Newmans Texte zur Kunst*, Hildesheim and New York, 1979 (*Studien zur Kunstgeschichte*, Bd. 10).

5 Jeremy Strick, *Enacting Origins*, in: *The Sublime is Now: The Early Work of Barnett Newman. Paintings and Drawings 1944–1949*, exhibition catalog, Walker Art Center, Minneapolis, 1994, pp. 7–31.

6 Gabriele Schor, *Barnett Newman. Die Druckgraphik 1961–1969*, Ostfildern-Ruit, Stuttgart, 1996.

7 Rosenberg, op. cit., p. 10.

I

When during the artists' discussions at Studio 35 on April 22, 1950, the question was raised as to whether paintings should have titles, Barnett Newman joined in the search for an answer: "I think it would be very well if we could title pictures by identifying the subject matter so that the audience could be helped. I think the question of titles is purely a social phenomenon. The story is more or less the same when you can identify them. I think the implication has one of two possibilities: (1) We are not smart enough to identify our subject matter, or (2) language is so bankrupt that we can't use it. I think both are wrong. I think the possibility of finding language still exists, and I think we are smart enough. Perhaps we are arriving at a new state of painting where the thing has to be seen for itself."[1]

Newman's comment reveals a certain indecisiveness. Whilst he advocates the use of titles to describe the subject matter, he also says that a painting should speak for itself, making any title either superfluous or misleading. Here Newman comes close to the "art for art's sake" position of Ad Reinhardt who, during the discussion, had maintained that titles had nothing to do with paintings themselves.[2] The direction in which Newman's thoughts were taking him became a little clearer on the next day of the debate. When the discussion turned to finding a name for the art movement to which the painters and sculptors felt they belonged—Abstract Expressionist, Abstract Symbolist, Abstract Objectionist—James Brooks and Bradley Walker Tomlin threw in for discussion such epithets as "direct" and "concrete". Newman suggested "self-evident" because, he said, the image was concrete. If we follow Robert Goodnough's account of this three-day debate, we will note that Newman hovered between two standpoints: either the subject matter of art is recognizable, comprehensible, and communicable by means of language, or it withdraws into self-evidence. This polarity—the transcendence of the artistic medium at the one extreme, and the immanence of the artistic medium at the other—was from then on a characteristic feature of Newman's oeuvre, and was also reflected in his titles. Whilst at times a title does indeed seem to refer to a central aspect of the work, in most cases it is impossible to link the title with the esthetic effect created by the work. Newman's ambivalence might be seen as a warning against basing our interpretation of a work primarily, not to say solely, on its title, and on the meaning or meanings suggested by it.

A change had obviously been taking place in Newman during the late forties, for he no longer clung uncompromisingly to his conviction, expressed in 1947, that the "basis of an aesthetic act is the pure idea."[3] Now the esthetic act had been replaced by the specific object, and the pure idea by the intention of the artist: "The artist's intention is what gives a specific thing form."[4] A prosaic change indeed, the metaphysical flight of ideas giving way to, or merging with, a preconceived pattern of action.

220 The negative response to Newman's second exhibition at the Betty Parsons Gallery, particularly among his artist friends, may perhaps be explained by the discrepancy between the formal reductionism of his works and the ambitious ring of many of their titles—such as "Vir Heroicus Sublimis"—which could not be easily reconciled, even by insiders. Newman's problem—that language was not always an adequate means of defining the essence of a work, that language and the reality residing in the work of art were often incompatible, and that even the artist himself was at times unable to recognize and express in words the subject matter of his work—was foreign to most of Newman's contemporaries. Consequently, whenever vision and language in Newman's paintings seemed poles apart, whenever the visual impression they created not only alienated the viewer but also had little or nothing to do with their high-flown titles, many of Newman's contemporaries would conclude that these paintings were the work not of an artist but of a theorist and academic (after all, Newman's essays and the exhibitions organized by him had helped to promote such an image) who was demonstrating his ideas with a directness bordering on amateurism. Even many years later, Motherwell still remembered Newman as being "basically a 'Sunday painter' in the minds of the rest of us."[5] All this may have contributed to Newman's personal crisis, and to the extreme isolation which he experienced after his second solo exhibition.[6]

The 1951 exhibition at the Betty Parsons Gallery, for which Newman had doubtless great expectations, was noteworthy not only because he was showing his most important paintings but also because the exhibits included his very first and, for a long time, only sculpture. It was an unusual sculpture, and one which invited many questions.

76 *Here I,* 1950, plaster, detail

II

"Here I" (Fig. 78) consists of two vertical elements which are 96 inches high and mounted on an almost square base measuring 26½ by 28¼ inches; the smooth, narrower element (two inches wide and one inch deep) stands in the rear right-hand corner, whilst the rough-edged, broader element (varying from approximately 5½ to 6¾ inches wide, and approximately 2 inches deep) stands halfway along the left-hand edge of the base (Figs. 76, 77, 79). The base itself features a dynamic plasticity, its fissured, undulating surface forming two differently sized mounds (approximately 6 and 7 inches high), out of which the two vertical elements rise. These mounds serve primarily as a means of stabilizing the vertical elements, and yet this amorphous, chaotic miniature landscape entirely conceals its functional purpose. The visual effect of the sculpture, however, is essentially created by the two slender uprights.

Newman himself preferred to position the sculpture in such a way that, when facing front, the broader upright was on the left and the narrower one on the right. Their paral-

77 *Here I,* 1950, plaster, detail

78 *Here I*, 1950
Plaster, 96 × 26¹/₂ × 28¹/₄ ins.
(excluding base)
The Menil Collection, Houston
Gift of Annalee Newman

79 *Here I*, 1950, plaster, detail

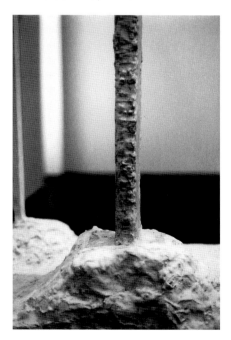

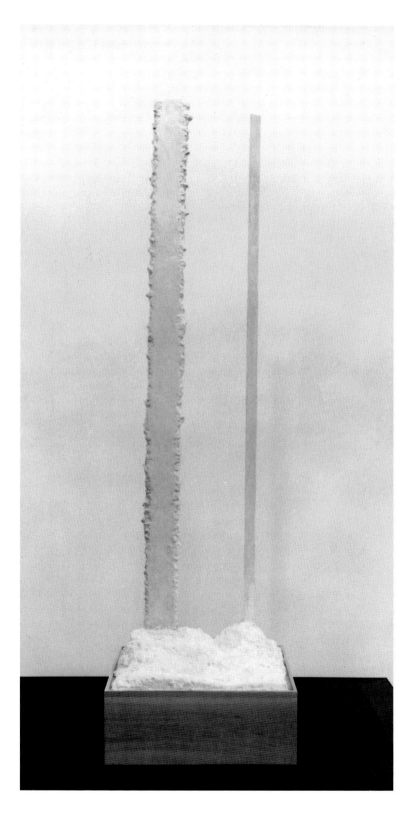

lelism and shared height make the one upright echo the other, whilst their asymmetrical positions, their varying widths and their different surface textures generate a situation in which they can interact in a number of ways. Moreover, the viewer's eye registers not so much the three-dimensionality of the uprights as the distances between them which, depending on the position of the viewer as he walks round the sculpture, narrow, disappear, reappear, and widen. Nothing was further from Newman's mind, however, than a desire to create exciting effects. Even the extreme plasticity of the base and the deliberately jagged edges of the broader upright seem to be of secondary importance. The significance of Newman's sculpture lies elsewhere, for it is the result of a gesture or act tantamount to the placing of marks or accents. What is defined, however, is not so much the space occupied by the uprights on their base as the entire room in which the sculpture stands.

The placing of these parallel, staggered marks on the terrain formed by the base of the sculpture posed a decisive problem, for a transition had to be effected from the vertical to the horizontal. Newman solved this problem by shaping the base in such a way that the impression created was ambiguous: the uprights seem both to have been pushed into the mounds and to have grown out of them. This ambiguity is suggested above all by the broader upright, for its jagged, narrow edges might be seen as an upward continuation of the base, or, conversely—and much more plausibly—as a lumpy, amorphous material running down the narrow edges of the upright, gradually spreading over the base and losing some of its lumpiness as it solidified. Obviously, the vertical elements could have been covered with plaster only when horizontal, and could not have been placed in an upright position until the plaster had set. Indeed, the outward form of the sculpture immediately provokes questions concerning the artist's way of working, though Newman does nothing to disguise his technique—quite the reverse.

Thus "Here I" has several aspects: transitoriness in the solidified material, spatiality in the arrangement of the uprights, an accentuating function in relation to its surroundings. Our reflections on its making, moreover, reveal an erstwhile liquid mass which, as it solidified, has been kneaded and shaped. The result is a confrontation of two vertical elements, the one flat and plank-like, with jagged edges, the other sharp-edged and smooth, covered with a thin skin of plaster, each leaning towards the other slightly when viewed from the side. It is in the correspondence of these vertical elements that the essential aspect of this sculpture lies.

That the vertical elements of "Here I" bear a direct relation to several of Newman's extremely narrow paintings and in fact represent two isolated "zips"[7] was obvious from the very beginning.[8] Indeed, this is clearly suggested by Hans Namuth's famous photograph showing "Here I" next to "The Wild" at the 1951 exhibition at the Betty Parsons Gallery

80 *Here I* and *The Wild,* installation view at the Betty Parsons Gallery, New York, 1951

(Fig. 80). It is as though Newman had isolated certain forms from his paintings, materialized them, and placed them in the room, but whether one can justifiably conclude that "[t]he emptiness in the paintings is matched in the sculptures by the space around instead of inside them"[9] remains open to debate.

III

Hess and Rosenberg, authors and critics who have exercised a decisive influence on the reception of Newman's work, both ascribed a symbolic meaning to "Here I"[10]. Hess saw in Newman's verticals a visionary quality: "We see them [the verticals], but they are witnesses—solid, objective witnesses—to something else, a vision beyond the 'here and now,' as if to prove that from *Here,* the hero can contemplate the radiance of man's ultimate vision: the Throne."[11] Although Rosenberg was critical of Hess's kabbalistic interpretation of Newman's oeuvre, about "Here I" he strikes a similar, albeit more nuanced, note. He claims that "measurement, proportion, [and] shape" awakened in Newman "ideas and feelings about God, man, and destiny",[12] but that "Here I" alludes not to the myth of creation but to the "intellectually indigestible junkpile of the present day."[13] He was referring primarily to the wooden milk crate on which Newman had shaped the plaster and which he retained as the base. But "Here I", like "Here II" and "Here III", Rosenberg writes, is also "[d]edicated [. . .] to the overarching themes of Place, with its many layers, from the *Makom* of God's presence to the hut-building celebration of Sukkoth as a resting place, to the Home of wandering Israel [. . .], to America as haven of immigrants, to the resolve to affirm New York art versus subservience to that of Paris [. . .]"[14] Moreover, "Here" itself is, as Rosenberg points out in the same book, "a declaration of aesthetic self-reliance, and a claim to the blessings that might descend upon those inhabiting the right time and place."[15] All in all, an extremely high-flown, fanciful interpretation, and one which shrouds Newman's lucid sculptures in mystery and fantasy. But if they were not seen to be so overcharged with symbolism—and this approach says more about the authors than about the actual work—the "Here" sculptures would, writes Rosenberg, "fall into place among the countless ABC structures—boards, boxes, beams, bins, tubes [. . .]"[16]—an intolerable thought for this author.

Before we go further, it would perhaps be useful to consider the context in which the sculpture was made. In June 1949, Clement Greenberg published an influential essay in which he pointed the way forward, emphasizing the enormous possibilities of sculpture while lamenting that painting, in his opinion, risked degenerating into mere decoration, thus forfeiting all possible means of expression: "[Sculpture] is now free to invent an infinity of new objects [. . .] Originally the most transparent of all the arts because the closest to the physical nature of its subject matter, sculpture now enjoys the benefit of being the art to which the least connotation of fiction or illusion is attached."[17] Such statements from the most authoritative art critic of the time might indeed have encouraged Newman to work in sculpture, especially as Greenberg maintained that the new sculpture began with Picasso's and Braque's collages.

From all accounts, it had been "at the urging of Pollock"[18] that Newman decided to include "Here I" in his 1951 exhibition at the Betty Parsons Gallery. Jackson Pollock was one of the few who at that time took Barnett Newman seriously. The reason for Pollock's insistence may have lain in his own experimentation in the medium of sculpture for the past several years. In 1949, for example, Pollock had produced a number of small, abstract terracotta sculptures at East Hampton[19]. One of these sculptures had been shown in the traveling exhibition "Sculpture by Painters", organized by the Museum of Modern Art. Moreover, Pollock's own exhibition at the Betty Parsons Gallery opening at the end of November 1949 included not only large-format paintings but also a selection of sculptures made by Pollock for a model by his friend Peter Blake. The model was of a museum designed specially for Pollock's works, the intention being to achieve a perfect integration of these works into their surroundings, that is, to establish an optimum spatial rapport between the painting and the room, and between the sculpture and the wall.[20] From March 27 through April 21, 1951, i.e. immediately preceding Newman's exhibition at Betty Parsons, the exhibition "Sculpture by Painters" was shown at the Peridot Gallery in New York. One of the exhibits was a sculpture by Pollock about five feet long and made of chicken wire covered with colored drawings on Japanese paper (Fig. 81).[21] But there were other painters, besides Pollock, who were then exploring the sculptural possibilities afforded by their paintings. Indeed, it had become

81 Jackson Pollock, Untitled
Colored drawings on paper over
chicken wire
Installation view at "Sculpture by Painters"
Peridot Gallery, New York, 1951

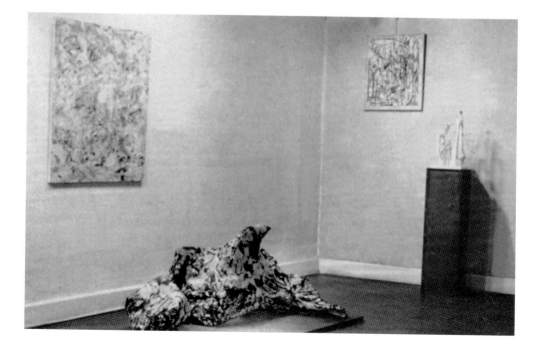

226 the fashion for painters to take an interest in sculpture, and it was evidently Newman's wish to do the same.

If we consider the amorphous structure of Pollock's sculptures—insofar as this is possible from the few surviving photographs—we recognize, in the work of Pollock as in that of Newman, the formal relationship between the artist's paintings and his sculptures. But whilst Pollock virtually projected the all-over style of his paintings onto the outer skin of his sculptures, or, in another case, attempted to transcribe his psychographic marks onto a "literally invisible ground plane"[22], Newman had taken a decisive step further, since his way of thinking had been decidedly three-dimensional. Indeed, Newman's approach was largely in line with Greenberg's, for his point of reference was abstract sculpture, which differed radically from the sculpture of most painters, with their explicit tendency towards the two-dimensional. Thus we are reminded of Max Ernst's "Moon Asparagus" (Fig. 84) of 1935, or, more aptly, of one or another of the works of David Smith (Fig. 83), who was a friend of Newman, or of the white stelae of Louise Bourgeois (Fig. 82). Bourgeois was at that time extremely successful—the Museum of Modern Art had purchased her "Sleeping Figure" of 1950 only a year after she had made it—and she not only moved in Abstract Expressionist circles but also took part in the discussions at Studio 35, and so we may safely assume that Newman was familiar with her work. The differences between Bourgeois and Newman, however, are obvious. That their respective pairs of uprights—those of Bourgeois's sculpture are figural and evocative, those of "Here I" are purely abstract—define their spatial environment is the only point of comparison. Many other examples of comparable works produced about 1950 could be cited, works by such artists as Seymour Lipton—who also exhibited at Betty Parsons—Isamu Noguchi, and Richard Lippold, but such examples would only make Newman's decisiveness and originality stand out even more clearly. Indeed, the origin of "Here I" is not to be found through comparisons with the work of Newman's contemporaries. Are not these uprights—whether rammed into the mounds or growing out of them—abstract versions of totem poles?[23] The analogy seems all the more tenable when we recall that Newman had organized, in the fall of 1946, an exhibition for Betty Parsons entitled "Northwest Coast Indian Painting" and had also written the foreword for the exhibition catalog. It was in this foreword that Newman drew a comparison between primitive art and modern American abstraction: "Does not this work rather illuminate the work of those of our modern American abstract artists who, working with the pure plastic language we call abstract, are infusing it with intellectual and emotional content, and who, without any imitation of primitive symbols, are creating a living myth for us in our own time?"[24] Only a few years later, in 1949, however, Newman dismisses the same totem poles as "hysterical, overemphasized monsters".[25] Considering this statement, finding the genesis of "Here I" among the relics of tribal art is out of the question.

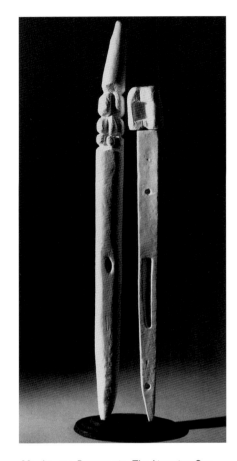

82 Louise Bourgeois, *The Listening One*, 1947/49
Bronze with white patina,
79 x 20 x 12 ins.
Private collection

83 David Smith, *Hero,* 1951/52
Steel, painted red, 73⅘ x 25½ x 11⅘ ins.
The Brooklyn Museum, New York
Dick S. Ramsey Fund

84 Max Ernst, *Moon Asparagus,* 1953
Plaster, height 65¼ ins.
The Museum of Modern Art, New York

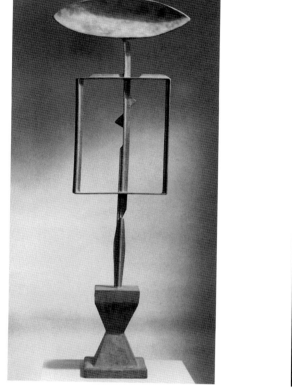

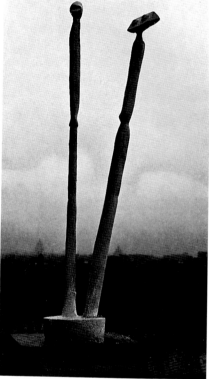

IV

Thus Newman had, within just a few years, entirely changed his attitude towards primitive
art. What had happened? From what we know today of Newman's artistic development,
there were two significant experiences which contributed to this abrupt change, and which
crystallized in "Here I": both were confrontations, the first with the works of Giacometti,
the second with North American Indian works which had little or nothing to do with totem
poles. Whilst these works defined their spatial environment, they did not have the charac-
ter of objects.

From January 19 through February 14, 1948, Pierre Matisse exhibited in his New York
gallery sculptures, paintings, and drawings by Giacometti—which was undoubtedly a special
event in New York. Newman visited the exhibition, was extremely moved, and, years later,
described his impression thus: "He made sculptures that look as if they were made out of
spit—new things with no form, no texture, but somehow filled; I took my hat off to him."[26]
Both Hess and other art critics and historians have discerned an immediate effect of this
confrontation in Newman's oeuvre, mainly in connection with Newman's key work, "One-

228

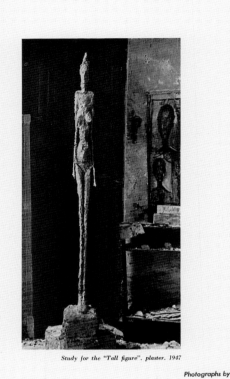

Study for the "Tall figure", plaster. 1947

Photographs by
PATRICIA

ment I" of 1948[27]. One circumstance is particularly remarkable. The cover of the catalog of the Giacometti exhibition had a narrow, vertical slit (Fig. 85), through which one could see one of Giacometti's elongated plaster figures, cropped very tightly by the frame formed by the slit. When the catalog was opened, the full photograph of the sculpture in studio surroundings was revealed (Fig. 86). Whether this graphic device impressed Newman, or even influenced his conception of "Onement I"—Newman painted it on his birthday, January 29, 1948—as has been suggested by many, will never be known for sure.[28]

Newman had long ceased to paint figuratively. He had destroyed all his early representational work. The biomorphic elements which characterized his drawings and paintings of the forties were gradually disappearing. His attitude toward Surrealism was becoming increasingly wary. What must have fascinated him about Giacometti, a European artist par excellence, were the qualities so impressively described by Jean-Paul Sartre: "[. . .] Giacometti was to write movement into the total immobility, unity into the infinite multiplicity, the

85 Catalog cover for Giacometti exhibition
Pierre Matisse Gallery, New York, 1948

86 Inside page of catalog for Giacometti exhibition
Pierre Matisse Gallery, New York, 1948

absolute into the purely relative, the future into the eternally present, the chatter of signs into the obstinate silence of things."[29] Even if Newman failed to recognize these qualities immediately, Sartre's brilliant and enlightening essay "The Search for the Absolute" must have opened his eyes to them, especially as an English translation of this essay was the introductory text of the 1948 Pierre Matisse catalog and its title alone must have aroused Newman's curiosity. Nor could Sartre's description of plaster as "the most perishable, the most spiritual"[30] of materials, or his commentary on Giacometti's "horror of the infinite"[31] have missed its mark. But the astonishing formal similarities between Giacometti's figures and Newman's "zips" and the broad stele of "Here I" are purely outward. The analogy must be sought on a much higher level, on that level fundamental to the conception of a work which gives "sensible expression to [. . .] pure presence [. . . and manifests] the unity of the Act."[32] Despite the many differences between Giacometti and Newman, their articulation of space is imbued with their experience of its execution, that is to say, with their subjectively conditioned perception of time. It is this feature which makes Newman's works stand out so decisively against those of his contemporaries.

Newman's second significant experience in the late forties is comparable with his encounter with the works of Giacometti. The starting point, however, was completely different. While Newman was visiting his wife's family in Akron, Ohio, in August 1949, he made an excursion to the Indian earthworks in the Ohio Valley—meandering walls of earth and heaped mounds in a vast landscape[33]. Here there were no pictograms, no animistic signs and symbols to marvel at. Newman later described his experience thus: "Looking at the site you feel, Here I am, *here* [. . .] and out beyond there [beyond the limits of the site] there is chaos, nature, rivers, landscapes. [. . .] But here you get a sense of your own presence. [. . .] I became involved with the idea of making the viewer present: the idea that 'Man Is Present.' "[34]

At the moment, Newman felt he was standing amidst the "greatest works of art on the American continent", recognizing in their "utter simplicity" the "self-evident nature of the artistic act", for these simple low mud walls defined the space and separated order from chaos. What was important for Newman was the sense of one's own presence. And it was precisely the experience of ordered nature against the backdrop of an enormous, chaotic landscape which, Newman realized, made the subject conscious of his own self.

Newman did not arrive at this realization suddenly or fortuitously. Newman's catalog foreword for an exhibition of the sculptor Herbert Ferber at the Betty Parsons Gallery in late 1947 and early 1948 ends with the words: "By insisting on the heroic gesture, and on the gesture only, the artist has made the heroic style the property of each one of us, transforming, in the process, this style from an art that is public to one that is personal. For each man is, or should be, his own hero."[35] Newman's closing line is revealing, and relevant to the

present discussion, though it was not until Newman visited Ohio that he had the heroic experience of self which the works of Herbert Ferber were presumably capable of evoking. What was crucial to Newman, however, was that the heroic experience of self was bound up with time, not space, and the sensation of time made all other feelings pale in comparison: "The concern with space bores me. I insist on my experiences of sensations in time— not the *sense* of time but the physical *sensation* of time."[36]

Newman's intentions at this time become clearer still if we recall the written statement which accompanied his first solo exhibition at the Betty Parsons Gallery. Newman saw his works not as "abstractions" or as depictions of "some 'pure' idea", but as "embodiments of feeling, to be experienced, each picture for itself."[37]

V

"Here I am [. . .]", the sense of one's own presence, the merging of the experiences of space and time—all this finds expression in Newman's sculpture. And the reasons are not necessarily bound up entirely with Newman's experiences in Ohio, though that would of course be the obvious conclusion to draw from his essay. The first "zip" and the stelae of "Here I" are vertical. Vertical, too, are the totem poles which Newman finally rejected so vehemently, and all the many other signs and symbols that mankind has used from time immemorial to make its mark, find its bearings, and define its horizons. The vertical pole or post has always had the meaning of an *axis mundi,* and counts in many cultures as the abstract symbol of human presence. Newman's views were confirmed by ethnological research, and by the writings of the psychologist Otto Rank, whose book *Art and Artists: Creative Urge and Personality Development,* published in New York in 1932, manifests many astonishing parallels with Newman.[38]

But there is something else. When the artist repeatedly speaks of place and presence with reference to his works, and lays such a strong emphasis on verticality throughout his oeuvre, he cannot be concerned just with stimulating a visual experience. About the end of the forties, Newman had evidently realized that the human body, as a synergic system, has a vertical axis of symmetry which is an essential constitutive component of our perception. And it is in the process of perception that the perceiver becomes aware of himself as the perceiver, and not just as a seeing, hearing being but as a physical being, too. In the conscious act of perception, the awareness of the object and the awareness of self become synonymous. To the painter Barnett Newman it was now obvious that his paintings and sculptures did not represent optical phenomena alone; rather, the entire human body functioned as the basis of all understanding. This was his experience when confronted by Giacometti's sculptures—once he had seen beyond their outward, anthropomorphous appearance—and,

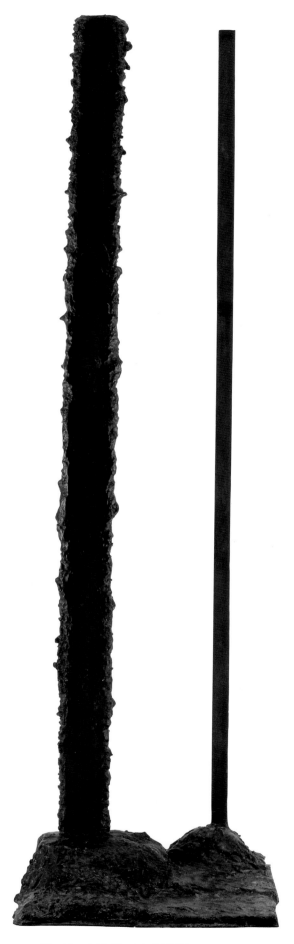

87 *Here I (To Marcia)*, 1950/62 (Cat. No. 34)
Los Angeles County Museum of Art. Gift of Marcia S. Weisman (M.90.194.2)

more impressively, when confronted by the Indian earthworks. "Here I" represents a response to this challenge, for manifest in this work is a deep-reaching anthropological insight, whose basis seems to be existential, not literary.

"My body is the fabric into which all objects are woven, and it is, at least in relation to the perceived world, the general instrument of my comprehension."[39] This is how Merleau-Ponty formulated the same insight in his *Phenomenology of Perception*, published in French in 1945. Following its translation into English in 1962, this standard work must have exercised a strong influence on American sculptors. But that was not until much later, and we may assume that Newman had neither read Merleau-Ponty nor illustrated his theorems. It is merely a coincidence, and quite an astonishing one, too, for Newman has renounced all metaphysical aspirations in "Here I" and concentrated on a creative act which, in the sense of Merleau-Ponty's "instrument of comprehension", is conditioned physically, a creative act which at once defines the object and the subject, and allocates a place to them both.

VI

Considering the work's complex background, Newman's hesitancy in 1951 about showing "Here I" in public is understandable. More than ten years were to go by before he decided—not least at the urging of the California collector Marcia Weisman—to have two bronze castings made at the Modern Art Foundry in Astoria, Queens. This he did with the help of his friend the sculptor Robert Murray, whom he had known since 1959. These two castings now stand in the Los Angeles County Museum of Art ("Here I [To Marcia]", Fig. 87) and the Moderna Museet, Stockholm. Newman decided to slightly modify these castings, however, which proved to be an enormous mistake. The wooden box, from which the sculpture rose so impressively and which was, in terms of both proportion and scale, so central to the effect, was not cast with the sculpture, but removed on Newman's reconsideration. The result, it soon became obvious, was unsatisfactory. The "mounds" seemed to melt into the floor instead of contrasting with it[40]. But no matter how astonishing Newman's decision may seem, there is a simple explanation for it: the wooden box—it was a milk crate[41]—looked too much like Pop Art and had to be removed. By that time, 1962, the era of Abstract Expressionism was over, and the assemblages of Rauschenberg and others were beginning to fill galleries and collections. Newman did not wish to leave himself open to any misunderstanding. His rough wooden milk crate, an ubiquitous *objet trouvé*, might have been interpreted as an attempt to curry favor with the new trend, especially if it were cast in bronze. Later, however, Newman changed his mind, and placed an order for a bronze cube, the dimensions of which roughly corresponded to those of the wooden crate (Figs. 88, 89).

88 *Here I (To Marcia),* 1950/62
(Cat. No. 34)
Los Angeles County Museum of Art
Gift of Marcia S. Weisman (M.90.194.2)

89 *Here I (To Marcia),* 1950/62
Bronze casting, 1962, and bronze base, 1971
Moderna Museet, SKM, Stockholm

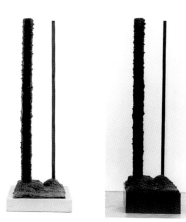

The extremely dark, patinated version of "Here I" did not meet with undivided approval. Much of the roughness of the original plaster sculpture had been eliminated. Both for this reason and through the unavoidable association of the bronze cast with traditional sculpture, "Here I" seemed to have lost all its character.[42] These shortcomings prompted the decision to reconstruct—posthumously—the plaster sculpture which had been used for the bronze casting. Robert Murray undertook this difficult task. When the box containing the plaster parts was opened in early 1987, the vertical elements were found to be in good condition, but only parts of the mounds could be used, and large parts were even missing. It was decided to recast the missing parts from the bronze. This was not easy to do, inasmuch as the plaster casting had to be adapted to the posthumously constructed base which had narrow walls all the way round to protect the fragile edges of the plaster mounds. This was a necessary compromise, and a justifiable one given that the authenticity of the work as a whole could not be ensured anyway. Robert Murray wrote a detailed report of the painstaking process of reconstructing Newman's sculpture.[43] The result, which now forms part of the Menil Collection in Houston, speaks for itself and conveys a good impression of what just a handful of people saw for themselves when they visited the Betty Parsons Gallery in 1951.

234

1 *Artists' Sessions at Studio 35 (1950)*,
ed. by Robert Goodnough, in: *Modern
Artists in America,* ed. by Robert Mother-
well and Ad Reinhardt, New York, [1951],
p. 15.
2 Ibid., p. 14.
3 Newman, *Writings*, p. 108.
4 *Artists' Sessions at Studio 35*, op. cit.,
p. 18.
5 Cf. *The Collected Writings of Robert
Motherwell*, ed. by Stephanie Terenzio,
New York and Oxford, 1992, p. 242.
6 Besides Newman's works, Betty
Parsons seems to have shown also the
works of Marie Taylor in a separate room.
And Newman's first exhibition was evi-
dently accompanied by another exhibition
with works by Amy Friedman Lee. Cf. Lee
Hall, *Betty Parsons. Artist, Dealer, Collector*,
New York, 1991, p. 182 f.
7 Hess, 1969, p. 70.
8 Cf. Rosenberg, *Broken Obelisk*, p. 13.
9 Rosenberg, p. 75.
10 Cf. Rosenberg, *Broken Obelisk*, p. 10;
Rosenberg, p. 74.
11 Hess, p. 76.
12 Rosenberg, *Broken Obelisk*, p. 9.
13 Rosenberg, p. 83.
14 Ibid., p. 77.
15 Ibid., p. 63.
16 Rosenberg, *Broken Obelisk*, p. 17.
17 Clement Greenberg, *The New Sculp-
ture*, in: *Partisan Review*, June 1949.
Reprinted in: Clement Greenberg, *The Col-
lected Essays and Criticism*, Vol. 2, *Arrogant
Purpose, 1945–1949*, ed. by John O'Brian,
Chicago and London, 1986, p. 313 ff.
18 Hess, 1969, p. 70.
19 Cf. Francis V. O'Connor, *Jackson
Pollock*, exhibition catalog, The Museum of
Modern Art, New York, 1967, p. 45.
20 The announcement for the exhibition
read: "Murals in Modern Architecture. A
Theatrical Exercise Using Jackson Pollock's
Paintings and Sculpture. By Peter Blake."
The exhibition was reviewed at length in
the press. Cf. O'Connor, op. cit., p. 48.
Cf. also Claude Cernuschi, *Jackson Pollock,*

Meaning and Significance, New York, 1992,
p. 238 f.
21 O'Connor, op. cit., p. 60.
22 Concerning Pollock's paintings on
glass and their connection to Newman cf.
Benjamin G. Paskus, *The Theory, Art, and
Critical Reception of Barnett Newman*,
University of North Carolina at Chapel
Hill, Ph.D. dissertation, 1974, p. 145.
23 Such a connection has been suggested
on the basis of Newman's having a collec-
tion of several Northwest Coast Indian
totem poles. Cf. W. Jackson Rushing, *The
Impact of Nietzsche and Northwest Coast
Indian Art on Newman's Idea of Redemption
in the Abstract Sublime*, in: *Art Journal*,
Vol. 47, No. 3, Fall 1988, p. 189.
24 Newman, *Writings*, p. 107.
25 Ibid., p. 174.
26 Quoted from Hess, 1969, p. 39.
27 Cf. Irving Sandler, *The Triumph of
American Painting. A History of Abstract
Expressionism*, New York, 1970, p. 190
(although Giacometti is not mentioned
here by name); Hess, p. 57; Ann Gibson,
Barnett Newman and Alberto Giacometti, in:
Issue (New York), Spring 1985, p. 2 ff.;
David Sylvester, *The Ugly Duckling*, in:
*Abstract Expressionism. The Critical Develop-
ments*, exhibition catalog, Albright-Knox
Art Gallery, Buffalo, New York, 1987,
p. 138 (Sylvester draws attention to the
opening of Giacometti's exhibition ten
days before Newman's birthday, the day
on which he painted "Onement I");
Stephen Polcari, *Abstract Expressionism and
the Modern Experience*, Cambridge, New
York etc.,1991, p. 200.
28 Cf. Polcari's remarks in this connec-
tion, op. cit., p. 200. Franz Meyer has dealt
with Newman's relationship to Giacometti
in great detail; he, too, considers it highly
likely that Newman visited the exhibition
at the Matisse Gallery prior to his birth-
day, and may there have found confirma-
tion of his own intentions. "Given that
Newman had already invented his 'zip', it
would probably be incorrect to speak of

an influence as such. As always, Newman had found his way and was already on it. But the confirmation of his intentions which he discovered in Giacometti's work spurred him on to their concrete realization. Newman, one might say, availed himself of what only one person—Giacometti—could give him." Franz Meyer, *Giacometti et Newman*, in: *Giacometti. Sculptures, Peintures, Dessins*, exhibition catalog, Musée d'Art Moderne de la Ville de Paris, November 30, 1991– March 13, 1992, p. 62.

29 Jean-Paul Sartre, *The Search for the Absolute*, in: *Giacometti*, exhibition catalog, Pierre Matisse Gallery, New York, January 19–February 14, 1948, p. 3.

30 Ibid., p. 5.

31 Ibid., p. 6.

32 Ibid., p. 14.

33 Cf. Yve-Alain Bois, *Barnett Newman's Sublime=Tragedy*, in: *Negotiating Rapture. The Power of Art to Transform Lives*, exh. organized by Richard Francis, Museum of Contemporary Art, Chicago, 1996, p. 138 f.

34 Hess, p. 73; Newman, *Writings*, p. 174.

35 Newman, *Writings*, p. 111.

36 Ibid., p. 175. This "Prologue for a New Aesthetic" was not published during the artist's lifetime, and the actual date of its writing is uncertain. It was probably written in the fall of 1949, just after his return from Ohio.

37 Ibid., p. 178.

38 Cf. David M. Quick, *Meaning in the Art of Barnett Newman and Three of His Con-*
temporaries: A Study in Content in Abstract Expressionism, University of Iowa, Iowa City, Ph.D. dissertation, 1978, pp. 138, 224.

39 Maurice Merleau-Ponty, *Phenomenology of Perception,* translated from the French by Colin Smith, London and New York, 1962, p. 235.

40 Hess, p. 75. See also Robert Murray, *The Sculpture of Barnett Newman*, in: *Voices of Fire. Art, Rage, Power, and the State*, ed. by Bruce Barber, Serge Guilbaut, and John O'Brian, Toronto, Buffalo, London, 1996, p. 167.

41 Newman kept such crates in his studio. He used to prop up his canvases on them (Newman never used an easel). I am grateful to Robert Murray for having pointed out, in our telephone conversation of February 14, 1997, that the wire compartments inside the box (for the milk bottles) were practical for anchoring the uprights. It was only by chance, however, that the crate came to be used as the base. Newman simply used whatever was around in his studio.

42 Cf. Rosenberg, *Broken Obelisk*, p. 14; Rosenberg, p. 78.

43 Robert Murray, *Reconstruction of Barnett Newman's Here I*. Manuscript, May 29, 1987. I wish to thank Paul Winkler, Houston, for having afforded me access to Murray's report which is today kept in the Menil Collection.

I

In the fall of 1963, the Jewish Museum in New York mounted an exhibition entitled "Recent American Synagogue Architecture"[1]. It was a topical theme, for during the fifties, in the aftermath of the Holocaust, a great many new synagogues had been planned, and built, in the United States. The results, in architectural terms, did not always meet with general approval. The aim was to achieve a dignified form without any historical or stylistic references, a form which was modern, not to say futuristic. The exhibition did full justice to the lively, ongoing discussion of the objectives of synagogue design, a fact reflected not only in the response from the media but also in the subsequent adoption of many of the exhibited designs and concepts, though not necessarily by the country's top institutions.

To everybody's astonishment, Barnett Newman participated in this exhibition with a Model for a Synagogue (Fig. 90) and, as the only painter among the exhibitors, attracted considerable attention from the press[2]. Newman was up against sixteen architects or firms including such famous names as Marcel Breuer, Philip Johnson, Louis I. Kahn, Eric Mendelsohn, and Frank Lloyd Wright. Richard Meier, who organized the exhibition, had heard of Newman's criticism of post-war synagogue architecture, as had Alan R. Solomon, the director of the museum. Evidently, Newman had compared the synagogues of the fifties with supermarkets[3] and expressed the view that their architects "were just putting chrome on delicatessens."[4] Newman complied with Meier's request that he sketch out some ideas of his own, and Robert Murray helped him to realize these ideas three-dimensionally using Plexiglas and plaster. After he and Solomon had paid several visits to Newman's studio, Meier requested a larger and more precise model for display in the exhibition.[5] Whatever the actual circumstances leading up to the exhibition[6]—most of the available information is oral—Newman accepted the challenge, but was then under enormous time pressure, as his model had to be ready by the opening of the exhibition. This would hardly have been possible without the dedicated help of Robert Murray and others. The model was finished just in time, and Newman, Murray, and Jonathan Holstein (another friend of Newman's) carried it into the museum on the eve of the opening. Its extremely simple structure made it stand out among the designs exhibited by the professional architects.

The concept on which Newman's model was based had been preceded by several sketches which show that the final version was the outcome of a lengthy thought process. One of the sketches (Fig. 91), for example, shows a ground-plan of the synagogue in which the basic square format of the building is emphasized diagonally by two opposing, zigzagging walls which not only form a passage but also enclose a circle at the center. Located at the two ends of this passage are, it may be assumed, the entrance and the Ark of the Law, whilst the bimah occupies the central circle. Although Newman follows the Ashkenazi tradition in

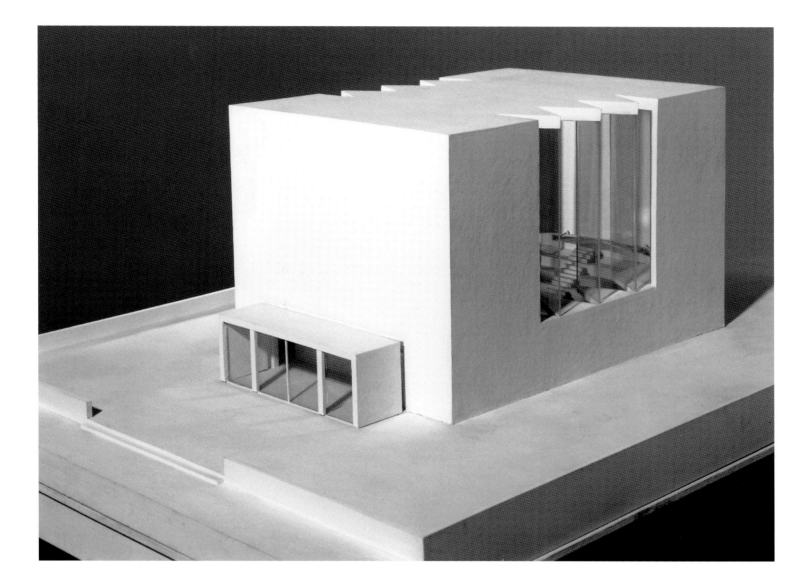

90 Model for a Synagogue, 1963
(Cat. No. 35)
Centre Canadien d'Architecture/
Canadian Centre for Architecture,
Montréal

this sketch, he provides us with no idea of the seating arrangement. Are there galleries? Are the men and women segregated? Or do they sit together?

Another sketch (Fig. 92) isolates the former diagonal structure such that the zigzagging elements become the outer, longitudinal walls of the building. The seating surrounds the square bimah on three sides, leaving open the side facing the Ark. One end of the building features a transverse annex, probably the entrance hall or lobby. The other small sketches on the same sheet testify to Newman's endeavor to concretize his ideas, especially with regard to the zigzagging walls which lend the structure of the building a crystalline aspect.

238 Newman's sketched view of the interior, executed in central perspective on ruled writing paper (Fig. 93), shows a concertina-like window arrangement supported on low walls and leading symmetrically, from left and right, to the Ark at the far end of the room. The Ark stands on a raised platform, taking up almost the entire end wall. Above the Ark is what seems to be a large window. A circle or oval in the center of the room marks the position of the bimah, and beneath it is a Hebrew inscription that translates: "The train of His mantle filled the temple"[7] (Isaiah 6:1).

The interior is detailed more precisely in a carefully executed pen-and-ink drawing (Fig. 94) in which Newman also has written the names of the main elements of the design. The zigzagging windows are the "Tzim Tzum", the seats beneath them the "dugout"; the seating area in the foreground, identified by a row of women wearing hats, is the "Women's Section Grandstand", the raised part in the center is the "Mound", and the two-winged decalogue is the "Ark". What seems most unusual here is Newman's choice of terminology, for at least three of the terms used by Newman (dugout, mound, and grandstand) are not of religious origin, but are baseball terms. I shall be dealing with this aspect in greater detail later. Suffice it to say, for the time being, that it was this drawing, and not the other aforementioned sketches, which served as the basis for the model.

As Robert Murray stressed during our conversation, Newman was concerned primarily with the design of the interior. The exterior of the synagogue (Fig. 90) did not interest him particularly. Indeed, this becomes obvious when we consider the model from the outside, for it is just a box (measuring 31½ inches long by 22½ inches wide by 19½ inches high) mounted on a raised rectangular platform which is accessed by two steps and surrounded by a low wall. At each end of the box is a smaller box measuring 4½ by 14½ by 5 inches, one of which was doubtless intended as the lobby. These three orthogonal elements are separated by narrow gaps which are glazed.

The interior is illuminated via the zigzag glazing in the longitudinal walls of the main structure of the building. The glazing commences at a height corresponding to the height of the annexes and reaches up to the eaves; the resulting window section is virtually square. The remaining parts of the wall on either side of the window are twice as wide as the annexes are deep. The zigzag glazing projects into the interior of the building; the apices of the three outward-pointing angles (approximately 60 degrees) are flush with the outer wall. These prismatic window sections are supported, on the inside of the building, by a gallery-like ledge, the outer edge of which, like the roof, follows the zigzag course of the windows and then runs parallel to the wall on either side. Consequently, the window section could be either continued on the inside of the building—along the ledge, parallel to the wall—or discontinued by means of an end window pane positioned at right angles to the wall. All in all,

91 Design for a Synagogue, 1963
Ground-plan
Estate of the artist

92 Design for a Synagogue, 1963
Ground-plan
Estate of the artist

93 Design for a Synagogue, 1963
Interior
Estate of the artist

94 Design for a Synagogue, 1963
Interior
Estate of the artist

a simple yet ingenious structure which would certainly have introduced a lot of daylight into the interior, but one which would have been very difficult to build, let alone maintain. Assuming that the model was built on a scale of 1:50, the window panes would be 59 feet high and about 10 feet wide, and, being frameless, would have to stabilize one another with connecting elements that were virtually invisible. But let us put this practical aspect aside and merely note, instead, that the width of two panes together—measured from apex to apex—corresponds to the depth of the annex.

As these observations show, Newman had put a great deal of systematic thought into his Model for a Synagogue. The carefully proportioned combination of three unadorned boxes not only lent severity to the central structure of the synagogue but also achieved an effect of reserved monumentality, an effect which was certainly intended by Newman as he set about designing the exterior. Newman's architectural design followed a minimalist principle which not a single one of the architects participating in the exhibition observed in his own design. This is highly unusual given that much contemporary synagogue architecture manifested tendencies towards radical simplicity. Take, for example, the International Synagogue at John F. Kennedy International Airport, designed by Bloch & Hesse (Fig. 95), or the extremely modest building designed by Percival Goodman for the Temple Israel Reform Congregation, on Staten Island, in 1964 (Fig. 96). Their similarities with Newman's design do not of course go beyond the cubic structure of their exteriors, as

240 a comparison of the three buildings' respective functional characteristics would make immediately obvious.

Let us try to illuminate this point by taking a closer look at the interior of Newman's model (Figs. 97, 98). After passing through the lobby on the west side of the building, we would enter the main room via the space underneath the women's "grandstand", either from the south-west or north-west corner. The entire central part of the interior is raised by three steps, and the platform for the Ark at the east end of the room is raised by a further three steps. On the sides, located directly underneath the huge prisms formed by the windows[8]—and not as much in the shade as the model suggests—are the rows of seats for the men. In the center, i.e. between the Ark and the grandstand, and between the men's seating on the left and the right, is a truncated cone, the bimah, with four steps affording access to a reading desk for the Torah scrolls. If we interpret Newman's sketches[9]—insofar as they are known to me—and his model correctly, the bimah has been completely isolated from the Ark, a feature which is entirely out of keeping with the more recent tradition of synagogue architecture. Thus it takes pride of place, assuming, of course, that Newman did not intend this raised round platform to be used for some other purpose, such as additional temporary seating for special festivals.

This peculiarity of Newman's design makes us wonder all the more why he decided to accept Richard Meier's challenging invitation to take part in the exhibition. Newman's criticism of popular synagogue architecture cannot have been the reason. His uncompromising,

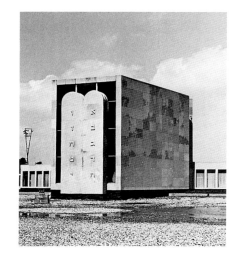

95 Bloch & Hesse, International Synagogue, John F. Kennedy International Airport, New York, 1963

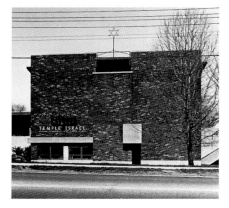

96 Percival Goodman, Temple Israel Reform Congregation, Forest Avenue, Staten Island, New York, 1964

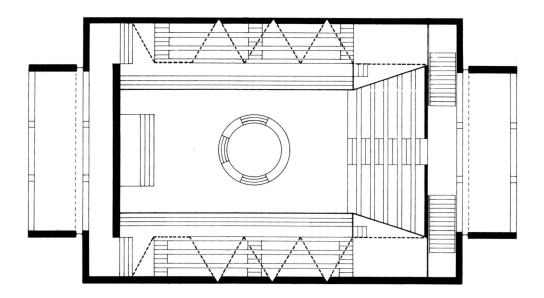

97 Model for a Synagogue, 1963 Ground-plan based on the finished model

undivided concern with architectural questions, which in many respects were completely

foreign to him[10], doubtless resulted purely from the task in hand.

We know that Newman was not religious, and did not attend synagogue even during the Jewish festivals. He could say Kaddish, but that was all. The reason lay in his upbringing. Although his father, Abraham Newman, had made him learn Hebrew as a boy and had familiarized him and his siblings with the religious life of the Jewish community, that seems to have been the end of the matter. As a pragmatically minded businessman with the interests of the

98 Model for a Synagogue, 1963
(Cat. No. 35)
View of interior

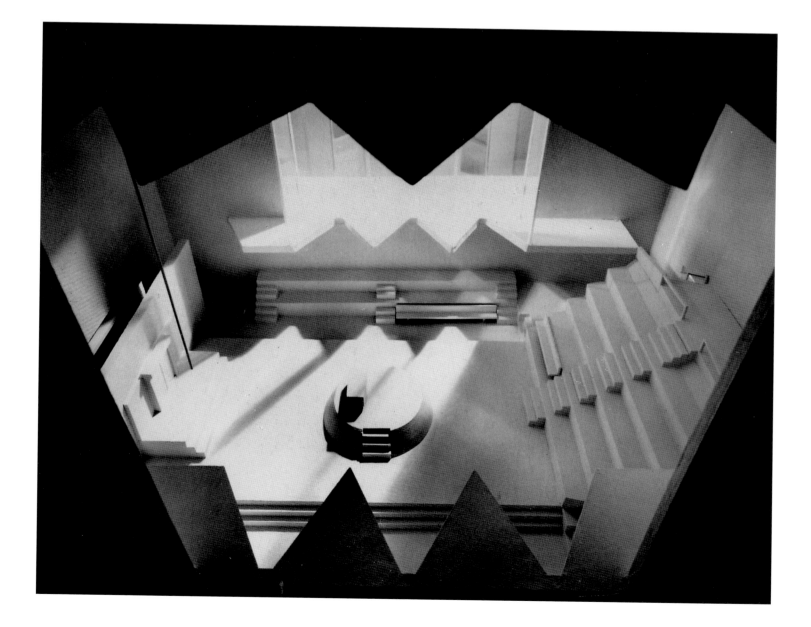

community at heart, Abraham Newman was a founder and trustee of the National Hebrew School in the Bronx and an ardent Zionist to whom humanitarian aid to Jewish immigrants was of prime importance.[11] Thus it was an extremely functionalized kind of religion that had been practised in the Newman household.

Newman's being non-religious is not all that makes his interest in synagogue architecture surprising. Politically, Newman had been virtually an anarchist all his life, and this must have undermined, or at least relativized, any religious tendencies which he may still have had. Thus Newman was interested in synagogue architecture primarily for esthetic reasons, and, more importantly, for his own esthetic reasons. This will perhaps be clearer if we recall, for example, Motherwell's response to the reproach that he, though neither Jewish nor religious, had worked on a synagogue project: "[. . .] those people," wrote Motherwell in 1952, "who were confused by my accepting the commission when I am neither Jewish nor religious in that sense don't see that it was neither for money nor fame, but from a desire to work with other people [. . .] in short, to enlarge not merely aesthetically but humanly my experience [. . .]"[12]

Such a desire would probably have seemed absurd to Newman. His ideas on synagogue design did have an esthetic motivation, but there was more to it than that. He was concerned, primarily, with the problem of evoking an experience of the sublime and the transcendental. In other words, the subject matter of the two-dimensional medium of painting had now become the subject matter of the three-dimensional medium of architecture. Meier's invitation had suddenly afforded him an opportunity to try out what he sought to achieve through his painting: "The room space is empty and chaotic, but the sense of space created by my painting should make one feel, I hope, full and alive in a spatial dome of 180 degrees going in all four directions."[13] Newman's sculpture "Here I" possibly figured in this development, though it cannot be said that it directly paved the way for Newman's excursion into architecture. For all his non-religious, primarily esthetic concern, however, Newman falls back upon kabbalistic vocabulary, mixing it with practical, secular terminology from everyday life, when describing the aims behind his synagogue design. This is particularly so in his statement in the exhibition catalog.

II

The catalog published on the occasion of the exhibition is revealing not only for the designs illustrated and the texts by Orthodox, Conservative, and Reform rabbis but also, and more importantly, because it contains explanatory statements submitted by the exhibiting architects. Indeed, it is only against the background furnished by this catalog that we can fully understand Newman's contribution.

In his introductory essay, Richard Meier raises several questions: What is the syna- gogue? What are its functions? What kind of architecture would be suitable for the modern world? The history of synagogue architecture has shown, Meier writes, experimentation with all kinds of styles. In the buildings on exhibition, however, it is questions of a general nature which are uppermost: what shape the sanctuary should take, how it can best be illu- minated, where the Ark and the bimah should stand, where the congregation should sit, etc. How, for example, does one solve architecturally the problem posed by the enormous difference between the large congregations on the Sabbath and festivals and the relatively few people who come into the synagogue to pray during the week? How, for example, does the architecture do justice to the triple function of the synagogue as a house of prayer, a house of assembly, and a house of study? Should the reforms begun in the nineteenth cen- tury be continued, or should there be a return to Orthodoxy? These reforms had exercised a decisive influence on the interior design of synagogues. Traditionally, the Ark and the bimah stood apart. Since the nineteenth century, in Reform synagogues—and in most Conser- vative synagogues as well—the bimah has been placed in front of the Ark, making listening and participation much easier for the mostly passive, not to say detached, members of the congregation. And, lastly, how does the architect deal with the traditional and still widely practiced segregation of men and women?

All of these problems were addressed by the exhibiting architects, both in their state- ments, some quite lengthy, and in their designs. Philip Johnson, for example, said that, con- sidering the many different requirements, "the problem of designing the contemporary synagogue is a nearly impossible one."[14] The other architects, too, had adopted a more or less practical approach to the problem. How, for example, can one integrate classrooms, offices, reception hall, and library into a place of worship?[15] Would not the ideal building for such a multiplicity of centrally oriented functions have to be based on a circle, a square, or an octagon?[16] Others, like Percival Goodman, concluded that the central position of the bimah was perhaps the only distinctively Jewish contribution to the history of architecture.[17] In an older text written in 1946, Eric Mendelsohn, who had died in 1953, dealt with such practical matters as lighting, materials, construction technique, scale, location of the build- ing site, surroundings, etc.[18] The only architect who made a direct, not to say naïve, attempt at designing a symbolic form was Frank Lloyd Wright: "[. . .] At last a great symbol! Rabbi Mortimer J. Cohen gave me the idea of a synagogue as a 'traveling Mt. Sinai'—a 'mountain of light.'"[19] However, the finished building, Beth Sholom Congregation in Elkins Park, Pennsyl- vania (Fig. 99), was more reminiscent of a stylized Bedouin tent. It is interesting to note that Louis I. Kahn, whose design had received the most attention from the press and who, besides Mendelsohn, had been afforded considerably more catalog space than the others,

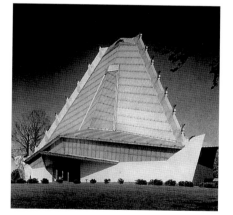

99 Frank Lloyd Wright, Beth Sholom Congregation, Elkins Park, Pennsylvania, 1953/59

did not himself publish any statement about his ideas in the catalog. Only indirectly—through Richard Meier's essay, which devotes a paragraph of praise to Kahn—do we learn anything about them. For the Mikveh Israel Synagogue in Philadelphia, Kahn had proposed a complete separation of the religious and secular parts of the building, with dramatic, extravagant lighting provided by round towers at the corners of an elongated octagon.[20]

All in all, the exhibition catalog presented a heterogeneous picture, and it is not until we read Richard Meier's essay and consider his own approach to synagogue architecture that we can begin to understand why he attached so much importance to Newman's participation: "The best synagogues are the purest architecture, the most straightforward expressions of what the synagogue should be. Among the least successful ones are those which depend on symbolism in determining the plan of the structure. This is true, not because there is anything inherently wrong in the use of symbols, but because the use of visual symbols in this way falsifies the form, since the space must be compromised in solving the symbolic visual problem. [. . .] symbolism in the synagogue plan is illicit."[21] Of extremely simple structure, Barnett Newman's model was largely in line with Meier's esthetic ideas. Yet the painter had evidently pursued one goal to the exclusion of all others, namely that of heightening, through the effect of space and light, experiences bound up with meditation and prayer. The other functions of the synagogue—and the practice-oriented architect Meier attached equal importance to these functions—had not been given any consideration by Newman. The synagogue as a center of communication, as a place of assembly and study, was not Newman's focus. The professional argument against Newman's design was thus a ready one: Newman could take such liberties because he had to consider neither clients' wishes, nor financial restrictions, nor technical problems.[22]

Since Newman's model—as we have seen—was not completed until after the catalog had gone to press, the catalog contained but three sketches (Fig. 100). These sketches did not, moreover, illustrate all that clearly what Newman had in mind. His intentions found better expression in a statement which stood out among the statements of the architects just as plainly as his model stood out among their models. It read as follows:

"The impression that today's popular architecture creates is that it has no subject. It talks about itself as if it were only an object, a machine or an organic object, or one of new materials, new forms, new volumes, new spaces.

"The subject of architecture is always taken for granted—that somehow it will supply itself or, what is worse, that the client will supply it, that a building automatically becomes a work of art.

"In the synagogue, the architect has the perfect subject, because it gives him total freedom for a personal work of art. In the synagogue ceremony nothing happens that is objec-

100 Project for a Synagogue
From *Recent American Synagogue
Architecture,* The Jewish Museum,
New York, 1963, p. 60

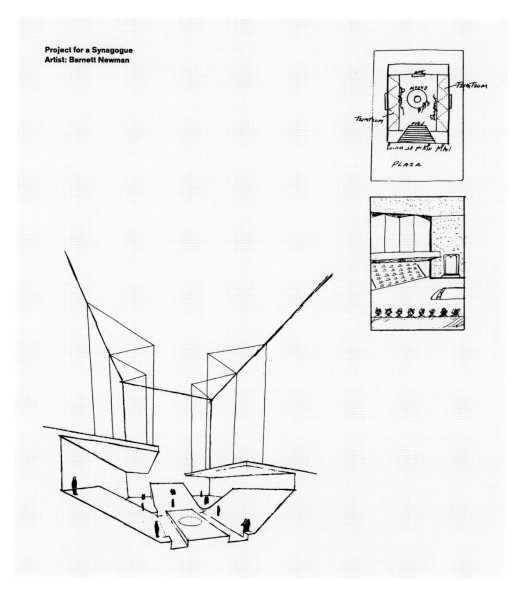

Project for a Synagogue
Artist: Barnett Newman

tive. In it there is only the subjective experience in which one feels exalted. 'Know before
whom you stand,' reads the command. But the concern seems to be not with the emotion
of exaltation and personal identity called for by the command but with the number of seats
and clean decor. We have broken out of the Alhambra. Is it only to fall into a new one?
The synagogue is more than just a house of prayer. It is a place, Makom, where each man can
be called up to stand before the Torah to read his portion. In the Amsterdam synagogue
tradition, men were put on a stage to become actors and the women were put behind silk
curtains. In the Prague synagogue, the women were even put behind walls. In the new

synagogues, the women are there, sometimes even sitting with the men, but they are there as members of the ladies' auxiliary.

"Here in this synagogue, each man sits, private and secluded in the dugouts, waiting to be called, not to ascend a stage but to go up on the mound, where, under the tension of that 'Tzim-Tzum' that created light and the world, he can experience a total sense of his own personality before the Torah and His Name.

"The women are also there, as persons and not as wives and mothers. Here the women are out in the open, sitting not in any abstract connection with what takes place but as persons, distinct from their men but in the full, clear light, where they can experience their identity as women of valor.

"My purpose is to create a place, not an environment, to deny the contemplation of the objects of ritual for the sake of that ultimate courtesy where each person, man or woman, can experience the vision and feel the exaltation of 'His trailing robes filling the Temple.'"[23]

Newman's criticism of popular synagogue architecture, expressed in the first few lines of his statement, need not be dealt with in detail here. The essential aspect of a synagogue, for Newman, is that it is a place—"Makom" (the place of God)—where each man can be called up to read from the Torah, where each man can actively participate in the ritual. This aspect is stressed again in the passage which refers directly to his own design. Newman pictures in his mind's eye how each man sits, "private and secluded in the dugouts", waiting to be called to ascend the bimah, the raised platform which Newman calls "the mound", where, "under the tension of that 'Tzim-Tzum' that created light and the world, he can experience a total sense of his own personality before the Torah and His Name". The crux of Newman's statement, however, lies not in any religious inspiration or ecstatic feeling of salvation but, rather, in an experience of self, that is to say, in the awareness of one's own personality in its entirety. Naturally, all this happens before the Torah and before God and "under the tension of [. . .] 'Tzim-Tzum'", but the essential aspect, for Newman, is the absolute autonomy of the esthetic subject in the face of the incommensurable being.

Several of the terms used by Newman seem—as already intimated—inappropriate to the subject matter. "Dugout" normally refers to a shelter for baseball players when not in the game, i.e. when they are not fielding, or are waiting their turn to bat, or being drilled by their coach—certainly an existential moment. The place from where the pitcher throws the ball is called the "pitcher's mound". In Newman's sketch (Fig. 94), the women's gallery is referred to as the "grandstand".[24]

The term "Tzim-Tzum" has its origin in the doctrines of Lurianic kabbala and means "contraction" or "withdrawal". According to Isaac ben Solomon Luria (1534–1572), God's first act of creation was not to come out of his hidden self but, rather, to withdraw into him-

self in order to make room for the Creation. God was able to manifest himself only by rea-son of this prior act of withdrawal. For the kabbalists of Safed, the doctrine of emanation was even more complicated inasmuch as the notion of "Tzim-Tzum" was bound up with the notion of reflected light. All light which was to become visible at some later time was already present, albeit in an undefined state, in the infinite light of the divine essence. The "with-drawal"—for kabbalists a principle of limitation and negation—partook of the nature of reflected light.[25] Newman's formulation—" 'Tzim-Tzum' that created light and the world"—certainly alludes to this Lurianic doctrine.

III

Thus Newman brings together the secular and the spiritual in one short statement. It is a strange syncretism, and one to which those who have written about Newman's Model for a Synagogue have responded in different ways. Hess, for example, defends Newman's contra-dictory terminology, seeing in it an acceptance of "the coexistence of extremes that seem mutually exclusive": "Baseball was real to Newman, a part of his life, and the pitcher's mound had its place among his *Sefiroth*."[26] Such an interpretation is in line with Newman's thinking, especially if we consider the significance of the Sefiroth, the ten entities in the hierarchy of kabbalistic cosmogony[27] whose interacting mystical forces allow creation to unfold in all its infinite diversity and through which God is said to manifest Himself in all His different attributes.

Rosenberg reacted to Newman's statement in a completely different way: "This description is a unique mixture of contemporary individualism, personal symbolic identi-fications ('dugouts,' 'the mound'), and traditional phrases. In no way can it be reconciled with an actual synagogue. Jews at worship are not 'private and secluded'; the essence of the synagogue is its use by the *kohal*, or congregation, with its minimum requirement of a *minyan*—ten adult males—for prayer. The worshipers do not 'wait to be called,' they pray. They are not substitute ball players crouching in a dugout or batters waiting their turn at the plate. Nor is the *bimah* a mound, neither Newman's Indian burial mound nor his pitcher's box—nor, to head off other exegetists, the mound of Venus. To close the list of Newman's nonconformisms, the Jew does not go to the synagogue to 'experience a total sense of his own personality' [. . .] He goes to submerge his personality in his tie with the 'nation of priests' to which he belongs by birth."[28] Thus Rosenberg considers Newman's ideas to be secular despite their religious associations. For him, Newman's writings are a kind of metaphysical hum, the product of a "one-man culture," that is to say, a culture "estranged from shared ideas": "[. . .] his consciousness of the Hebrew God as One, whose 'Glory fills the Universe,' is pertinent to his paintings only as an aspect of his passionate

continuation of the tradition in modernism—from Emerson and Kierkegaard to Mondrian—that holds both inner unity and coherence in practice to depend upon reduction, concentration, and repetition. Newman's enthusiasm for Jewish mystics and their sayings was a matter of poetic delight in their eloquent symbolism, as if they were a tribe of East European Mallarmés to which he could feel himself akin, rather than a matter of religious or philosophical solidarity [. . .]"29

All things considered, Newman's Model for a Synagogue addresses the problem of combining abstract form with concrete function, lighting with ritual, tradition with modernity, distraction with meditation, secular reality with spiritual transcendence, when the means and methods used must more than meet their purpose, indeed, reach far beyond devotional needs in the traditional sense. Newman's synagogue is meant to convey an overwhelming sensation and experience in which, simultaneously, the heterogeneous is homogenized, and the immediacy of the occasion—a mixture of spatial experience, personal involvement, and individual challenge—is transcended. The performance of a specific ritual in a way far removed from tradition and in a situation dominated by light allows one to experience a total sense of one's own personality. One does not, however, experience a sense of one's greatness and significance but, rather—"under the tension of that 'Tzim-Tzum' that created light and the world [and] before the Torah and His Name"—the opposite, namely one's frailty and smallness in the face of the immeasurable cosmos. As the notion of redemption in the Christian sense does not exist in Judaism, the ultimate goal is existential self-reassurance, and this in each case becomes an heroic act.

That this was in fact Newman's intention is borne out by other statements by him. For the catalog of the eighth São Paulo Bienal (1965), for example, Newman wrote a short text, in which he declared: "The fetish and the ornament, blind and mute, impress only those who cannot look at *the terror of Self. The self, terrible and constant,* is for me the subject matter of painting and sculpture [emphasis added]."30

This subject matter, moreover, is closely linked with something else. In the late summer of 1967, Newman participated in the First International Congress on Religion, Architecture, and the Visual Arts, in New York and Montreal. The Jesuit priest Thomas F. Mathews had spoken about Newman's oeuvre, specifically his "Stations of the Cross". Newman responded: "[. . .] to my mind the basic issue of a work of art, whether it is architecture, painting, or sculpture, is first and foremost for it to create a sense of place, so that the artist and the beholder will know where they are. [. . .] What matters to a true artist is that he distinguish between a place and no place at all; and the greater the work of art, the greater will be this feeling. And this feeling is the fundamental spiritual dimension. If this doesn't happen, nothing else can happen."31

That experience of self (terrible and constant) which is bound up with a specific place (and hence, indirectly, with a specific moment) may readily be associated with the notion of the sublime. Newman himself had addressed the problem of creating a sublime art during the late forties in his essay "The Sublime Is Now"[32]: "We do not need the obsolete props of an outmoded and antiquated legend. We are creating images whose reality is self-evident and which are devoid of the props and crutches that evoke associations with outmoded images, both sublime and beautiful. [. . .] Instead of making *cathedrals* out of Christ, man, or 'life,' we are making [them] out of ourselves, out of our own feelings."[33] Art as a "metaphysical exercise"[34] directly involved the artist's self, and the work of art must be comprehensible to the viewer in this sense. All this, however, was conceivable for Newman only "under the tension of [the] 'Tzim-Tzum'", the principle of creativity.

There exists a piece of notepaper on which Newman had evidently penciled his initial thoughts about synagogue architecture for his contribution to the exhibition catalog. Newman ends his notes (or at least this page) by juxtaposing three terms which are central to his theory: "aesthetic object—subjectivity—Zimzum."[35]

Bringing these three terms to coincidence and making them visually and existentially experienceable—this was Newman's intention. The conjunction of terms perhaps also explains in part why Newman seeks to reconcile the contradictory: subjectivity, in all its complexity and diversity—the self, terrible and constant—must remain the basis of art even when art's concern is the pure form of the esthetic object and the visualization of the metaphysical process of creation. It is this strange combination of pragmatism and life-affirming worldliness on the one hand, and a spiritual, not to say mystical, aspiration on the other, which forms the basis of Newman's interpretation of the synagogue.

But that is not all. This dichotomy also characterizes Newman's historical position. On the one hand, he continues the tradition of modernism but refuses to recognize it, while, on the other, he seeks to reach beyond modernism but cannot escape the demands it makes on him. This is evidenced, for example, by his attitude towards Mondrian, whom he considers to be overly concerned with the balance of art and life[36], and who, in his opinion, has sacrificed the expression of feeling to the expression of form.[37] In the final analysis, however, Newman's claim to transcendence differs little from that of Mondrian, except that Newman radicalizes this claim and relates it to the subject, whilst Mondrian holds that through painting it is possible to reveal the laws and relationships governing reality: "These are more or less hidden in the reality which surrounds us and do not change. Not only science, but art also, shows us that reality, at first incomprehensible, gradually reveals itself, by the mutual relations that are inherent in things."[38] But Newman seems to go against the grain of modernism, for he emphasizes the pure facticity of the material, effects a semiotic revolution,

101 Notes on Synagogue Project
Estate of the artist

separating the symbol from what is symbolized, and, like the Minimalists, speaks of "whole-ness". For Newman, Mondrian's esthetic exploration of the modalities of perception does not suffice as the subject matter of art, for the subject—as an emotional being—is excluded from it and art forfeits its character as a "metaphysical exercise".

Newman seeks to achieve the totality of experience, the immediacy of emotion, the transcendence of the physical world, the spiritualization of the subject, and the transforma-tion of the sensation of space into the sensation of time. His art presupposes the subject, at once overwhelming and fortifying it in its absolute autonomy. Newman has combined all these elements—both verbally and visually—in his contribution to the exhibition "Recent American Synagogue Architecture", his aim being not least the creation of an esthetic place of ritual for the self.

1 The exhibition took place from October 6 until December 8, 1963. During the two years that followed, the exhibition was shown at the following venues: February 1–29, 1964: The Temple, University Circle at Silver Park, Cleveland, Ohio; May 2–31, 1964: Rose Art Museum, Brandeis University, Waltham, Mass.; September 15–October 14, 1964: Hopkins Center, Dartmouth College, Hanover, N.H.; February 1–28, 1965: The Rochester Memorial Art Gallery, University of Rochester, N.Y.; November 1–30, 1965: Department of Architecture, University of Notre Dame, Notre Dame, Indiana; March 12–April 10, 1966: Faculty of Architecture, University of Manitoba, Winnipeg, Canada. A further showing was planned in Florida, but this did not materialize because the display and text panels (which constituted most of the exhibition) and several of the models had sustained considerable damage. Murray restored Newman's model during the seventies and replaced the Plexiglas windows. It was later shown in the exhibition "200 Years of American Synagogue Architecture", March 30–May 2, 1976, at the Rose Art Museum, Brandeis University, Waltham, Mass.

252

2 Cf. *Newsweek*, November 4, 1963, p. 92.

3 Recollections of Robert Murray during a telephone conversation with the author on February 14, 1997. Much of the information for this chapter was furnished by Robert Murray during this conversation.

4 *Newsweek*, November 4, 1963, p. 92.

5 Richard Meier recently confirmed this version of events during a discussion at the Jewish Museum, New York. I am indebted to Heidi Zuckerman, The Jewish Museum, New York, for having kindly informed me of this, and for having made the relevant literature available to me.

6 From all accounts, Percival Goodman, too, had discussed synagogue architecture with Newman. Goodman, who was likewise participating in the exhibition, and was a specialist in this field—he had well over fifty synagogues to his credit—was, like Meier, interested in painting and sculpture, as evidenced by his Congregation B'nai Israel in Millburn, N.J., built in 1952. Motherwell, Gottlieb, and Ferber had been commissioned to design its décor.

7 I am indebted to Doreet LeVitte Harten for the translation from the Hebrew.

8 The zigzag arrangement of the window panes has been the subject of much conjecture. Newman once told Tony Smith about an idea he had had for the design of exhibition rooms based on alternating walls and windows arranged in zigzag formation and positioned at right angles to each other, an arrangement which would not only isolate the paintings but also illuminate them ideally from the side. According to Hess, this idea found its way into Newman's Model for a Synagogue (Hess, p. 110). Far less comprehensible is Hess's reference in this context to a sixteenth-century woodcut which shows a kabbalist with the Tree of the Sefiroth. Cf. Hess, p. 114.

9 Cf. Richardson, p. 210, D.

10 Cf. Hess's vivid account of Newman's endeavor to acquire the necessary architectural expertise by viewing, together with Robert Murray, several New York buildings and measuring the height of the steps or examining bay windows to see how they had been fitted, etc. Hess, p. 110 f.

11 Hess, 1969, p. 8 ff.

12 Motherwell had done a mural for the Congregation B'nai Israel in Millburn, N.J., in 1952. Cf. *The Collected Writings of Robert Motherwell*, ed. by Stephanie Terenzio, New York and Oxford, 1992, p. 97.

13 Newman in an interview with Dorothy Gees Seckler, published in the summer of 1962. Cf. Newman, *Writings*, p. 250.

14 *Recent American Synagogue Architecture*, organized by Richard Meier, The Jewish Museum, New York, 1963, p. 22.

15 Peter Blake and Julian Neski, ibid., p. 19.

16 Davis, Brody, and Wisniewski, ibid., p. 19.

17 Percival Goodman, ibid., p. 21.

18 Eric Mendelsohn, ibid., p. 22 ff.

19 Ibid., p. 25.

20 The synagogue was never built. One of the reasons was the failure to raise the necessary funds. The other reason lay in a crucial decision to change the building plans. At the beginning of the seventies, the general council decided, for publicity reasons, to annex a museum to the synagogue, and also to combine the assembly, study, and prayer rooms, and not, as Kahn had proposed, to separate them. Thus the original plan was dropped, and Kahn withdrew from the project. Cf. Michele Taillon Taylor, *Mikveh Israel Synagogue*. In: *Louis I. Kahn: In the Realm of Architecture*, by David B. Brownlee and David G. De Long, The Museum of Contemporary Art, Los Angeles, 1991, p. 362 ff.

21 *Recent American Synagogue Architecture*, op. cit., p. 8.

22 Hess, p. 113.

23 Newman, *Writings*, p. 180 ff.

24 One might, however, ask oneself—as does David M. Quick—whether elements of religious ceremonies have survived in a secularized form in games and sports, and whether such an idea inspired Newman to relate his synagogue design to a baseball park. Cf. David M. Quick, *Meaning in the Art of Barnett Newman and Three of His Contemporaries: A Study in Content in Abstract Expressionism*, University of Iowa, Iowa City, Ph.D. dissertation, 1978, p. 216 ff.

25 Concerning Lurianic kabbala cf. Gershom Scholem, *Sabbatai Zwi. Der Mystische Messias*, Frankfurt, 1992, p. 50 ff. This book, originally in Hebrew, was first published in 1957; the English translation was published in 1973.

26 Hess, pp. 114–15.

27 Gershom Scholem, *Die jüdische Mystik in ihren Hauptströmungen*, Frankfurt, 1967, p. 82.

28 Rosenberg, p. 79 f.

29 Ibid., pp. 81, 83.

30 Newman, *Writings*, p. 187.

31 Ibid., p. 289.

32 "The question that now [i.e. 1948] arises is how, if we are living in a time without a legend or mythos that can be called sublime, if we refuse to admit any exaltation in pure relations, if we refuse to live in the abstract, how can we be creating a sublime art?" Ibid., p. 173.

33 Ibid.

34 Ibid., p. 145.

35 Insofar as it is legible, the text reads: "Instead of glass they feel light / They are not blinded by the light / They sit in the shadows to appear / under the light. The light created / by Zim Zum. / [Zim Zum] the subjectivity of the / ceremony has to be carried through / into the building itself — / The feeling of the personal seeing / is what the synagogue should create / & by doing so gives [then] the name / of Judaism greatest — courtesy. / [Know before whom you stand] / The cause is to know where one / stands — / Yet everyone is concerned with / whom he sits — / aesthetic object — / subjectivity — Zimzum". Written in the margin, and underlined, is the word "exalted". I am indebted to Doreet LeVitte Harten for her translation of the line in Hebrew immediately following the word "courtesy" ("Know before whom you stand"). This document is preserved in the archives of The Barnett Newman Foundation, New York.

36 "Art and life illuminate each other more and more; they reveal more and more their laws according to which a real and living balance is created." Piet Mondrian, *Plastic Art and Pure Plastic Art (Figurative Art and Non-Figurative Art)*, in: *Circle. International Survey of Constructive Art,* ed. by J. L. Martin, Ben Nicholson, N. Gabo, London, 1937, p. 46.

37 "[. . .] for me the important thing is the 'saying,' which becomes an expression of feeling rather than, as in Mondrian, an expression of form [. . .]". Interview with David Sylvester in 1965. Newman, *Writings*, p. 254.

38 Mondrian, op. cit., p. 45.

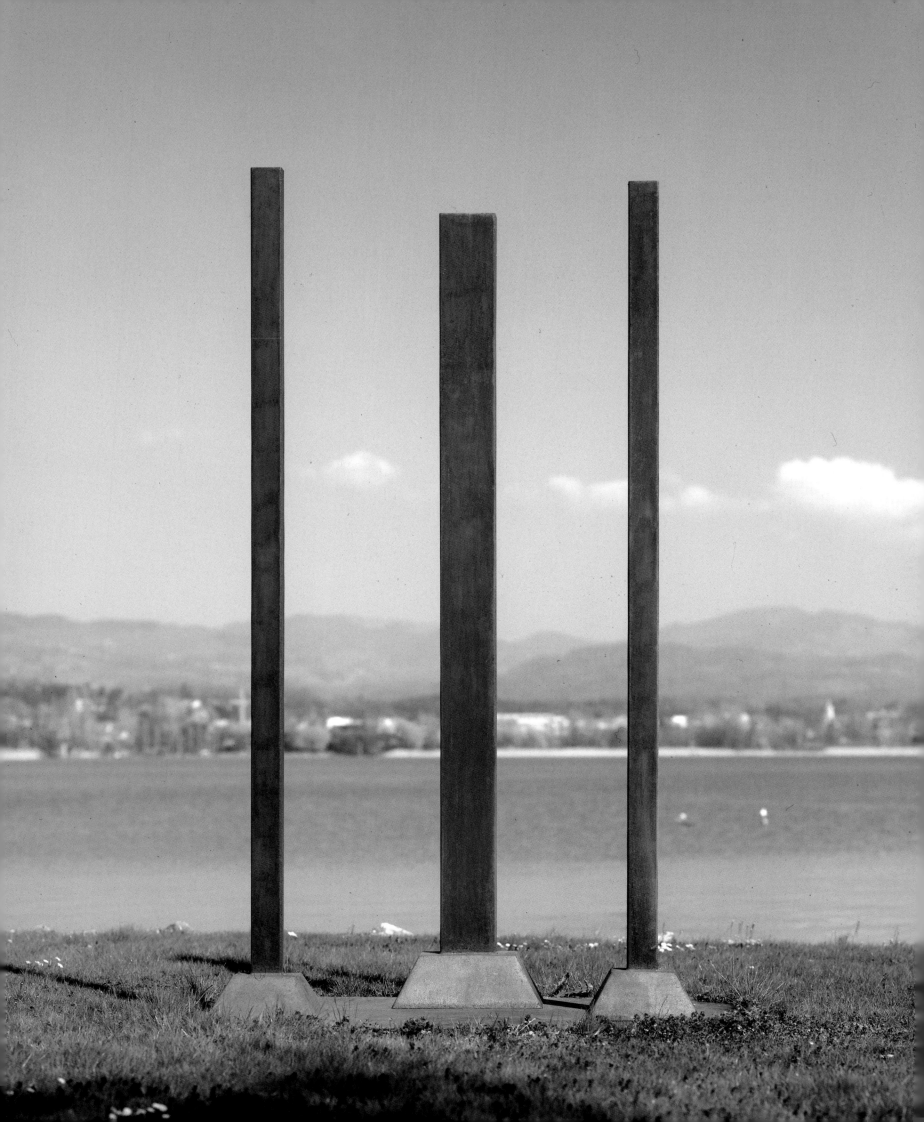

Barnett Newman did not make his second sculpture until 1965. Having been introduced to the firm of Treitel-Gratz by the sculptor Alexander Liberman, Newman seized the opportunity to produce with the company the two exemplars of "Here II" (Figs. 105, 106). It was obvious both that "Here II" harked back to Newman's first sculpture, made fifteen years before, and that it was essentially different. Instead of two, there were now three uprights of equal height, one thick one and two narrower ones, all sharing the same base. Instead of plaster or bronze, "Here II" was fabricated from rolled and COR-TEN steel. The contrast between rough and smooth surfaces had been abandoned. Everything seemed to have been straightened out. What in "Here I" had been reminiscent of small, irregularly shaped hills or mounds had now been replaced by smooth, truncated pyramids overlooking a flat plain. The initial impression conveyed by "Here II" is one of compactness and hierarchy. As we move closer, however, the sculpture seems to lose its solidity and heaviness. The narrow, rectangular tops and trapezoidal sides of the pyramids seem to be the outer surfaces of hollow rather than solid bodies. Something similar occurs with the base. Its reinforced, two-inch edge has been deeply cracked and furrowed with a cutting torch, whilst the removable, invisible wheels underneath the base facilitate the raising of the entire sculpture from the floor by approximately one inch. The resulting hovering effect, created by the shadowy gap between the base and the floor, was evidently of particular importance to Newman.

The arrangement of the uprights on the base was carefully tested with wooden models beforehand. Even the dimensions of the individual elements were not left to chance. For example, the ratio of the overall height ($121^{11}/_{16}$ inches) of the sculpture to the width ($78^5/_8$ inches) of the base is the same as the ratio of the width of the base to its depth ($50^3/_8$ inches). This cannot possibly be a coincidence.[1]

The uprights themselves clearly differ from one another. The middle one is 3 by 8 inches and $112^1/_2$ inches high, and rises from a truncated pyramid whose base measures 17 by $21^1/_2$ inches and is $7^1/_2$ inches high. The two more slender uprights are each 2 by 4 inches and $113^1/_2$ inches high. Their pyramids each measure $15^3/_4$ by 15 inches at their bases, and they each have a height of $6^1/_2$ inches. Whilst the bases of the smaller pyramids are almost square, the base of the large pyramid is rectangular: the ratio of the short to the long side is 7:9. These relationships are reflected in the uprights. With a width-to-depth ratio of 2:1, the thinner uprights seem, astonishingly, to be more compact than the solid middle upright whose corresponding ratio is 2.5:1. The angles of the slopes of the pyramids also vary slightly. Whilst in the case of the large pyramid these angles are identical on all four sides, in the case of the two smaller ones, which measure an inch less in height, the angles of the slopes are slightly less steep on the broader sides. Although these differences are scarcely noticeable, they are central to the esthetic effect of the sculpture, as is the the location on

the same plane of the tops of all the uprights, though this is not visually obvious, as the pyramidal bases of the uprights are not in line with one another but seem to have been distributed on the base purely at random.

This fortuity, however, is only apparent. The thicker central upright is positioned centrally in relation to the front edge of the base and $2^3/_4$ inches away from it. As Newman had a relatively large piece cut out of the front left-hand corner of the base, making the base seem incomplete, damaged, even fragmentary, the upright's central position is not readily discernible. The left-hand upright is positioned at a distance of $22^1/_2$ inches from the front edge and 7 inches from the side. The right-hand upright stands at a distance of $31^1/_2$ inches from the front edge and 4 inches from the side. All three uprights and their pyramidal bases are square with the edges of the base. If the two outer uprights were pushed inwards so as to share the central axis with the central upright, the space between the central pyramid and the left-hand pyramid would measure approximately $2^3/_4$ inches, whilst the left-hand and the right-hand pyramids would overlap by approximately $6^1/_2$ inches. If the two outer uprights were pushed forward so as to be in line with the central upright, the distance between the central upright and the left-hand and the right-hand uprights would measure $5^3/_4$ inches and $8^1/_2$ inches respectively.

Whilst such arithmetical excursions may seem superfluous, they do give us some idea of the extent to which Newman experimented with the positions of the uprights in order to obtain an arrangement affording the greatest possible diversity of aspects. The chosen arrangement is decidedly symmetrical and center-weighted. If we project the vertical elements onto an ideal plane, however, we will sense how the symmetry is disturbed. Viewing the sculpture from different positions in a room undermines this impression and reinforces the latent equilibrium of the work. Viewed from the front, the narrower uprights seem to be following the thicker central one, that is to say, the sculpture seems to generate a forward motion across the base towards the viewer. A completely different impression is gained when the sculpture is viewed from the opposite side. Here, the narrower uprights seem to frame the central one, generating motion away from the viewer that rests momentarily in the center of the sculpture before finally coming to a complete standstill in the broad central upright at the back. If the viewer slowly walks round the sculpture, he will perceive an ever-changing constellation. Gaps will open and close, edges will be concealed and revealed, surfaces will merge with one another, the slopes of the pyramids will steepen and flatten in a constant process of reciprocation. The homogeneity of the surfaces, the precision of the edges, the calculated positions of the uprights, the interplay of symmetry and asymmetry— all these features make "Here II" very different from "Here I". There is severity in its variability, a hint of the impersonal in its perfection. Only the rough-cut edge of the base sug-

103 Alberto Giacometti, *Tall Figures I, III, II, IV*, 1960, bronze
From *Alberto Giacometti*, The Museum of Modern Art, New York, 1964, p. 72

104 *Shining Forth (To George)*, 1961
Oil on canvas, 114 x 174 ins.
Musée national d'art moderne
Centre Georges Pompidou, Paris

257

gests manual intervention, laying bare the materiality of the work precisely—for this seems significant—in that part of the sculpture which is but an inch from the floor. The distance between the work and the viewer decisively influences the viewer's perception of the respective heights of the three uprights. However simple this may seem, it is still astonishing to note how Newman at once emphasizes the symmetry and neutralizes it; how he creates a spatial effect, then destroys it; how he empties the center and yet—virtually—fills it. When we observe the way the individual uprights relate to one another—how they move apart, how they overlap optically, how they seem to touch one another—our point of reference is always this empty center. Although there is nothing in it, it is our means of orientation. This is because the broader upright is the dominant element of the sculpture only when the work is viewed directly from the front. It is then, and only then, that we subordinate everything else to it. If we move out of this line of vision, we will sense how the three steel uprights begin to define an area without actually enclosing it. This is because, on the one hand, we perceive the three uprights as a group, especially as one of them is clearly intended as the dominant element, and, on the other, we observe the tendency of the other two uprights to liberate themselves from this group, to detach themselves, to move as close to the edge as possible, asserting their autonomy and thereby both releasing and isolating the broader upright from the group. Of course, nothing actually moves in this sculpture, but we still sense—subliminally— the tendency of the sculpture to relate the elements to one another in this way. Slight shifts of position always seem possible. And it is this potentiality of motion, in spite of the rigidity of the components, which seems to be central to "Here II". That we register this phenomenon at all certainly has something to do with the apparently fortuitous, though in fact carefully balanced, arrangement of the three uprights on the base.

But let us break off here. Residing in "Here II", a work which at first glance seems to promise nothing, is an abundance of fascinating phenomenological possibilities. Its open structure offers a diversity of equivalent perspectives without in any way detracting from its main aspect. It may owe its clarity and purity of concept to Newman's renewed interest in the works of Giacometti, whose large retrospective exhibition had been shown at the Museum of Modern Art from June 5 until October 10, 1964 (Fig. 103). Very probably, Newman had not yet started work on "Here II" at that time.[2] "Here II" has also been compared, by a number of artists and art critics, with Newman's "Shining Forth (To George)" of 1961 (Fig. 104).[3] Whilst most commentators do not go beyond the obvious similarity between the "zips" and the uprights, these two works, the painting and the sculpture, do indeed operate according to the same principles. This subject was treated by Donald Judd in an exemplary essay written in 1964. Newman's junior by more than twenty years, Judd was impressed by the formal stringency of Newman's oeuvre, but had little understanding of emotional inter-

258 pretations of it. For Judd, it was the painting's form alone, not its content, which was decisive, and he attached particular importance to its wholeness. Nothing, wrote Judd, is merely a part of something else. Nothing suggests that the parts of the painting extend beyond the frame, nor is there anything to suggest that they appear (just) within the frame. For Judd, Newman's painting represented a totality which was new and significant: "Everything is specifically where it is."[4] Whilst this may seem a somewhat banal statement, it does hit the bull's-eye.

In the case of "Here II", however, the experience of totality is combined with the experience of latent mobility, a feature which Judd would not perhaps have considered convincing. All the same, Judd had recognized in Newman's paintings the endeavor to realize the very principles with which he himself was concerned, but that was as far as it went as regards a possible parallel between paintings such as "Shining Forth" or sculptures such as "Here II" and Minimal Art. Latent symmetry or the suggested "hierarchical structure of center and subordinate sides"[5] did not fit in with Judd's own intentions.

Newman was undoubtedly concerned with coming to terms with a place of heightened significance, with setting a scene within a small confined area, with realizing a monument as an open structure, with creating a sculpture as a visually variable, three-dimensional entity, but the forms he uses to these ends are forms which awaken no particular associations. What is more important, however, is the way these forms relate to one another, the way "Here II", as an integral whole, is formed from its individual parts such that these individual parts are not experienced as such—all due to Newman's use of machine-made elements. He uses similar or identical parts, leaves much to chance, and intervenes creatively only here and there. But there is in fact no place in such a work for the creative individual, with his ideas, fantasies, and feelings, unless of course we consider the jagged base with its missing corner to be proof of his existence and authorship.

Both "Here II" and the other "Here" sculptures have provoked a wide range of interpretations. Hess, for example, first felt reminded of the "mesas, buttes and chimneys in the Navajo country of Nevada"[6] and, later, of the spires of "Combray", as described by Proust, and of Calvary.[7] The idea that this sculpture symbolized Christ on the Cross, with the two thieves on either side, fascinated Hess, and led him to compare the side view of the sculpture with a painting by Brueghel.[8] Rosenberg reacted completely differently: "These tall, undistinguished beams convey nothing but their presence, as if one were to wake up and find a piece of mountain jutting into the bedroom. *Here II* generates a strange silence around itself [. . .]—the silence of a sanctuary or place set apart."[9] The spirituality sensed by Rosenberg is echoed by Elizabeth Baker when she writes: "[. . .] the verticals standing in splendid isolation seem to take on a more descriptive, dramatic role as bearers of Newman's meta-

105 *Here II*, 1965
COR-TEN steel, 103 x 79 x 51 ins.
National Gallery of Canada, Ottawa ▷

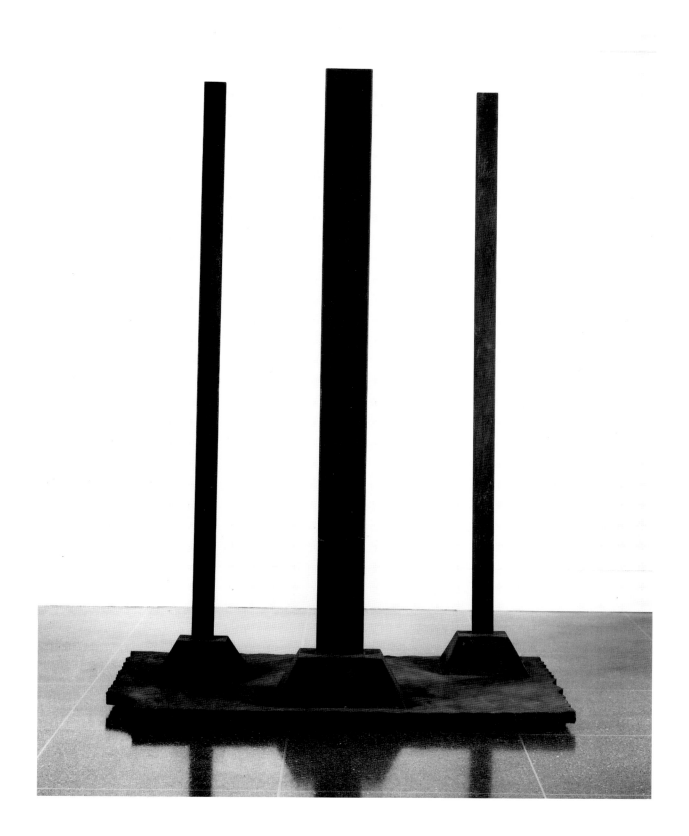

physical attitude toward his subject matter, whether surrogates for the human figure, for crosses, as a masculine symbol, or some heroic absolute [. . .]"[10]

All these interpretations, however, seem vague, arbitrary, and, in most cases, difficult to comprehend. Newman himself never spoke about "Here II", nor do the few surviving sketches betray anything of his intentions.[11] In an interview given shortly after completing the sculpture, however, Newman did make a general observation which may be applied to "Here II": "I do not consider my sculpture to be a three-dimensional equivalent of my paintings. I think the problems are altogether different. Painting is a planar art. Sculpture involves for me the problem of volume. But I hope that both the sculpture and the painting give the onlooker a sense of place, a sense of being there."[12]

There are two exemplars of "Here II". The one exhibited here belongs to the Daros Collection, Switzerland; the other one has been in the collection of the National Gallery of Canada, Ottawa, since 1978. Although they were produced individually—the base required particular attention—the two versions of "Here II" scarcely differ. The execution of the sculptures did, however, pose considerable problems, for Newman insisted that the flame-cut edges of the base be reproduced exactly. It was Newman's intention, using a process which was altogether unsuitable for such a purpose, to reproduce the marks left fortuitously by the cutting torch and the molten steel—thus eliminating their fortuitousness. Such problems were not encountered with the bronze cast of "Here I", and they could have been avoided in this case, too, if Newman had built "Here II" solely from parts, such as the uprights and the truncated pyramids, which could be readily mass-produced.

Two exemplars constitute a very small edition; indeed, it might be more appropriate to speak of a duplication than of an edition. Newman himself had no problems in this regard: "I don't believe in the unique piece. [. . .] I think every piece of sculpture can be duplicated. [. . .] I used to argue this with David [Smith] all the time. [. . .]"[13] Smith lamented that sculptures existed in large editions and that the same sculptures could be seen everywhere. But when pressed for an opinion, Smith conceded that he had, in principle, nothing against casts. He objected to them only when they were made by dealers and museums. For him, a sculpture was "only good if it [came] from the hand and from the eye of the artist. Otherwise it's reproduction."[14] In other words, a cast is acceptable provided the artist controls its manufacturing process from start to finish.

But this is precisely what Newman has done. He has given the mechanical character of his sculpture a personal note, but without embracing the principle of uniqueness. Such details point to the basic difference between the sculptural concepts of these two artists. Smith's sculpture is in the tradition of the Cubist collage. He works with found objects, freely combining them with forms of his own making, and playing opposites off against each

106 *Here II*, 1965 (Cat. No. 36)
Daros Collection, Switzerland

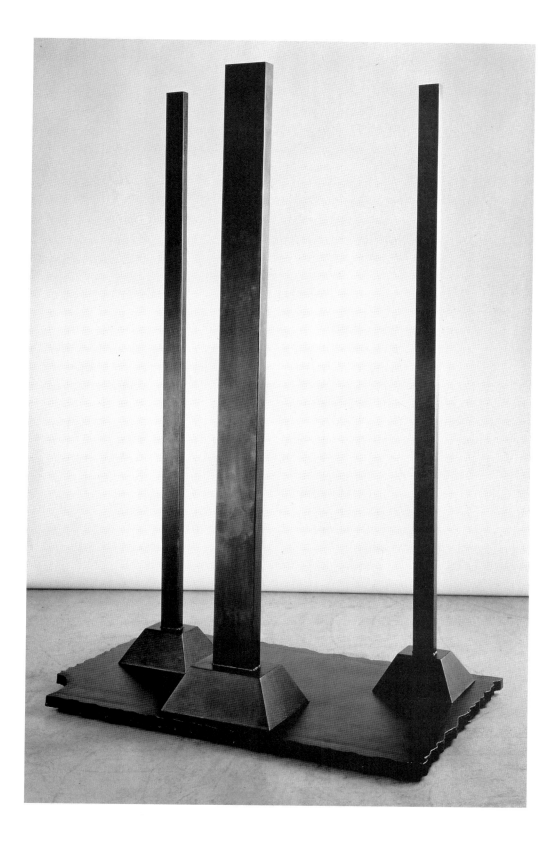

262 other—the supporting against the supported, the curvilinear against the straight, the circular against the angular, the positive against the negative, the organic against the geometrical. Newman's sculpture, on the other hand, is based on Constructivist principles inasmuch as he combines geometrical solids tectonically, though he concentrates solely on their towering function. His uprights have a base, but they support nothing. And they rest on foundations which contradict the mechanical character of the anonymous, nondescript forms, for they permit a certain degree of individuality. The jagged edges of the bases of the two exemplars of "Here II" have the character of a signature, for they are identical to the letter, though slight deviations are acceptable provided they do not affect legibility.[15] In a genetic sense, those splashes and drops of plaster which fell from the actual base of "Here I" onto the milk crate and dried on its sides live on in the jagged edges of "Here II". That Newman attached enormous importance to this form of base is reflected in his decision to repeat it in "Here III" and "Broken Obelisk", a detail which takes away the anonymity of these works and saves them from the danger of sterility.

1 I wish to thank Peter Fischer, Zürich, for his assistance in obtaining the measurements of the version of "Here II" shown in this exhibition.

2 Cf. Franz Meyer, *Giacometti et Newman*, in: *Alberto Giacometti. Sculptures, Peintures, Dessins*, Musée d'Art Moderne de la Ville de Paris, November 30, 1991– March 15, 1992, p. 63.

3 Hess, p. 116.

4 Donald Judd, *Barnett Newman*, in: *Studio International*, February 1970, p. 69. (According to the introductory remarks, the article was written in 1964 but not published until 1970.)

5 Cf. Barbara Reise, *The Stance of Barnett Newman*, in: *Studio International*, February 1970, p. 61.

6 Hess, 1969, p. 70.

7 Hess, p. 118.

8 Ibid., p. 119.

9 Rosenberg, *Broken Obelisk*, p. 15.

10 Elizabeth C. Baker, *Barnett Newman in a New Light*, in: *ARTnews*, Vol. 67, No. 10, February 1969, p. 61.

11 Richardson, p. 210, E.

12 Newman, *Writings*, p. 273.

13 Ibid., p. 284.

14 *The Secret Letter*. An interview with David Smith, June 1964, by Thomas B. Hess. In: *David Smith,* Marlborough-Gerson Gallery, New York, October 1964, [n.p.].

15 Cf. Newman's remarks, while in conversation with Pierre Schneider during their visit to the Louvre, on adding his signature to his paintings. Standing in front of a portrait of the Baroness de Rothschild, Newman points to the Rothschild coat of arms and says: "It is like Whistler's butterfly—a collage. Ingres is the only man, with Whistler, who can stamp on a symbol as if it were outside the picture. I try to do it when I sign my paintings." Newman, *Writings*, p. 298.

"Here III" was begun at Treitel-Gratz on Long Island in 1965, and three exemplars were completed a year later. The exemplar exhibited here belongs to the Kunstmuseum Basel, whilst the other two belong respectively to the Whitney Museum of American Art in New York and the Nasher Collection in Dallas.[1] The similarity between this sculpture and "Here II" is obvious. Indeed, it is as though Newman has simply isolated the broader upright (three by eight inches) and its truncated pyramid from "Here II" and mounted them on a base which projects almost an inch beyond the bottom of the pyramid on all four sides. The result is one of succinct simplicity. Reduced to a single vertical element having an overall height of 126 inches, "Here III" seems graspable at a single glance.

But perhaps not entirely. Although this sculpture, like "Here II", seems to hover slightly above the floor, and its seemingly solid base is just as hollow as its other parts, there are several aspects which make "Here III" considerably different from "Here II". Its base, with its jagged edge, is an inch thicker than that of "Here II", measuring a full three inches. Moreover, the base and the pyramid together form a composite unit, with the rusty surface of the COR-TEN steel further strengthening the link between these two elements. From the flat top of the pyramidal base rises the stainless steel vertical, its smooth, rounded edges answering the jagged edges of the base and the obtuse angles of the pyramid, while its matte-polished, silvery sheen contrasts with the rusty base. And this is where the essential difference between "Here III" and "Here II" lies. There, in "Here II", three verticals define a spatial situation; here, in "Here III", a single element, in its isolation, emphasizes its own volume. There the centering around an empty middle; here the defining of a central axis without any surrounding field. There the silent yet constant suggestion of transitory moments and changing aspects; here the definite fact of absolute immobility, combined with the gentle interplay of light and shadow. Whilst in "Here II" space is compressed, surfaces are displaced, and lines are made to intersect, in "Here III" the entire environment relates to the single upright, for the upright provides—irrespective of the attention which the sculpture itself attracts—a means of orientation for top and bottom, left and right, front and back, permanence and transience. In the unrestricted interplay of "Here II", the emphasis is on materiality; in the concentration on a single element in "Here III", there is a suggestion of immateriality.

Having nothing sensational about it in the accepted sense of the word, "Here III" is dependent on its surroundings to a much greater extent than "Here II". This is demonstrated most impressively by the exemplar at the Kunstmuseum Basel. At the museum the sculpture stands in the center of a room whose walls are hung with paintings by, among others, Newman, Still, and Kline. It is an unusual situation, and one in which "Here III" seems to be defining the surrounding space, allocating a place to everything which is in the room (Fig. 107).

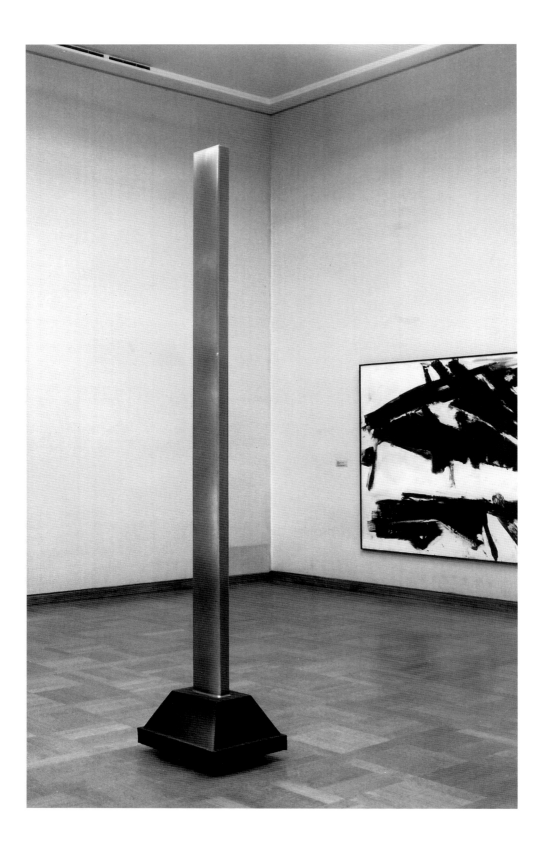

107 *Here III*, 1965/66 (Cat. No. 37)
Öffentliche Kunstsammlung Basel
Kunstmuseum

Elizabeth C. Baker saw in the "softly reflecting surface" of "Here III", in "its immaculate slimness" and "dematerializing silvery luminosity", both an expression of "pure spirituality" and a presence which was astonishingly "humanoid".[2] The pyramidal base and the upright are joined together by a concave, stainless-steel weld which reflects the light in a completely different way from the vertical surfaces of the upright itself. This weld was interpreted by Thomas B. Hess thus: "[. . .] the weld is where, in Newman's temperament, the jaunty old-fashioned expertise of the baseball pro—the can-do American craftsman—meets the objective intellectual-emotional logic of the avant-garde artist: Babe Ruth, Sultan of Swat, and Ari Luria, Lion of Safed."[3] Rosenberg saw "Here III" as the embodiment of "the numeral 1, the figure that for Newman is the primal symbol. It stands for the first, the originator of substance, celebrated by Newman in such titles of his paintings as *Genesis, Beginning, Day One, The Name, Onement* [. . .]"[4] Rosenberg repeated this idea several years later, though this time with the additional interpretation of the isolated vertical of "Here III" as the letter "I", that is to say, a symbol not only of the originator of substance but of the self.[5] Other authors were considerably less imaginative in their interpretations, and were content with a phenomenological analysis of "Here III", with particular emphasis on its reflections of light and on the way the upright related to its surroundings.[6] In choosing stainless steel as his medium, Newman seems to have been seeking a direct confrontation with David Smith[7], who employed stainless steel and had expressed himself explicitly about the properties of this material in an interview with Thomas B. Hess in 1964[8]. "They [Smith's sculptures] are conceived," Smith declared on another occasion, "for bright light, preferably the sun, to develop the illusion of surface and depth [. . .] Stainless steel seems dead without light—and with too much, it becomes car chrome."[9] Thus Smith deliberately left the marks of the grinding and polishing wheels on the boxes and cylinders of his "Cubi" series, creating a lively, shimmering, allover-like texture. Newman, on the other hand, avoided such psychographic effects, for he was concerned with obtaining a matte satin sheen which was as homogeneous as possible. Unlike Smith, whose work was primarily atmospheric, Newman sought to create a sense of space. A few years before, in an interview with Dorothy Gees Seckler in 1962, Newman had said: "I don't manipulate or play with space. I declare it. [. . .] I remember years ago shocking my friends by saying I would prefer going to Churchill, Canada, to walk the tundra than go to Paris. For me space is where I can feel all four horizons. [. . .]"[10] And in 1965, when he had finished "Here II" and was just starting work on "Here III", Newman talked about his painting in terms which might apply to his sculptures, too: "One thing that I am involved in about painting is that the painting should give man a sense of place [. . .] that the onlooker in front of my painting knows that he's there. To me, the sense of place not only has a mystery but has that sense of metaphysical fact. I have come to distrust the

266 episodic, and I hope that my painting has the impact of giving someone, as it did me, the feeling of his own totality, of his own separateness, of his own individuality, and at the same time of his connection to others, who are also separate."[11] What Newman describes in his own characteristic terminology as a "metaphysical fact" is his intention to transport the place of the sculpture to the innermost realm of our experience, or to visualize it in such a way that the paradox becomes obvious, as indeed the sculpture in itself may appear to us. The question of how things in themselves appear to us has been the subject of much philosophical reflection, above all by Merleau-Ponty.[12] I do not, however, wish to give the impression that Newman had studied the works of this French phenomenologist. Rather, I wish to point out that the abstract configurations of Newman's paintings and sculptures do not pay homage to any vague mysticism. On the contrary, Newman was very much concerned with defining as precisely as possible the transcendental character of the esthetic experience. Completely free from anecdote, narration, or suggestion, Newman's creative act resides in the final analysis in the relationship between subjective experience and objective observation, in the interaction of awareness of self and awareness of object, wherein the one is no longer distinguishable from the other, each having interpenetrated and become identical with the other. Newman's greatness lies not least in his success in achieving this interaction in such a convincing yet astonishing way, both in his paintings and also in the few sculptures he produced[13], each of which in its own way says everything there is to say and—essentially—shows everything there is to show.

1 *Masterworks of Modern Sculpture: The Nasher Collection.* Fine Arts Museums of San Francisco, October 1996–January 1997, p. 250.

2 Elizabeth C. Baker, *Barnett Newman in a New Light,* in: *ARTnews,* Vol. 67, No. 10, February 1969, p. 61.

3 Hess, p. 119.

4 Rosenberg, *Broken Obelisk,* p. 15.

5 Rosenberg, p. 78.

6 Cf. Benjamin G. Paskus, *The Theory, Art, and Critical Reception of Barnett Newman,* University of North Carolina at Chapel Hill, Ph.D. dissertation, 1974, p. 208: "[. . .] the shaft [. . .] reads both as negative band and energized presence in the light-space which surrounds and forms it." Paskus also refers to the affinity of this sculpture with the painting "Profile of Light".

7 Cf. Hess, p. 120.

8 *The Secret Letter.* An interview with David Smith, June 1964, by Thomas B. Hess. In: *David Smith,* Marlborough-Gerson Gallery, New York, October 1964, n.p.

9 David Smith, *Notes on My Work,* in: *Arts Magazine,* Vol. 34/2, No. 5, 1960. Here quoted from: *David Smith,* op. cit. (Note 8), n.p.

10 Newman, *Writings,* p. 249.

11 Ibid., p. 257 f.

12 Cf. Maurice Merleau-Ponty, *Phenomenology of Perception,* translated from the French by Colin Smith, London and New York, 1996, p. 71: "We must discover the origin of the subject at the very center of our experience; we must describe the emergence of being and we must understand how, paradoxically, there is *for us* an *in-itself*."

13 Newman possibly planned a further sculpture, probably with four uprights on a base, but it was never realized. It seems that only a few sketches have survived in Newman's estate. Cf. Lawrence Alloway, *One Sculpture,* in: *Arts Magazine,* Vol. 45, No. 7, May 1971, p. 22.

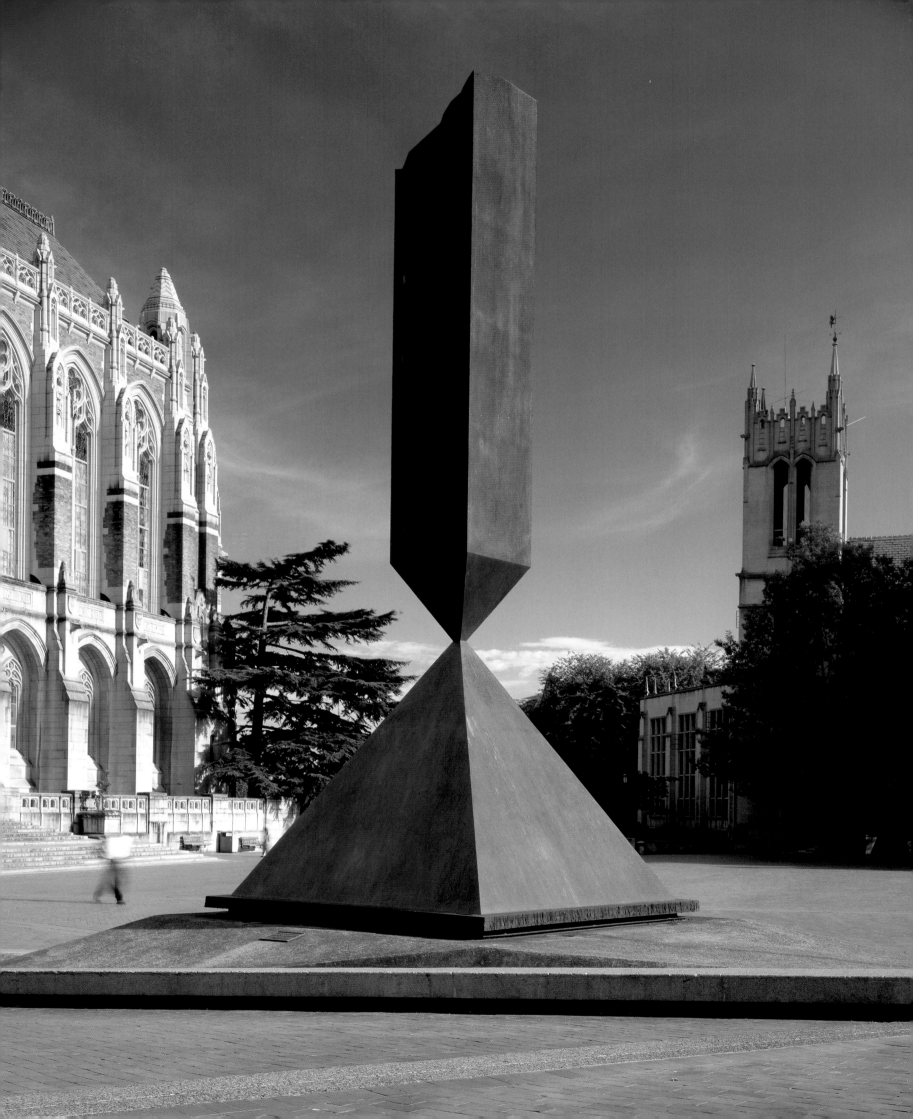

I

"Broken Obelisk" (Fig. 108), Newman's largest work and, according to Hess, "one of the most impressive monumental sculptures of the twentieth century"[1], was fabricated in two exemplars in 1967 by the firm of Lippincott Inc., North Haven, Connecticut (Lippincott fabricated a third exemplar, now in the Museum of Modern Art, New York, in 1969). Robert Murray, after having done several large jobs himself at Lippincott's, recommended this firm to Newman. Unlike Treitl-Gratz, Lippincott was equipped to handle work of considerable dimensions.

Simple though the concept of this sculpture may be, its effect is beyond comparison. An inverted obelisk, its shaft broken, is mounted on a pyramid in such a way that their tips touch and slightly penetrate each other—an upward-moving force meets a downward-sweeping movement, or, to put it another way, a vertical load is supported by an opposing thrust. Whilst these dynamic forces maintain equilibrium, each interacts with the other in a different way. The broad upward thrust seems to be aimed at a specific point, and to be decelerating; the narrow downward thrust seems to accelerate and shoot beyond the point of contact. The result is an unstable balance of vertical forces which seems to neutralize gravity rather than overcome it. The dramatic collision of upward- and downward-moving objects strikes the observer most, whilst the constriction and expansion of the forms in the horizontal plane seem to be of secondary importance. All forces seem to cancel each other out, creating the impression of absolute repose, but it is a repose full of tension, a repose which could snap at any minute into its opposite and end in upheaval. What this sculpture visualizes is a simultaneous concentration and neutralization of energy in the state of equilibrium achieved by the risky balancing act performed by the obelisk on the pyramid.

All lines and vectors converge at the point of contact between the pyramid and the obelisk. This point is the center of the sculpture not only in a technical or physical sense, however, but also in terms of form and content. There is hardly any other example of a work of art of such dimensions which culminates in a single point. No matter how far-fetched it may seem, many authors—Jean-François Lyotard, for example—have suggested a parallel between the meeting point of "Broken Obelisk" and the Sistine Chapel ceiling fresco of the Creation of Adam, where God's finger almost touches Adam's. Whilst such a comparison is hardly tenable in an art-historical context, it is valid inasmuch as Newman was concerned not with demonstrating a physical phenomenon but with visualizing a spiritual act. And it was of decisive importance that the collision of opposing forces take place vertically and not horizontally.

It is obvious that Newman attached the utmost significance to keeping the point of contact as small as possible and that he envisioned this point, ideally, as the juncture of two straight lines. This was impossible to achieve in a steel structure of such dimensions, how-

◁ 108 *Broken Obelisk,* 1963/67
COR-TEN steel, 26 x 10½ x 10½ feet
University of Washington, Seattle

ever, and so he agreed to a slight truncation of the apices of both geometrical solids. The resulting weld, measuring only $2^1/_4$ inches along each of the four sides, was so minimal that it scarcely detracted from the effect which Newman was striving to achieve. And he was able to accept it not least because the angles of the converging apices were identical. Thus the viewer would subconsciously correct the slight misalignment of the converging forms and assume that the one led directly into the other, the pyramid up into the obelisk, and the obelisk down into the pyramid. In a drawing[2] doubtless produced prior to the execution of the sculpture and perhaps for the purpose of showing Lippincott what he had in mind, Newman had proceeded from completely different dimensions and proportions (Fig. 109). In this drawing, the obelisk is not only extremely thin in relation to the pyramid but also so steeply pointed that the angles of the apices of the solids differ vastly. The result is that the two solids appear to be completely separate, and not, as in the case of the ultimately executed sculpture, integral parts. Indeed, one of the most surprising aspects of "Broken Obelisk" is that, despite the collision of opposing forces and the shaky equilibrium, the sculpture is immediately experienced as a unit and not as a conscious combination of two geometrical solids, one of them broken and turned upside down.

II

This impression is strengthened the more closely we examine the sculpture. If we disregard the purely visual quality of the sculpture for the time being and consider the relationship of the parts to one another in terms of their dimensions and proportions, we realize how carefully Newman worked to achieve the desired effect. Reliable points of reference may be taken from the Lippincott engineering drawing (Fig. 119), according to which the sculpture measures 25 feet 5 inches from the floor to its highest point, including the gap of 2 inches underneath the edges of the base (Newman's intention was to create a hovering effect). The dimensions of the pyramid were probably based on the dimensions (9 feet 6 inches by 24 feet) of the existing steel plate, from which four isosceles triangles could be cut, each with sides measuring 10 feet 4 inches and a base measuring 9 feet 6 inches. A triangle whose sides are longer than its base has a different angle at its apex than at its two base corners; these are 53 degrees and 63.5 degrees respectively. What is surprising about the apex angles and the resulting proportions is that they more or less correspond to those of the Great Pyramid and the Pyramid of Chephren at Giza.[3] Although this correspondence does seem more than a coincidence, the question whether Newman had based his calculations on the pyramids at Giza remains unanswered.

 Newman's steel pyramid stands on a 4-inch-thick base which projects 6 inches beyond it on all four sides; the length of each side, consequently, is 10 feet 6 inches. The height of

109 *Broken Obelisk*, n.d. (Cat. No. 18)
The Menil Collection, Houston
Gift of Annalee Newman ▷

"Broken obelisk"

Barnett Newman

base of pyramid
app 9½' each side

height pyramid - app: 8' at apex
height obelisk - app - 16'
height base - app - 1' or 2'
all over height app - 25' or 26'

272

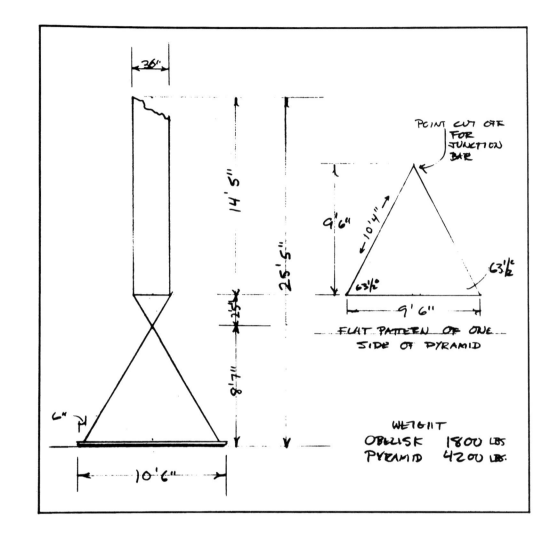

the pyramid itself is 8 feet 1 inch. The overall height of the pyramid, including the 4-inch base and the 2-inch gap, is 8 feet 7 inches.

The inverted obelisk measures 14 feet 5 inches from its highest point to the end of its shaft. Its pyramid has a height of 2 feet 5 inches. The total height of the obelisk is thus 16 feet 10 inches, exactly twice the height of the pyramid and base, i.e. 2 x 8 feet 5 inches. This ratio of 2:1 makes one wonder whether Newman was working according to the golden section. Indeed, the sculpture measures from the base of the pyramid to its highest point 299 inches (= 25 feet 5 inches minus base and gap) and 114 inches along the bottom edge of the pyramid—which is remarkable inasmuch as the relationship between 299 inches and the difference between 299 inches and 114 inches (= 185 inches) is exactly in accordance with the golden section, that is to say 299:185 = 185:114.

Vertically, the point between the extreme and mean ratio lies some distance above the intersection of the pyramid and the obelisk. Given a height of 305 inches, the point between the extreme and the mean ratio is 116$^1/_2$ inches above the floor, i.e. 13$^1/_2$ inches above the point of contact of the two geometrical solids, in other words, roughly in the center of the pyramid of the obelisk. There is good reason for this. Since the viewer, who is standing on the same level as the sculpture, experiences a foreshortening of its upper part, and this foreshortening increases as the viewer approaches the sculpture, Newman compensated for this effect by locating the point between the extreme and mean ratio not at the intersection between the two geometrical bodies—as one would expect—but a good foot higher. Finding just the right balance between mathematical calculation and visual effect was probably one of the problems which preoccupied Newman during his preparations for "Broken Obelisk".

Proportionality is an element not merely in the overall height of the sculpture and its subdivision but also in the widths of the individual elements. The width of the obelisk, for example, is 36 inches. That is slightly less than one third of the base of the pyramid. The precise ratio is 1:3.16. Coincidence or not, this figure comes very close to *pi*, namely 3.14. And it is certainly no coincidence if Newman indeed based his sculpture on the proportions of the Egyptian pyramids: the mathematicians of ancient Egypt used $\pi \approx (4/3) \approx 3.1604$. Finally, the ratio of the width of the obelisk to the overall height of the sculpture is 1:8.5.

The proportions change, however, as soon as the viewer moves from the front towards the side and observes the sculpture from an angle, in such a way that his line of vision coincides with the edges of the obelisk and the pyramid and the surfaces on either side are visible to an equal extent (Figs. 111, 112). The sculpture becomes extraordinarily broad: the base of the pyramid grows from 9 feet 6 inches to 13 feet 5 inches, and the shaft of the obelisk broadens from 36 inches to 50$^7/_8$ inches. Thus, whilst the height of the sculpture hardly seems to change when the viewer moves to a different position, it is 40 percent broader when viewed from the side than when viewed from the front, and, conversely, it is 30 percent narrower when viewed from the front than when viewed from the side. Another change also takes place: the angle formed by the tips of the pyramid and the obelisk becomes more acute, reaching almost 90 degrees when viewed from the side. And so elegance gradually becomes transformed into density, but without disturbing the balance between pyramid and obelisk (though the upward thrust does seem a shade stronger than its opposing force when viewed from the front, whilst from the side the opposite seems to be the case, that is to say, gravity seems to be the more dominant force). Thus "Broken Obelisk" is a work whose appearance and effect are evidently meant to change as the viewer changes his

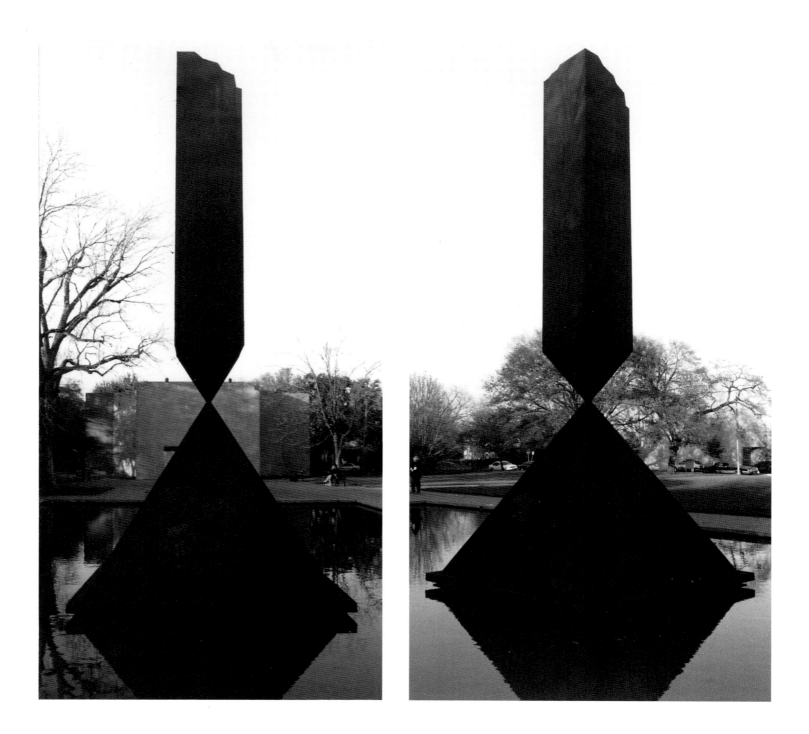

111 *Broken Obelisk*, The Rothko Chapel, Houston. Front view 112 *Broken Obelisk*, The Rothko Chapel, Houston. Diagonal view

position and it was undoubtedly this aspect which preoccupied Newman as he drew up the final specifications.

The spatial effect of "Broken Obelisk" could not be calculated beforehand. It could, however, be tested by means of a full-scale model, and that is exactly what Newman did. Nonetheless, it was a difficult process of trial and error, for various parameters had to be considered, e.g. the varying distance between the viewer and the sculpture and the resulting change in the viewing angle. Newman did not just provide Lippincott with a small cardboard maquette to be mechanically enlarged. One critic suggested he had done so, and Newman repudiated her suggestion emphatically: "The cardboard cut-outs she [Mrs. Green] saw were done only because I wanted to test the internal height of the bottom pyramidal shape. It is possible, of course, to do this mathematically. The internal height can be calculated. However, since I work directly, I felt I had to see the possibilities in terms of scale, visually. I even made full-size mock-ups of other sections of the piece in the factory for the same reason. The making of cardboard or wooden mock-ups is normal practice in any machine shop before metal is cut, even with small items, let alone nine and a half foot triangles, whether the factory is making sculpture or machines. The point I wish to make is that under no circumstances were these sculptures blow-ups of any cardboard maquettes."[4] Newman's strategy was above all concerned with the problem posed by the triangles which, when joined together to form the pyramid, seemed to become broader on account of their angle of incline. Such problems of scale and proportion were also to preoccupy Newman as he began work on his triangular paintings "Chartres" and "Jericho" (Figs. 58, 59) only a year later.

There are two details which must yet be mentioned. They are particularly important. The first is the edges of the base. As in "Here I" and "Here II", so in "Broken Obelisk" the edges of the base have been flame-cut and are rough and cracked. The result is an uneven interplay of light and shadow, lending the steel an air of naturalness, and making it seem almost dematerialized. This enhances the hovering effect created by the gap between the base and the floor. The reason why the pyramid does not seem to be about to be ripped apart by the downward thrust of the obelisk lies not least in the form's apparent buoyancy. Thus, by means of devices which were as simple as they were effective, Newman succeeded in making his sculpture seem to rise out of the ground.

The second detail is the obvious correspondence between the rough and cracked edges of the base and the broken end of the obelisk. Together they seem not only to rid the sculpture of all rigidity but also to lend it a transitory aspect. According to Donald Lippincott, Newman took the greatest pains over these details, making sure they were correctly shaped[5] —the broken end of the obelisk had to create the illusion of a burst solid. Whether Newman was in fact harking back to his painting "Achilles" of 1952 (Fig. 53), in which,

according to Lawrence Alloway, a similar "ragged edge [. . .] stops the central plane from spanning the whole surface of the picture"[6], cannot be said for sure. What seems more revealing is Lucy Lippard's observation that architects and engineers use such ragged edges as a shorthand for extensions which, on account of their length, cannot be represented on the drawing board.[7] This implies, when applied to Newman's sculpture, that the broken shaft is potentially extensible to a much greater height. In much the same way as the pyramid seems to hover above the ground, the broken obelisk gives the impression of having descended from a great height and of being a small part of something bigger and potentially infinite.

The hovering effect created by "Broken Obelisk" is further strengthened by an indefinable sensation of lightness which we experience when we stand in front of it. The reason is simple: all the elements of the sculpture are hollow, including the base.

III

Although figures in this context say very little, they do confirm that Barnett Newman's sculpture is not the result of work carried out purely on the drawing board, though the drawings from Lippincott's office might at first glance prompt us to make such an assumption. If we consider Newman's initial sketch (Fig. 109) and the enormous differences between his original idea and the finished sculpture, it becomes obvious that the ultimate solution was the product of a relatively long process. It was a process which had to reconcile two things: the artist's idea, realized by means of full-size wooden and cardboard mock-ups, and its technical feasibility, in which the weight—a total of 6,000 pounds—and, above all, the connection between the pyramid and the obelisk were the chief factors. If the sculpture was to be installed outdoors—this was Newman's idea from the outset—it would have to withstand considerable wind loads and the stresses generated by these loads would be at their maximum at a point where the width of the sculpture was at its minimum ($2^1/_4$ by $2^1/_4$ inches). The challenge for the engineer was to find a solution to the problem of stabilizing the sculpture, a solution which would also permit a dismantling of the sculpture into two parts for transport and ready reassembly elsewhere. The problem was solved by means of a bar of specially hardened steel and corresponding reinforcements and guides inside the pyramid and the obelisk.

For all Lippincott's ingenuity in finding such a simple and effective solution, it must be said, thirty years later, that this connecting device—which is so central to the visual effect of the sculpture—has its weak points. The reason lies less in the design of the connecting device than in the materials used. Newman decided to use COR-TEN steel, which at that time was a relatively new material, as it did not require any protective coating of paint.

113 *Broken Obelisk*, 1963/67
COR-TEN steel, 26 x $10^1/_2$ x $10^1/_2$ feet
The Rothko Chapel, Houston ▷

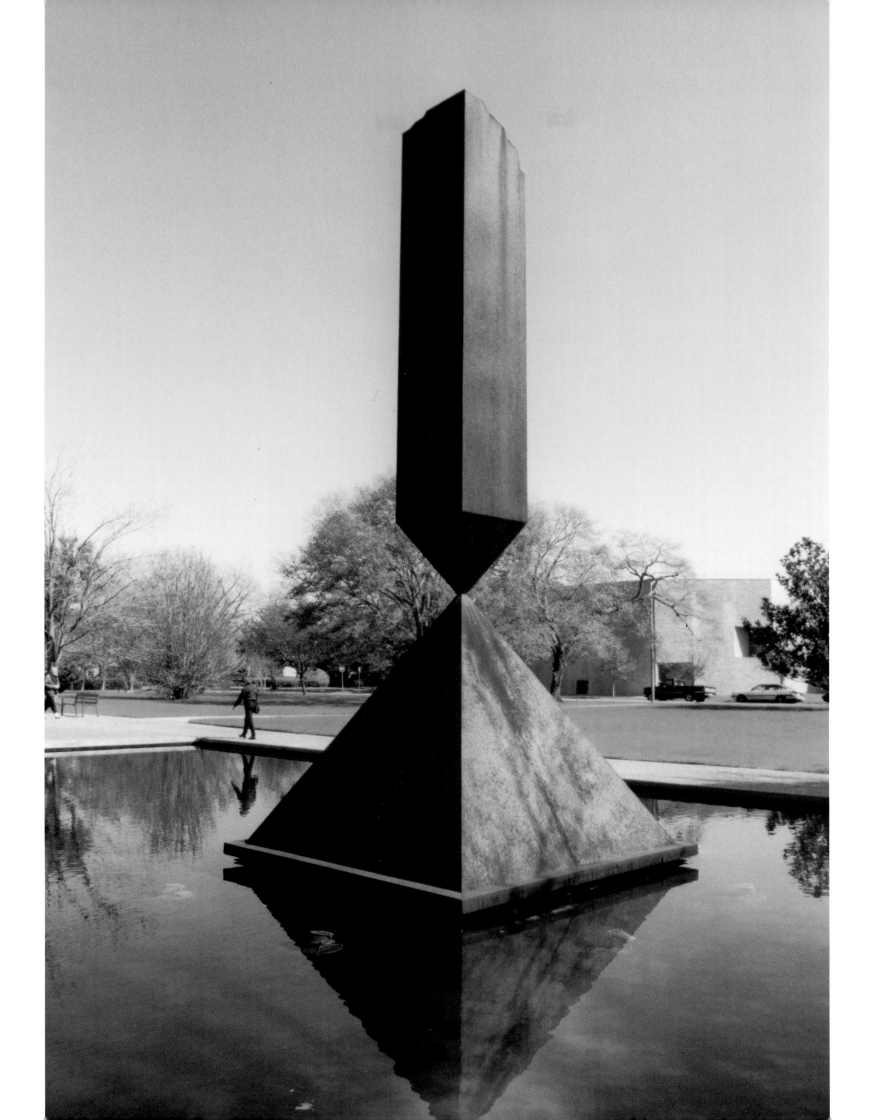

278 Although corrosion did take place when the material came into contact with moisture, it ceased once the surface was covered with a uniform layer of reddish-brown rust. No doubt this was the reason why Newman preferred to use COR-TEN steel, for his balancing act of two earth-colored bodies must have seemed like a metaphor of human existence.[8] Newman did not wish to use bronze—as he had not for "Here II" and "Here III"—but in view of what he had in mind a casting in bronze would not have been feasible anyway.

Whilst COR-TEN steel has proved itself in a diversity of applications, from large-scale industrial plant construction to Richard Serra's sculptures, it gave rise to serious problems with "Broken Obelisk". Through permanent condensation in the interior, and through the ingress of moisture through fine hairline cracks, the corrosion process continued uninterrupted. This was particularly the case in the humid climate of Seattle, where one of the sculptures stands on the campus of the University of Washington. Corrosion has caused rapid deterioration to the point of damage, even danger. And the two other exemplars are endangered similarly. In the case of the Seattle sculpture, the connecting bar had become so loose that the obelisk had twisted out of alignment with the pyramid. According to a repair report of the Physical Plan Department of the University of Washington dated March 7, 1978, the only possible solution had been to shorten each pyramid by approximately $1/5$ inch, thus increasing the length of the weld on each side by $1/2$ inch and, in turn, permitting better reinforcement of the interior. Instead of $2 1/4$ inches, the Seattle sculpture now measured $2 3/4$ inches at its narrowest point.[9] Although this undoubtedly affected the appearance of the sculpture, it could scarcely have been noticed by any but the initiated. Nonetheless, considering the enormous importance which Newman attached to the point of contact between the pyramid and the obelisk, we must ask whether such a radical solution is appropriate for a work which counts among the outstanding examples of his oeuvre. Whilst the significance of the intervention in material terms was minimal, it was fundamental and far-reaching in other ways, not to mention that the artist's rights had been infringed.

IV

Although Newman had not envisioned "Broken Obelisk" as an edition, he did have two exemplars made by Lippincott in 1967, thus forestalling possible criticism that the one work was merely a copy of the other. Both of them, Newman wrote, were produced at the same time and place. "They are identical twins. I make a point of making an edition of two because I do not believe in the unique piece in sculpture when sculpture is cast or fabricated. The unique piece in sculpture can exist only when one is carving stone."[10] But there was something else which was much more important to Newman than this clarifying statement (which was undermined by the subsequent production of a third exemplar). Newman maintained

that "Broken Obelisk" had been neither commissioned nor made for a specific purpose or occasion, such as an exhibition. The opposite might indeed have been assumed, for "Broken Obelisk" was produced at a time when "art in public places" was the theme of a number of projects. "Broken Obelisk" had been conceived as early as 1963[11], but it was not until 1967 that Newman had been able to realize it with Lippicott's help. Moreover, Newman emphatically rejected the suggestion that he and Lippincott collaborated on the project: "Mr. Lippincott is a marvelous, sensitive engineer and was very helpful in solving many problems, but I think he would be embarrassed to think of himself as a collaborator. So careful is he about this that he marks the work he does as 'executed by,' with all the implications of that phrase, so that there can be no possibility of associating him as being in collaboration with the artist. [. . .] The notion of 'collaboration' between artist and factory so prevalent today is just so much folklore."[12] This statement is clearly an invective against the Minimalists and shows how much Newman subscribed to the traditional notion of the artist as a creative genius.

V

In 1967, August Heckscher, Administrator of Recreation and Cultural Affairs in New York, commissioned Samuel Adams Green, the former Director of the Institute of Contemporary Art, Philadelphia, to organize a city-wide outdoor exhibition of sculpture. The exhibition "Sculpture in Environment" took place in the fall of the same year and was the first opportunity for Newman to exhibit "Broken Obelisk" in public. It stood for several weeks in the center of Manhattan, on the plaza in front of the Seagram Building which had been built by Mies van der Rohe and Philip Johnson between 1954 and 1958 on the east side of Park Avenue between 52nd and 53rd Street. Evidently it had not been all that easy to obtain such a prominent position for "Broken Obelisk", as Newman's letter to Philip Johnson dated September 9, 1967, gives us to understand.[13] Newman's rust-brown sculpture was readily able to assert itself against two shallow pools on either side and against the Seagram Building, a bronze-colored, thirty-nine-storied steel-skeleton structure. Whilst the sculpture's verticality corresponded with the facade of the building, it also ran counter to it, both in static and in tectonic terms. At the same time, the sculpture captured attention through its very scale, totally negating the almost four-hundred-foot-high facade of the building behind it. Moreover, the urban environment strengthened the impression that the figure-ground relationship was inverted. As Benjamin Paskus notes, "The relationship of the two major forms is such that great wedges of space seem impacted between the pyramid and the inverted tip of the obelisk. These grow to activate the total space around the sculpture, creating an effect, powerful enough at times, of producing the 'certainty' that the obelisk is held firmly in place by the surrounding space. [. . .] The figure-ground relationship is inverted [. . .] Space acts as

a figure to the ground of the sculpture."[14] Whilst "Broken Obelisk" had not been intended specifically for this site, it was nevertheless able to assert itself as an independent entity in architectural surroundings full of contrasts and contradictions, and not just on account of its size but also because it had been installed at the intersection of various axes of vision dictated by the streets, the paving of the plaza, the pools, and so on.

Hilton Kramer, who reviewed the exhibition in the *New York Times*, found most of the exhibited sculptures mediocre, for their creators had failed to take their respective urban environments into account. Nor was he enthusiastic about Newman's "Broken Obelisk". "The work," he wrote, "is basically a studio conception and does not require or [. . .] gain much from its open-air installation."[15]

Taking place about the same time was the exhibition "Scale as Content" at the Corcoran Gallery in Washington, D.C. Organized by Eleanor Green, this exhibition featured, besides Ronald Bladen's "The X" and Tony Smith's "Smoke", the other exemplar of "Broken Obelisk". Standing outside, at the corner of the gallery's neo-Renaissance building, one could take in at a single glance the obelisk of the Washington Monument and "Broken Obelisk"—a fascinating confrontation indeed. Here, too, Hilton Kramer found Newman's contribution, compared with those of Bladen and Smith, to be "a rather modest, almost traditional conception"[16], an opinion which Lucy Lippard was to share with him. Moreover, she thought "Broken Obelisk" illustrated "an idea less sculptural than graphic at heart, for contour is its most important visual element."[17] One's overall impression is that, of the sculptures shown at the exhibition in Washington, Tony Smith's attracted far more attention than Barnett Newman's.[18] "Broken Obelisk" was also shown at other exhibitions: in Detroit[19], for example, in the summer of 1969, and again in New York[20] in the fall of the same year. The Washington "Broken Obelisk" remained standing beyond the end of Corcoran's exhibition, and Newman did not request its return until the middle of 1969[21], not least because the opportunity of selling one of the two exemplars had suddenly arisen.

VI

Rosenberg considered "Broken Obelisk" to be "more 'pictorial' than Newman's paintings; that is to say, through its total image, the shapes that compose it, its color, its title, it carries more associations and external references than the artist normally allowed in his canvases."[22] That this opinion was shared by many is borne out not only by the exhibition reviews but also by letters written directly to the artist. Waldo Rasmussen of the Museum of Modern Art wrote, for example: "I can't verbalize it, but somehow put in front of the Seagram Building (which I love, it means something to me like maybe the best of the rational/scientific/technological spirit which we can produce and still keep some beauty in) it's like a

reminder of the human and tragic. I noticed that its scale put the surrounding space in perspective, prevented it from making you feel like a dwarf as you used to in that vast plaza, and instead made you more aware of your own body and gave it some sense of power."[23] Such attempts at relating the sculpture to its surroundings, however, were the exception rather than the rule. Rare, too, were remarks concerning the function of the sculpture in a public environment, though since it was "emotionally affecting and physically exhilarating"[24], "Broken Obelisk" evidently furthered communication between passers-by. Mostly it was the symbolic content of the forms which was sought and interpreted, forms which inevitably awakened associations with the past. The shattered obelisk was reminiscent of "the baroque memorial image of an abbreviated or blasted column"[25], i.e. a traditional vanitas symbol, and the break itself was interpreted as an allusion to "a tragic weakness"[26], whilst the inversion of the obelisk symbolized the "vivification of a dead form."[27] Hess referred to the meanings and functions of pyramids and obelisks in ancient Egypt —"The pyramid and the obelisk are two of the oldest monumental forms known to man"[28]—and saw in "Broken Obelisk", as did others, too,[29] "a celebration of life, of birth and renewal, in art and in man. It celebrates the faith of the artist in his art, in his ability to break through dead styles, to find his own forms and subject, his own past and present."[30]

Is that how we ought to see "Broken Obelisk", as a monument to esthetic self-reflection and artistic self-assertion? What is merely intimated by Hess is asserted with conviction by Rosenberg: "The ultimate meaning of the work lies in its affirmation of the collapse of past grandeurs and the transcendence of that collapse in the experience of the sublime that survives because the artist wills it."[31] Rosenberg had been even more explicit in another, earlier work: "Around *Broken Obelisk* cluster references to destroyed cults, the wizards and mathematicians of the Pharaohs, the rust-colored sands of the deserts, the broken tablets of Sinai, a sanctuary in the wilderness, a divine token but with all its writings and signs obliterated; the obelisk is not only broken but turned upside down so that its apex points earthward. Yet above this rejection and chaos hovers the cosmic feeling of the sublime that survives because the artist has willed that it shall be there."[32] The sculpture, says Rosenberg, "conveys high feeling but with no content, except for the fact of being experienced. It is intensity without a cause, except a common memory, without moral purpose, without deity, without name. It is thought that breaks off, truncated. In a word, it is the aesthetic, in which all history and all beliefs are equalized."[33] I have quoted Rosenberg at length because he, like hardly any other author, emphasizes the voluntaristic aspect of Newman's esthetic approach. For Newman, says Rosenberg, the sublime had long since ceased to be a valid esthetic category. It survives any associations that might be awakened by the combination of pyramid and obelisk only by reason of the artist's willpower. "The

282 cosmic feeling of the sublime [. . .] survives because the artist has willed that it shall be there." But what is the artist in fact evoking? "High feelings but with no content, except for the fact of being experienced"?

Not to be able to ascribe any definite meaning to a sculpture having such symbolic forms as a pyramid and an obelisk seemed unsatisfactory. A great many interpretations have been offered, but these are mainly in tune with Hess or Rosenberg, and need not be discussed here. There is one example, however, which stands apart from the others. Only a few years ago, Stephen Polcari attempted an iconographical interpretation of "Broken Obelisk" in a larger context. In his opinion, three streams of thought manifest themselves in this sculpture: "the modern memorialization and monumentalization of the dead, especially the war dead; widespread high and low imagery of regeneration amid disaster during and after the interwar years and the Second World War; and Newman's symbolization of the cycle of human life and death."[34] Polcari substantiates his argument with examples of French revolutionary architecture, monumental tombs, military cemeteries, war memorials, propaganda material, and so on, and links them with the central force of Abstract Expressionism such that Newman's "Broken Obelisk" mutates into an antiwar monument.[35] "*Broken Obelisk* modernizes the tradition of the sublime and embodies for the war generation the merger of the individual into a larger self of community and infinite, eternal human creativity in space and time. [. . .] *Broken Obelisk* thus signifies the struggle and triumph of new life in an antique vocabulary. Its source is historical, its intent inspirational, its language ancient but modern. It is a private citizen's engagement with the most terrible of historical experiences."[36] Such an interpretation is not altogether convincing, and Newman himself would have objected strenuously to his sculpture's being considered an antiwar monument, for that was a category of sculpture from which he had rigorously dissociated himself all his life.[37] Newman's sculpture undoubtedly evoked a wealth of associations, including associations of the kind mentioned by Polcari. The pyramid and the broken inverted obelisk afford, in their surprising combination, scope for interpretation, no more and no less. The sculpture is not to be understood as a baroque allegory, in which every detail has a specific meaning, nor is it as empty of content as a work of Minimal Art, nor is it merely a trigger for vague experiences of self under the general heading of the sublime. The only work in Newman's oeuvre to be based on the principle of the collage, "Broken Obelisk" is, with its clearly defined forms, an overwhelming sculpture, and its meaning is not so readily definable as to permit any certain conclusions or theories. Like so many works of modernism, "Broken Obelisk" is a completely open work of art.

114 *Broken Obelisk*, 1963/69 (Cat. No. 38)
The Museum of Modern Art, New York
Given anonymously, 1971 ▷

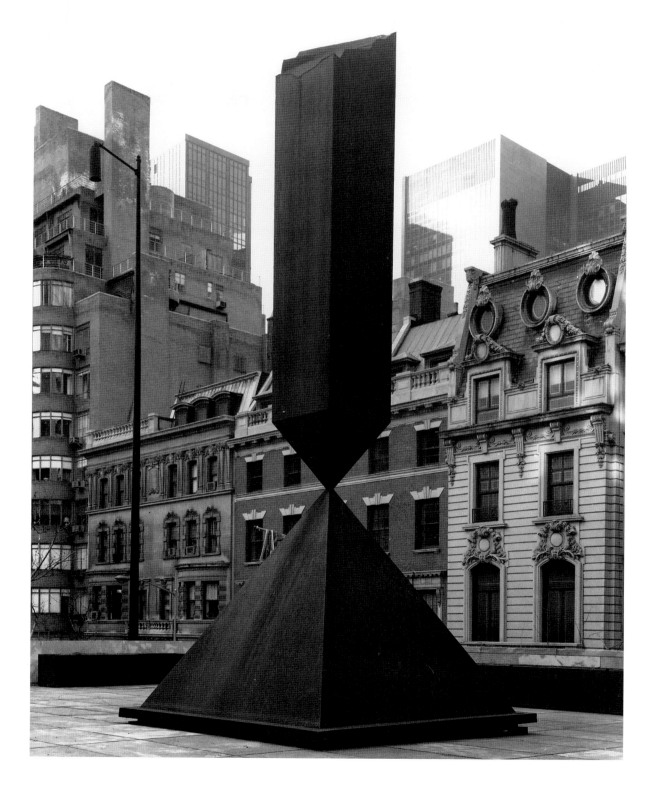

284 VII

The combination of pyramid and inverted obelisk in "Broken Obelisk" is so unusual that one
assumes it is an original invention. This is not the case, however, as Hess points out: "[. . . it
is] nothing more than an oddity [. . .] that Newman's *Broken Obelisk* was 'predicted' in 1934
by, of all people, the Non-Objective painter Rudolf Bauer."[38] Whilst Hess dismisses this
circumstance as mere coincidence, we cannot rule out the possibility that Newman was
familiar with Rudolf Bauer's large painting "Blue Triangle" (Fig. 115), for it hung in the Museum
of Non-Objective Painting, now the Solomon R. Guggenheim Museum. Rudolf Bauer was
keenly patronized by Hilla Rebay, the influential director of the museum, for in her estima-
tion Bauer's work was far better than Kandinsky's. At least that was her opinion until 1945,
the year in which they finally broke with each other. From then on, Bauer's work enjoyed

115 Rudolf Bauer, *Blue Triangle*, 1934
Oil on canvas, 51 1/8 x 51 1/8 ins.
Solomon R. Guggenheim Museum,
New York

116 "Die freie Strasse", 1918
Berlinische Galerie, Berlin

117 Paul Klee, *Double Tent*, 1923
Watercolor, 20 x 12½ ins.
A. Rosengart Collection

very little public exposure, and after 1952, when James Johnson Sweeney took over from Rebay, nothing more was seen of it, perhaps also because the museum's collection of Bauer's works had by then largely been sold.[39]

Even though "Broken Obelisk" and "Blue Triangle" essentially have very little in common, their undeniable similarity gives us reason to ascribe Newman's sculpture to a tradition which goes back much further than might first be assumed. Another, albeit remote example is the title-page of the short-lived Berlin magazine "Die freie Strasse" (Fig. 116), which may be cited here primarily because the notion of the obelisk as a phallic symbol[40], ubiquitous though it may appear, is expressed in this Dada pamphlet, with particular emphasis on the tip of the triangle.[41] Klee's watercolors "Eros" and "Double Tent" (Fig. 117) furnish additional substantiating evidence.

In formal terms, however, the aforementioned works have little or nothing to do with Newman's sculpture.[42] Indeed, they permit one to assume that it was Newman's own stelae which prompted him to combine a pyramid with an inverted obelisk. The uprights of "Here II" and "Here III" stand on truncated pyramids inspired not least by the bases of several of David Smith's sculptures. Was it not logical for Newman to enlarge on his preceding sculptures by restoring the truncated pyramid to its original form and using it as the base for the stele? Whilst we refer to the upper part of the sculpture as the obelisk, we do so primarily because this is dictated by the title. It in fact bears little similarity to an obelisk, for it lacks one decisive feature—the gradual broadening of the shaft towards its base. This feature would have justified an identification of the upper part of the sculpture with the characteristically tapering pillar of ancient Egyptian origin. In truth, the upright element balancing on Newman's pyramid is not an obelisk but a pointed stele. Indeed, Newman occasionally used various expressions to describe this part of his sculpture. It was to be "neither a rocket nor a pencil", Newman told Hess as he was deciding on its final proportions and testing the cuts for its broken end.[43]

VIII

Whilst the obelisk might indeed reflect Newman's childhood memories of "Cleopatra's Needle"[44] in New York's Central Park[45], it was the pyramid to which the artist attached greater significance. He repeatedly mentioned it in his writings and made numerous extremely revealing associations with it. Newman made explicit reference to ancient Egypt, however, only during the late forties, never subsequently. This circumstance deserves to be dealt with in some detail. It means departing from the subject of sculpture, but it will shed more light on the background central to an understanding of the artist's approach and intentions.

In an essay entitled "Art of the South Seas", written in 1946 in reaction to an exhibition of the same name at the Museum of Modern Art, Newman maintains that every artistic epoch seeks its ideal in the past—the Renaissance in classical Greece, and the Greeks in ancient Egypt. "And for the Greeks," Newman writes, "the Egyptian pyramid stood as a standard of absolute beauty, the symbol of all their aesthetic hopes."[46] This idea is again taken up by Newman in a 1948 essay in which he reflects upon the psychological and cultural consequences of the Second World War. The sense of tragedy and fate which now prevails prompts Newman to return to the past, for he sees a parallel between the present day and Greek tragedy:

"We are living, then, through a Greek drama; and each of us now stands like Oedipus and can by his acts or lack of action, in innocence, kill his father and desecrate his mother.

"In this new tragedy that is playing itself out on a Greek-like stage under a new sense of fate that we have ourselves created, shall we artists make the same error as the Greek sculptors and play with an art of overrefinement, an art of quality, of sensibility, of beauty? Let us rather, like the Greek writers, tear the tragedy to shreds."[47]

Ending his essay with these words, Newman clearly sees Greek sculpture and Greek drama as irreconcilable opposites, and ascribes a particular significance to the pyramid, for it "excited and dominated their plastic thinking, but instead of seeing it as a symbol, they were enraptured by its physical purity in an excess of ecstasy over its perfect geometry."[48] "Pride of civilization," says Newman, had prevented the Greeks "from understanding the barbarian's totemic fanaticism. Unable to penetrate the noumenal base of barbarian objects, they misunderstood the Egyptian symbols of purity, so that Greek plasticity developed as an art of refinement of the pure shape. [. . .] And that is why we have rejected it, for an art of refinement must in the end lead to an art of self-conscious sensibility, to the love of ideal sensations, to an economy of beauty. [. . .] But what is more serious, beauty—that is, the love of ideal sensations—creates in us today sheer physical embarrassment."[49]

If Newman constructs—entirely in Nietzsche's sense—a dichotomy of Greek culture and does not, for example, make the Egyptian pyramid the ideal, the reason lies in Newman's understanding of the pyramid and other Egyptian monuments as absolute symbols of inevitability. The Greek notion of tragedy was not ontological, however, but social. As in Greek tragedy, Newman sees human beings as "the helpless victims of an insoluble fate"[50] resulting from the inability to control, or even understand, the consequences of their own actions. "This is quite different," says Newman, "from the Egyptian notion that each man is his own tragic entity and that the nature of his being is in inevitable death; a death-in-life and a life-in-death."[51] Newman wrote this essay with the reports of the atrocities of World War II still fresh in his mind. The picture which he had formed of antiquity, whether apt or

not, is in this context of less significance than the function which art was in his opinion to assume. All historical models had at all events lost their meaning. What now counts is Greek tragedy. This alone is the criterion. Newman sees the Egyptian pyramid as the counterpart of Greek sculpture. For him, the pyramid represents nothing but the absolute inevitability and irreversibility of death. Unlike the art of so-called primitive cultures which reflects much more than the mysteries of life and death, the tragic and the chaotic—in other words, the "terror of the unknowable"[52]—the pyramid cannot be considered as a model for the contemporary painter.

If we picture the background against which Newman wrote this essay, the conclusions he arrived at, insofar as they concern Newman himself, do indeed seem comprehensible. His descriptions of the pyramid, however, must arouse suspicion. When he describes its perfect geometry, its physical purity, and the noumenon of its appearance, we sense his fascination. Yet he refuses to succumb to this fascination, the immediacy and incomprehensibility of the war's millions of dead being reason enough.

Whether Newman changed his mind after having read more about Egyptian culture and came to see the pyramid less as a tomb for the Pharaohs than as their stairway to the sun, and the obelisk as a symbol of life and renewal, can only be conjectured[53], but not substantiated. Moreover, we must ask whether, fifteen years later, the fascination which the form of the pyramid held for Newman had not forced into the background those symbolic meanings of providence and death (or their opposites) on which he had placed so much emphasis during the immediate post-war years. In other words, had the form now rid itself, at least partially, of its specific content? Naturally, it is scarcely possible to give a definite answer to this question, but it is perhaps significant that Newman not only avoided answering it but also explained the meaning of "Broken Obelisk" in such general terms that it was not possible to draw direct parallels between antiquity and the present day.

Quite astonishing, moreover, is that for Newman the pyramid had already paled into insignificance by 1949. Overwhelmed by the Indian mounds in the Ohio Valley, Newman considered them to be the greatest works of art on the American continent, indeed the greatest in the world, for they made not only the Northwest Coast totem poles—whose praises he had sung only a short time before—seem like "hysterical, overemphasized monsters" but also the Egyptian pyramid appear by comparison as "nothing but an ornament"[54]. In the present context, however, we must not read too much into this statement. Newman had just completed "Onement I" and it had taken him several months of deep reflection to realize the significance of this key work in his oeuvre. His attention and expectations were focused on other phenomena, phenomena for which such historical forms as pyramids and totem poles no longer had anything to offer.

288 It is highly probable that, during the sixties, Newman was interested above all in the three-dimensional form *per se* and that his endeavor to "break the horizon"[55] caused the meanings of the pyramid and the obelisk, whilst living on, to remain very much in the background. Indeed the pyramid and the obelisk forfeited their importance as symbolic forms and no longer operated exclusively as such. By the middle of the sixties, it was emotional content, and not historical significance, which was important to Newman, and this was reflected in the titles of his works. Newman was, however, careful to qualify what he meant by emotional content: "I'm not illustrating an emotion. The problem of a painting is physical and metaphysical, the same as I think life is physical and metaphysical. [. . .] Otherwise we would be creating either fetishes or images or objects."[56] "Broken Obelisk" is none of these. It is an extraordinary sculpture, for it stimulates our imagination, activates our feeling for space, irritates our sense of equilibrium, challenges our historical memory, and couples this complex of associations directly with the visual and physical experience of the viewer who, in the sculpture's fragility of structure, in its instability of balance, in its presence, and in the autonomy of its horizon-breaking verticality, can see and experience a valid metaphor for his own existence.

IX

Owing to the complexity of "Broken Obelisk" we may become entangled in unending reflections and observations, not least because standing between the work and ourselves is the latent knowledge used by our eye, whose rational development remains merely potential, for it operates on this side of perception and evidently cannot be made to synthesize in our consciousness. Newman's sculpture activates, as it were, those primary layers of sense experience which can be regained provided one allows oneself to be fully absorbed in the act of perception and refrains, at least temporarily, from adopting a critical approach. In his definition of the human being as a "sensorium commune", Merleau-Ponty describes one's experience of the unity of the subject and the intersensory unity of the thing, which are not conceived "after the fashion of analytical reflection and science."[57] "Broken Obelisk" heightens both at the same time—the experience of the unity of the subject and the experience of the intersensory unity of the thing—and temporarily blends the one with the other. And because this is so, all interpretations based purely on the iconography of "Broken Obelisk" miss the mark as widely as interpretations based exclusively on phenomenology. Since the synthesis of intuition, sensation, consciousness, and reflection is evidently not measurable, however, "Broken Obelisk" presents itself in ever new ways, depending on what we perceive, when we perceive it, and how we react to it. These slight yet countless deviations in interpretation, however, hardly detract from the sculpture's essence. Perhaps "Broken

Obelisk" achieves what Newman recognized in the sculptures of Herbert Ferber in 1947, shortly before he painted "Onement I": "Ferber's skeletal line, by the majesty of its abstract freedom, touches the heroic base of each man's own nature."[58] The sculpture's openness of meaning, which is necessarily bound up with the viewer's experience of self when confronted by the work, gives rise to a complexity which cannot be described in just a few words.

This openness of meaning, however, also involves the risk that "Broken Obelisk" might become a screen on which divergent attitudes and interests can be projected. This is evidenced not only by the many different interpretations of "Broken Obelisk" but also, and primarily, by one spectacular attempt to use the sculpture for extraneous purposes, thus undermining the sculpture's esthetic autonomy. The response to "Broken Obelisk" in the years that followed was to a certain extent influenced by this event.

X

In the spring of 1969, Dominique and John de Menil endeavored to obtain "Broken Obelisk" for the city of Houston. For the past two years, the National Foundation on the Arts and Humanities had been holding open the offer of $45,000 in matching funds for the purchase of a sculpture for installation in a public place. The offer had been made to four cities. Whilst Seattle, Philadelphia, and Grand Rapids had already availed themselves of the offer, choosing works by Isamu Noguchi, Seymour Lipton, and Alexander Calder respectively, Houston, the fourth city on the list of beneficiaries, could not make up its mind. As donations had neither been requested nor made, and the deadline for accepting the matching fund was approaching, the de Menils offered to donate the entire $45,000 themselves. This donation was, however, subject to certain conditions. The chosen sculpture would have to be Barnett Newman's "Broken Obelisk", its installation would have to be supervised by an architect of Newman's choice, and the sculpture would have to be dedicated to the black minister, civil rights campaigner, and winner of the Nobel Peace Prize, Dr. Martin Luther King Jr., who had been assassinated a year before.

The Houston City Council rejected the offer. The donors' intention of turning the sculpture into a memorial evidently posed a problem. Indeed, the matter threatened to become a highly explosive political issue, and every effort was made by the City Council to furnish convincing evidence that, in the event of such a dedication, the matching fund would not be paid. The National Foundation on the Arts and Humanities had stipulated that no funds would be granted for memorials to persons of outstanding merit—mayors, governors, presidents etc.—the intention being to prevent any further population of parks, squares, and other public places with more or less naturalistic statues or busts. The gov-

ernment in Washington had no objections to the dedication, however, nor did it envision any problems. Nevertheless, the exclusively white city fathers of Houston stuck to their decision. John de Menil thereupon suggested installing the sculpture in front of the city hall with the inscription "Forgive them for they know not what they do." This naturally aggravated the matter still further, with the result that, at a hearing convened by the City Council, the suggestion was made to erect a memorial to the astronauts of Apollo 11, whose triumphant return to Houston had taken place only a few days previously, though there was of course no chance of obtaining money from the National Council on the Arts and Humanities for such a project.

After all this wrangling, the de Menils decided to purchase "Broken Obelisk" themselves, making the full $90,000 available. The purchase received the attention of the media[59], and Barnett Newman thanked the de Menils in a letter dated August 26, 1969:

"Dear John and Dominique:

"I am sending you the Washington Post and New York Times stories. Considering the circumstances, I think they did very well. I am, however, annoyed at the New York Times for not have [sic] made a sufficient effort to reach me, so that I could publicly express my thanks to you for your generosity and pay tribute, in particular, to your courageous act.

"May I now express my appreciation and my admiration for your great courage, which it was thought I should not do in the Houston release.

"When you honored your gift by dedicating it to the memory of Martin Luther King, you also honored my work by rescuing it from the Philistines, who would have destroyed it as a work of art and made it a political 'thing'.

"I am very moved by what you have done and I feel with you, I am sure, a very special sense of happiness. After all it is not every day that we can stand up to the Philistines and win. Bless you both for making it possible.

"I hope that my sculpture goes beyond only memorial implications. It is concerned with life and I hope that I have transformed its tragic content into a glimpse of the sublime.

"Annalee joins me in sending you both our love."[60]

This letter, an unparalleled example of diplomacy on Newman's part, is revealing in several respects. Its polite, not to say obsequious tone is astonishing. Evidently it was important to Newman, not least for financial reasons, that "Broken Obelisk" be sold and optimally placed. His view of the events in Houston in what seem to be Old Testament terms —"stand up to the Philistines and win"—may have been provoked by the dedication. There was of course no reason why the memory of Martin Luther King should not be honored—on the con-

trary—but the transformation of "Broken Obelisk" at the behest of collectors into a memorial, and a memorial to a particular person at that, must have troubled Newman deeply. From what we know today about Barnett Newman, we can say that nothing was more foreign to his way of thinking than the association of his sculpture, no matter how restrained, with the memory of a concrete historical figure. And Newman's annoyance at the *New York Times*, mentioned at the beginning of his letter, is doubtless disingenuous. What would he have said to the journalists, if they had made the effort to reach him, in answer to the inevitable question concerning the dedication? The truth would likely have displeased the de Menils, to say the least.

The assassination of Martin Luther King had deeply shocked the entire American nation and had further widened and deepened the gulf between the white establishment and the various civil rights movements, the war protesters, the political left, and the black activists. Newman had been right to describe the de Menils' act as courageous, especially as the conflict between whites and blacks in Texas was, as in other southern states, particularly stark. In agreeing to dedicate "Broken Obelisk" to the memory of Martin Luther King, Newman was reacting not as an artist but as an enlightened, politically minded citizen. This distinction is clearly expressed in the last paragraph of Newman's letter: whilst Newman the citizen makes a gesture of political commitment, Newman the artist is concerned with transcending mere "memorial implications". His work, he says, is concerned not with the fate of the individual but with life itself and with the transformation "of its tragic content into a glimpse of the sublime."

When Newman visited Houston towards the end of October of 1969 in order to help choose the site for "Broken Obelisk", the wording of the dedication had evidently not yet been decided upon. The signboard which today stands well to one side, though not inconspicuously, was probably not installed until just before the unveiling ceremony on February 27–28, 1971.[61] The reference to Martin Luther King is made only in the bottom line, after the name, hours, and address of the Rothko Chapel and mention of "The Barnett Newman Broken Obelisk" (Fig. 118).

The Houston sculpture was installed in the middle of a rectangular reflecting pool measuring approximately 69 by 39 feet (Fig. 113). Slightly off center longitudinally, the sculpture marks the intersection of an imaginary Latin cross and is reflected in the water, so that reflected glints of light dance in turn on the sculpture's deep-brown surface. Spotlights installed in the bottom of the pool illuminate the sculpture at night, creating a highly theatrical effect. The installation did not win undivided approval[62], as the sculpture seemed, in the slightly choppy water, to have been detached from its foundation and, for many, conveyed the impression of a fountain-sculpture.

The unveiling of "Broken Obelisk" and the opening ceremony of the non-denominational Rothko Chapel, the interior of which is adorned with paintings by Mark Rothko, took place over two days.[63] The sculpture and the chapel together form a unit and belong to the Institute of Religion and Human Development. This institute is "devoted to the study of theological thought and its application to contemporary experience and expression".[64] Our notion of Newman's main sculptural work is decisively influenced by our impression of the Houston exemplar. This impression is colored by the presence of the Rothko Chapel which, more so than Newman's sculpture, has become a place of pilgrimage. Indeed, the Rothko Chapel draws considerably more attention from visitors to this unique place than does "Broken Obelisk", inducing most to stay awhile inside, to pray or meditate, or simply to stand and marvel. The sheer facticity of "Broken Obelisk", however, has nothing of the mysticism suggested, not to say conveyed, by the dark paintings of Mark Rothko.

118 Visitors' information sign, Rothko Chapel and "Broken Obelisk", Houston

The second exemplar of "Broken Obelisk" has never attracted comparable attention. Donated by the Virginia Wright Fund, it was installed in the main plaza of the University of Washington, Seattle, in the fall of 1971 and unveiled on October 6 of the same year (Fig. 108). The occasion was marked by a publication by Harold Rosenberg on Newman's sculptures. Virginia Wright, in a preface, dedicated the sculpture to the students of the university.[65]

It is difficult to come to terms with the installation of the sculpture in this huge, cobbled plaza. "Broken Obelisk" stands against building facades in a variety of architectural styles. Whilst it is not positioned in the center of the plaza, it stands at the intersection of the most traveled walkways on the campus. As the plaza is not level, but slopes away towards one corner, it was decided to mount the sculpture on a large concrete base which merged with the ground on one side and was stepped on the other. This solution not only was costly but also had an esthetic all its own, with the result that "Broken Obelisk" became completely isolated from its environment and stood out against it. A small cardboard model at The Barnett Newman Foundation, New York, shows that the opposite had been intended, namely the integration of "Broken Obelisk" into the disparate surrounding architectural ensemble.

The sculpture shown in the present exhibition (Fig. 114) was produced in the fall of 1969, slightly later than the other two exemplars, as an invoice from Lippincott dated November 13 indicates.[66] It was shown, two years later, in the Newman retrospective at the Museum of Modern Art; it then remained for many years in the museum's Sculpture Garden. In the late eighties, it was shown at the Storm King Art Center, Mountainville, New York, before finally being installed, on extended loan, in front of the Nassau County Museum of Art on Long Island.[67] This journey has—along with photographs of the Houston sculpture—

contributed to the notion that Newman's only public sculpture is meant for installation in a neatly kept, almost rural environment with plenty of greenery, water, and the Rothko Chapel as its enhancing complement.

1 Hess, p. 120.

2 Richardson, p. 210, F.

3 Hess, p. 121. I.E.S. Edwards, *The Pyramids of Egypt*, London, 1947, had made this observation about the Egyptian pyramids. According to Hess, Newman possessed two copies of the Pelican edition of this publication.

4 Letter to the editor, in: *Artforum*, Vol. 6 (1967/68), No. 7, March 1968, p. 4. Surprisingly, this letter is not quoted in Newman, *Writings*.

5 Letter from D. Lippincott to Paul Winkler, July 29, 1982. The Menil Collection, Houston.

6 Lawrence Alloway, *One Sculpture*, in: *Arts Magazine*, Vol. 45, No. 7, May 1971, p. 23; Hess, p. 122.

7 Lucy R. Lippard, *Escalation in Washington*, in: *Art International*, January 1968, p. 43.

8 In Newman's essay on the paintings of Tamayo and Gottlieb, published in 1945, there is a brief passage on the psychological effects of color, of which one feels reminded when confronted by the rusty, reddish brown of "Broken Obelisk". Both painters, writes Newman, use a color scale which extends from orange to dark brown: "They have succeeded in expressing man's elemental feelings, the majestic force of our earthly ties and natures. In so bringing us down to earth they confront us with the problems of man's spirituality." Newman, *Writings*, p. 77.

9 I am indebted both to Paul Winkler, Houston, who first made me aware of the problem, and to Kurt H. Kiefer, Seattle, who afforded me access to the corresponding status and repair reports of 1977/78 and 1991.

10 Letter to the editor, *Artforum*, op. cit., p. 4.

11 In an October 7, 1967, letter to Waldo Rasmussen, Director of Circulating Exhibitions at the Museum of Modern Art, Newman wrote: "It will interest you to know that this is the piece that I told Frank about in 1963 and which I then hoped to make before I made 'Here, II'. Unfortunately the fabricator at that time did not have the facilities to do it. It must have had an effect on Frank even in the telling because he talked a great deal about it. I wish he could have seen it finished but I feel at least that 'he knew' the piece." The Barnett Newman Foundation, New York. Newman is doubtless referring to Frank O'Hara (1926–1966), a poet and friend of the artist. As a curator at the Museum of Modern Art, O'Hara conducted a television interview with Newman in 1964. Cf. Julian Heynen, *Barnett Newmans Texte zur Kunst*, Hildesheim and New York, 1979, p. 100 ff.

12 Letter to the editor, *Artforum*, op. cit., p. 4.

13 As this letter is also interesting in another respect, I am quoting it here in full: "Dear Philip: I want to thank you for making possible the showing of my new piece of sculpture in front of the Seagram Building. Sam Green tells me that if it were not for you, it could not have hap-

294

pened. For me, it's the only place in the
city where I would like to be and I am, of
course, very happy to have this opportu-
nity. I also want to tell you how much I
liked your talk at the Hilton at the Confer-
ence on Religion and Art. It seems that
the suburban way of life is invading all
areas and the new young theologians are
all talking about the church as a living
room. The day before on the same plat-
form, when it was my turn to talk, I
ridiculed this notion so I, therefore, was
so glad to hear you defend the high road
and the high style. I want to thank you
again for giving me the best place in New
York to show my work and I can only say
that it makes me feel great that two of my
sculptures are with two of your own
works. Best regards. Sincerely, Barnett
Newman. PS: I am enclosing a copy of a
letter I sent to Ben Shahn which may
amuse you. I have owed him this letter for
a long time." The Barnett Newman Foun-
dation, New York. Philip Johnson once
owned the version of "Here II" shown in
this exhibition.

14 Benjamin G. Paskus, *The Theory, Art,
and Critical Reception of Barnett Newman*,
Ph.D. dissertation, University of North
Carolina at Chapel Hill, 1974, p. 214.
15 Hilton Kramer, *The Studio vs. the
Street*, in: *The New York Times*, October 15,
1967, Section D. Also Thomas B. Hess,
New Man in Town, in: *ARTnews*, November
1967, p. 27.
16 Cf. *The New York Times*, October 6,
1967.
17 Lucy R. Lippard, *Escalation in Washing-
ton*, op. cit., p. 42.
18 Cf. the unsigned review "*Sculptor Tony
Smith: Art Outgrows the Museum*", in: *TIME
Magazine*, October 13, 1967, p. 78 ff., in
which "Broken Obelisk" in front of the
Seagram Building is also reproduced.
19 "Sculpture Downtown", Michigan
State Council for the Arts, July 1–
August 31, 1969. Participants included,
besides Newman, Louise Nevelson,

Clement Meadmore, George Sugerman,
and Robert Murray.
20 In the exhibition "New York Painting
and Sculpture: 1940–1970", organized by
Henry Geldzahler, The Metropolitan
Museum of Art, New York, October 18,
1969–February 8, 1970.
21 Meryle Secrest, *An Era Ends. Corcoran
Gallery Obelisk Removed by Creator*, in: *The
Washington Post*, July 11, 1969. Newman
and his wife were both present at the dis-
mantling of the sculpture. The article inti-
mated that Newman was removing the
sculpture in protest against the departure
of James Harithas from the post of Direc-
tor of the Corcoran Gallery. Cf. also Paul
Richard, *Woe Follows the Obelisk*, in: *The
Washington Post*, August 25,1969.
22 Rosenberg, *Broken Obelisk*, p. 10.
23 Letter from Waldo Rasmussen to
Barnett Newman, September 29, 1967.
The Barnett Newman Foundation, New
York.
24 Cf. Elizabeth C. Baker, *Barnett New-
man in a New Light*, in: *ARTnews*, Vol. 67,
No. 10, February 1969, p. 61: "[. . .] it is
not anonymous-public, it is
communicative-public, being emotionally
affecting and physically exhilarating."
25 Lawrence Alloway, *Notes on Barnett
Newman*, in: *Art International*, Vol. XIII/6,
Summer 1969, p. 38.
26 Lawrence Alloway, *One Sculpture*,
op. cit., p. 23.
27 Ibid., p. 24.
28 Hess, p. 121.
29 Cf. also David M. Quick, *Meaning in
the Art of Barnett Newman and Three of His
Contemporaries: A Study in Content in
Abstract Expressionism*, Ph.D. dissertation,
University of Iowa, Iowa City, 1978,
p. 234 ff. ("Broken Obelisk [. . .] a sacred
place, marked by a vertical, which can be
associated with an idea of man's transcen-
dent nature [. . .]", p. 237.)
30 Hess, p. 123.
31 Rosenberg, p. 77.
32 Rosenberg, *Broken Obelisk*, p. 19.

33 Rosenberg, p. 75 f.

34 Stephen Polcari, *Barnett Newman's Broken Obelisk*, in: *Art Journal*, Winter 1994, p. 48.

35 Ibid., p. 51.

36 Ibid., pp. 54, 55.

37 In his letter to Newman dated September 29, 1967, Rasmussen expressed a similar idea, but placed it in the present: "Broken Obelisk", he writes, "brought to mind in some curious way Viet Nam, and I thought of the sculpture, right where it stands now, as a monument about it. I wish it could always stay in that Plaza." Jasper Johns wrote a letter to Barnett Newman on October 3, 1967, expressing the same desire that the sculpture remain permanently on Park Avenue. The Barnett Newman Foundation, New York.

38 Hess, p. 129.

39 Cf. Susanne Neuburger, "*Kunst und nicht Natur*". *Zu Leben und Werk Rudolf Bauers*, in: *Rudolf Bauer*. Exhibition catalog of the Museum moderner Kunst/Museum des 20. Jahrhunderts, Vienna, and the Staatliche Kunsthalle Berlin, 1985, p. 82.

40 Cf. Polcari, op. cit., p. 53: "The obelisk could also be a phallic, or regenerative, symbol [. . .]".

41 *Die freie Straße*, No. 10, December 1918. In the right-hand column on the title page, under the heading D.A.D.A., Hausmann writes: "But the apex of the triangle, in whose middle my spirit will always be for as long as mankind thinks about the world, will henceforth be carried by every man in the foremost tip of his erect member."

42 Such associations could be taken even further by referring, for example, to Duchamp's object "A regarder de près", 1918, at the Museum of Modern Art. Whilst the pyramid hovers above the obelisk on a transparent plate, the one does not touch the other, and that is where the analogy ends except perhaps for the damage which Duchamp's work once incurred in transit.

43 Hess, 1969, p. 70.

44 "Cleopatra's Needles"—these are the names given to two obelisks erected by Thutmose III in Heliopolis and subsequently moved to Alexandria. One of them was shipped to New York in 1880 as a gift from the Egyptian government.

45 Hess, p. 123.

46 Newman, *Writings*, p. 99. The essay was published in Spanish in 1946 in the magazine *Ambos Mundos* and did not appear in English until 1970, in: *Studio International*, February 1970, p. 70 f.

47 Newman, *Writings*, p. 169.

48 Ibid., p. 166.

49 Ibid., p. 166–67.

50 Ibid., pp. 168–69.

51 Ibid., p. 169.

52 "The Ideographic Picture" (1947), in: Newman, *Writings*, p. 108.

53 Hess, p. 121 f.

54 Newman, *Writings*, p. 174.

55 We know from Alloway that this expression ("to break the horizon") was used by Newman in conversation with Don Lippincott while working on "Broken Obelisk". Cf. Lawrence Alloway, *One Sculpture*, op. cit., p. 22.

56 Interview with David Sylvester, broadcast by the BBC on November 17, 1965. Cf. Newman, *Writings*, p. 259.

57 Maurice Merleau-Ponty, *Phenomenology of Perception*, op. cit., p. 238 f.

58 Newman, *Writings*, p. 110.

59 This account is based on the following documents: Letter from John de Menil to Barnett Newman, May 27, 1969, and the memorandum of the same date (The Barnett Newman Foundation, New York); excerpts from the minutes of the City Council of the City of Houston, August 20, 1969, The Barnett Newman Foundation, New York; *Council Turns to Moon in King Sculpture Issue* (unsigned), in: *Houston Chronicle*, August 21, 1969; Fred Ferretti, *Houston Getting a Sculpture After All*, in: *The New York Times*, August 26, 1969.

296

60 The Barnett Newman Foundation, New York.

61 In his opening address, John de Menil spoke mainly about the Rothko Chapel, mentioning Barnett Newman only in passing. It was obviously Dominique de Menil who, in her capacity as Director of the Institute of the Arts at Rice University, had devoted more attention to Newman's sculpture. It is particularly noticeable, moreover, that many announcements mentioned only Rothko, and not Newman: "Dedication of the Rothko Chapel and The Martin Luther King Memorial / Institute of Religion and Human Development [. . .]".

62 Lawrence Alloway, *One Sculpture*, op. cit., p. 22: "*The Broken Obelisk* looks better on earth."

63 Concerning the opening ceremony cf. the following reports: Martin Waldron, *14 Rothko Works Adorn New Chapel in Houston*, in: *The New York Times*, March 1, 1971;

Emily Genauer, *Art and the Artist*, in: *New York Post*, March 13, 1971; *Art and Faith in Houston* (unsigned), in: *Newsweek*, March 15, 1971, p. 63.

64 "Rothko Chapel Opens in Houston", press release, The Barnett Newman Foundation, New York.

65 Rosenberg, *Broken Obelisk*, p. 7. According to a letter written to Annalee Newman on October 20, 1971, Spencer Moseley, then Director of the Henry Art Gallery at the University of Washington, wanted to mount an exhibition of all of Newman's sculptures in the following year. The exhibition, however, did not come to fruition. Moseley's letter is in the archives of The Barnett Newman Foundation, New York.

66 Susan J. Barnes, *The Rothko Chapel. An Act of Faith*. A Rothko Chapel Book. Austin, 1989, p. 97, note 136.

67 Concerning the various exhibitions of "Broken Obelisk" cf. ibid., p. 93.

The sculpture "Lace Curtain for Mayor Daley" (Fig. 119) occupies a special place in the painter's oeuvre. This has always been so, for it has been considered a sculpture done for a special occasion, for a specific purpose, a sculpture which does not have the same importance and spiritual quality as Newman's other works. Significantly, Hess mentions "Lace Curtain" merely in passing, in a footnote. Its simple steel frame and barbed-wire lattice evidently ran counter to Hess's notion of a painter whose oeuvre gave abstract form to the transcendental experience of Jewish mysticism.[1] What was unusual about this sculpture was not only its structure—Newman had evidently placed his order for this sculpture with Lippincott in New Haven by phone[2]—but the red paint splashed on the barbed wire and on the bottom of the frame next to the signature "Barnett Newman 1968". The association with blood was both inevitable and intended. Moreover, the ordered arrangement of the seven vertical and eleven horizontal wires, their neatly welded ends and the comparatively regular pattern formed by the barbs (these are positioned roughly half-way between the intersections of the wires) clearly allude to a violent form of exclusion or captivity, for no one would try to force his way through such an opening, and if he did, he would certainly injure himself, as the artist implies through the splashes of red paint. Yet, this aggressive piece of martial furniture can be easily circumvented. As a free-standing sculpture—or perhaps a suspended one[3]—it is dangerous only if one takes up its challenge. Since one inevitably decides to take an alternative route, the function of the sculpture remains purely symbolic.

But let us pause and reflect upon the basic implications of this sculpture: restriction of movement, prohibition of action, danger to life and limb. Its deeper meaning cannot be recognized merely by looking at it, as one looks at a picture, for example. Essentially, the sculpture reflects upon intended actions and the potentially violent prevention of them. Such a subject is unusual in Newman's oeuvre and can be properly understood only if we know something about the circumstances under which "Lace Curtain" was produced.

Let us begin with the title. The term "lace-curtain"—especially its extended form "lace-curtain Irish"—is, as Richard L. Feigen points out, a derogatory synonym for "affected". According to the definition in *Webster's Third International Dictionary*, "lace-curtain" is "often used to imply ostentation or pushing parvenu traits".[4] And in Chicago the phrase is apparently still used today to describe people "aspiring in particular to the gentility of the middle class—with its implicit suggestion of moralistic posturing and hypocrisy."[5] Newman's title aims all the term's associations at Richard J. Daley who, as mayor of Chicago, had in 1968 become the embodiment of political power and brutal enforcement of authority, acting primarily in the interests of those to whom he owed his position: the white establishment, of which a large percentage, like Daley himself, were of Irish descent.

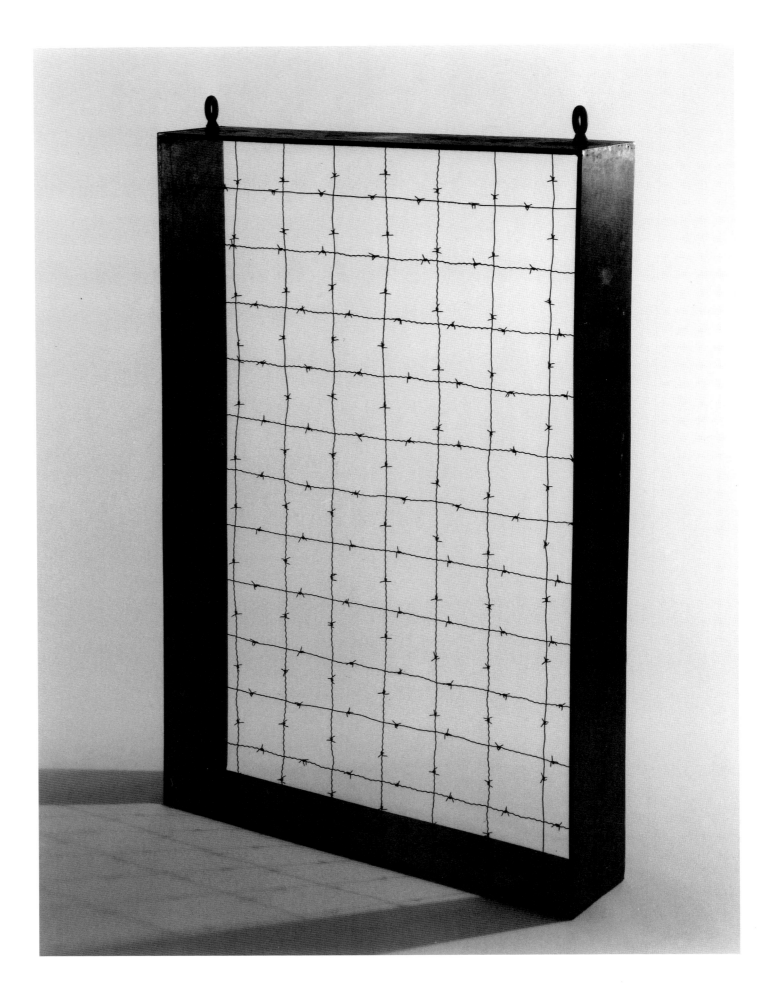

What had happened? It started with the Democratic National Convention which took place in Chicago at the end of August 1968. At that time, the political debate in the United States was dominated, as it was everywhere else in the world, but even more so, by the war in Vietnam. President Johnson had not only ordered a stop to the bombing north of the twentieth parallel but had also announced his decision not to run for a second term. The events in Chicago must be viewed against the background of the fierce election battle which pitted the Republican Richard Nixon against the Democrat Hubert Humphrey. In Chicago, too, there were demonstrations against the war in Vietnam. These demonstrations were hardly directed against the Democrats, some of whom were considering, even openly advocating, a change of policy towards Vietnam, but violence broke out all the same, for Chicago's police force proved incapable of preventing an escalation of violence and of reacting flexibly to civil disobedience. Arriving in great numbers from all over the country, opponents of America's official Vietnam policy found themselves up against a police force which ruthlessly and indiscriminately cudgeled its way through the crowd, cordoned off the convention grounds with barbed wire and subjected all who wished to enter the grounds, whether they were protesters or not, to strict surveillance. Even Richard L. Feigen, himself a member of the Democratic party, was attacked by Daley's "custodians of law and order" and brutally pushed aside. The delegates were outraged, and even more so when Daley railed at Senator Abraham Ribicoff in anti-Semitic slogans for having criticized the actions of his police force.[6] The reaction was foreseeable. The newspapers all told virtually the same story[7]: The television reports on the police brutality in Chicago had triggered vast indignation among intellectuals, especially in New York and California. Jesse Reichek, a painter and a professor of art at the University of California, Berkeley, drafted a declaration of protest which stated that, out of disgust at the brutal police attacks and the many injuries that they had caused, fifty American artists would boycott all exhibitions in Chicago for a period of two years—the city had shown itself unfit to belong to civilized society. Reichek's initiative was greeted by the approval of many, including Gottlieb, Lichtenstein, Saul Steinberg, and Motherwell. Newman, for his part, wrote a letter on September 3, 1968, to C. C. Cunningham, then the Director of the Art Institute of Chicago, informing him that, "in protest against the uncalled-for police brutality of Mayor Daley," he was asking Cunningham to remove "Gea" from the forthcoming exhibition "Dada, Surrealism and Their Heritage". The exhibition had opened in New York, was currently in Los Angeles, and was scheduled to travel to Chicago in October.[8] Acting in a similar spirit, Claes Oldenburg cancelled his exhibition planned for September at the Feigen Gallery in Chicago. Oldenburg formulated his protest in a letter to Feigen thus: "I, like so many others, ran head-on into the model American police state. I was tossed to the ground by six swearing troopers who kicked me and choked

◁ 119 *Lace Curtain for Mayor Daley*, 1968
(Cat. No. 39)
The Art Institute of Chicago
Gift of Annalee Newman

me and called me a Communist. A gentle one-man show about pleasure seems a bit obscene in the present context."[9] But was there much use in boycotting a city which, at the time, was completely in the shadow of the art metropolis New York? Like several others, Richard Feigen saw no sense in the protest, and feared—not unjustifiably—that it would hurt the artists themselves more than anyone else, as well as the museums and galleries. Moreover, it was doubtful whether the boycott would bother Chicago's political leaders, considering that the same political faction had approved, or at least not prevented, the demolition of several of Sullivan's important buildings, and had shown itself to be not averse to the preposterous proposal to remove Picasso's large sculpture from the city center. Instead of supporting the boycott his, Feigen decided to mount his own protest. Although he quickly gained the solidarity of artists who had initially joined in the boycott, his hectic telephone campaign did not win over everyone. Joseph Albers, for example, said he was not political and so refused to take part.

The four-week exhibition "Richard J. Daley" opened at the Feigen Gallery at 226 E. Ontario Street on October 23. The exhibition was remarkable inasmuch as the works of most of the exhibiting artists did not directly convey a political message but were more or less representative of the artists' usual work. Claes Oldenburg, for example, exhibited a series of plaster hydrants, an ironical reference to a type of hydrant distinctive to Chicago. They were also meant, however, to remind visitors of the "plug-ugly Chicago cops"[10]. In the same vein was Robert Morris's derisive contribution: a telegram worded "Re-do Chicago Fire of 1871", a reference to the devastating fire which had destroyed most of Chicago almost a hundred years before and still traumatized the city. Oldenburg also made drawings for a public monument: Richard Daley's gigantic head on an enormous platter. James Rosenquist applied Daley's effigy to a support made of plastic strips, enabling visitors to hit the mayor without damaging the work of art.[11] George Cohen's images of a falling figure were inspired by one of the mayor's many intemperate remarks—"Next time shoot to kill". Red Grooms went beyond the immediate subject of the exhibition and transformed Orphan Annie into a "Miss Napalm". Other exhibits, however, were completely apolitical, such as those of Lichtenstein and Motherwell. Motherwell declared that he was not capable of making direct political statements through his art, but wanted to demonstrate his solidarity with artists who were.

It is against this background of polarized positions—political commitment at the one extreme, l'art pour l'art at the other—that Newman's sculpture assumes particular significance. Could he not have reacted like Motherwell and been content to exhibit one of his paintings instead of going to all the trouble of making a completely new, politically relevant sculpture, and within such a short time? But Newman had even planned to submit a second

work—"Mayor Daley's Outhouse"—but he was unable to realize it through lack of time.[12] As we can see from his letter to Cunningham, Newman felt personally provoked by the events in Chicago, as a citizen and also as an artist. The content of "Lace Curtain" has always been interpreted according to Newman's remarks and the political direction in which it was aimed has always been considered immediately obvious. The sculpture was, as Rosenberg puts it pointedly, "[. . .] a construction with a frankly polemical purpose that comments on Chicago as a concentration camp and on the ethnic and cultural background of its then mayor."[13] Rosenberg's observation that "Newman's sculpture was the only work in the show that delivered a political blow without abandoning the artist's customary format, in other words, while remaining a work of art"[14] seems inappropriate considering the works of the other artists on show. Grace Glueck later lamented the fact that the "Muse of Protest just didn't make it to their studios."[15] Considering the high pathos which characterizes New-man's oeuvre, what Rosenberg called the "literary flavor"[16] of "Lace Curtain" must have been quite alienating, and all the more so because Newman had not worked with any abstract geometrical forms which, as in the case of "Broken Obelisk", were of high cultural and his-torical significance. On the contrary, "Lace Curtain" is extremely concrete, for it is made from barbed wire, a commonplace article of everyday use. Although Newman has therein followed the example of the Pop artists, this is not immediately apparent, for the wire has been shaped into a comparatively exact lattice-work, a stylized barrier, an abstract structure of verticals and horizontals determined by the seemingly fragile arrangement of the sharp barbs. With its frame and open lattice, Newman's sculpture is obviously meant to be looked through, just like a lace curtain, in fact. The message seems obvious: Daley should be put behind bars, or subjected to an even worse fate if we consider another meaning which might be implied by the title: It's curtains for Mayor Daley! The splashes of red paint, however, sug-gest that the sculpture be viewed from a completely different perspective. The red paint implies violence and injury. The victims are the antiwar protesters. And so the question remains unanswered whether the barbed wire is meant to represent a restriction of free-dom of movement, as occurred during the demonstrations in Chicago; whether it symbol-izes deprivation of freedom by police brutality in general—our visual impression of the sculpture corroborates this interpretation; or whether the it represents the side of the mayor of Chicago from which the citizens must be protected—this is the interpretation sug-gested by the title. Thus Newman's work commits itself neither one way nor the other. Whilst Rosenquist and Oldenburg are unambiguous, Newman retains a certain ambivalence. There is no doubt that he too is against the inappropriate use of power, but he does not side so clearly with the protesters, no matter how convinced he is of their cause. Newman's forcing us to adopt a Janus-faced approach to his work—in other words, to see barbed wire

as a double-edged, freedom-restricting instrument which can be used against both protesters and the authorities—has its roots in his political convictions.

It should be remembered that when Peter Kropotkin's "Memoirs of a Revolutionist" were republished in America in 1968, the foreword was written by Barnett Newman. His long-felt sympathy with anarchism is obvious: "Anarchism [. . .]," writes Newman in his foreword, "is the only criticism of society which is not a technique for the seizure and transfer of power by one group against another, which is what all such doctrines amount to—the substitution of one authority for another. What is particular about anarchism is not its criticism of society but the creative way of life it offers that makes all programmatic doctrine impossible."[17] For Newman, Kropotkin was almost fanatical in his defense of the freedom of the individual. "It's the establishment," Newman writes later in the foreword, "that makes people predatory. [. . .] Only those are free who are free from the values of the establishment."[18] It is in Kropotkin that Newman finds all arguments against the authority of the state, and against organization and every form of monopolization of the individual for the sake of some "higher good". And so Newman is only being consistent when he also sees the New Left building "a new prison with its Marcusian, Maoist, and Guevara walls."[19] Indeed, it may be assumed, in this content, that Barnett Newman's sculpture is directed first and foremost against the authoritarian state, against police brutality and against the violent treatment of antiwar protesters exemplified by Daley. Newman's partisanship, however, is not so clear as one might at first assume, for as a disciple of Kropotkin he was skeptical of all who opposed the Vietnam war for reasons other than purely pacifist ones—reasons born, for example, of the wish to bring about a fundamental change in political and social conditions.

The pointedness of "Lace Curtain for Mayor Daley" is ascribable less to Newman's surprising use of barbed wire than to the splashes of red paint and, above all, to the title. With its combination of concrete objectivism, color, and words, this quasi-minimalist sculpture is so full of meaning that it can be readily used for polemical purposes. And yet "Lace Curtain for Mayor Daley" is not just a political statement. This successful synthesis of veiled agitation and persuasively simple form transcends its immediate purpose. Whilst it is indeed a political work of art, and one which can be understood only against the background of the events which took place in Chicago in the summer of 1968, its significance reaches far beyond those days of violence, for "Lace Curtain" not only occupies a special place in Newman's oeuvre but also is one of the few examples of politically committed art of the sixties which were of any consequence as works of art.

And in terms of form, too, "Lace Curtain" was not without consequences. Newman's transformation of a picture into an object—a reduced form comprising but a frame and a picture plane of barbed wire—anticipates a work by Antoni Tàpies produced five years later

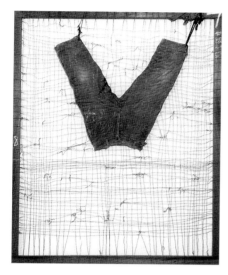

120 Antoni Tàpies, *Pants and Woven Wire*,
1973, 78 × 62¹/₄ ins.
Hirshhorn Museum and Sculpture Garden,
Washington, D.C. The Martha Jackson
Memorial Collection: Gift of Mr. and Mrs.
David K. Anderson, 1980

(Fig. 120). Naturally, considering their diametrically opposed intentions, one cannot say that Tàpies was influenced by Newman, but their similar formal strategies invite comparison: whilst Newman's free-standing (or suspended) sculpture is flat, Tàpies's wall-mounted work is three-dimensional; Newman's message is pointed, unwelcoming, even aggressive; Tàpies's message is, despite its extremely concrete form, poetically enigmatic. Its high degree of abstraction is the quintessence of Newman's "Lace Curtain for Mayor Daley". Richard Feigen returned "Lace Curtain" to the artist's widow in 1973, and she donated it to the Art Institute of Chicago, where only in recent times has it been shown to the public with any frequency.[20]

1 Hess, p. 123, Note 8.

2 According to Hess, ibid.

3 The two eyebolts on the top of the frame suggest that Newman might have intended to suspend the sculpture from the ceiling. Richard Feigen could not remember—in our conversation on October 24, 1996—whether this was in fact the case, but he did not rule out the possibility, though the ceiling of his Chicago gallery (where the sculpture was first shown) would have had to be specially reinforced on account of the enormous weight of the sculpture. Annalee Newman could not imagine that her husband envisioned suspending the sculpture (conversation with the author, October 23, 1996). Nonetheless, placing the steel frame on a base or plinth seems an unsatisfactory alternative. Indeed, the problem posed by this traditional form of presentation had been resolved by Newman—certainly since "Here II"—when he had made the base or plinth an integral part of the sculpture, a solution which had already been anticipated in "Here I". Moreover, if we consider "Zim Zum I" and "Zim Zum II", both of them plinthless and both of them conceived about the same time as "Lace Curtain", skepticism that Newman intended "Lace Curtain" to be mounted on a base or plinth seems doubly justified. Another point to be considered is that, despite the pronounced shape of their bases, Newman's stelae seem to hover on account of the a gap between the bases and the floor. Early photographs—such as the one published in *TIME Magazine* on November 1, 1968, show "Lace Curtain" mounted, slightly inclined, on a narrow base, as though the arrangement was only temporary. Other photographs show the sculpture raised slightly from the floor on two bricks (Hess, p. 123, for example).

304

Nonetheless, the crucial question is: Why were the eyebolts fitted? To facilitate transport? If that were so, Newman would definitely have had them removed, if not in Chicago—it seems that he did not attend the exhibition there—then certainly before the one-evening exhibition at Feigen's New York gallery on February 19, 1969. Although Robert Murray had never seen the sculpture suspended by its eyebolts, he recalls, in a letter to the author dated March 7, 1997, that Don Lippincott had mentioned that "Lace Curtain" had been hung up in the workshop so that the artist could look through it. Lippincott, who had manufactured the sculpture for Newman, told Murray that he vaguely remembered that Newman intended the sculpture to be installed near a window in Feigen's gallery, but since it could not be safely suspended from the ceiling, it was decided to mount it on bricks. Consequently, the information available to us does not clarify how the artist intended "Lace Curtain" to be presented. Even the title of the work, "Lace Curtain for Mayor Daley" does not enlighten us, as its meaning is purely metaphorical.

4 I am indebted to Heidemarie Colsman-Freyberger, The Barnett Newman Foundation, for this reference.

5 Letter to the author from Daniel Schulman, The Art Institute of Chicago, November 22, 1996.

6 For background information on the political and cultural situation, especially in Chicago, see the small brochure published by Richard Feigen to mark the twentieth anniversary of his exhibition: *"Richard J. Daley": The 20th Anniversary*, Richard L. Feigen & Co., Chicago, New York, London, October 1988.

7 The events were widely reported in the press. The following represent only a narrow selection: *New York Times*, September 5; *Chicago Daily News*, September 12; *Christian Science Monitor*, September 14; *Los Angeles Times*, October 20; *Newsweek*, November 4; *TIME Magazine*, November 1, 1968. As one of the artists directly affected, Claes Oldenburg archived all the reports. David Platzker of Oldenburg's studio kindly afforded me access to these reports.

8 Newman, *Writings*, p. 43.

9 Quoted from *Newsweek*, November 4, 1968, p. 117.

10 *TIME Magazine*, November 1, 1968, p. 76.

11 Illustrated in *Newsweek*, November 4, 1968, p. 117.

12 Hess, p. 123, Note 8.

13 Rosenberg, p. 74 f.

14 Rosenberg, *Broken Obelisk*, p. 14.

15 Unidentified clipping, probably *New York Times*, n. d.

16 Rosenberg, *Broken Obelisk*, p. 10.

17 Newman, *Writings*, p. 45.

18 Ibid., p. 51.

19 Ibid., p. 45.

20 The exhibition "Richard J. Daley" was shown at the Contemporary Arts Center, Cincinnati, from December 19, 1968, through January 4, 1969, and again, for the last time, at Feigen's New York gallery on February 19, 1969.

I

In the fall of 1968, Newman received an invitation from the Director of the Hakone Open-Air Museum, Tokyo. The Secretary General of the Museum, Toyooki Tanaka, was preparing a sculpture exhibition, to open in the summer of 1969, and wanted to include a work by Newman. Its dimensions were not to exceed 200 by 200 by 700 cm (approximately 79 by 79 by 275 inches) and it should not weigh more than 3 tons. The sculpture was to be shipped by sea, and the exhibition was scheduled to last three months, from August 1 to October 31, 1969.[1]

Newman accepted the invitation, but on one condition: he had no wish to take part in the competition which was to accompany the exhibition. He was obviously aware that, as a painter, he hardly stood a chance of winning any of the prizes, which, at least financially, were extremely attractive. And he would certainly not have been satisfied with a commendation, or even a second or third prize.

In February 1969, Tanaka requested the usual information, e.g. the title of the work, its medium, its dimensions, its insurance value, Newman's biography, etc. Newman's notes for his reply (now in the archives of The Barnett Newman Foundation, New York) are extremely revealing, for they include sketches which clearly demonstrate the gradual evolution of his concept. It also becomes clear that, without the invitation from Japan, the sculpture would never have come into being.

Newman evidently planned from the outset to produce a two-part sculpture comprising zigzag elements reminiscent of the window of his Synagogue Model (Fig. 121). His initial concept was based on a mirror-image juxtaposition of two such elements. His positioning them very close to each other indicates his interest in the viewer's spatial experience when standing between them. In some of his sketches, Newman drew wavy lines representing the viewer's possible path around and through the sculpture, beginning at a funnel-shaped opening formed by two vertically positioned rectangular steel plates. Once inside, the viewer would experience a space which widened equally on both sides and then narrowed again as he moved further into the sculpture. After experiencing this widening and narrowing of space three or four times, the viewer would finally emerge at the other end.

Newman did not pursue this idea, however, as it evidently dissatisfied him for a number of reasons. The side views of the sculpture, for example, would have been identical, as would the end views. What must have been even more problematical for Newman was that the distance between the zigzag elements could not be based on any kind of system but, rather, had to be established by trial and error. This had not been a problem with the Synagogue Model, as the distance between the two rows of windows was dictated by the pro-

121 Sketch for *Zim Zum*, 1969
The Barnett Newman Foundation,
New York

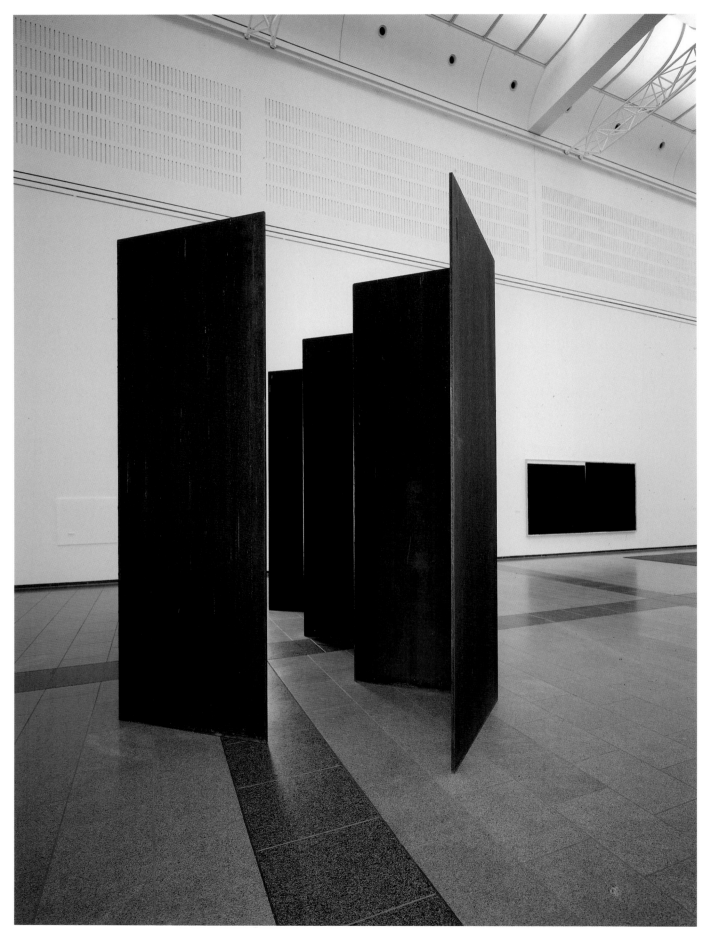

122 *Zim Zum II*, 1969/85 (Cat. No. 41)
Kunstsammlung Nordrhein-Westfalen, Düsseldorf

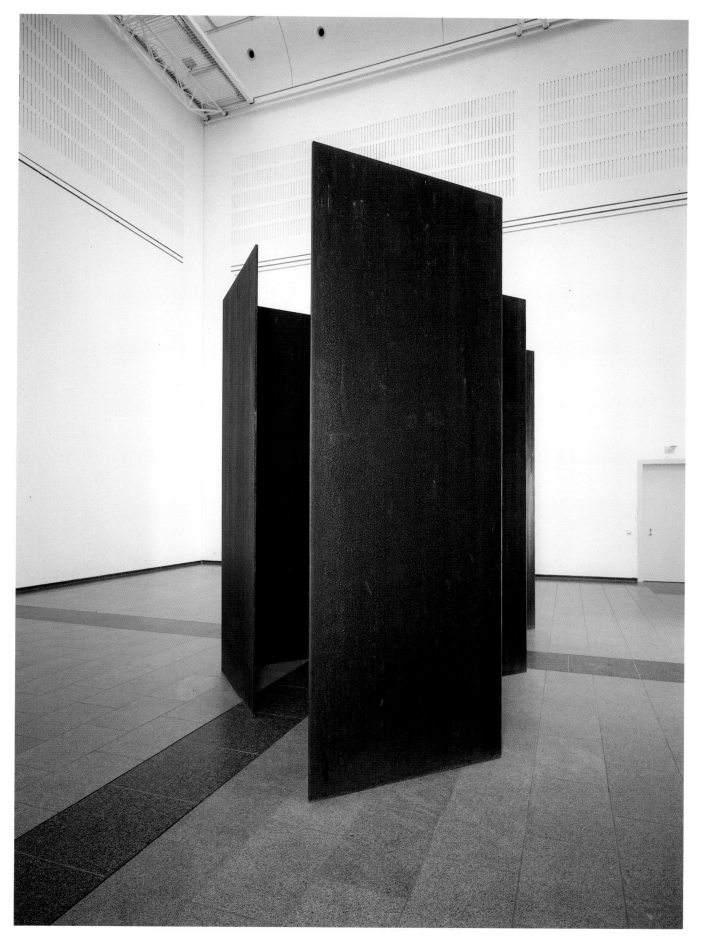

123 *Zim Zum II*, 1969/85 (Cat. No. 41)
Kunstsammlung Nordrhein-Westfalen, Düsseldorf

308 portions of the building. Moreover, Newman had focused attention more on the bimah as a static architectural element occupying the center of the synagogue than on the sculptural aspect of movement and its direction. Finally, there was the question of whether the zigzag elements should be acutely or obtusely angled (Fig. 124); here, too, the answer must have seemed arbitrary.

Thus Newman rejected the idea of a symmetrical, mirror-image arrangement of the zigzag elements, and sought a different approach, but without abandoning his basic concept. Whilst the windows of the Synagogue Model had zigzagged at an angle of 60 degrees, Newman now decided to use right-angled elements. Moreover, simply by repositioning the parallel zigzag elements in relation to each other, Newman arrived at the convincing solution he had been searching for, and the one which the finally executed sculpture featured. This solution not only enabled him to justify, structurally, the juxtaposition of the two zigzag elements but also made for a more exciting spatial experience inside the sculpture and permitted a stronger differentiation between its end and side views.

Newman may have been inspired by the graph paper which he used for his sketches. He sketched his ultimate solution on a sheet of memo paper from David Smith Steel Co., Inc. (Fig. 125). The result seems to be based on the following operation: three squares are first arranged such that their diagonals form a straight and continuous line. This line divides the configuration into two equal halves, each half comprising three triangles. These halves are then separated by a distance equal to the side length of the basic grid element, i.e. the square, and in a direction likewise dictated by the grid. Put another way: the three closed squares are transformed into three staggered rectangles whose long sides are half open and at opposite ends. Since the apices of all the angles are aligned, this arrangement, like the mirror-image version, affords an unrestricted passageway between the two halves of the sculpture (here the width of the passage is equal to half the diagonal of the basic grid element). The result, however, is completely different from Newman's original plan. The staggering of the two zigzag elements changes the experience of space. Instead of being able to walk in a straight line through symmetrically widening and narrowing spaces, the viewer finds himself forced to change direction constantly. Although it is possible to walk through the sculpture in an upright position, a wall of steel approaches the viewer either from the left or from the right, almost menacingly, whilst at the same time the opposite wall recedes to the same extent. Seconds later the situation is reversed, and the wall that was receding only a moment ago makes a right-angled turn and returns to the middle. Newman's sketch of the sculpture's layout makes this asymmetry clear, helping us to comprehend the viewer's alternating sensation of proximity and distance. As he passes through the sculpture, the viewer cannot help but walk in a wavy line.

124 Sketch for *Zim Zum*, 1969
The Barnett Newman Foundation,
New York

125 Sketch for *Zim Zum*, 1969
The Barnett Newman Foundation,
New York

310 Newman planned to have his sculpture executed in COR-TEN steel, as his notes tell us. About the dimensions, however, Newman's notes are less conclusive. Whilst the height had been fixed at 8 feet, the width of the individual steel plates varies from one set of notes to the next, fluctuating between 26 inches and 38 inches, and the total length between 13 feet 6 inches and 13 feet 3 inches. The weight of each zigzag element was calculated at 2 tons.

Also interesting are Newman's thoughts concerning the title. Evidently he was considering three alternatives (Fig. 126): "The Self", "Zim Zum", and "The Squeeze". He finally decided in favor of the kabbalistic term *tsimtsum*, though the sculpture—as we shall see—deals more consistently than any of his other works with the viewer's experience of self. This intention is also signified by the two alternative titles, "The Self" and "The Squeeze", the latter undoubtedly referring to the compaction of space.

In a letter to Tanaka dated July 23, 1969, Newman furnishes further information.[2] The sculpture was originally made in four sections which were to be screwed together to form two pairs. The sculpture today consists of two complete zigzag elements; the screws were replaced by Lippincott with welds after the artist's death—as it had always been Newman's intention to do. Newman's letter to Tanaka also mentions the wings at the bottom ends of each zigzag wall which were provided with holes to be placed over bolts anchored to the floor. Whilst this proves that Newman approved of such safety measures, these small attachments at the ends and angles of the sculpture spoil the visual effect to a problematical extent.

II

The sculpture (Fig. 127) was executed exactly according to the concept outlined in Newman's notes and letters. It is not known, however, whether the dimensions finally decided upon were obtained with the aid of a full-size model, although we may assume that Newman did build such a model in order to be sure that the proportions were right. Whilst such trials had been necessary for "Broken Obelisk", "Here II", and "Here III", they were less so in this case. There is a critical difference between the sculptural concept of "Zim Zum I" and that of Newman's previous works. Whereas he had hitherto been preoccupied with the visual appearance of the solitary form (the stelae of "Broken Obelisk" and "Here III") or with the spatial interaction of a sculpture's individual elements ("Here I" and "Here II"), Newman was now concerned with a completely different aspect, and one on which he had carried out systematic research.

This is clear from Newman's notes. "Zim Zum I" is concerned with seriality, with the uniformity of its component elements, with repetition and parallel movement, i.e. with phe-

The Leef

HaKoneseum | Zim Zum Mosqueje
Zim Zum

In reply to letter April 11

2. ~~Sculptures~~

1. Zim Zum

2. cor-ten steel

3. height 8 feet width 26½ in
 length 13' 6" weight each 2 tons

6. Insurance 100000,

the rest will follow in a letter.
Drawings of piece

Sent my letter with biography
information

126 Draft of letter, 1969
The Barnett Newman Foundation,
New York

312

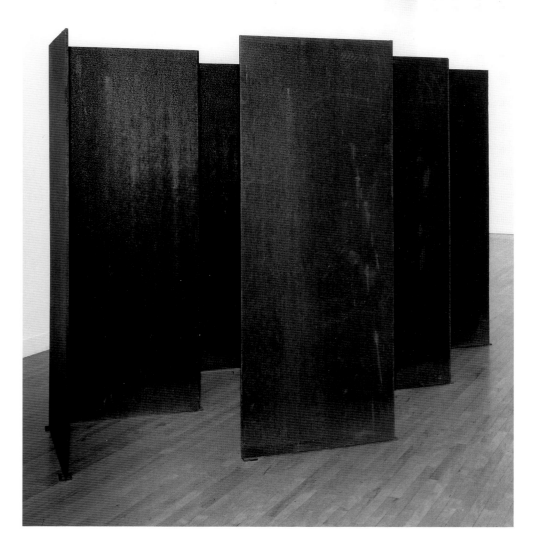

127 *Zim Zum I*, 1969 (Cat. No. 40)
San Francisco Museum of Modern Art
Purchased through a gift of Phyllis Wattis

nomena which hitherto had not found expression in Newman's sculptural oeuvre. An antic-
ipation of this development might be sought in those paintings by Newman which feature
several vertical "zips", such as "The Name I" (1949) (Fig. 128), "Covenant" (1949) (Fig. 47),
and, above all, the paintings in the "Stations of the Cross" series, but these works are con-
cerned with the rhythm of the "zips", with the relationship of the areas of color to one
another and to the picture plane, with the relationship of line and surface, with the process
of painting, and with color itself, in other words, with phenomena that have nothing to do
with sculpture. All the same, one detail links the two mediums together: the welds of the
steel plates are like materialized "zips" (Fig. 129).

128 *The Name I*, 1949
Oil on canvas, 48 x 60 ins.
Daros Collection, Switzerland

129 *Zim Zum II*, weld, detail

The key to understanding "Zim Zum I", however, is to be found neither in Newman's paintings nor in his sculptures but in his Synagogue Model. "Zim Zum I"—and this is the view generally held so far—is based on the basic architectural principles governing spatiality. Newman's reorientation was doubtless encouraged by contemporary developments in art. Indeed, his sculpture isolates and monumentalizes what seems to be the quintessence of "non-relational" strategies of art. Moreover, Newman's notions of gestalt perception and self-experience are in some respects akin to those of the Minimalists.

"Zim Zum I" thus consists of twelve identical parts welded together in two rows of six, each row zigzagging at right angles. Although the two rows are parallel, they are staggered such that the viewer, when looking at the sculpture from the side, sees a termination at the left-hand end, whilst at the right-hand end both zigzag elements are visible and form an opening which seems to invite the viewer to step inside. The same impression is gained by the viewer when looking at the sculpture from the other side. Here, too, the left-hand end seems to be closed, whilst the right-hand end forms an opening. This opening narrows or widens as the viewer changes position, accentuating the double-walled character of the sculpture and inducing the viewer to move to the right, towards the opening, and, as he does so, to appraise the configuration, structure and size of the work.[3]

Looking at the sculpture from the end, the viewer reaches a point whence he can perceive only the outer rim of the first plate of the right-hand zigzag element, whilst the side of the first plate of the left-hand element is still in full view. The viewer is clearly invited to proceed towards the zone defined by the fully visible plate on the left and the narrow rim of the plate on the right, though from this position he still cannot see inside the sculpture, for his vision is obstructed by the second plate of the right-hand zigzag element which runs parallel to the first plate of the left-hand one, creating what at first glance seems to be a closed niche, an effect enhanced by the shadow resulting from the proximity and the staggered arrangement of the two zigzag elements. Not until the viewer gradually nears the sculpture, instinctively increasing the radius of his own movement, do the other inward projections come into view one by one, whilst the outward projections disappear at the same rate. The viewer continues until he can look through the sculpture from one end to the other, taking in the staggered perspective of all eight inward projections, the alternating edges and surfaces, the interplay of light and shadow. The eye leaps forward, darting to the left and to the right, before finally focusing on the opposite end of the sculpture. The passageway formed by the zigzag elements is the center of the sculpture. Viewed from the outside, it is a displacement of space: solid, compact, fortified, hierarchical, a triptych without a dominant center; from the inside, the opposite: a contraction of space, staggered,

protective, symmetrical, with a beginning and an end. Thus the structure of "Zim Zum I" allows completely different perceptions and experiences.

If one were to follow the course suggested by the zigzag formation of the sculpture, one would have to make a 90-degree turn six times before reaching the other end. If one were to follow an imaginary pool ball as it bounced off the steel plates one after the other in a 45-degree zigzagging trajectory, one would change direction twelve times as one walked from one end of the sculpture to the other. All such observations show that the experience the viewer might have inside the sculpture remains limited in spite of the effect the sculpture exercises simultaneously on the viewer's sense of sight and his motor functions. This limitation is deliberate, however. The idea of extending the double walls to four external angles each—as sketched by Newman on a sheet of graph paper (Fig. 121)—and providing them with parallel walls at both ends was not pursued by Newman. On the contrary, he was concerned primarily with realizing a uniform, rhythmical "threesome", as though he wanted to say, in just one short sentence comprising subject, verb and predicate: "The Self", "The Squeeze", "Zim Zum".[4]

Here, too, we are impressed by the Cartesian clarity of concept, the succinctness of the solution, and the perfection of execution. Whilst "Broken Obelisk" is undoubtedly Newman's most impressive sculpture, a solitary form on a pedestal, at once radical and classical, full of literary connotations and yet reduced primarily to pure geometry and static equilibrium, in other words, a monument in the traditional sense, "Zim Zum I" is, by comparison, modest, unobtrusive, and unemotional; it is neither evocative nor allusive. The sculpture is the product of the artist's reflection on the square, the double square, the triple rectangle, the number twelve, on seriality and right angles, on opening and closing, on the confinement of space, and on the function of the passageway both as a means to an end and as an end in itself. Above all, Newman decided to do without a base. Whilst this was not unusual in 1969, it does not signify deference to contemporary trends. Newman's decision was dictated, rather, by the severity of his concept. "Zim Zum I" is an astonishing sculpture: simple and unpretentious, austere and exact, sublime and hermetic.

III

The sculpture was—as Newman planned—executed in COR-TEN steel. Again, Lippincott was entrusted with precisely realizing Newman's idea. The material was ⅗-inch-thick steel plate. The individual components were 96 inches high—96½ inches if we include the welded-on "wings". In my opinion, these small wings, fitted for stabilizing purposes, have a negative effect on the appearance of the sculpture, for they raise the sculpture a slight distance from the floor, forming a gap which either lets light through or throws a shadow,

depending on the lighting conditions. This gap is not like the gaps between sculpture and floor featured in "Here II", "Here III", or "Broken Obelisk"—which were intentional—but like a crack beneath a door that lets in cold air. In spite of the solidness of its material, the 1969 version of "Zim Zim" conveys in certain lighting conditions the impression of a screen which is much too heavy for its purpose. The intended effect of the sculpture definitely seems to have been weakened, not to say undermined, by these wings. Newman must have seen the sculpture prior to its shipment to Japan, and he mentioned the wings in his June 23, 1969, letter to Tanaka. It is hardly likely that the effect created by the slight gap between the sculpture and the floor escaped his notice. This strengthens the assumption that Newman attached no significance to this phenomenon, indeed, it suggests that he was interested less in volume than in surfaces, less in mass than in line, less in tectonics than in movement in space. What Newman sought to demonstrate was a principle. The details were evidently not all that important so long as the proportions were correct, the sculpture was optically balanced, and its double-walled configuration would provoke that ideomotor movement which mattered so much to Newman.

But if this were in fact so, why, we must ask, did Newman have the sculpture made from such thick and heavy steel plate? Would not sheet metal have achieved the same, or virtually the same, effect? We must remember that Newman is not Serra. Weight and counterweight, pull and thrust, support and load—such elements of sculpture had never interested Newman particularly. The intrinsic value of the material was at best of secondary importance to Newman. However abstract "Zim Zum I" may be, it has as little to do with the semiotic revolution of modernism as "Broken Obelisk". "Zim Zum I" is not self-referential, and its zigzag elements do not exist simply for their own sake. On the contrary, they represent in abstract form what they in reality are not. In other words, they are a symbol. Hence Newman's choice of a title loaded with meaning, and hence also Newman's acceptance of the safety devices—for only as such do the "wings" make any sense—to the detriment of the sculpture's esthetic appearance.

The matter may seem irrelevant, but if we consider how meticulous Barnett Newman was as an artist, we must ask why he was prepared to accept features which would inevitably detract from the visual effect of this great work, if only to a small extent. The answer possibly lies in the genesis of "Zim Zum"—not in a sculptural idea but, rather, in a spatial concept which was meant to convey a specific meaning. This dovetails with the argument that "Zim Zum" has its origin in Newman's Synagogue Model. In that case, Newman probably chose thick steel plate for purely technical reasons. The zigzag elements had to make the viewer sense the displacement and compacting of space. Thinner sheet metal would have easily warped, creating an effect opposite to the one desired, that is, the viewer would gain the

316

impression that it was space which was deforming the sculpture, and not the other way round. Moreover, both elements were required to stand firmly by dint of their own weight, eliminating the need for a special base or foundation and necessitating the use of only anchor bolts and wings.

Other features of "Zim Zum I" reveal Newman's painstaking attention to detail. The individual steel plates of the zigzag elements are 96 inches high and 37 inches wide. The ratio of height to width is based on the golden section (96−37= 59; 96:59 = 59:37).[5] Each zigzag element measures, from outer edge to outer edge, 180 inches, just over twice the sculpture's overall width of 78 inches.

IV

The title of the sculpture, "Zim Zum", is an alternative spelling of the kabbalist term *tsimtsum* which has its origin in the doctrines of Isaac ben Solomon Luria (1534−1572), a Jewish mystic who, in coming to terms with the expulsion of the Jews from Spain, developed a myth to give meaning to the exile of the Jews. The myth was based on three concepts: *tsimtsum*, the contraction or withdrawal of God; *shevirah*, the breaking of the vessels; and *tikkun*, the restoration of the cosmos. As Gershom Scholem points out, the concept of *tsimtsum* is unusual inasmuch as God's first act of creation was not one of emanation but one of withdrawal. For Luria, the act of *tsimtsum* guaranteed the process of creation, as God's withdrawal permitted the presence of something other than God himself in his divine essence.[6]

Luria's doctrine need not receive any further attention here. The reflection of kabbalist ideas in Newman's art has been emphasized by a number of writers and critics, and especially by Thomas B. Hess. Hess's interpretation of Newman's sculpture, however, is very general, noting the obvious similarity between "Zim Zum I" as a "walk-through" sculpture and Newman's Synagogue Model.[7] Rosenberg, too, says little about "Zim Zum I". In his publication on Newman's sculptures, he relates "Zim Zum I" to "Lace Curtain for Mayor Daley", but only because they feature the same basic rectangular form and, consequently, are "somatic extensions of the format of the paintings."[8] Rosenberg's Newman monograph mentions "Zim Zum I" only in the context of his discussion of the Synagogue Model.[9] Indeed, it can be said that "Zim Zum I", unlike "Broken Obelisk" and Newman's "Here" sculptures, has received very little attention in literature hitherto.[10]

V

If we accept certain inconsistencies in Newman's sculpture, especially the wings and their unwanted effect of elevating the work from the floor, and conclude that the artist was indeed concerned with the transcendence of reality and, in principle, subscribed to the notion that art should have a symbolic function, and if, at the same time, we recapitulate the experiences of the viewer as he walks through and around "Zim Zum I", we can only assume that Newman was striving to achieve two ends: a symbolic meaning which reached beyond the factualness of the sculpture, and the immediacy of a physical and intellectual experience which went no further than that. "Zim Zum I" is unique because its two zigzag elements are the point of convergence of two streams of modernism, the one regarding art as a meta-physical experience, the other asserting the autonomy of the medium, denying all meaning beyond the physical reality of the work and at the same time emphasizing the active partici-pation of the viewer. The discarded title "The Self" thus makes a twofold reference, to the subject of experience and, in the sense intended by the ultimately chosen title, to the *tsim-tsum* of the kabbala. The same is true of "The Squeeze", which refers not only to the action of the sculpture but also to an essential aspect of Luria's concept of *tsimtsum*.

Despite an apparent ambivalence, not to say indecisiveness, in Newman's approach, his works do tend more towards self-referentiality and towards a relatively strong empha-sis on the transitoriness of experience. These tendencies, which were present, if only latently, in Newman's sculptural oeuvre from the beginning, seem to have become absolutes in "Zim Zum I". This work thematizes, more than any other of Newman's sculp-tures, the interaction of the human organism with its surroundings. "There is no experi-ence in which the human contribution is not a factor in determining what actually happens. The organism is a force, not a transparency,"[11] said John Dewey. Dewey's *Art as Experience* is also relevant to our understanding of "Zim Zum I" when he describes "the very same relation of doing and undergoing, outgoing and incoming energy, that makes an experience be an experience."[12]

This insight was shared by several American artists of the sixties. Robert Morris, for example, saw sculpture as "a function of space, light, and the viewer's field of vision. The object is but one of the terms in the newer esthetic. It is in some way more reflexive because one's awareness of oneself existing in the same space as the work is stronger than in previous work, with its many internal relationships."[13] There are evident analogies with Minimalism in Newman's late oeuvre. Whilst in theory Newman is committed to "the tran-scendental, the self, revelation"[14], i.e. notions which such artists as Judd and Andre reject, in practice Newman works in a way that has more than superficial parallels with Minimalism. A sculpture like "Zim Zum I" is a correlate of the human body and, by extension, the viewer's

318 existence (whose fixed structure is the viewer's body). "Zim Zum I" does not take subjec-
tive shape until the viewer examines it physically, that is, until he walks around it and through
it, pauses between its zigzag elements, senses the direction in which he is expected to go,
and either goes in that direction or goes some other way, and so on. Thus, if we are to
understand it, "Zim Zum I" must be explored not only visually and intellectually, but also
physically. In all of Newman's oeuvre, the work and the viewer are inseparable, but with
"Zim Zum I" this inseparability is much stronger, for the sculpture's dual spatial configura-
tion also expresses the viewer's existence. "Zim Zum I" is both perceived by the eye and
explored by the senses. "To this extent, every perception is a communication or a com-
munion, the taking up or completion by us of some extraneous intention or, on the other
hand, the complete expression outside ourselves of our perceptual powers and a coition, so
to speak, of our body with things."[15] Thus it would seem that "Zim Zum I" sums up all of
Newman's sculptural efforts hitherto. Whilst "Broken Obelisk" was undoubtedly Newman's
coup de maître in terms of public sculpture, "Zim Zum I" broke out of the framework within
which all of Newman's other sculptures operate, and ventured into completely new sculp-
tural territory. Fundamentally different, "Zim Zum I" seems to be a criticism of everything
that Newman had previously achieved in sculpture. Indeed, "Zim Zum I" contains elements
which, only a few years later, were to culminate in such epochal works as Richard Serra's
"Circuit" of 1972 and Bruce Nauman's "Corridors" of 1970/71, though such extreme expe-
riences of self as those manifest in the installations of these two younger artists were not
Newman's intention. Nothing was further from his mind than to question the identity of the
subject. On the contrary, Newman's intention was to create a place in which the subject
could be aware of his own self.

VI

In the catalog which accompanied the Newman retrospective at the Museum of Modern Art
in 1971, Thomas B. Hess wrote that Newman originally planned a twelve-foot-high sculpture
for the exhibition in Japan, but had to change his calculations on account of the shipping
specifications and limit himself to a height of eight feet.[16] When Newman died of a heart
attack on July 4, 1970, the originally envisioned version of the sculpture had still not been
realized, as Hess remarked ("The second, and definitive, version is still to be executed")[17].
The necessary preparatory discussions between Newman and Lippincott had, however, pro-
gressed far enough that an execution of the sculpture could occur at any time. Like "Lace
Curtain for Mayor Daley", which Lippincott executed according to Newman's telephoned
instructions, "Zim Zum II" could be easily built in the artist's absence. The cutting and weld-
ing of the steel plates were merely a matter of observing the instructions Newman had

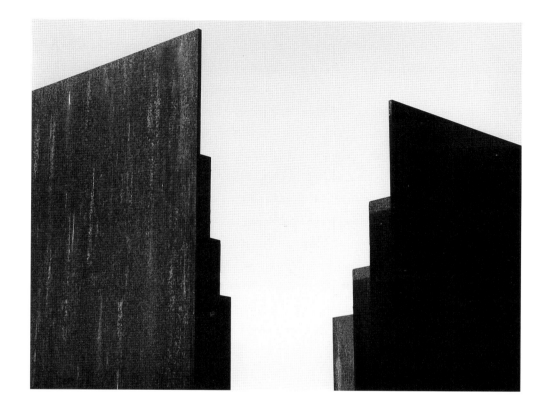

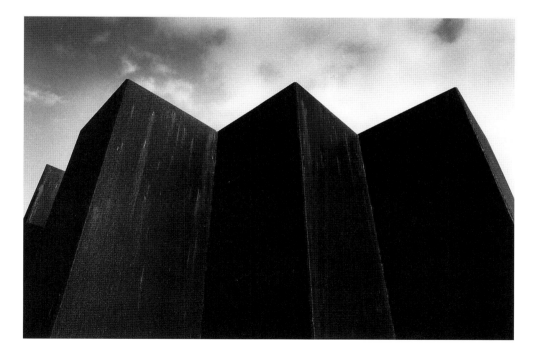

130 *Zim Zum II*, 1969/85

131 *Zim Zum II*, 1969/85

320 already given. According to a letter from Donald Lippincott to Annalee Newman written on October 14, 1970[18], the execution of the large version of "Zim Zum I", originally scheduled for the summer of 1969, had had to be postponed in order to fabricate the third exemplar of "Broken Obelisk", which was to be shown at Henry Geldzahler's exhibition "New York Painting and Sculpture, 1940–1970" at the Metropolitan Museum from October 18, 1969, to February 8, 1970. Lippincott's letter also states that the specifications had been finalized between the fall of 1969 and the beginning of 1970: the material was to be ¾-inch-thick COR-TEN steel plate; each wall would measure 11 feet 10 inches by 4 feet; and approximately six weeks would be required for manufacture. Lippincott also mentioned in his letter that Newman had thought it sensible to postpone execution until an opportunity to exhibit the work presented itself. This is plausible and in keeping with his way of working. Newman would frequently conceive and realize a sculpture for some exhibition without it first having to be commissioned; witness "Broken Obelisk" and the first version of "Zim Zum".

"Zim Zum II" was not executed until many years after Newman's death (Fig. 132). Lippincott fabricated the sculpture in 1985, exactly as the artist envisioned it. It was first shown publicly at the beginning of 1992, in an exhibition at the Gagosian Gallery, New York.[19] No less than "Zim Zum I", "Lace Curtain for Mayor Daley", and Newman's other sculptures "Zim Zum II" is an authentic work of the artist.

Hess stated that the plates of the "definitive version" of the "twelve-foot-high" sculpture would have a width of 55½ inches.[20] This was not the case. Newman had envisioned different proportions for the larger version. It was not the golden section which determined the ratio of height to width this time, but rather the simple relation of 1 to 3. The plates are 48 inches wide. Each zigzag element is 207 inches long, and the overall length of the sculpture is 242 inches, the overall width 102½ inches. The largest side-to-side distance walkable by the viewer in a straight line corresponds to the diagonal of the rectangle formed by two grid elements (48-inch squares), namely 107 inches, whilst the width of the passageway corresponds to half of the diagonal of the grid square, namely 34½ inches. Thus "Zim Zum II" is considerably larger than "Zim Zum I". The passageway between the two zigzag elements seems more spacious, and the ratio of height to overall length seems greater (in the case of "Zim Zum I" the ratio is 1:1.63; in the case of "Zim Zum II" it is 1:1.43). The thickness of the plates also has been increased, by almost 30 percent; they now measure ¾ inch instead of ⅗ inch.

What is far more important than these figures, however, is that "Zim Zum II" stands directly on the floor, and has not been equipped with wings, as was the first version. And even more important for the visual effect of the sculpture is that it is over twice the height of a person of normal stature. The relationships of scale resulting from these proportions

132 *Zim Zum II*, 1969/85, in the Gagosian Gallery, New York, 1992 ▷

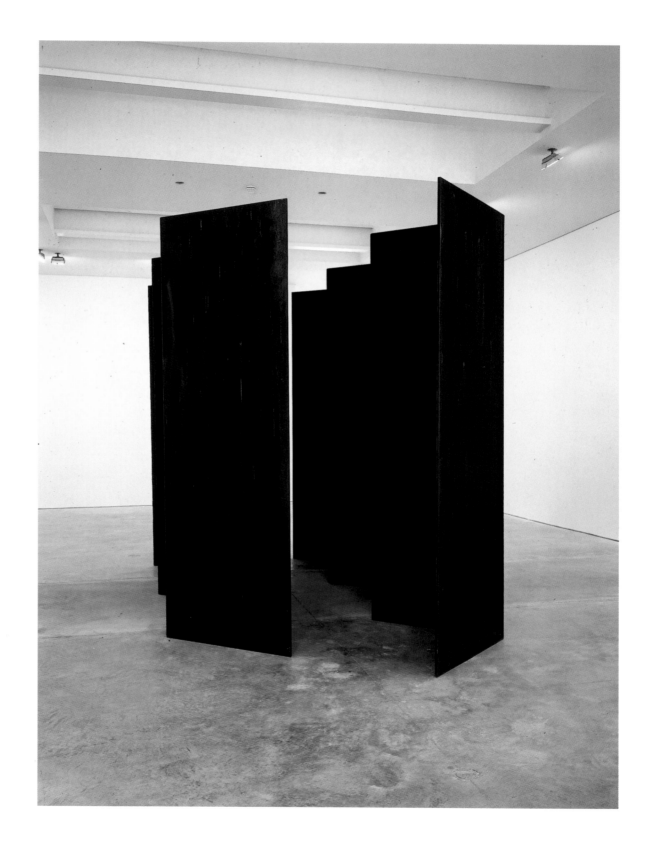

transport the sculpture into a new dimension, lending it a monumentality missing from "Zim Zum I". The greater volume, both internal and external, and the emphasis on verticality evoke a considerably stronger impression of sublimity than does the smaller version. Viewed from the outside, "Zim Zum I" seems stockier, more compact, more defensive. Its visual impact is dominated by its breadth. "Zim Zum II" seems more like a work of architecture; space is embraced rather than displaced. Despite the obvious massiveness and stability of the structure, "Zim Zum II" also gives a subliminal impression of lightness.

Walking through "Zim Zum I", the viewer feels threatened, but not imprisoned, by the walls of the sculpture, whilst the opposite is true with "Zim Zum II": the viewer experiences a strong feeling of claustrophobia, but without gaining the impression that the steel walls of the sculpture constitute an immediate threat. In both cases the viewer is aware of his freedom of movement, but in the first case his awareness is physical, in the second case it is intellectual. No sooner has the viewer entered "Zim Zum I" than he is able to concentrate on the exit. In "Zim Zum II", however, this process is impeded by the viewer's constant feeling of having to look upwards in order to take in the sculpture in its entirety. In other words, "Zim Zum I" activates two main directions of perception: from front to back and from side to side. This also happens in "Zim Zum II", with the addition of a third and more important direction of perception: upward. The strong sense of verticality transforms the viewer, as it were, into a walking stele. What was materialized in the "Here" sculptures in plaster, bronze or stainless steel finds figurative expression here in the body of the viewer. The feeling experienced in "Zim Zum II" of having firm ground under one's feet and an unrestricted view above one's head gains in importance and counteracts the threatening effect of the surrounding steel walls.

In drawing attention to these aspects I do not wish to suggest that there are any fundamental differences between the two sculptures. On the contrary, everything achieved by "Zim Zum I" is also accomplished by "Zim Zum II", only more convincingly and more impressively. "Zim Zum II" is not a corrected or improved version of "Zim Zum I". Both are formulations of one and the same concept, with subtly nuanced differences.

If we look back to Newman's beginnings as a sculptor, we will realize that the two versions of "Zim Zum" represent a new solution to a sculptural problem already thematized by "Here I", namely the relationship of two vertical elements to each other and/or the articulation of the space between them. The two stelae are now zigzag walls, and the sculpture invites us to walk through it, not around it. Whilst in the case of "Here I" the viewer's experience was dominated by visual impressions, his experience in the case of "Zim Zum" is dominated by physical sensations, and these physical sensations play an essential part in the process of perception. "Zim Zum" is not an untouchable esthetic arte-

133 *Zim Zum II*, 1969/85, on the
grounds of Lippincott Inc., North Haven,
Connecticut

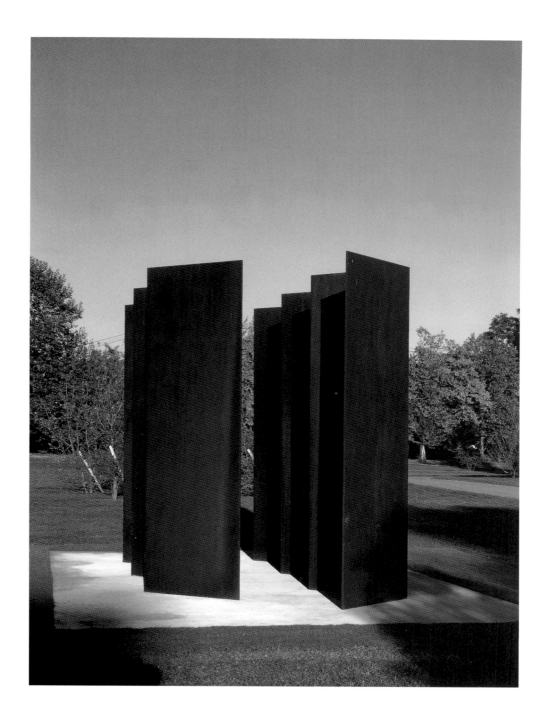

fact, a remote isolated object on a pedestal but, rather, an object of no practical use which
one must, quite literally, appropriate physically in order to understand it. Esthetic experi-
ence is not bound up solely with the viewer's sense of sight and his intellect; it is also linked
with his physical presence and motor functions, that is, with his active involvement in the
sculpture.

No matter how incomparable "Here I" and the two versions of "Zim Zum" may seem—separated as they are by almost twenty years—they are the result of an artistic development which increasingly shifted its emphasis from the transcendental to the phenomenological, from the metaphysical to the physical. With "Zim Zum I" and "Zim Zum II", Barnett Newman finally renounced all his noble ambitions of the forties in favor of a prosaic goal: the fusion of art with life. Whether, and to what extent, he succeeded in achieving this goal cannot be decided here. One thing, however, is clear: the sculpture does not deliver what its title promises. The kabbalistic associations are verbal, awakened solely by the title "Zim Zum", whilst in the actual sculpture they seem to be partially contradicted, even denied. The symbolic function observed in "Zim Zum I" plays only a subordinate role in "Zim Zum II", finding expression in the title rather than in the work itself. Unlike "Zim Zum I", with its tiny disadvantageous "wings", "Zim Zum II" has such a strong physical presence that the medium of expression becomes as important as what is expressed, indeed, they blend into self-referentiality, creating an even sturdier framework for the viewer's experiences when walking around and through the sculpture. The transcendence of these experiences is now bound up solely with the subject and no longer with the work.

Whereas in 1947 Newman's declared aim was to evoke "a memory of the emotion of an experienced moment of total reality."[21], by the sixties he was saying "the only way you can achieve human scale is by content"[22], and trying, in his titles, "to create a metaphor that will in some way correspond to what I think is the feeling in them [his paintings] and the meaning of it."[23] Generally, however, Newman sought to evoke an emotional complex. Whilst in the beginning it is an existential impulse which prevails and manifests itself in Newman's work, Newman later places greater emphasis on structural features, and even goes so far as to ascribe a social significance to his work.[24] For Newman, painting posed both physical and metaphysical problems.[25] In his last works—including "Zim Zum II", his very last work—the emphasis seems to have shifted more and more towards an evocation and articulation of physical experiences that were the precondition for intellectual and, in consequence, esthetic experience. Viewed in this light, "Zim Zum II" is Newman's ultimate sculptural legacy.

134 *Zim Zum II*, 1969/85 (Cat. No. 41)
Kunstsammlung Nordrhein-Westfalen,
Düsseldorf

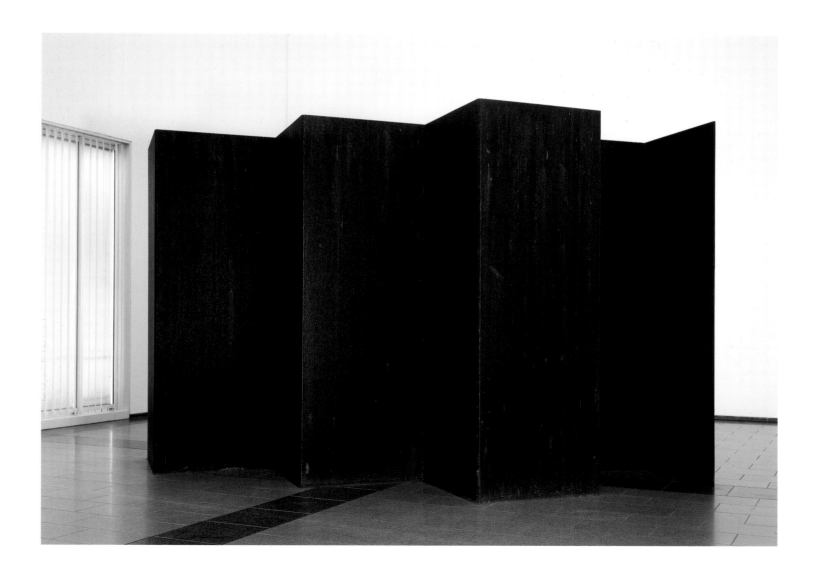

326

1 The exhibition was subsequently extended until November 30, 1969.

2 The letter is in the archives of The Barnett Newman Foundation, New York.

3 A photograph of "Zim Zum I" on the Lippincott factory grounds (Rosenberg, p. 223, Fig. 236) shows the sculpture positioned so that, when the sculpture is viewed from the side, the "entrance" is at the left. The posthumously fabricated "Zim Zum II" was also installed in this position. The engineering drawings from Lippincott show an "entrance" at the right-hand end in both cases (The Barnett Newman Foundation, New York). Consequently, at the Newman retrospective at the Museum of Modern Art, "Zim Zum I" was exhibited in the museum's Sculpture Garden with its "entrance" at the right-hand end. I cannot say whether Newman's sketch on the David Smith Steel Co. memo paper (Fig. 125) is proof that the right-hand positioning of the "entrance" is correct. To Western eyes accustomed to reading and looking at pictures from left to right, the positioning of the sculpture with the "entrance" on the right seems more convincing than the alternative.

4 Newman indeed compared the creative process with the structure of a sentence. In an interview in 1963, Newman said: "The empty canvas is a grammatical object—a predicate. I am the subject who paints it. The process of painting is the verb. The finished painting is the entire sentence, and that's what I'm involved in." Newman, *Writings*, p. 253.

5 The plate would actually have to be a fraction of an inch less than 37 inches in order for the proportions to be exactly in accordance with the golden section (ratio of 0.627 to 1).

6 Gershom Scholem, *On the Kabbalah and Its Symbolism.* Translated by Ralph Manheim. New York, 1965 [New edition 1996], p. 110.

7 Hess, p. 123 f.

8 Rosenberg, *Broken Obelisk*, p. 14.

9 Rosenberg, p. 79.

10 "Zim Zum I" appears rarely to have been exhibited. It formed part of the posthumous retrospective at the Museum of Modern Art (October 21, 1971– January 10, 1972) and was later shown at the Sculpture Center, New York (September 26–October 21, 1972), at the suggestion of Thomas B. Hess.

11 John Dewey, *Art as Experience* [1934], New York, 1958, p. 246.

12 Ibid., p. 48.

13 Robert Morris, *Notes on Sculpture, II* [1966], in: Gregory Battcock, *Minimal Art. A Critical Anthology*, New York, 1968, p. 232.

14 Newman in an interview with Dorothy Gees Seckler: "It would be easy for me now to talk about the transcendental, the self, revelation, etc. All painting worth anything has all this." Newman, *Writings*, p. 251.

15 Maurice Merleau-Ponty, *Phenomenology of Perception*, translated from the French by Colin Smith [1962], New York, 1996, p. 320.

16 Hess, p. 123.

17 Ibid., p. 124.

18 The Barnett Newman Foundation, New York.

19 *Barnett Newman. Zim Zum II*, Gagosian Gallery, New York, January 29–March 14, 1992. The exhibition catalog, with a preface by Robert Pincus-Witten and Ealan Wingate, also contains photographs of the Synagogue Model and texts by Barnett Newman. Cf. also Erik Saxon, *Steel Cosmogony*, in: *Art in America*, July 1992, p. 98 ff.

20 Hess, p. 124.

21 Newman, *Writings*, p. 163. In reply to a December 6, 1947, review by Clement Greenberg of the work of Adolph Gottlieb, Newman wrote a lengthy essay describing the character and aims of the new movement in American art. The essay was first published in Thomas B. Hess's 1969 Newman monograph.

22 Newman in an interview with Emile de Antonio. Newman, *Writings*, p. 307.

23 Newman in an interview with David Sylvester. Newman, *Writings*, p. 258.

24 "I still believe [. . .] that my work in terms of its social impact does denote the possibility of an open society, of an open world, not of a closed institutional world." Newman in an interview with Emile de Antonio. Cf. Newman, *Writings*, p. 308.

25 "The problem of a painting is physical and metaphysical." Newman, *Writings*, p. 259.

328 1905 Barnett Newman is born in New York on January 29 to Anna and Abraham
Newman, recent immigrants from Russian Poland. Throughout his youth,
Newman is a frequent visitor to the Metropolitan Museum of Art.

 1922 Attends courses at the Art Students League in New York. In the following
years he attends City College of New York, majoring in philosophy. Reads
Spinoza and Kropotkin.

 1931 Works full-time as a substitute art teacher in New York high schools
(until 1939). Makes the acquaintance of Mark Rothko.

 1933 Rents a studio; argues in favor of greater political commitment on the part
of artists.

 1936 Marries Annalee Greenhouse.

Barnett Newman working on
"Broken Obelisk" at
Donald Lippincott's plant, 1967

1939–41 Serious study of botany and ornithology.

1943–47 Makes the acquaintance of Betty Parsons for whose gallery he organizes exhibitions of pre-Columbian stone sculpture (1944) and Northwest Coast Indian painting (1946). New friends and acquaintances include Adolph Gottlieb, Hans Hofmann, Clyfford Still, Lee Krasner, and Jackson Pollock.

1948 Breaks with biomorphic style of painting. Paints "Onement I", his first abstract color-field painting with a "zip". Publishes his essay "The Sublime Is Now".

1950 First solo show at Betty Parsons Gallery.

1951 His second solo show at Betty Parsons Gallery receives annihilating criticism from reviewers and artists alike. Totally discouraged, Newman withdraws his paintings and decides not to exhibit again for the time being.

1958 Solo show at Bennington College, Vermont. Participates in the Museum of Modern Art exhibition "The New American Painting" which tours Europe.

1959 Successful solo show at French & Company, New York.

from 1962 Teaches at various American universities and delivers lectures.

1963 Participates in the exhibition "Recent American Synagogue Architecture" at the Jewish Museum, New York.

1964 First trip to Europe: London, Basel, Colmar, Paris, Chartres.

1965 Represents United States at the eighth São Paulo Bienal.

1966 Exhibits "The Stations of the Cross: Lema Sabachthani" at the Solomon R. Guggenheim Museum, New York.

1967/68 Two trips to Europe: Ireland, England, France, Switzerland, The Netherlands, Spain.

1969 Exhibition of Newman's lithographs at the Kunstmuseum Basel. Visits Houston, Texas, in order to view the future site of his sculpture "Broken Obelisk".

1970 Awarded Brandeis University Creative Arts Medal in Painting for 1969–70. Dies on July 4.

330

Cat. No. 1
Moment, 1946
Oil on canvas
30 x 16 ins.
Tate Gallery, London
Presented by Mrs. Annalee Newman, the
artist's widow, in honor of the Directorship of
Sir Alan Bowness, 1988
Fig. 5

Cat. No. 2
Two Edges, 1948
Oil on canvas
48 x 36 ins.
The Museum of Modern Art, New York
Gift of Annalee Newman, 1990
Fig. 46

Cat. No. 3
Abraham, 1949
Oil on canvas
82¾ x 34½ ins.
The Museum of Modern Art, New York
Philip Johnson Fund, 1959
Figs. 26, 48

Cat. No. 4
Covenant, 1949
Oil on canvas
48 x 60 ins.
Hirshhorn Museum and Sculpture Garden
Smithsonian Institution, Washington, D.C.
Gift of Joseph H. Hirshhorn, 1972
Fig. 47

Cat. No. 5
The Wild, 1950
Oil on canvas
95¾ x 1⅝ ins.
The Museum of Modern Art, New York
Gift of the Kulicke Family, 1969
Fig. 50

Cat. No. 6
Eve, 1950
Oil on canvas
96 x 68 ins.
Tate Gallery, London
Purchased 1980
Fig. 49

Cat. No. 7
Untitled (Number 2), 1950
Oil on canvas
48 x 5¼ x 2½ ins.
The Menil Collection, Houston
Fig. 52

Cat. No. 8
Cathedra, 1951
Oil and magna on canvas
96 x 213 ins.
Stedelijk Museum, Amsterdam
Fig. 51

Cat. No. 9
Prometheus Bound, 1952
Oil on canvas
132 x 50 ins.
Folkwang Museum, Essen
Fig. 54

Cat. No. 10
Achilles, 1952
Oil on canvas
96 x 79 ins.
National Gallery of Art, Washington, D.C.
Gift of Annalee Newman in honor of the
fiftieth anniversary of the National Gallery of
Art (1988.57.5)
Fig. 53

Cat. No. 11
Tertia, 1964
Oil on canvas
78 x 35⅛ ins.
Moderna Museet, SKM, Stockholm
Fig. 55

Cat. No. 12
Profile of Light, 1967
Acrylic on linen
120 x 75 ins.
Museo Nacional Centro de Arte
Reina Sofía, Madrid
Fig. 57

Cat. No. 13
Anna's Light, 1968
Acrylic on canvas
108 x 240 ins.
Kawamura Memorial Museum of Art
Fig. 60

Cat. No. 14
Shimmer Bright, 1968
Oil on canvas
72 x 84 ins.
The Metropolitan Museum of Art, New York
Gift of Annalee Newman, 1991
Fig. 56

Cat. No. 15
Jericho, 1968/69
Acrylic on canvas
106 x 112½ ins.
Musée national d'art moderne,
Centre Georges Pompidou, Paris
Joint purchase with B. and E. Goulandris (1986)
Fig. 58

Cat. No. 16
Chartres, 1969
Acrylic on canvas
120 x 114 ins.
Daros Collection, Switzerland
Fig. 59

Cat. No. 17
**Who's Afraid of Red, Yellow and Blue IV,
1969/70**
Acrylic on canvas
108 x 238 ins.
Staatliche Museen zu Berlin – Preußischer
Kulturbesitz
Nationalgalerie und Verein der Freunde der
Nationalgalerie
Fig. 61

Cat. No. 18
Broken Obelisk
Felt-tip pen on paper
11 x 8½ ins.
The Menil Collection, Houston
Gift of Annalee Newman
Fig. 109

Cat. No. 19
Untitled, 1944
Oil, oil crayon and pastel on paper
19³/₈ x 25¹/₂ ins.
Courtesy Anthony d'Offay Gallery, London
Fig. 6

Cat. No. 20
Untitled, 1946
Brush and ink on paper
23³/₄ x 17³/₄ ins.
Mr. and Mrs. Stanley R. Gumberg
Fig. 62

Cat. No. 21
Untitled (The Break), 1946
Brush and ink on paper
36 x 24 ins.
Musée national d'art moderne,
Centre Georges Pompidou, Paris
Gift of Annalee Newman
with the aid of Georges Pompidou Art and
Culture Foundation (1986)
Fig. 63

Cat. No. 22
Untitled, 1946
Brush and ink on paper
19 x 13 ins.
Collection Richard Serra and
Clara Weyergraf-Serra
Fig. 64

Cat. No. 23
Untitled, 1946
Brush and ink on paper
24 x 18 ins.
Louisiana Museum of Modern Art, Humlebaek
Gift of Annalee Newman
Fig. 65

Cat. No. 24
Untitled, 1946
Brush and ink on paper
11 x 7¹/₂ ins.
Constance R. Caplan, Baltimore
Figs. 15, 68

Cat. No. 25
Untitled, 1949
Brush and ink on paper
17 x 21¹/₄ ins.
Courtesy Anthony d'Offay Gallery, London
Fig. 66

Cat. No. 26
Untitled, 1949
Brush and ink on paper
21 x 7¹/₂ ins.
The Menil Collection, Houston
Fig. 67

Cat. No. 27
Untitled, 1960
Brush and ink on paper
14 x 10 ins.
The Metropolitan Museum of Art, New York
Gift of Annalee Newman, 1992
Fig. 69

Cat. No. 28
Untitled, 1960
Brush and ink on paper
14 x 10 ins.
The Art Institute of Chicago
Through prior gift of the Charles H. and
Mary F. S. Worcester Collection
Fig. 70

Cat. No. 29
Untitled, 1960
Brush and ink on paper
14 x 10 ins.
The Art Institute of Chicago
Through prior gift of the Charles H. and
Mary F. S. Worcester Collection
Fig. 73

Cat. No. 30
Untitled, 1960
Brush and ink on paper
14 x 10 ins.
The Art Institute of Chicago
Through prior gift of Mrs. Arthur T. Aldis
Fig. 72

Cat. No. 31
Untitled, 1960
Brush and ink on paper
12 x 9 ins.
Louisiana Museum of Modern Art, Humlebaek
Gift of Annalee Newman
Fig. 71

Cat. No. 32
18 Cantos, 1963/64
Portfolio of 19 colored lithographs: 18 prints
and title page
Original box (designed by the artist, hand-
made by Caroline Horton)
With preface by the artist and dedication to
Annalee Newman, and colophon page
Limited edition, No. 9/18
Staatliche Museen zu Berlin – Preußischer
Kulturbesitz, Kupferstichkabinett

Title Page, 1964
Lithograph
25 x 19 ¹/₄ ins.

Colophon Page, 1964
22¹/₂ x 17¹/₂ ins.

Preface
22¹/₂ x 17¹/₂ ins.

Canto I, 1963
Lithograph
25¹/₄ x 20 ins.

Canto II, 1963
Lithograph
16³/₈ x 15³/₄ ins.

Canto III, 1963
Lithograph
19³/₄ x 13³/₄ ins.

Canto IV, 1963
Lithograph
20¹/₈ x 13⁷/₈ ins.

Canto V, 1963
Lithograph
19¹/₂ x 14³/₄ ins.

Canto VI, 1963
Lithograph
16¹/₂ x 13 ins.

Canto VII, 1963
Lithograph
16³/₈ x 16 ins.

Canto VIII, 1963
Lithograph
17⁷/₈ x 15 ins.

Canto IX, 1964
Lithograph
16³/₈ x 15³/₄ ins.

Canto X, 1964
Lithograph
17³/₄ x 14⁵/₈ ins.

Canto XI, 1964
Lithograph
17¹/₂ x 14³/₄ ins.

Canto XII, 1964
Lithograph
17⁵/₈ x 15 ins.

Canto XIII, 1964
Lithograph
17³/₄ x 14³/₄ ins.

Canto XIV, 1964
Lithograph
16³/₈ x 13¹/₄ ins.

Canto XV, 1964
Lithograph,
15³/₈ x 13⁷/₈ ins.

Canto XVI, 1964
Lithograph
17¹/₂ x 13¹/₂ ins.

Canto XVII, 1964
Lithograph
17¹/₂ x 13 ins.

Canto XVIII, 1964
Lithograph
25 x 19¹/₂ ins.
Fig. 74

Cat. No. 33
Notes, 1968 (I–XII)
18 etchings (limited edition, No. 4/7)
Öffentliche Kunstsammlung Basel
Kupferstichkabinett
Gift of Annalee Newman,
the artist's widow, 1979

Note I, 1968
Etching
20 x 14 ins.

Note II, 1968
Etching
20 x 14 ins.

Note III, 1968
Etching
20 x 14 ins.

Note IV, 1968
Etching
20 x 14 ins.

Note V, 1968
Etching
20 x 14 ins.

Note VI, 1968
Etching
20 x 14 ins.

Note VII, 1968
Etching
20 x 14 ins.

Note VIII – State I, 1968
Etching
14 x 20 ins.

Note VIII – State II, 1968
Etching and aquatint
14 x 20 ins.

Note IX – State I, 1968
Etching and aquatint
20 x 14 ins.

Note IX – State II, 1968
Etching and aquatint
20 x 14 ins.

Note IX – State III, 1968
Etching and aquatint
20 x 14 ins.

Note X, State I, 1968
Etching and aquatint
20 x 14 ins.

Note X – State II, 1968
Etching and aquatint
20 x 14 ins.

Note XI – State I, 1968
Etching and aquatint
20 x 14 ins.

Note XI – State II, 1968
Etching and aquatint
20 x 14 ins.

Note XII – State I, 1968
Etching
20 x 14 ins.

Note XII – State II, 1968
Etching and aquatint
20 x 14 ins.
Fig. 75

Cat. No. 34
Here I (To Marcia), 1950/62
Bronze
107¹/₈ x 28¹/₄ x 27¹/₄ ins.
Los Angeles County Museum of Art
Gift of Marcia S. Weisman (M.90.194.2)
Figs. 87, 88

Cat. No. 35
Model for a Synagogue, 1963
Painted wood and Plexiglas
72 x 47³/₅ x 21³/₅ ins.
Centre Canadien d'Architecture/
Canadian Centre for Architecture, Montréal
Gift of Annalee Newman
Fig. 90

Cat. No. 36
Here II, 1965
COR-TEN steel
122¹/₂ x 78¹/₂ x 50³/₈ ins.
Daros Collection, Switzerland
Figs. 102, 106

Cat. No. 37
Here III, 1965/66
Stainless steel and COR-TEN steel
132 x 23⁵/₈ x 18¹/₂ ins.
Öffentliche Kunstsammlung Basel
Kunstmuseum
Fig. 107

Cat. No. 38
Broken Obelisk, 1963/69
COR-TEN steel,
26 x 10¹/₂ x 10¹/₂ feet
The Museum of Modern Art, New York
Given anonymously, 1971
Fig. 114

Cat. No. 39
Lace Curtain for Mayor Daley, 1968
COR-TEN steel, galvanized barbed wire, and
enamel paint
70 x 48 x 10 ins.
The Art Institute of Chicago
Gift of Annalee Newman
Fig. 119

Cat. No. 40
Zim Zum I, 1969
COR-TEN steel
8 x 6¹/₂ x 15 feet
San Francisco Museum of Modern Art
Purchased through a gift of Phyllis Wattis
Fig. 127

Cat. No. 41
Zim Zum II, 1969/85
COR-TEN steel
11 feet 10 inches x 17 feet 2¹³/₁₆ inches x 8 feet
6³/₈ inches
Kunstsammlung Nordrhein-Westfalen,
Düsseldorf
Figs. 122, 123, 130–34

Hess
Thomas B. Hess, *Barnett Newman*, The Museum
of Modern Art, New York, 1971.

Hess, 1969
Thomas B. Hess, *Barnett Newman*, New York,
1969.

Newman, *Writings*
Barnett Newman, *Selected Writings and Inter-
views*, ed. by John P. O'Neill; text notes and
commentary by Mollie McNickle; introduction
by Richard Shiff, New York, 1990.

Richardson
Brenda Richardson, *Barnett Newman. The
Complete Drawings, 1944–1969*, The Baltimore
Museum of Art, 1979.

Rosenberg
Harold Rosenberg, *Barnett Newman*, New York,
1978. Reprint 1994, ed. by John P. O'Neill, with
additions to bibliography and index of exhibi-
tions by Heidi Colsman-Freyberger.

Rosenberg, *Broken Obelisk*
Harold Rosenberg, *Barnett Newman: "Broken
Obelisk" and Other Sculptures*, Seattle and
London, 1971 (=Index of Art in the Pacific
Northwest, No. 2).

Basic sources
Listed chronologically

Thomas B. Hess, *Barnett Newman*. New York,
1969.
——— *Barnett Newman*. Exh. cat. The Museum
of Modern Art, New York, 1971/72.
Reprinted in: exh. cat. Stedelijk Museum,
Amsterdam, 1972 (in Dutch); exh. cat.
The Tate Gallery, London, 1972; and exh.
cat. Grand Palais, Galeries Nationales,
Paris, 1972 (in French).
Harold Rosenberg, *Barnett Newman. "Broken
Obelisk" and Other Sculptures*, Seattle and
London, 1971 (Index of Art in the Pacific
Northwest, No. 2).
Max Imdahl, *Barnett Newman. Who's Afraid of
Red, Yellow and Blue III*. Stuttgart, 1971
(= Werkmonographien zur Bildenden
Kunst 147). Reprinted in: Christine Pries
(ed.), *Das Erhabene. Zwischen Grenzer-
fahrung und Größenwahn*. Weinheim, 1989,
pp. 233–253, and: Max Imdahl, *Zur Kunst
der Moderne. Gesammelte Schriften*. Vol. I,
ed. by Angeli Janshen-Vukićević,
pp. 244–73.
Harold Rosenberg, *Barnett Newman*. New York,
1978 (2nd edition, New York, 1994).
Brenda Richardson, *Barnett Newman. The
Complete Drawings, 1944–1969*. Exh. cat.
Baltimore, 1979.
Hugh M. Davies and Riva Castleman, *The Prints
of Barnett Newman*. Exh. cat. University
Gallery, University of Massachusetts, Fine
Arts Center, Amherst, 1983. German-
language edition: *Barnett Newman. Das
druckgraphische Werk*. Exh. cat. Städtisches
Museum Abteiberg, Mönchengladbach,
1986, and Städtische Galerie im
Städelschen Kunstinstitut, Frankfurt am
Main, 1987.
Yve-Alain Bois, *"Perceiving Newman"*, in: Yve-
Alain Bois, *Painting as Model*. Cambridge,
Mass., 1990, pp. 186–213. First published
in: *Barnett Newman. Paintings*. Exh. cat.
The Pace Gallery, New York, 1988.
Barnett Newman, *Selected Writings and Inter-
views*. Ed. by John P. O'Neill. With an
introduction by Richard Shiff and text
notes and commentary by Mollie
McNickle. New York, 1990.

Gabriele Schor, *Barnett Newman. Die Druck-
graphik 1961–1969*. Exh. cat. Staatsgalerie
Stuttgart; Camden Arts Centre, London;
Kunstmuseum Bern; and Albertina,
Vienna, 1996/1997. Ostfildern-Ruit, 1996.
Barnett Newman, *Schriften und Interviews
1925–1970*. Ed. by John P. O'Neill. With
an introduction by Richard Shiff and text
notes and commentary by Mollie
McNickle; translated into German by Tar-
cisius Schelbert. Bern and Berlin, 1996.

Additional sources

Books
Listed alphabetically by author

Michael Auping (ed.), *Abstract Expressionism. The
Critical Developments*. Buffalo, New York,
1987.
Bruce Barber, Serge Guilbaut, and John O'Brian
(eds.), *Voices of Fire. Art, Rage, Power, and the
State*. Toronto, Buffalo, and London, 1996.
Anne Tiffany Bell, *Barnett Newman's Art*. (Bache-
lor's thesis, Princeton University), 1976.
Michael Bockemühl, *Die Wirklichkeit des Bildes.
Bildrezeption als Bildreproduktion. Rothko,
Newman, Rembrandt, Raphael*. Stuttgart,
1985.
Stewart Buettner, *American Art Theory
1945–1970*. Ann Arbor, 1981 (Studies in
the Fine Arts: Art Theory).
Annette Cox, *Art-as-Politics. The Abstract Expres-
sionist Avant-Garde and Society*. Ann Arbor,
1982 (Studies in the Fine Arts, The Avant-
Garde, No. 26).
Madeleine Deschamps, *Barnett Newman et
Mark Rothko. La création d'un lieu*. (Ph.D.
diss., Université de Paris, Panthéon-
Sorbonne), n.d. [early 1970s].
Sebastian Egenhofer, *The Sublime is Now. Zu den
Schriften und Gesprächen Barnett
Newmans*. Koblenz, 1996.
Serge Guilbaut, *How New York Stole the Idea of
Modern Art. Abstract Expressionism,
Freedom, and the Cold War*. Chicago and
London, 1983.
——— (ed.), *Reconstructing Modernism. Art in
New York, Paris, Montreal 1945–1964*.
Cambridge, Mass., and London, 1990.

Nicolas Hepp, *Das nicht-rationale Werk: Jackson Pollock, Barnett Newman. Ansätze zu einer Theorie handelnden Verstehens.* (Ph.D. diss., Ruhr-Universität Bochum), Essen, 1982.

Julian Heynen, *Barnett Newmans Texte zur Kunst.* (Ph.D. diss., Technische Hochschule Aachen, 1976), Hildesheim and New York, 1979 (= Studien zur Kunstgeschichte, 10).

Christa Erika Johannes, *Relationships between Some Abstract Expressionist Painting and Samuel Beckett's Writing.* (Ph.D. diss., University of Georgia, 1977), Ann Arbor, 1978.

Michael Leja, *Reframing Abstract Expressionism. Subjectivity and Painting in the 1940s.* New Haven and London, 1993.

Lily Mark, *The Relevance of Title to Form and Content in the Mature Work of Barnett Newman.* (Master's thesis, University of the Witwaterstrand, South Africa), n.d.

Patrick Negri, *Signs of Being. A Study of the Religious Significance of the Art of Barnett Newman, Jackson Pollock, and Mark Rothko.* (Ph.D. diss., Graduate Theological Union, Berkeley, California), 1990.

Benjamin G. Paskus, *The Theory, Art, and Critical Reception of Barnett Newman.* (Ph.D. diss., University of North Carolina at Chapel Hill), 1974.

Stephen Polcari, *The Intellectual Roots of Abstract Expressionism.* (Ph.D. diss., University of California), 1980.

———— *Abstract Expressionism and the Modern Experience.* Cambridge, 1991.

David M. Quick, *Meaning in the Art of Barnett Newman and Three of His Contemporaries. A Study in Content in Abstract Expressionism.* (Ph.D. diss., University of Iowa), 1978.

Barbara Reise, *"Primitivism" in the Writings of Barnett B. Newman. A Study in the Ideological Background of Abstract Expressionism.* (Master's thesis, Columbia University), 1965.

Max Reithmann, *L'espace et la problématique du sujet dans la peinture de Barnett Newman.* Thèse de 3è cycle sous la direction de Roland Barthes. Ecole des Hautes Etudes en Sciences Sociales, Paris, 1977 [typescript].

Karl Ruhrberg, *Barnett Newman. Dem Grenzenlosen gegenüber.* Munich, 1992 (= Künstler. Kritisches Lexikon der Gegenwartskunst, 19).

Irving Sandler, *The Triumph of American Painting. A History of Abstract Expressionism.* London, n.d. [1970].

David and Cecile Shapiro (eds.), *Abstract Expressionism. A Critical Record.* Cambridge and New York, 1990.

Esther Sparks, *Universal Limited Art Editions. A History and Catalogue. The First Twenty-Five Years.* New York, 1989.

Raimund Stecker, *"The Stations of The Cross, lema sabachthani" von Barnett Newman. Untersuchung über die Aufhebung der Widersprüchlichkeit von Form und Inhalt.* (Ph.D. diss., Ruhr-Universität Bochum), 1993.

Paul Wood, Francis Frascina, Jonathan Harris, and Charles Harrison, *Modernism in Dispute. Art since the Forties.* New Haven and London, 1993.

Essays
Listed alphabetically by author

Lawrence Alloway, "Barnett Newman", in: *Artforum* 3 (June 1965), pp. 20–22.

———— "Notes on Barnett Newman", in: *Art International* 13 (Summer 1969), pp. 35–39.

———— " One Sculpture", in: *Arts Magazine* 45 (May 1971), pp. 22–24.

———— "Color, Culture, The Stations. Notes on the Barnett Newman Memorial Exhibition", in: *Artforum* 10 (December 1971), pp. 31–39.

Dore Ashton, "New York Report", in: *Das Kunstwerk* 16 (November – December 1962), p. 68 f.

———— "Barnett Newman and the Making of Instant Legend", in: *Arts and Architecture* 83 (June 1966), pp. 4–5, 34.

Elizabeth C. Baker, "Barnett Newman in a New Light", in: *ARTnews* 67 (February 1969), p. 38 ff.

Susan J. Barnes, "The Making of the Chapel: *Broken Obelisk*", in: *The Rothko Chapel. An Act of Faith.* Austin, Texas, 1989, pp. 90–99.

Roland van der Berghe, "Piet Mondrian und Barnett Newman", in: *Die Wirklichkeit des Geistigen in der abstrakten Kunst.* Stuttgart, 1988, pp. 59–75.

Yve-Alain Bois, "Artist as Critic", in: *Art in America* 79 (April 1991), pp. 37–41.

———— "Barnett Newman's Sublime = Tragedy", in: *Negotiating Rapture. The Power of Art to Transform Lives.* Exh. cat., Museum of Contemporary Art, Chicago, 1996.

Nicolas Calas, "Subject Matter in the Work of Barnett Newman", in: *Arts Magazine* 42 (November 1967), pp. 38–40.

Barbara Cavaliere, "Barnett Newman's 'Vir Heroicus Sublimis'. Building the 'Idea Complex'", in: *Arts Magazine* 55 (January 1981), pp. 144–52.

Paul Crowther, "Barnett Newman and the Sublime", in: *Oxford Art Journal* 7 (1984), pp. 52–59.

Rolf-Gunther Dienst, "Absolute Malerei: Zu einer Kunst der Reduktion und Differenzierung", in: *Das Kunstwerk* 34 (1981), pp. 3–47.

Thierry de Duve, "Who's Afraid of Red, Yellow, and Blue?" in: *Artforum* 22 (September 1983), pp. 30–37.

Andreas Franzke, "Newmans absolute Formen", in: *Skulpturen und Objekte von Malern des 20. Jahrhunderts.* Cologne, 1982, pp. 228–34.

Anne Gibson, "Abstract Expressionism's Evasion of Language", in: *Art Journal*, Vol. 47, No. 3 (Fall 1988), pp. 208–14.

Anne Gibson, "Retracing Original Intentions. Barnett Newman and Tiger's Eye", in: *Art International* 31 (Winter 1988), pp. 14–23.

David J. Glaser, "Transcendence in the Vision of Barnett Newman", in: *The Journal of Aesthetics and Art Criticism* 40 (Summer 1982), pp. 415–20.

Laszlo Glozer, "Barnett Newman", in: *Kunstkritiken*, Frankfurt/M, 1974, pp. 236–41.

E. C. Goossen, "The Philosophic Line of Barnett Newman", in: *ARTnews* 57 (Summer 1958), pp. 30–31, 62–63.

Peter Halley and Jeremy Gilbert-Rolfe, "On/Über Barnett Newman", in: *Parkett* 16 (1988), pp. 18–27.

Thomas B. Hess, "Newman", in: *ARTnews* 49 (March 1950), p. 48.

———— "Editorial. Barnett Newman, 1905–1970", in: *ARTnews* 69 (September 1970), p. 29.

Donald Judd, "Barnett Newman", in: Donald Judd. *Complete Writings 1959–1975.* Halifax and New York, 1975, pp. 200–202. First published in: *Studio International* 179 (February 1970), pp. 66–69.

Allan Kaprow, "Impurity", in: *ARTnews* 61 (January 1963), pp. 30–33, 52–55.

———— "Barnett Newman. Ein Klassiker?" in: Jürgen Claus, *Kunst heute—Personen, Analysen, Dokumente.* Hamburg, 1965, pp. 74–78.

Bernhard Kerber, "Der Ausdruck des Sublimen in der amerikanischen Kunst", in: *Art International* 13 (December 1969), pp. 31–36.

———— "Streifenbilder. Zur Unterscheidung ähnlicher Phänomene", in: *Wallraf-Richartz-Jahrbuch* 32 (1970), pp. 235–56.

334

Jean-Claude Lebensztejn, "Homme nouveau, art radicale", in: *Critique*, XLVII, 528 (May 1991), pp. 323–37.

Charlotte Lichtblau, "Willem de Kooning and Barnett Newman: The Paintings of Two Friends in Antithesis But Not in Conflict", in: *Arts Magazine* 43 (March 1969), pp. 28–33.

Roelof Louw, "Newman and the Issue of Subject Matter", in: *Studio International* 187 (January 1974), pp. 26–32.

Jean-François Lyotard, "L'instant Newman", in: Michel Baudson (ed.), *L'Art et le temps*. Brussels, 1984, pp. 99–105. Published in German: "Der Augenblick, Newman", in: Jean-François Lyotard, *Das Inhumane, Plaudereien über die Zeit*. Vienna, 1989 (=Edition Passagen 28), pp. 159–88.

———— "The Sublime and the Avant-Garde", in: *Artforum* 22, No. 8 (April 1984), pp. 36–43. Published in German: "Das Erhabene und die Avantgarde", in: Jean-François Lyotard, *Das Inhumane, Plaudereien über die Zeit*. Vienna 1989 (= Edition Passagen 28), pp. 159–88.

Franz Meyer, "Zur Gültigkeit des Christusbildes in der ungegenständlichen Kunst. Die Kreuzwegstationen Barnett Newmans", in: *Kunst und Kirche* 2 (1982), pp. 60–66.

———— "Giacometti et Newman", in: *Alberto Giacometti. Sculptures, peintures, dessins*. Exh. cat. Musée d'Art Moderne de la Ville de Paris, Paris, 1991, pp. 59–65.

Robert Murray, "The Sculpture of Barnett Newman", in: Bruce Barber, Serge Guilbaut, and John O'Brian (eds.), *Voices of Fire. Art, Rage, Power, and the State*. Toronto, Buffalo, and London, 1996, pp. 165–71.

Peter Plagens, "Zip. Another Magazine Article on Barnett Newman", in: *Art in America* 59 (November 1971), pp. 62–67.

Stephen Polcari, "Barnett Newman's 'Broken Obelisk'", in: *Art Journal* (Winter 1994), pp. 48–55.

Judith Kay Reed, "Newman's Flat Areas", in: *Art Digest* 24 (February 1,1950), p. 16.

Barbara Reise, "The Stance of Barnett Newman", in: *Studio International* 179 (February 1970), pp. 49–63.

Max Reithman, "Newman et Mondrian", in: *Artistes* 1 (special issue, June 1984), pp. 50–67.

Harold Rosenberg, "Barnett Newman. The Living Rectangle", in: *The Anxious Object. Art Today and Its Audience*. New York, 1964, pp. 168–74.

———— "Barnett Newman and Meaning in Abstract Art", in: *Art International* 16 (March 1972), pp. 64–65, 72.

———— "Newman. Meaning in Abstract Art, II", in: *Art on the Edge. Creators and Situations*. New York, 1975, pp. 50–59.

Robert Rosenblum, "The Abstract Sublime", in: *ARTnews* 59 (February 1961), pp. 38–41, 56–58. Published in German: "Das Sublime in der abstrakten Malerei", in: Wieland Schmied (ed.), *Zeichen des Glaubens. Geist der Avantgarde*. Stuttgart, 1980, pp. 132–36.

Karl Ruhrberg, "Gegenbilder. Grenzüberschreitungen bei Barnett Newman und Mark Rothko", in: *Kunst und Kirche* 3 (1983), pp. 156–58.

———— "Ich arbeite mit dem gesamten Raum". Anmerkungen zu Barnett Newman, in: *Raum Zeit Stille*. Kölnischer Kunstverein, March 23 – June 2, 1985, pp. 51–65.

———— "Vom Schweigen der Bilder. Anmerkungen zum malerischen Werk Barnett Newmans", in: *Kölner Museumsbulletin* 2 (1991), pp. 4–17.

W. Jackson Rushing, "The Impact of Nietzsche and Northwest Coast Indian Art on Barnett Newman's Idea of Redemption in the Abstract Sublime", in: *Art Journal* 47 (Fall 1988), pp. 187–95.

Erik Saxon, "Steel Cosmogony", in: *Art in America* 80 (July 1992), p. 98 ff.

Sigrid Schade, "Inszenierte Präsenz. Der Riß im Zeitkontinuum (Monet, Cézanne, Newman)", in: G. C. Tholen and M. O. Scholl (eds.), *Zeit – Zeichen*. Weinheim, 1990, pp. 211–30.

Gabriele Schor, "Barnett Newman. Freie Farbe, lebendige Form", in: *Berner Kunstmitteilungen* 307 (November/December 1996), pp. 3–5.

Dorothy G. Seckler, "Frontiers of Space", in: *Art in America* 50 (Summer 1962), pp. 82–87.

Jeanne Siegel, "Around Barnett Newman", in: *ARTnews* 70 (October 1971), pp. 42–47, 59–62, 65–66.

David Sylvester, "The Ugly Duckling", in: Michael Auping (ed.), *Abstract Expressionism. The Critical Developments*. Buffalo, New York, 1987, pp. 137–45.

Germain Viatte, "Barnett Newman: l'illumination de *Shining Forth*", in: *Cahiers du Musée National d'Art Moderne* 1 (July–September 1979), pp. 108–19.

Beat Wyss, "Ein Druckfehler: Panofsky versus Newman. Verpaßte Chancen eines Dialogs", in: *Kunstforum International* 119 (May–June 1992), pp. 121–26.

Michael Zakian, "Barnett Newman and the Sublime", in: *Arts Magazine* 62 (February 1988), pp. 33–39.

———— "Barnett Newman. Painting and a Sense of Place", in: *Arts Magazine* 62 (March 1988), pp. 39–43.

Exhibition catalogs
Listed chronologically

Barnett Newman. First Retrospective Exhibition. (With contributions by Clement Greenberg and E. C. Goossen). Bennington College, Vermont, 1958.

Barnett Newman. A Selection, 1946–1952. (Text by Clement Greenberg). French & Company, Inc., New York, 1959.

Barnett Newman—de Kooning. Allan Stone Gallery, New York, 1962.

Barnett Newman. 18 Cantos. Nicholas Wilder Gallery, Los Angeles, 1965.

Barnett Newman. The Stations of the Cross— Lema Sabachthani. (Text by Lawrence Alloway). Solomon R. Guggenheim Museum, New York, 1966.

Barnett Newman. 22 Lithographien. (Text by Carlo Huber). Kunstmuseum Basel, 1969.

Barnett Newman. (Text by Thomas B. Hess). M. Knoedler & Co., Inc., New York, 1969.

Barnett Newman. January 29, 1905–July 4, 1970. Pasadena Art Museum, 1970.

Barnett Newman Memorial Exhibition. The Museum of Modern Art, New York, 1970.

Barnett Newman. Das lithographische Werk. (Text by Carlo Huber). Kammerkunsthalle, Bern, 1970.

Barnett Newman. (Text by Thomas B. Hess). The Museum of Modern Art, New York, 1971.

Barnett Newman. The Complete Drawings, 1944–1969. (Text by Brenda Richardson). Baltimore Museum of Art, 1979.

Barnett Newman. Tekeningen 1944–1969. (Text by Barbara Rose). Stedelijk Museum, Amsterdam, 1980.

Barnett Newman. Les Dessins 1944–1969. (With contributions by Barbara Rose and Alfred Paquement). Musée national d'art moderne, Centre Georges Pompidou, Paris, 1980/81.

Barnett Newman. Das zeichnerische Werk. (With contributions by Barbara Rose, Christoph Brockhaus, Bernd Vogelsang, and Karl Ruhrberg). Museum Ludwig, Cologne, and Kunstmuseum Basel, 1981.

Hommage à Barnett Newman. (With contributions by Dieter Honisch et al.), Nationalgalerie Berlin, Staatliche Museen Preußischer Kulturbesitz, Berlin, 1982.

PHOTOGRAPH CREDITS

336

The Prints of Barnett Newman. (With contributions by Hugh M. Davies and Riva Castelman). University Gallery, University of Massachusetts, Amherst, 1983

Barnett Newman. Paintings. (Text by Yve-Alain Bois). The Pace Gallery, New York, 1988.

Barnett Newman. Zim Zum II. Gagosian Gallery, New York, 1992.

Barnett Newman, Notes. 18 etchings and aquatints, 1968, and a lecture by Franz Meyer. Stedelijk Museum Amsterdam, 1993.

The Sublime is Now. The Early Work of Barnett Newman. Paintings and Drawings 1944–1949. (Text by Jeremy Strick). Walker Art Center, Minneapolis, Minnesota; The Saint Louis Art Museum, Missouri; and The Pace Gallery, New York, 1994.

Barnett Newman. Die Druckgraphik 1961–1969 (Text by Gabriele Schor). Staatsgalerie Stuttgart; Camden Arts Centre, London; Kunstmuseum Bern; and Albertina, Vienna, 1996/97, Ostfildern-Ruit, 1996.